Critical Praise for *Southland by Nina Revoyr*

- A *Los Angeles Times* Best Seller
- Winner: Lambda Literary Award
- Winner: Ferro-Grumley Literary Award
- Winner: American Library Association's Stonewall Honor Award
- Finalist: Edgar Award
- A Book Sense 76 Pick
- Selected for the *Los Angeles Times'* Best Books of 2003 list
- Selected for the InsightOut Book Club

"The plot line of *Southland* is the stuff of a James Ellroy or a Walter Mosley novel . . . But the climax fairly glows with the good-heartedness that Revoyr displays from the very first page."
—*Los Angeles Times*

"Compelling . . . never lacking in vivid detail and authentic atmosphere, the novel cements Revoyr's reputation as one of the freshest young chroniclers of life in LA."
—*Publishers Weekly*

"If Oprah still had her book club, this novel likely would be at the top of her list . . . With prose that is beautiful, precise, but never pretentious . . ."
—*Booklist* (starred review)

". . . an ambitious and absorbing book that works on many levels: as a social and political history of Los Angeles, as the story of a young woman discovering and coming to terms with her cultural heritage, as a multigenerational and multiracial family saga, and as a solid detective story."
—*Denver Post*

"Nina Revoyr gives us her Los Angeles, a loved version of that often fabled landscape. Her people are as reticent and careful as any under siege, but she sifts their stories out of the dust of neighborhoods, police reports, and family legend. The stories—black, white, Asian, and multiracial—intertwine in unexpected and deeply satisfying ways. Read this book and tell me you don't want to read more. I know I do."
—Dorothy Allison, author of *Bastard Out of Carolina*

"Subtle, effective . . . [with] a satisfyingly unpredictable climax."

—*Washington Post*

"Fascinating and heartbreaking . . . an essential part of L.A. history."

—*LA Weekly*

"An engaging, thoughtful book that even East Coasters can enjoy."

—*New York Press*

"A remarkable feat . . . Revoyr's novel is honest in detailing Southern California's brutal history, and honorable in showing how families survived with love and tenacity and dignity."

—Susan Straight, author of *A Million Nightingales*

"Dead-on descriptions of California both gritty and golden."

—*East Bay Express*

"*Southland* gripped my attention and would not let go until I turned the last page."

—*International Examiner*

"*Southland* is a simmering stew of individual dreams, family struggles, cultural relations, social changes, and race relations. It is a compelling, challenging, and rewarding novel."

—*Chicago Free Press*

Critical Praise for *The Necessary Hunger*

"*The Necessary Hunger* is the kind of irresistible read you start on the subway at 6 p.m. on the way home from work and keep plowing through until you've turned the last page . . . It beats with the pulse of life . . ."

—*Time Magazine*

"Quietly intimate, vigorously honest, and uniquely American . . . Tough and tender without a single false note."

—*Kirkus Reviews*

"Revoyr triumphs in blending many complex issues, including urban poverty and violence, adolescent sexuality, and the vitality

of basketball, without losing sight of her characters. She creates a family, in all senses of the word, of characters who are complex, admirable, and aggravating; readers will root for them on and off the court."

—*Detroit Free Press*

"Revoyr focuses on a number of issues, including competition, interracial relationships, and same-sex relationships . . . A thoughtful work . . ."

—*Library Journal*

"A wholesome coming-of-age novel about two high-school basketball stars, Revoyr's debut is a meditation on consuming passion and a reflection on lost opportunities . . . The basketball action, which builds climactically, honors the split-second timing and excitement of the game. Revoyr also evokes the feel of contemporary L.A., capturing crackheads, gang-bangers, and car-jackings in sharp, street-smart dialogue."

—*Publishers Weekly*

"Revoyr has unerringly caught the angst of teenagers, as well as the rarified, self-involved world in which they live . . . A sympathetic, tender rendering of the frustration of unrequited love."

—*Cleveland Plain Dealer*

"This book may in fact contain the most loving prose we'll see on basketball until John Edgar Wideman writes about his daughter Jamila, the gifted point guard for Stanford."

—*Chicago Tribune*

The
AGE of
DREAMING

The
AGE of
DREAMING

by NINA REVOYR

AKASHIC BOOKS
NEW YORK

This is a work of fiction. Names, characters, places, and incidents are the product of the author's imagination or are used fictitiously. Any resemblance to actual persons, living or dead, as well as events or locales, is entirely coincidental.

Published by Akashic Books
©2008 Nina Revoyr

ISBN-13: 978-1-933354-46-0
Library of Congress Control Number: 2007939593

First printing

Akashic Books
PO Box 1456
New York, NY 10009
info@akashicbooks.com
www.akashicbooks.com

Printed in Canada

For Patsy

That for which we find words is something already dead in our hearts.
—Friedrich Nietzsche

CHAPTER ONE
September 24, 1964

When I heard about the opening of the Silent Movie Theater, I should have known that someone would look for me—but the young man's phone call yesterday morning was still a surprise. He found me the easy way—by calling the operator—and the fact that my number is listed, under my own real name, is some measure of how rarely I've received such calls in the course of the last forty years. Yesterday morning, for example, when the telephone rang, I expected the caller to be Mrs. Bradford, from the town houses down the street— we often take breakfast together on weekend mornings, a practice that has become more frequent since her husband passed away—and I wasn't prepared for the young, unfamiliar voice which asked, "Excuse me, sir, but are you *the* Jun Nakayama, from the classic silent movie *Sleight of Hand*?" I was caught off-guard, and asked curtly how he had come to possess my number.

"My name is Nick Bellinger," the young man said, undaunted. "I'm an advisor to the people who are opening the new Silent Movie Theater. They've been trying to figure out what films to show—they don't know much about the silents except for Fairbanks and Chaplin—and when I suggested *your* films—I'm a huge fan, by the way—it occurred to me that I didn't know what happened to you. I mean, if it really *is* you. I figured you might still be around somewhere, and on a whim, I just dialed information."

By the time he finished, I had gathered myself again,

and I said as sternly as I could manage to without appearing rude, "Young man, this is a private residence, and my number is not for public use. Please don't call again. I no longer give interviews."

I realized my mistake when the caller exclaimed, "So you really *are* Jun Nakayama!"

But rather than answering I simply hung up, and then retreated into the kitchen to make some tea.

You might think my reaction to the phone call strange, but I didn't welcome this reminder of my past. It is not that I am ashamed of my career in film; no, quite the opposite. I remain proud of the films I appeared in, of which there were more than sixty; the works my peers and I created in the first two decades of this century laid the foundation for the subsequent growth of the movie industry. But it all happened so long ago, in such a different world, that these things seem like the accomplishments of an entirely different man. And the stranger's phone call yesterday morning was akin to a chance meeting with a friend from one's youth, who reminds one of how much has changed in the intervening years, and how far one's strayed from the course one first embarked upon. One must be friendly, both out of courtesy and to honor the past, but as soon as there's a chance to cut the conversation short, one does, and then quickly moves on.

I didn't always shy away from such attention. For more than a decade, and particularly in the years between 1915 and 1922, I gave countless interviews and posed for photographs and was often featured in the fan magazines. The lavish parties I held at my home in the Hollywood Hills sometimes drew up to five hundred people, and the opening nights for each one of my new films sold out at the country's most prestigious theaters. I was as famous and recognizable as a man could be at that time—an era quite different from the star-worship and tabloid sensationalism that started later, in the '30s and '40s, and that by now has

grown entirely out of control. I am grateful that the arc of my career was complete before the advent of television, which both cheapened films and destroyed the privacy of those actors who appeared in them. Still, I can't deny that it was jarring to go from being frequently recognized—and more importantly, from being identified in the autobiography of someone of the stature of Cecil B. DeMille as "easily the greatest dramatic actor of the silent era"—to entering my present state of invisibility. Although I am only seventy-three, few others from my era survive. Gerard Normandy and Ashley Bennett Tyler, my two most famous directors, are both long dead, as are most of my other directors and fellow actors. Nora Minton Niles is still alive somewhere, but I have not heard any word of her for years. Even the reporters who covered our movies all seem to be gone, and the few modern viewers who show an interest in silent films weren't even born when I retired. There is no one else who remembers what we did or who we were. No friends remain from that era. And I have no family.

Perhaps because of the completeness of my erasure from public memory, I have learned to take comfort in my obscurity. For the last forty-two years, I have lived in the same small town house at the foot of the Hollywood Hills, part of a complex that was opened in 1922, the year of my final film. I live a quiet life of morning walks up to the top of Runyan Canyon and afternoons of reading and tea, my routine altered only by phone calls or errands regarding my various properties. Occasionally I go down to the Boulevard to attend a film or a play, and on those evenings, as I pass by the Walk of Fame, I see the tourists taking pictures of the concrete-preserved signatures and hand-prints of my contemporaries—Chaplin, Pickford, Swanson, Fairbanks—as well as those of the stars who followed us to even greater fame—Bogart, Stewart, Monroe. None of my neighbors in the complex know that the older Japanese gentleman in unit 2B was once not only an actor, but an

international star. None of them, I think, would believe it. Just last week, in fact, when I went down to my corner pharmacy to purchase medication for my allergies—an affliction that fifty-three years in Los Angeles has done nothing to change—the pharmacist, Mr. Buchanan, a harried man in his middle forties, gave me a funny look and asked, "Mr. Nakayama, you weren't ever an actor, were you?"

I took the bag of pills from his hand and let out a small laugh. "What gave you *that* idea, Mr. Buchanan?"

"Mrs. Bradford," he answered. "You know how she always talks. She mentioned that you were once in a movie or something, but I should have known not to believe her."

"Our dear Mrs. Bradford has quite an active imagination."

The pharmacist nodded soberly. "Especially since she lost her husband." Then he brightened again. "Just imagine. Old Nakayama a movie star. What a funny idea!"

"Indeed!" I answered, forcing a smile.

This Mrs. Bradford has been a friend of sorts these last few years, ever since she and her husband moved into a town house just a half-block down the hill. Not long after they arrived, I happened upon her, in her gardener's gloves and hat, tending to the bougainvilleas that spilled over her gate. We struck up a conversation about the plants that flourished in our area—she and Mr. Bradford had just moved inland from Malibu—and that topic opened up into many others over the next several weeks, as we discovered a mutual love of classical music, literature, and theater. Less than a year after my new neighbors arrived, Mr. Bradford was struck with Alzheimer's disease. Mrs. Bradford had to care for him, which grew more difficult as the disease progressed, and her weekly breakfasts with me eventually became her one regular time of respite. Just before he died, at a moment when she seemed particularly burdened by her imminent loss, I mentioned, on the spur

of the moment, that I had once been an actor of some renown. I thought this admission might cheer her somehow, or at least distract her from her own sad circumstance. But her alarmingly blue eyes opened wide and she said, "Mr. Nakayama, are you pulling my leg?"

"No, Mrs. Bradford," I said. "I appeared in more than sixty films. If you refer to Davis Croshere's definitive *History of the Silent Film Era*, you will find a short account of my career, as well as several photographs."

She apparently did so, for the very next day she called with the news that a former colleague at the Los Angeles Public Library, where she'd been the director of program development for more than twenty years, had found references to me in several books.

"And to think," she said, "that all this time, without even knowing it, I've been spending Saturday mornings with the man who used to make young women faint in the theaters, the man the magazines called the 'Dashing Oriental.' Why didn't you ever tell me you were famous, Mr. Nakayama? And why does no one speak of you now?"

She then informed me that she intended to see all of my films, and to learn everything she could about my career. I didn't think much about the first possibility—most of my films, like most silents in general, were simply not preserved, and the few copies that have survived are parts of private collections. And when she did go searching through the histories of film, I trust that she found very little. There are just a few short paragraphs to document my ten years in Hollywood, scant words to describe the sum of a decade's work. I could have pointed her to them and saved her the trouble of looking. There is Mr. Croshere's classic, which she had already seen, Mr. DeMille's autobiography, J.B. Stark's *Encyclopedia of Film*, Terry Canterbury's *Hollywood: A Historical Perspective*, and William Anderson's *Black and White and Silent: The Birth of American Film*. In each of these works, there is at least a full-page account of my career, and in the

books by Mr. Croshere and Mr. Canterbury, I warrant a full subsection of a chapter.

While both men are able critics and clear lovers of film, I believe their analyses of my career to be incomplete, with facile and inaccurate conclusions. For example, they both greatly exaggerate the disapproval in Japan and Little Tokyo of the role I played as the casino owner in *Sleight of Hand*, and they mistakenly assert that my career was later affected by rising sentiment against the Japanese. In the first instance, it is true that some officials in Japan, and a few of the more conservative members of the Japanese community in Los Angeles, objected to my role as Sasaki. They thought his characterization as a deceptive seducer reflected poorly on the Oriental male. But I have always thought it was misguided to attach too much significance to something so fanciful and ephemeral as film. Moreover, the fact that I even appeared in such prominent roles was itself an indication of racial progress.

It is also a mistake to assume that the waning of my career was attributable to prejudice. While it may be true that some Americans did not embrace the Japanese, this had little to do with the reception of my films, and the accounts by both historians overlook the extent to which I engineered my own departure. The fact is, my retirement from film in 1922 was completely voluntary. My star was simply too bright to be extinguished by a handful of narrow-minded studio executives, and while I certainly appreciate these writers' indignation, their accounts are simply inaccurate. Nobody forced me to stop making pictures. It was I who made that decision.

My career ended, however, just as the Hollywood publicity machine was fully maturing, and perhaps that is why I am now almost totally absent from the national collective memory of early film. My contemporaries, like Chaplin and Fairbanks, were once no more recognizable than I—but from almost precisely the moment I stopped mak-

ing films, their fame grew, while my own began to fade. Yet what has surprised me more than my excision from official documentation of early Hollywood is my absence from more personal accounts. Mr. DeMille is the only director who discussed me extensively in his memoirs, and Faith Valiant, the accomplished dramatic actress, was once quoted as saying that everything she knew about the craft of acting she learned from watching me. But in Fairbanks' memoirs, in Pickford's, my name appears a total of three times, and William Moran only lists me as one of his "discoveries" without going on to discuss my future success. All accounts of the Normandy Players make me sound like a bit player, and the flurry of articles on the unsolved murder of Ashley Bennett Tyler barely mentioned me at all. This, despite the fact that I starred in twelve of his pictures, and that I, along with the teenage actress Nora Minton Niles, was set to start shooting a new film with him the very week he died. This, despite the fact that I was held by the police for several hours for questioning and released with the threat of further interrogation. I was his player, I was one of the people who helped secure his fame, and yet I appear nowhere in the stories of that period. It is as if I never truly existed, as either an actor or potential witness. But that is a different story I will not consider here.

I mention all of this—Mrs. Bradford, the pharmacist, my forgotten career—to give some sense of why I was so startled by the phone call yesterday morning. It has been fifteen years since I granted an interview, and that one occasion, in 1949, which coincided with the remake of my picture *The Stand*, never led to an actual article. Before that interview, I had not spoken to anyone regarding my films for over twenty years.

If I had been more cognizant of how ardently fans behaved in this new era; if I'd been aware of the focused attention that simple contact could trigger, I might have anticipated Mr. Bellinger's second call. But again this

morning, when the telephone rang, I expected someone else: the painters I've hired to repaint my living room, who seem to run perpetually late. But instead of Mr. Gomez, the head of the crew, I heard the now-familiar breathless voice. "Mr. Nakayama, sir," said Nick Bellinger, "I'm sorry to bother you again, but I never got a chance to tell you why I'm calling. You see, I'm not just an advisor to the Silent Movie Theater. I'm also a writer for the *L.A. Observer*, and I'm doing a piece on the theater. And as part of that article, I'm trying to find stars from the silent era to see what they've been doing all these years. I was especially interested in your career, since it ended so abruptly. And I know you worked with all the major directors from that time, and that you were one of the original actors at Perennial Pictures. I was hoping that I could meet you and do an interview."

This news provoked several responses in me at once. It is true that I was one of the original players under contract at Perennial—the studio that the Normandy Players, along with several other small companies, evolved into. And while I cannot deny that there was a certain appeal to the idea of recalling my colleagues and some of our now-arcane methods of filmmaking, of describing the glamorous parties and dinners and myriad love affairs, there was also something about the young man's proposition that made me profoundly uneasy. There are many memories from that period I have treasured over the years—the films I worked on, the characters I portrayed, the late-night parties at the Cocoanut Grove—but there are also things that I would rather forget. I do not know what happened to most of my peers, the great majority of whom did not achieve lasting fame. And I felt that learning what had become of them, dredging up their once-bright but now forgotten careers, would diminish not only their memories, but all their past accomplishments. It is a tragedy when a man's great contributions to the world, once heralded by all, simply vanish beneath the rolling waves of time. I did not wish to be re-

minded of all that we had achieved momentarily, and lost. And so I said to the young man, "I am not interested."

I could almost hear him deflate, but he rejoined without a second's delay. "Mr. Nakayama," he said, "this is a great opportunity. If I can be frank, there just aren't that many of you left from the silent era, and this article could help give you the recognition you deserve."

I took a deep breath before I answered. "Young man, you are clearly not as avid a student of film as you profess to be. For if you were, you would certainly be aware that I received *tremendous* recognition throughout the course of my career. I . . ." and here I took a breath to level my voice. "I was twice named the year's most popular actor by *Moving Image Magazine*. I was regularly featured in *Photoplay* and *Motion Picture Classic*. For three years, I was the highest paid actor at Perennial Pictures, and the premiere of *Margin of Error* nearly caused a riot when it opened at Ebbets Field in Brooklyn. It is quite inaccurate to insinuate that I was somehow overlooked—I could not have asked for a higher degree of fame."

Bellinger paused for just a moment. "Yes, sir," he said. "I know that's all true. I didn't mean to imply . . . what I mean is, this article could be a way for *modern* audiences to learn of your accomplishments. Certainly your work could be more . . . *appreciated* today."

I tried not to sound angry when I replied. "I do not need you, young man, to tell me what *could* happen or what I should do. I thank you for your interest in my career, but I am content with my life, and do not wish to endure any further interruptions." With that, I hung the phone up, then went over to the window to look out for Mr. Gomez.

About twenty minutes later, Mr. Gomez and his two young workers arrived. I stayed with them for an hour, supervising as they moved the couch and armchairs away from the walls, taped off the floorboards, and covered all the furniture with drop cloths. Once they had completed

this preliminary work, Mr. Gomez gave me a patient look, which indicated that he wished me to leave. Since I could do nothing in the kitchen or my bedroom while this commotion was occurring, I changed into walking shoes and stepped outside.

As I do at least three mornings of every week, I walked two blocks to the entrance of Runyan Canyon Park. There is a lovely path that hugs the canyon walls and winds up into the hills; with each turn, more of the city disappears. One gains elevation at a surprisingly rapid rate, so that by fifteen minutes into the walk, when the path curves out toward the city again, one is startled by the smallness of the buildings below. It takes roughly half an hour to reach the summit, and it still surprises me that the Hollywood Hills—which seem daunting from the ground—are so painless and easy to climb.

For some reason, few people seem to know about the path. This morning, the conversation with Bellinger still fresh in my mind, I walked briskly up into the hills and saw only two other walkers. At the top I sat on a split log bench and looked out in all directions at the city. To my left, the majestic San Gabriel Mountains, which would be covered in a month or two with snow. To my right, the endless chain of the Santa Monica mountains, of which the Hollywood Hills are the final descending link. Behind me, the San Fernando Valley, flat and full of bungalows and greenery. And in front of me, spread all the way from the hills to the ocean, lay the city of Los Angeles proper. The few tall buildings of downtown stood in a clump to the left; the ocean created a lovely, sparkling blue border to the right. And in between, a vast tableau of humanity. One can easily identify Wilshire Boulevard, for it is marked by a steady line of high-rise buildings straight across the center of the landscape. Hancock Park is recognizable as well—not because of its lovely mansions, which are too far away to distinguish, but because of the lush green foliage, sustained

by imported water and hired care, that marks all wealthy areas of Los Angeles. The arches of Mann's Chinese Theater are visible from behind; Lake Hollywood lies above it, in the hills.

On many mornings, from this bench, I have watched the sun rise from behind the San Gabriel Mountains; on many evenings, I've watched it set over the ocean. I have been here when the neon signs atop the DuBarry and the Argyle light up at the first hint of darkness. I have been here, too, on evenings of movie premieres, when spotlights spring up from Hollywood Boulevard and shoot beams, like crossing swords, into the sky. When I first started taking this walk, in the 1920s, the landscape was full of barley fields, orange groves, and trees; there were only a few office buildings and scattered clumps of houses, and then the self-contained compounds of the studios. The green hills were pristine and almost totally free of structures, and miles of horseback trails meandered through the brush. That open, new, bucolic place has long since vanished now. I have watched this city grow from farmland into a vibrant metropolis.

This spot—the very top of the Hollywood Hills—is where I always go to clear my head. As a young man, before I came to America, I spent a week at a Zen Buddhist temple in the mountains of Nagano Prefecture, and those seven days of silence and meditation, of oneness with the world around me, I now remember as the most peaceful of my life. Now, the only time I ever achieve the sense of emptiness, awareness, and oneness I so yearn for is up on top of the hills, looking out at the rest of humanity. There, I feel both part of, and removed from, the everyday world of man. There, I am completely at peace with my own insignificance.

After an hour of looking out at the city, I made my way down the hill and onto the Boulevard. It was 11:30 now, and I suspected that Mrs. Bradford would be in one of two restaurants, where she often took her lunch at this pre-

noon hour to arrive in advance of the crowd. These res-
taurants are on the eastern end of the Boulevard, past the
countless gift shops and souvenir stands that have sprung
up in the last ten years. It is popular now to say that Hol-
lywood is a state of mind more than an actual place, since
the Boulevard itself has become as tasteless and as sub-
ject to bad elements as that other den of American excess,
Times Square. But in the '20s and '30s—indeed, all the way
through the early '50s—the physical Hollywood, the actual
place, was as real and glamorous as its image. It housed
the best restaurants, the finest nightclubs and cafés, and
sleek limousines were always pulling up in front of ele-
gant doorways to deposit this or that star or director. The
cheap knickknacks, the litter, the desperate people trading
in flesh—they did not appear until the 1950s, and did not
take the Boulevard over completely until the dawn of this
present decade. These days, only a scattering of the old
establishments remain, and it goes without saying that the
clientele is different. Only a few people with links to the old
Hollywood still frequent such places. The rest of the cus-
tomers are local businessmen who are largely ignorant of
the restaurants' history.

This noontime, I stopped first at the Café Figaro, a fine
establishment where Clark Gable used to dine. The inte-
rior was dark and intimate, with wood paneling and heavy,
leather-covered chairs. Even at midday it was difficult to
see; the lights were dim and the waitstaff moved around
in a hush. One could imagine what it looked like in the
1940s, when groups of thick-bellied men, smoking cigars
and drinking port, would talk and laugh well into the end-
less nights. After a moment, my eyes adjusted to the lights
and I looked around the restaurant. I was in luck—Mrs.
Bradford was seated at a small table near the window—
and, as she had not yet been served her meal, she waved
me over and invited me to join her. After a few pleasantries
about the weather and a recent visit from her daughter,

she paused and then looked at me curiously. "You seem rather harried today, Mr. Nakayama. Is something bothering you?"

I was surprised by her observation; she didn't normally remark upon my demeanor. "No, Mrs. Bradford. What gives you that idea?"

She looked at me closely. Although she is nearing seventy herself, she is quick-witted and energetic, and her eyes, by the light of the window, were still piercingly blue. "I'm not sure," she said. "But you look agitated. Like you've just seen a ghost."

I gave a small laugh and took the heavy, folded napkin off the table. "Well, to be quite honest, Mrs. Bradford, I received a surprising phone call this morning. As a matter of fact, it was the second such phone call in as many days. A young man who is working with the new silent movie theater has discovered that I am the actor he has seen in several films."

Mrs. Bradford leaned back, her smooth, unspotted hands spread flat on the table. "Why, that's marvelous, Mr. Nakayama! You have a fan!"

"But it is *not* marvelous, Mrs. Bradford. You see, he is also a reporter. Frankly, I have no interest in dredging up memories of my career, and this young man—it appears he will not easily be discouraged."

"Oh, don't be silly," said Mrs. Bradford, and there was no mistaking the scolding tone of her voice. "You know you love the attention. You can't stand that you've been forgotten—that's why you finally told *me*. I don't believe your modest act for a minute."

I was, of course, taken aback by her assertion, and while I knew that she meant it in a good-hearted fashion, I still found myself rather annoyed. This bluntness is a characteristic of American women to which I have never grown accustomed. I am certain that it is part of the reason why, despite a significant courtship with an American woman

and several other minor liaisons, I never chose to marry one. But Mrs. Bradford was not yet finished.

"And you were a sex symbol too," she said teasingly. "That makes it even worse. I don't care if you're Japanese, German, or from Dayton, Ohio. If a man was ever desirable to women, he thinks that everyone had better well remember it."

"Mrs. Bradford, you're gravely mistaken," I said, and I was about to embark on a more impassioned defense. Just at that moment, however, the waiter appeared, a diminutive and ageless man named Franco who has been employed at the restaurant for as long as I've been a customer.

"Would you like to order something, Mr. Nakayama?" he asked. "Mrs. Bradford didn't tell me she was expecting a lunch companion."

"I wasn't," said Mrs. Bradford. "But Mr. Nakayama here is full of surprises."

"Oh?" said Franco disinterestedly.

"Yes, full of *many* surprises. For example, do you know what he revealed to me a few months ago, Franco? He revealed that he was once an actor. A veritable star, in fact, who appeared in many films during the silent era."

"I see," said Franco. He flipped to a blank sheet of his notepad, pen poised to take my order. It was clear from his look of indifference that he didn't believe her.

"He was written about in all the magazines," Mrs. Bradford continued. She leaned toward Franco conspiratorially. "And apparently, he was quite a ladies' man."

At this, the waiter let out a sharp, short laugh. "I'll bet," he said. "A real Casanova."

Franco's casual disbelief provoked something in me, and I pulled myself up straight. "She is not joking, Mr. Franco. Although I do not often discuss it, I was once indeed a well-known actor."

"Oh, I believe you, sir," said Franco, bowing slightly

in his bright red coat. "I'm sure you were the toast of the town."

"Haven't you heard of *Sleight of Hand*?" My anger was rising. "It was the top-grossing film of 1915. Or *The Stand* or *The Noble Servant*? In each of these classic silent films, I played the male lead."

Franco grinned now, wearing a look of mirth that didn't fit his hangdog face. "*Sleight of Hand*," he said. "Yes, I think I've heard of that picture. But wasn't that Douglas Fairbanks?"

"It was I," I insisted, with a force that surprised me. "It was I, Jun Nakayama. If you do not believe me, consult the history books. Or ask Mrs. Bradford. She herself has read accounts of my career."

I appealed to her for help, but all she did was shake her head and laugh.

"Oh, Mr. Nakayama," said Franco. "Please, stop teasing me already. I've got a long shift ahead. Now, what can I bring you for lunch?"

He faced me with an expression of patient indulgence, which sent Mrs. Bradford into another fit of laughter. I was so frustrated that I got up and stormed out of the restaurant without speaking another word. I could hear Mrs. Bradford calling after me, but I refused to turn back. The whole episode had been extremely disconcerting. I did not see why these revelations regarding my past were so difficult for Franco to believe. He must have gathered over the years that I was a man of intelligence and refinement, and if he had happened to overhear even a few of my conversations, he would have been aware of my encyclopedic knowledge of early film. Perhaps his disbelief was heightened because of the fact that I'm Japanese, which I admit is quite unusual for a Hollywood actor. But none of this assuaged my displeasure.

When I returned to the town house, I found a message on the pad beside my phone, taken by Mr. Gomez

while I was gone. It was Nick Bellinger's number—he had called again—and without thinking about what I was doing, I picked up the receiver and dialed. After three rings, a young man answered. "Mr. Bellinger," I said. "This is Jun Nakayama. I've reconsidered your request for an interview."

CHAPTER TWO
September 29, 1964

This morning, as I waited for Mr. Bellinger on a bench in Plummer Park, I had the pleasure of observing a most delightful family. A Negro couple in their fifties, dressed as if for church, passed by with a gaggle of little girls. The children—there were three of them—ranged in age from perhaps three years old to seven or eight, and they too wore Sunday outfits, with the tiniest carrying a backpack that was nearly as large as she. The girls were all holding hands but they kept losing their grip, the chain unlinking and then reattaching itself again. The two adults—who I assumed were the children's grandparents—were trying to keep them together, but the girls were fast losing patience with each other, and bickering sweetly, each attempting to disengage from her sisters. They made their way slowly across the park, but when they were twenty feet away from me the entire chain broke, and all three girls sprung loose in different directions. At this point, instead of scolding them or running off to get them, the adults threw their hands up and laughed. They shook their heads in exasperation and shared a look of amusement, and then moved off to collect their charges. Just when everyone was gathered again, the oldest girl looked around and wailed, "Where's my dolly?" The man slapped a hand to his forehead, and the woman rolled her eyes. "Oh Lord," he said, smiling, "we must have left it in the restaurant." And so slowly, carefully, they all turned around and made their way back down the path.

This tableau made me think of my own advancing years, and the fact that, at the age of seventy-three, I do not have any grandchildren. The absence of grandchildren relates directly to my lack of immediate family. While there was, as I've said, an American woman with whom I was close, as well as a Japanese woman who played a significant role in my early career, the vagaries of Hollywood, and of American social norms, made all such unions impossible. My failure to marry is not something that pleases me—indeed, the absence of a family is my greatest regret. But, as with so many things that turned out differently than I'd hoped, there is nothing to be done at this late hour, and it does me no good to second-guess my choices. I cannot deny, however, that my life would now be richer if there were grown children as well as little ones, like those I saw this morning, to give my days purpose and joy.

In my youth and early adulthood, I never entertained such thoughts. My early days in Hollywood were unpredictable and heady. There was no future, only the present, and the project of the moment was everything. One tried to stay as uncommitted as one possibly could, in order to be prepared for the next development. And for the young, rising players in the early days of film, there was always a next development.

The great irony of my success in the motion picture world is that I never set out to become an actor. Such an existence seemed utterly frivolous to me. Indeed, other than my lifelong love of literature, I had no connection to the arts at all as a boy, and certainly no premonition that I myself would one day become a figure that other people paid to see. My intention when I came to America for schooling in 1907, all the way up until two days before my ship was scheduled to sail for Tokyo, was to return to Nagano Prefecture and become a schoolteacher. I had arranged to take a post at my old secondary school and teach courses in English and literature, and my time in America only added

to my value as a legitimate instructor in these subjects. At the University of Wisconsin, where I was an English major, I studied the literature of Britain and France; I developed a particular love for Hardy, Eliot, Dickens, and Forster, as well as a passable knowledge of Balzac and Flaubert. I loved the Russians, whose work I read in Japanese translation—Tolstoy, Turgenev, Dostoevsky. And I read plays and watched every theater company that passed through Madison, particularly those who performed Shakespeare and other classics of the English stage. Once, I even had the good fortune to see the Kyoto Players, the Japanese company led by the young actress and playwright Hanako Minatoya, when they performed *Spring Blossom* at the university theater. I was able to arrange my studies to include modern Japanese authors as well, such as Mori Ogai and Natsume Soseki; it was my dream to eventually do my own translations.

So it was with the intention of boarding a ship back to Tokyo that I took a train across the country to Los Angeles. This was in the spring of 1911, just after my twentieth birthday, and I faced my trip to Japan with apprehension. Although I looked forward to seeing my homeland and my family for the first time in four years, there had been many changes while I was away. My father had died during my second year at university, and I was afraid that his sickness and passing had aged my fragile mother as well. My older brother, Akira, who was managing the farm, had married a year previously, and his wife had borne a sickly child. My younger sister, Miya, had just turned seventeen; she was finished with school and there were apparently no prospects for marriage. And my little brother, Toru, who had been a mischievous and amusing boy of eight when I left, was twelve now, and driving everyone mad with his rebellions and declarations of autonomy. My presence, although I was only the second son, was expected to bring stability. Indeed, I had always been somewhat of a calming figure

in the family, despite the fact that I often lived outside of it. My mother wrote me many letters during the spring of my senior year, urging me to come home as quickly as I could.

But fate, I suppose, had something different in mind. When I arrived in Los Angeles, I stayed at the home of a Japanese-American friend, a classmate from the University of Wisconsin. His family, the Yamadas, lived in Boyle Heights, and they insisted that I experience some of the pleasures of the city and visit the center of its Japanese community. I was to spend five days in Los Angeles, and on each day they showed me a new wonder of the city: the ocean, the mountains, the orange groves. And on each of these nights we dined at an establishment owned by one of their friends—always in Boyle Heights or Little Tokyo, of course, the only parts of town where Japanese were welcome. By the end of the third evening, I was feeling so indulged and so tired of socializing that I asked my host, John Yamada, if we could strike out on our own. I wished to do nothing more than have a quiet meal and perhaps take in a performance. As a fellow English major and lover of the arts, John knew exactly where to take us.

The place was named simply, the Little Tokyo Theater. It was a small, plain structure, recently built, which held about a hundred people. It was located just off of First Street, walking distance from the many bars, and so John and I stopped for sake and snacks before rushing into our seats just as the lights went down. Perhaps we had consumed too much of the sake, for I can think of no other reason why I behaved as I did, which was, to say the least, uncharacteristic. But when the play began—a work so minor and forgettable I don't recall its name—it was so awful I couldn't mask my displeasure. Everything about it was wrong: The writing was awkward, the acting overwrought, the stage direction, sets, and lighting looked like the work of total amateurs. I was so offended by the poor quality

of the production, and by the fact that I had squandered one of my final nights in America on such a piece of rubbish, that I unleashed a stream of criticism, pointed but whispered, to John, who suffered beside me. No one, including us, was rude enough to walk out of the theater, but I could tell from the pursed lips and sagging eyelids that other people were as miserable as we. When the play ended, mercifully, a full two hours later, I stormed into the back hallways with a reluctant John behind me and demanded to see the manager. John pleaded with me to stop, but I was not to be denied, and I stood in the hallway complaining until a rumpled gentleman in his fifties finally stepped out of a doorway.

"I am Okamoto, the owner," he said to us, bowing. "And what can I do for you, young sirs?"

I bowed back quickly, introducing myself, and then forsook the usual pleasantries. "My friend and I just saw the play this evening, and it smells worse than the manure on my family's farm."

The man looked stunned. "I beg your pardon?"

"It was terrible," I said. "Badly written, badly acted, and an utter waste of my time and money. Excuse me for saying so, but if this is the kind of fare you usually offer at your theater, I would not be surprised to see it fail within the year."

Behind me, I could feel John shrinking in embarrassment. Okamoto's lips worked madly, and his glasses slid down his nose. "Well, I suppose *you* could do better, Mr. . . ."

"Nakabayashi," I said, "Junichiro Nakabayashi. And indeed I *could* do better! My friend John and I could put up a play that would keep your theater full for a month. Couldn't we, John?" I turned toward him for confirmation, but he looked away.

Okamoto, shifting in his too-large suit, considered me as if I were a madman. "What play do you propose to put on?" he asked.

"I have one in mind," I assured him, although in fact I had no idea.

"And exactly what kind of experience do you have in the theater?"

"None."

"None? Never acted? Never directed?"

"No. But I have seen enough theater to know what makes a good play. Give me a chance, Okamoto-san. Certainly a play that I produced couldn't be any worse than what I saw tonight."

Okamoto's eyebrows wiggled as if they had a life of their own. "Well, I *am* searching for another new play this season," he said, more to himself than to us. "And the last three productions have not been well-attended."

I sensed my opening, and forged ahead. "You won't be sorry, Okamoto-san. And besides, you have nothing to lose."

After another moment of hand-wringing, Okamoto beckoned us to join him in his office. John continued to shake his head in disbelief, and I was fully aware that he had little time to devote to my sudden project, as he was due to start working in his father's dry goods company the following Monday. But he sat patiently as Okamoto and I conversed. The owner told me about the history of the theater, which had opened two years earlier with the backing of several of Little Tokyo's most prominent businessmen; and about the daily challenges of running an artistic enterprise with actors, directors, and stagehands who all had regular full-time jobs. Apparently, after sellouts of the theater's first three productions, attendance had dropped off markedly—that night the theater had been half-full—and Okamoto and his backers were at a loss to explain why. When he told me the plays they'd put up there, I immediately saw the reason. They were all old Japanese dramas, tales that people had seen before, and probably to much greater effect.

"You have to engage people," I argued. "The people who came to America are the ones who were brave enough to leave everything behind. They don't want to see the same old stories. You need to excite them, give them something that is both entertaining and thought-provoking."

He nodded thoughtfully. "So what do you propose?"

By this time, an idea had come to me. There was a novel, published ten years earlier, entitled *The Indifferent Sea*, about a naval officer who falls in love with a girl in the town where he is stationed. The officer is promised to another young woman from his hometown, and to make matters worse, he discovers that the girl he loves is actually the daughter of his superior, the naval commander. Because she belongs to a higher social class than he, neither family would approve of their match. The lovers bemoan the cruelty of fate, but after several months of meeting secretly, they decide to do the proper thing and part. Within a year the young officer is married to the woman from his hometown—but then she passes away during childbirth. By the time he locates the commander's daughter, she is already married to someone else. He is left with neither the woman he loved nor the woman he married, and with a child he must raise by himself. By letting himself get caught between duty and desire, he gains nothing and loses all that he cares for.

It was a story whose themes of responsibility and social duty would appeal to the transplanted Japanese audience. But it was also a story with enough of a romantic twist to satisfy their desire for intrigue. I first encountered this novel when I was twelve; I surprised a classmate who was crying over a book on his stoop one afternoon as I passed him on my way home from school. After teasing him for his sensitivity, I asked what was having such a deep effect on him. He wordlessly handed over the book, and I started reading it right there, so engrossed in the story of young Officer Kubota that I forgot my friend was present. Later,

after he finished the book, he passed it on to me. Because
my family would have disapproved of me reading some-
thing so frivolous as a novel, I kept the book out in the
chicken coop and read it in bits when I went out to feed
the animals. For several days, when I came back into the
house, it was obvious I had been crying, until one day my
mother looked at me and shook her head. "Jun-chan, you
are growing too attached to the chickens. Don't mourn for
them. We may have to kill them soon, but I promise there
will always be more."

This novel had a tremendous effect on me—indeed, I
could go so far as to say that it ignited my love for the arts—
and it was one of the few items I had brought from Japan
that was not a strict necessity. I had playacted all the parts
as a boy hundreds of times, and knew almost every line in
the book. It was clear to me that this was my opportunity to
really play Kubota, and I already had an actress in mind for
the crucial part of Emiko, the commander's daughter—the
least terrible of the players from that night's performance.

I explained the story line to Okamoto and saw his eyes
brighten with excitement. "Young man," he said, "you are
a gift from Buddha. I hand you the fate of my theater."

Although this may seem like a large burden to place on
the shoulders of a twenty-year-old with no experience, I
was—perhaps because of my youth—undaunted. In fact,
I was enthused about the prospect of putting on an entire
production, and after postponing my passage to Tokyo and
sending a telegram to my mother, I quickly got down to
business. The play was scheduled to open in exactly six
weeks, but there was not yet an actual play. The novel had
never been adapted—a detail I had neglected to share with
Okamoto—so while I spent the evenings holding audi-
tions and arranging the construction of the set, I passed
the days furiously transforming the story of Kubota into
the dialogue and stage directions of a play. This could have
been tedious work, but since I had committed nearly the

entire book to memory, and was energized by the prospect of bringing it to an audience, the hours flew quickly by. Within two weeks, the transformation was complete, and after four more frantic weeks of set design, fittings, advertisements, and rehearsals, the play opened on a Friday in the June of 1911.

The first night's performance had sold out quickly, partly because my challenge to Okamoto had become public knowledge, and partly because the family of John Yamada, who played Kubota's best friend, had ensured that all their friends were in attendance. I remember gazing out of the wings at the crowded theater and wondering if I had been mad; wondering how I had ever thought that someone like me could come from nowhere and put on a play. I was anxious now—we all were—and I remained nervous through the raising of the curtain, through a moment of feeling naked when I first walked out on stage, and through the delivery of my first several lines, which suddenly seemed trite and inadequate. But soon enough, as I concentrated on how Kubota was feeling during his first chance meeting with Emiko, I forgot the people in the audience altogether. The only person in the world was the admiral's daughter, played well by Midori Hata—and as I stopped worrying about the reactions of the audience, I could feel them engaging in the story. Near the end of the first act, when Kubota confesses his love, he impulsively grasps Emiko's hand—and as we touched, I heard a gasp rise from the audience. We had captured them completely. The rest of the play went smoothly, with only a few hardly noticeable errors, and after it ended to thunderous applause, the audience brought us back four times for curtain calls. It was a triumph of the highest order. And I remember looking out at the standing, cheering audience; at the beaming faces of my fellow players, and thinking, It was I who made this happen. And I realized at that moment that the course of my life had suddenly, irrevocably changed.

The Indifferent Sea earned a rave review in the Japanese newspaper, the *Rafu Shimpo*. The second night sold out, and also the third, and so Okamoto added another week to its original one-week run. After the final performance, the businessmen who backed the theater threw a party at Haraoka, an exclusive restaurant to which I never before could have gained legitimate entry. After many toasts, and countless emptied bottles of sake, beer, and champagne, one of the businessmen put his arm around me and said, "Thank you for saving our theater, Nakabayashi. What do you have in mind for the next production?"

I was due to sail for Tokyo—once again—two weeks later, and I didn't relish the idea of sending my family a telegram announcing another delay. But it would be disingenuous to say I wasn't prepared for such a question, and as the people around me all fell into a hush, I pulled myself up straight. "A mystery," I said, "entitled *Double Bind*. I saw it in a theater in Tokyo just before I sailed to America, and it was a fine piece of work, taut and resonant." The businessmen all nodded solemnly, and then looked at Okamoto, who was as happy and red-faced as Buddha. "Well, prepare the theater, Okamoto!" the first businessman said. "The boy's got a play to put on!"

The second play, *Double Bind*, was as successful as the first. It was followed by *The Swallows*, and then *Futility* and *The Shadow of the Mountain*, all plays that had been produced very recently by the new theater companies springing up in Tokyo. By the time the third play opened, the theater had become the talk of Boyle Heights and Little Tokyo—as had the young new actor/director behind it. I had been staying with the Yamada family through the summer months, but once I began to collect some of the earnings from the plays—and once it became clear that I would not be returning to Japan in the immediate future—I took two rooms in a house off Second Street. Now, suddenly, I was being recognized on the streets of Little Tokyo. People bought me

drinks when I ate in local restaurants; launders competed for my business; middle-aged women offered me their daughters' hands in marriage. I cannot claim that I didn't enjoy this attention, but my real devotion—as it was from the moment I first demanded to speak to Okamoto—was to the quality of the plays we presented.

It was in the interest of expanding my artistic range that I decided to produce, as my next play, *Twelfth Night*. This was not the first work the theater had presented in English—one of the plays that Okamoto had produced before my arrival was an English translation of a German play—but it was the first that had been penned by an English-speaking writer. Few of the theatergoers were familiar with Shakespeare, and those who were had seen the master's plays in Japanese translation, where much of his poetry and verbal trickery were lost. I did not know how well a Shakespeare play would be received in its original English, but I was ready to make the theatergoers stretch their minds—and I had built up enough credibility and good will by that point that the audience would trust me. Moreover, the backers of the theater, who were concerned with how the growing Japanese population was perceived by the Americans, were pleased by this production of a Western classic. It turned out that we gambled correctly. Although the actors were more nervous than usual—especially those who felt uncertain that they could convey the subtleties of English—the play was a tremendous success.

Because the production of *Twelfth Night* by a Japanese theater was considered somewhat of a novelty, this play garnered a level of interest that was completely unprecedented for the Little Tokyo Theater. For the first time, there were Caucasian faces in the audience. Then, a week into the run, a favorable review appeared in the *Los Angeles Times*, which had previously ignored the existence of Japanese in California except to express concern about their growing numbers. It was clear that our play was a hit.

While Okamoto and some of the players were unnerved by this increased exposure, I enjoyed the fact that our work was receiving accolades from a broader audience. Then one night after a performance, an usher came into the dressing room and ceremoniously cleared his throat.

"Mr. Nakabayashi," he said breathlessly, "someone is here to see you."

I finished changing into my street clothes and stepped out into the hallway where I had first encountered Okamoto eight months earlier. There I saw a beautiful young Japanese woman and a slightly older Caucasian man. They both stepped forward to greet me.

I recognized the lady at once. She was Hanako Minatoya, the accomplished leader of the Kyoto Players, the traveling theater company. She had recently made the jump into the new medium of film, a move that had already met with considerable success. It was of no small significance that she had come to see me that evening. I was honored and terribly nervous.

"Mr. Nakabayashi," she said in English, "I am Hanako Minatoya."

I bowed deeply and forced myself to meet her lovely brown eyes. "I know precisely who you are, Miss Minatoya, and I am very humbled that you attended my play."

"It was a pleasure," she replied. "I am a true admirer. I have seen each one of your plays, and they continue to improve in quality. What you have done here is simply remarkable." Here, she smiled enough to show her perfect white teeth, and I thought—although I probably imagined it—that a flush came into her cheeks. She was exquisite—small in frame, graceful in movement, but with an understated assurance. She had porcelain skin and a charming dimple when she smiled, as she did now.

"In that case, I am five times flattered," I said. "I am an admirer of your work as well. In fact, I saw you perform two years ago in Madison, Wisconsin."

She smiled again, and then turned to the man beside her, whose presence I had completely forgotten. "Mr. Nakabayashi, this is Mr. Moran of the Moran Film Company. I brought him against his will to see your performance tonight, and now I've had to hold him back from rushing the stage to talk to you."

"Good to meet you," said Mr. Moran, holding out his hand. I offered mine in return, and he shook it heartily.

While I had not recognized William Moran by face, I certainly knew who he was. He'd directed half a dozen successful films in the year since he'd established his company, including three that featured Miss Minatoya. He was admired, and also somewhat controversial, because he actually used Chinese and Japanese actors to play Oriental parts, instead of following the usual practice of making Caucasian actors up to look like Orientals. Moran was medium-sized and stocky, with baggy clothes that befitted a salesman more than an artist. Although he was only in his early thirties when I met him, he had the focus and assurance of an older man. After I thanked him for coming to see my performance, he moved closer and quickly cut to the chase.

"Look here, Nakabayashi," he said. "I'd like to sign you to a picture. I've got a film in production that takes place in Japan during an epic battle, and I need a male lead. I was scratching my head to figure out who was strong enough to play opposite Hanako—the actors I already have are all crap—and she insisted that I come and see your play. She was right. You're tremendous—you have the kind of natural talent and intensity I'm looking for. Forgive me for being presumptuous here, but you need to move on from this neighborhood theater. And we need to do something about your name right away. It's really just too damned long."

I didn't know what to say to this. Eight months before, when I'd stormed into that very hall, I had no inkling that I would ever be involved in a play, let alone offered a part in

a picture. Even after I was established, and my plays consistently successful, I'd had no idea that Hanako Minatoya was aware of my work, or that she'd recommend me to her very own company. In those eight months, I had received a lifetime's worth of good fortune. I was under the admiring gaze of a beautiful and accomplished woman, and being offered a role by one of the rising young powers in the brand-new industry of moving pictures. I already knew what to do about my name. I would simply use the shortened version of my given name, and assume the surname of my beloved high school literature teacher, Nakayama-sensei.

"I am left speechless by your offer, Mr. Moran," I said, "and I would be honored to appear in your picture." And with those words, I became Jun Nakayama, an actor in American films.

CHAPTER THREE

I see that I've become somewhat carried away by these
thoughts of my early career. But these digressions are
surely related to the nature of this morning's appoint-
ment. What I had intended to discuss before I grew so dis-
tracted was my meeting with the writer, Nick Bellinger.

About twenty minutes after I saw the family with the
little girls—and thus ten minutes past our scheduled meet-
ing time—a young man came walking briskly from Santa
Monica Boulevard and headed directly for the bench where
I was sitting. He was thin, of medium height, with unruly
brown hair, wearing blue jeans and a brown leather jacket.
He had on horn-rimmed glasses that intensified the green
of his eyes, and he carried a worn leather briefcase. He
broke into a large grin when he saw me, and as he neared
the bench, he asked the same thing he had on the phone:
"Excuse me, sir, but are you Jun Nakayama?"

"Indeed I am," I said. "And you must be Nick Bellinger."

I stood up to shake his hand. He was perhaps four inches
taller than I, and he grinned like a schoolboy, although I
guessed his age to be around thirty. We talked of insignifi-
cant things as we walked back to Santa Monica Boulevard:
the weather, the restoration of the park. Bellinger was
gracious and eager, holding my elbow when I misjudged
a curb, and he seemed to lack the anger and restlessness
that was starting to infect so many other young people of
his generation. At the restaurant he chose—a newer place
with too-bright furnishings—we took a booth by the win-
dow and ordered refreshments: coffee for Bellinger and tea

for myself. After the waitress left, he looked at me, still grinning.

"You'll have to excuse me, Mr. Nakayama," he said. "I still can't quite believe that I'm talking to you. I've seen four of your films—*Sleight of Hand* and *The Noble Servant* are my favorites—and even though I also love John Gilbert and Lionel Barrymore and some of your other contemporaries, to me, you were the best of the lot."

Something about the young man's manner put me instantly at ease. "Why, thank you, Mr. Bellinger. But really, my work was not terribly significant. Just a few films before the advent of sound."

"Oh, I beg to differ, Mr. Nakayama! It was *extremely* significant. You brought an understatement and intensity to the screen that were totally new at a time when histrionics and overacting were the norm. Your work influenced everyone from Humphrey Bogart to Montgomery Clift."

Indeed, I had heard this claim on many occasions, and I'd also heard that Mr. Clift, in private conversation, had credited me for shaping his view of acting.

"I am afraid," I said, "that not everyone shares your view."

"Well then that is their loss, sir. And their ignorance does not diminish for a moment the importance of your accomplishments."

I decided that Bellinger, while sloppily dressed and badly coifed, was actually a young man of substance and character. As the waitress reappeared with our drinks, I asked, "How did you happen to see so many of my films? It is not a simple matter to locate them."

"My father is a silent film nut. He has a pretty big collection. And my mother *loved* you. She always jokes that it's lucky for my dad that she never met you in person, because she'd never have let you out of her sight." He took a drink from his coffee. "Anyway, thank you for meeting me. Everyone at the paper knows I'm a silent film fan. So when

we heard that someone was opening a theater dedicated
to silents, it was pretty obvious who was going to do the
story. My idea was that we try to find some of the actors
and actresses from that time who might still be around. I'd
write about what they did after their acting careers, and
about how they're doing now."

"Who's opening this theater?" I asked.

"Just a pair of film buffs. Ken and Geri O'Brien, a couple
from Cleveland. They're very enthusiastic, but they know
nothing about running a business. So this story has taken
on a lot of significance. If I do a good job, it could help
publicize the theater and get it off on the right foot. And
the really fun part is that it's given me an excuse to dig up
people like you."

We talked for perhaps an hour more about the current
crop of actors. Sidney Poitier and Gregory Peck were his
favorites, which made me think more of him, and he also
liked Sean Connery, which reminded me of his youth. Then
we circled round to the early days of Hollywood and the
formation of the various small film companies. We spoke
only briefly of my career, and I later realized how intelli-
gent this was; Bellinger was trying to make me comfortable
before asking any real questions, and his strategy was suc-
cessful. I found him a pleasant companion, and after our
talk had come to a natural stopping point, he suggested we
meet again. I agreed, for I was eager to resume our conver-
sation. Then he handed me a folder of his articles, all clips
from the *L.A. Observer* and the *Los Angeles Times*, as well as a
piece from *Life*. The fact that he had pieces in such repu-
table publications was enough to convince me that he was
legitimate. "Very well," I said. "I look forward to continu-
ing our discussion."

Bellinger beamed, and then suggested that we meet
two days later at a coffee shop in Hollywood, where the tall
booths afforded more privacy. He pulled a different folder
out of his bag, removed an old photograph, and pushed it

shyly across the table. It was a publicity still of me from my eleventh film, *The Archivist*. The camera captured me gazing intently at a spot just beyond it. I wore a crisp white shirt and dark tie, my hair was slicked back, and I looked like nothing in the world could defeat me. I had not seen this image, or any image of myself from the movies, for more than forty years. This photo had appeared on the cover of *Motion Picture Classic*. In it, I was twenty-two years old.

"I feel silly asking this, Mr. Nakayama," Bellinger said, "but would you mind signing this picture? It's very special to me, and it would thrill me to have your autograph."

I said that I would be glad to, and he handed me a pen. I wrote, *For Nick Bellinger, All the best in your future endeavors, Jun Nakayama*, and then slid the picture back across the table. He picked it up carefully and read the inscription.

"Thank you, Mr. Nakayama. I'm going to go out right now and buy a frame." Then he looked at the picture, smiled, looked back up at me, and said, "You certainly were a handsome devil, weren't you?"

Nick Bellinger was not the only one who used such words to describe me. Indeed, "handsome devil" was a term I heard quite often early in my career. There was something about the way he said it, however, something sly and mischievous, that made me recall the first time someone referred to me in this manner. It was at one of the big all-night parties in Whitley Heights, and the speaker was none other than the Mistress of Mayhem, the actress Elizabeth Banks.

The party took place in July, about a month after the release of my second picture, *Jamestown Junction*. Since I had signed with Moran's company, I had been attending such functions on a weekly basis. At first I did not enjoy them. The attendees, who were largely the same from party to party, all seemed to know one another, and they drank and danced and carried on with a vigor that initially shocked me. But gradually I found that the revelers, when sober,

were in fact charming and intelligent people, serious artists devoted to their craft. Many of the partygoers were actors and actresses who are now long forgotten, once illustrious names like Mae Marsh, Louise Glaum, and Earle Williams. Some better-known stars were also regularly in attendance, people like Wallace Reid and Blanche Sweet. Moran had insisted that I attend these functions, to make people think that I was someone to be seen. So I bought several tuxedos and tailored shirts, as well as a gold watch and cuff links, in order to dress the part of a gentleman.

Both *The Stand* and *Jamestown Junction*, my first two films, were notable successes. They only played for a few days, usually Thursday to Saturday, as was customary for that time. But they were exciting days, with reports of ticket sales that thrilled Moran and his investors. Both films were well-received, and *Photoplay*, in its reviews, heralded the arrival of a brand-new talent. "*The Stand* marks the impressive debut of a Japanese actor named Jun Nakayama," wrote the magazine's critic. "Although he has not yet mastered the techniques of acting for film, his presence—and his striking intelligence—are totally captivating." All of the reviews were along these lines. They noted my inexperience, but also said that I possessed a compelling, mysterious quality that would serve me well in later films. "Nakayama, the young Jap, is someone to watch," wrote the *Los Angeles Times* in its review of *Jamestown Junction*, a film about Chinese mine workers during the California Gold Rush. "His royal bearing and his intensity—and his exotic good looks—should captivate Occidental and Oriental audiences alike."

As a result of such reviews and the box office success of the films, my life was changing again. My star was even brighter in Little Tokyo, where I could hardly step out of my apartment now without someone requesting an autograph. The money from my contract—I was making $100 a week—was much more than I had ever imagined. It en-

abled me to buy fine clothes and a fast little town car. It also allowed me to rent a six-room house in Pico Heights, one of the few areas outside of Little Tokyo and Boyle Heights where it was possible for Japanese to live.

It is hard to describe, now, the heady atmosphere of those first few years of Hollywood. The modest film operations of New York City had moved to the wider, warmer region of Los Angeles, where, like seedlings suddenly exposed to water and light, they shot up and flourished unchecked. Soon, the films made in Los Angeles were being shown across the country, and then, in due time, across the world. And any young person with talent and desire might find himself swept up in the tide. A penniless ranch hand might be plucked from the hopefuls who gathered each day at Gower Gulch and be transformed into a highly paid star. A young woman walking down the street, lingering at store windows, might be spotted by a director, who might cast her as the heroine of his next film. An unknown Japanese university graduate, putting on a production of Shakespeare, might be seen by the head of a film company, who might decide he has a quality and a burgeoning talent that would translate well to the screen.

It happened just that quickly, that unexpectedly, and it happened for those who made the films as well. William Moran was a traveling auto mechanic before he became a director; Marshall Neilan had been a chauffeur; W.S. Van Dyke had worked as a lumberjack and gold miner; and Mack Sennett was a blacksmith before entering pictures and opening his famous studio. It didn't matter that these men lacked formal education and had not spent years working on their craft. No one had. The industry was totally new, and the directors' relative lack of refinement actually worked to their advantage, for they had no pretenses, they were willing to work round the clock, and they all told wonderful stories. These men were real people, often from the working classes, and that grasp of life, that

authenticity, made its way onto the screen. Even the classically trained theater men like Ashley Bennett Tyler—the Englishman who directed several of my films before his untimely death—were of this resolute and entrepreneurial breed. And nobody—not the directors, not the actors, not the cameramen, not the carpenters who made the sets or the property men who furnished them—complained about the hard work or the long hours. We were all delighted to be there. We were at the nascent stages of something totally new, something wonderful, and everybody knew it.

It was in the spirit of this excitement that I attended the party in Whitley Heights. I do not recall the occasion—people needed little excuse to have a party—but the event drew at least a hundred people. I had driven with Moran, who had also brought his young wife, Margaret; Hanako Minatoya, who disliked such functions, had not accompanied us. After we made our way through the living room to give our regards to the host, we ventured out to the garden area, where a band was playing and several quick-moving men in tuxedos were serving drinks and hors d'oeuvres. It was lovely outside, and elegant couples were dancing around the garden. Every now and then peals of laughter would rise above the general clamor, loud bursts of joy that broke out of the crowd and floated off into the warm, clear night.

We took glasses of champagne from one of the waiters and scanned the lively crowd. Well-wishers approached and gave their regards, then wandered off again. Although I was starting to enjoy these functions, I did not yet feel at ease enough to stray from Moran's side; guests at earlier parties, assuming I was a servant, had tried to give me their dirty plates. That night, as always, the only people I spoke with were the ones who came to us. Now, it was the director and producer Gerard Normandy. He was, despite his romantic name, an unimposing man—short and slight, with thinning hair and round glasses. Even with his thick

cigar and glass half-full of whiskey, he looked like a boy beside Moran's imposing frame. He engaged Moran and his wife in a discussion about editing, and my attention began to wander.

Then I spotted a young woman about twenty feet away. She was standing in front of a tall stone fountain, talking to a group of men in tuxedos, resting one hand on the curve of her hip as she inhaled a cigarette from a long silver holder. The men stood around her in a semi-circle, and it was clear from their stance, and from the way she tossed her head, that they were entirely at her mercy. I immediately understood why. The woman was lovely. She had thick chestnut hair that fell about her shoulders in impossibly round curls, a shapely figure whose curves were echoed by the outline of the fountain, and a knowing smile that, when she first displayed it, made my stomach fly up into my throat. Unlike so many of the other young women in Hollywood, then as well as now, she did not appear eager or innocent. There was something in the shape of her eyes and the set of her mouth that denoted a certain world-weariness, a hard-earned wisdom. This woman, for all her radiance, had known disappointments, had lived, and it was the incongruity of these elements—her loveliness and the scars that even beauty could not hide—that so captured me that evening of our youth. I watched her for several minutes. She appeared to be in the middle of a long, involved story, and the men listened eagerly as she gestured with her graceful hands, and laughed in unison whenever she paused. She pulled out another cigarette and held it, suspended, while the men all fumbled in their pockets to produce a match. I was so involved in watching her that I completely lost track of the directors' conversation.

". . . isn't that right, Jun?" said Moran, with an affectionate elbow to my arm.

"Excuse me, Mr. Moran?" I said, bringing myself back to my immediate company.

"I was telling Gerard that I've got to write you up another contract, before one of these sharks here tries to steal you away."

This was a topic we had discussed frequently in recent weeks. My two-picture contract had been fulfilled, and I was under no obligation to work with Moran again. With the success of my films—and with the American public's growing interest in Japanese subject matter—I was suddenly a desirable property. But at that moment, I had no interest in discussing contract matters. "Pardon me, Mr. Moran," I said. "I was momentarily distracted."

Normandy, another rising young filmmaker who had shown interest in my work, looked over to where I had been staring. "Ah, you've been distracted by Miss Banks," he said, laughing. "As you can see, many gentlemen are distracted by Miss Banks."

At that very moment, the four men standing around her burst into laughter again, and she happened to look over in my direction. Our eyes met and she smiled, tilting her head slightly as if asking me a question. Then she turned back to her admirers.

"Who is Miss Banks, sir, if I may ask?"

"She's an actress," Normandy answered. "A comic actress, not your speed. Very charming, but a real handful—temperamental as hell, and a bit too friendly with the bottle. I've worked with her once, and it was an experience I won't soon forget. They don't call her the Mistress of Mayhem for nothing."

"We better keep Jun away from her," Moran said, smiling. "If she has the same effect on him that she does on *those* poor fools, she'll use him up and leave us with the shell of an actor. And besides, she's too old for you, Jun. I believe she's twenty-five."

"Ah, it may be too late," said Normandy. Miss Banks had broken away from her circle of men and was proceeding to walk straight toward us. She appeared to feel no

trace of self-consciousness or modesty, despite the eyes that reached toward her like hands. It was clear from the way she carried herself—confidently, smiling—that she was accustomed to being watched.

"Mr. Normandy," she said, offering her long, graceful hand, and the director, smiling wryly and suddenly flushed, obligingly bent over and kissed it. "Mr. Moran," she said, curtseying. "How good to see you." She did not even acknowledge Mrs. Moran, who glared at her disapprovingly. Then she turned her attention to me. "I'm Elizabeth Banks. And who might you be?"

When her dark green eyes fixed on my face, all language momentarily escaped me. "Jun Nakayama," I finally managed, bowing deeply. "I have made two films for Mr. Moran."

"Ah, we should all be so lucky," she said, giving my employer a bemused look. "Mr. Moran has never expressed an interest in *my* services. I *must* say I'm rather insulted."

Moran smiled. "I don't think I'm the proper director to bring out your genius, Miss Banks. You know my strong suit is serious drama."

"Well, where did you find *this* one?" she asked, nodding at me. "His presence has made your pictures a hundred times better. They're almost watchable now."

Both men laughed, and I realized that she knew precisely who I was. I, to my dismay, was unaware of *her* work, although the two directors' responses to her, and the whispered pointing from the other partygoers, confirmed that she was indeed a figure of importance. Just then, the director James Greene approached and engaged the attention of both Normandy and Moran. That left me alone to contend with Miss Banks.

"Well, it's a pleasure to finally meet you, Mr. Nakayama," she said. "The screen does *not* do you justice."

I had no idea how to respond. Despite her compliment, or because of it, I felt tongue-tied and hopelessly awk-

ward. And I was stirred by her voice, which was textured and deep, making even the most innocent phrases sound like veiled promises.

"You know," she said, leaning in so close I could feel her breath on my cheek, "Moran's a good director, but he's not a *top rate* director. You should talk to some other people before you sign another contract."

"He has been very kind to me," I protested.

"I know, I know," she said. "But with the right men behind you, you could become a bigger star than Moran could ever imagine." As she said the word "star," she lay her hand on my arm—and even through the material of my jacket and shirt, I could feel the heat of her touch. I sucked in my breath and felt a current course through me, as powerful and direct as an electric shock. And it was at that moment that Miss Banks smiled up at me and said, "You certainly are a handsome devil, aren't you?"

All the qualities I witnessed in Elizabeth Banks that night—her bemusement and beauty, her directness, her effect on men—were qualities that remained consistent throughout the years of our acquaintance. In the shamefully small amount that has been written about Elizabeth, there is—perhaps inevitably—far too much emphasis on her personal entanglements and her role in some of the period's more unfortunate episodes. She was, indeed, a compelling figure, and the story of her rise from a humble past inspired many young women in that time of possibility. But what survives of her in history is a sadder portrayal, and it is unfair that she is remembered now only in relation to events over which she had little control. The few written accounts that do address her career pay scant attention to her actual films, and almost universally ignore what a singular talent she was. Those historians did not know her as I did. And although I made it home alone on the evening of that party in Whitley Heights, I was ignited

by the memory of Elizabeth's smile and touch, and stayed awake half the night planning what I would say on the occasion I should see her again.

I met Elizabeth just after I'd finished working for two months in succession with Hanako Minatoya. Through April and May, during the making of our films, we saw one another every day. Since we were both still living in Little Tokyo at that time, and since Mr. Moran's fifty-acre filming complex was in Pacific Palisades, Moran would send a car to pick us up and bring us to the ocean. The driver took Sunset Boulevard, which was then just a dirt road that wound through canyons and hills, passing citrus groves so lush that one could reach out the window and pluck oranges right off the trees. Los Angeles was beautiful on those early spring mornings. The sun rose slowly from behind the mountains and cast an ethereal light across the city; the air was filled with the scent of flowers and the morning songs of birds. There was a stillness then, a perfection, that existed at no other time of the day, and I felt fortunate to be able to share it with such agreeable company. The trip to the Palisades took an hour and a half, and during the drive, Hanako and I would talk of anything that came to our minds—the theater, the growing numbers of Japanese in California, the people, sights, and foods we missed from home. We would speak in both English and Japanese, the two languages woven together, between them making possible a world of topics and descriptions that neither could encompass alone.

It was on one of these drives that Miss Minatoya described to me the unusual circumstances of her upbringing. She had come to the U.S. with her parents at the age of fourteen to take a driving tour of California. But while Hanako was at the home of family friends in San Francisco, her parents, the Kuriyamas, were killed in an automobile accident. Since she had little remaining family left in Japan—

both sets of her grandparents were dead, and her older sister had a family of her own—she decided to accept her hosts' invitations to stay with them in San Francisco. She assumed their name and entered an American high school, but when Japanese students were barred from attending public schools, she decided to follow her dream and join a theater troupe. With that company—and much against the Minatoyas' wishes—she traveled around the country, which is how I came to see her perform in Madison. Within a year, she was the head of the company, and two years after that, she and several other members were signed by William Moran.

"And what about you, Nakayama-san?" she asked when she had finished. "Is your family still back in Japan?"

"Yes," I said. "I haven't seen them in several years. In some ways it seems like I just left Nagano; in others it feels like I've been away forever."

Hanako nodded. "They must have been sorry to see their eldest son go."

"I am not the eldest, despite my name. In fact, I am the second son. But on the day of my birth, I struggled to escape my mother's arms, and my father said he knew I would always choose my own path. He gave me the -ichiro designation to prepare me."

She smiled. "He sounds like a wise man, your father."

"Yes, I suppose he was."

Once we arrived at Moran's filming complex, it was as if we had entered not one but several different worlds. Because the landscape was so varied, any number of films could be shot at once. In the valleys, you might see dozens of horses and men recreating a Western shootout. In the hills, the small figures of a group of fictional prospectors, panning the rivers for gold. Down below, a shipwrecked crew on the beach, building a fire in the sand. And in the flats, a replica of a Japanese village, with a red Shinto shrine, rickshaws, pagoda-roofed building façades, even

fichus trees with glued-on bits of white paper that were meant to be cherry blossoms. There was constant activity at the complex, constant noise, and Moran, when he wasn't busy directing, traveled from set to set on horseback, surveying his various projects.

It is amusing, in retrospect, to think how primitive our efforts were in those early years. For my first two films, all of the interiors were shot on outdoor sets, with canvases draped over them to soften the sun. All copies of *Jamestown Junction* have long been lost, but if the film had survived, and if you could see it, you would notice that during the office scene the papers on my desk are disturbed by a mysterious breeze. And in the very next scene, you would see a shadow moving in the corner, caused by the canvas flapping in the wind. These were the conditions in which we shot at that time, and because we worked without the benefit of artificial light, there was always a rush to complete the day's filming before the shadows grew too deep in the afternoon. In late May, when we endured an unexpected heat wave, Moran had giant ice blocks delivered to the sets, and powerful fans placed behind them to blow the cool air in the direction of the players. If it rained, filming would halt altogether, and we would scramble to move all the furniture and props under the complex's few permanent roofs. But despite these challenges, everyone remained in good spirits. We were working, yes, but it felt like play, and it was hard to comprehend the tremendous good fortune that had suddenly befallen me.

Through the making of both films, Hanako gave me constant guidance, which I eagerly accepted. And I immediately discerned the difference between myself, an untrained amateur, and a seasoned professional who knew everything about the art of acting. Indeed, she was perhaps the largest influence on my development as an actor—with the possible exception, a few years later, of Ashley Bennett Tyler.

"There is no audience to see you," she said one day in Japanese, as I gestured expansively to convey my anguish at the death of one of my fellow soldiers. "You don't need to project like you would in the theater, as if you're trying to be seen by the person in the last row. Pretend the camera is the one man you're playing to."

On another occasion when I was perhaps *too* understated, Hanako approached me after Moran called "cut." "You're painting a picture with your body," she said. "Think of pantomime. You must express physically what you can't with your voice. And use your face, your eyes. You have such eyes. They alone speak volumes."

Moran nodded in agreement, although he couldn't have understood, and I adjusted my actions accordingly. I was surprised by the extent to which he let Hanako direct things—not only my own performance, but also the placement of props, even the movements of the other actors. Yet all of her suggestions improved the films. And between her advice and Moran's direction, I was slowly learning what to do. The transition from theater, which depends on dialogue, was more difficult than I had imagined—indeed, many stage actors, even those who didn't disdain the new medium of moving pictures, did not make the change successfully. Hanako Minatoya was one of the few who was equally accomplished in both realms. I was learning under her tutelage every day.

On certain days, when we weren't in scenes, Hanako and I would leave the sets and walk into the hills. They were vibrant with color, with flowers wherever one looked—blue brodiaea and lupin, Mariposa lilacs, the wispy orange California poppies. Even the cacti, which she loved, put forth dense and vibrant flowers, unexpected bursts of yellow and pink against their sturdy, sharp, untouchable bodies. The beauty of that landscape, when the air was cool, the sun glinting off the ocean, and the breeze carrying the scent of the flowers, was so dramatic I could hardly believe

it real. And I was seeing it, feeling it, in the company of an artist whose work I had admired for years.

One day on our walk we were discussing a well-known actor, and Hanako surprised me by her reaction to his name. "He is nothing but a face for the fan magazines," she said dismissively. "He is not a genuine actor."

"What do you mean?" I asked, although I didn't disagree.

"It is impossible to distinguish one of his roles from another. He is always the same, and it is obvious why. In order to project a believable fiction, the actor himself must have substance. You must possess something *internally* to perform it externally. He has only a fraction of the talent of an artist such as you."

I was, of course, deeply flattered by her compliment, and I did not know how to respond. Hanako continued talking of this actor and that, without noting my reaction. That night, however, and for many nights after, I recalled what she had said with much pleasure.

Because Hanako had always been unfailingly proper, I was surprised by her judgment of her famous peer. But I soon realized that beneath the unassuming exterior lay strong convictions and a will of utter steel. And while I quickly got over my initial awe of her, I remained grateful and honored that she treated me as her equal. I was so engaged in our work and our daily conversations that I found myself saddened when our time together drew to its inevitable end.

After we finished our second film, I did not see Hanako again for more than a month. We did not have occasion to speak at all, in fact, until three weeks after the party in Whitley Heights, when I made a trip to see Mr. Moran alone. When I arrived at his office, he greeted me warmly and invited me to sit by the window, where there was an unobstructed view of the ocean. I was cordial, but nervous,

for the news I had would not be taken lightly. Indeed, as I spoke, the smile on Moran's lips quickly faded.

"I had a meeting with Gerard Normandy earlier this week," I said. "He informed me that he was starting a new film company and that he would like me to be one of his players."

Moran was sitting behind his heavy wooden desk, and he took a cigar from the drawer. "Did he offer you a contract?"

"Yes, he did. He offered to pay me a thousand dollars a week."

Moran had just bitten off the tip of the cigar, and now he spat it out. "A thousand dollars a *week*? He must have been bullshitting. He can't afford that kind of money, especially not for a newcomer with only two films to his name. I mean, I know that Oriental subjects are all the rage right now, but this is ridiculous."

"He showed me the contract, Mr. Moran. And I am here because I'm asking you to match it. I would prefer to continue working with you . . ." and here I broke off, surprised by my surge of emotion. "I would prefer to continue working with you, sir, as long as there is not a great disparity in the terms."

Moran put down the cigar and pressed his fingers together; they were as papery and thick as the cigar. "What do I pay you now, Jun? One hundred dollars a week?"

"Yes, sir."

"Well, I can increase your salary to four hundred a week, but no more." He paused. "You understand that this will make you the highest-paid actor in my company."

"Mr. Normandy offered me a thousand, sir."

"I don't believe it. I think he's bluffing to scare me. Go talk to him again, Jun, and then come back to me. I have no desire to lose you, that's for sure. But I won't get into a bidding war on such unreasonable terms."

I considered him sadly. This was the man who had of-

fered me my first two roles; this was the man who had brought me into pictures. My regret at leaving him was genuine, but the future was wide open now, and Mr. Normandy's deal was simply too good to refuse. So while Moran raised the unlit cigar to his mouth, I stood and then bowed to him deeply. "Goodbye, Mr. Moran," I said. "You have my sincerest gratitude."

With that, I turned my back on the man who started my career. I felt sadness as I descended the steps from his office, and my spirits plummeted further when I saw Hanako, who was taking a break from filming her latest picture. She stood talking with Steve Hayashi, an easygoing young actor from her theater company who had also signed with Moran. She was dressed in a kimono and full white makeup, and she looked lovely, like a member of the royal court. When she saw me, she left Hayashi and walked over to where I stood. "Why are you so glum, Nakayama-san?" she asked.

I peered at her sadly, understanding that my departure from Moran's film company would result in the end of my regular contact with her. It occurred to me that this would be a significant loss. I thought of Elizabeth Banks, who I had seen now at several more parties. But whatever need Elizabeth ignited in me, it was not her with whom I wished to share my days. "I am leaving Moran Films," I said with as much assurance as I could muster. "I am joining Mr. Normandy's new company."

She looked at me, not with the surprise or anger I expected, but with an expression of sad resignation. Perhaps the losses she had already suffered, as well as her own experience with the vagaries of show business, had inured her to these inevitable transitions. "I am sorry to hear that," she said. "I have enjoyed working with you."

"And I with you. My debt to you is immeasurable."

"You will go far, Nakayama-san. I have no doubt. Your talent is unequalled by that of any other young actor. Indeed, it drives me to work harder."

I did not reply at first, for I was again moved by her assessment, which was more meaningful than any critic's praise. "Thank you, Minatoya-san," I finally said. And then, having no idea of how true this would be: "You will always be the standard against which I measure myself. May I always fall just short of your mark."

She glanced toward the ocean and my eyes followed, but not before I saw her face in profile, the exquisite jaw, the long and graceful neck. "These last few months," she said. "I wish . . ." And here she stopped, just as a particularly large wave broke against the cliff beneath us, sending a spray of water almost to our feet. "You will be missed. I hope that no matter where our lives may take us, you and I will continue to be friends."

"I would like nothing more," I said, looking into her face, and our eyes met for a moment before I turned and walked away.

CHAPTER FOUR

October 5, 1964

The Green Lantern, on Santa Monica Boulevard, is one of the few true coffee shops in Hollywood. It is still rare in this part of the country to find a comfortable place that lends itself to discussion or study. In New York, in San Francisco, such cafés abound—perhaps because of the greater concentration of people; perhaps because of the higher value those cities place on the workings of the mind. But in Los Angeles, where one needs a car to run even the most mundane errands, and people seldom gather to engage in substantive conversation, it is still difficult to find a place where one can spend the afternoon relaxing with a book or companion.

When young Bellinger suggested the Green Lantern as a place for our next meeting, my opinion of him only improved. It had already risen, frankly, since I'd read the articles he gave me. His piece on Faulkner's screenplays struck the appropriate balance between appreciation for the presence of this great talent in Hollywood, and sadness that such a genius set aside his primary work in order to pursue a stable livelihood. His article on the film adaptation of Truman Capote's first novel was astute in its observations on the limits of film in conveying the subtle rhythms of written language. His long essay on the activities of certain Hollywood stars in politics included several interesting points about the interplay of real life and image, although I was uneasy with the notion that actors should attempt to get involved in the great issues of the modern

world. Nonetheless, I saw in the body of Bellinger's work a sensitivity and wisdom that belied his years, and this greatly increased my willingness to speak with him about my own career.

I arrived at the Green Lantern ten minutes before our meeting time; Bellinger again was slightly late. He seemed harried—his dark hair was even more unkempt than the first time we met, and his eyes darted back and forth across the room. While we were waiting for our drinks to arrive, I told him how much I'd enjoyed his articles. At this, Bellinger brightened again and thanked me. Once the wait-ress arrived with our coffee and tea, he took out his note-pad and asked me to recount my early career—how I had gotten involved in the theater, and how I'd come to meet William Moran. Bellinger remained quiet through most of my monologue, speaking only to ask about Hanako Mina-toya and my impressions of Moran. I described the fierce competition between the various small movie outfits, the directors who carried guns to work to fend off potential rivals, and the sometimes difficult untangling of contracts and jobs when several small companies were absorbed into larger ones.

Bellinger listened and nodded. "Was there any discus-sion of you losing your contract when the Normandy Play-ers were rolled into Perennial?"

"No. In fact, when Perennial was formed, I received a new contract as well as a significant raise."

"And the parts changed, I noticed. You went from light comedies and Japanese period pieces to roles that were more substantial."

I straightened my back and lifted my chin before I answered. "Mr. Bellinger, the roles I played were never *in*substantial."

He fumbled with his cup and leaned anxiously over the table. "Oh yes, sir, I know. What I mean is, at Perennial you became a genuine star."

I nodded. "Well, yes, I would say that's accurate."

"They knew they had something in you, obviously."

"Yes, they certainly did. I had made perhaps twenty films by that time, and most of them did well. But my time at Perennial was certainly the height of my career. Gerard Normandy ensured that Perennial acquired suitable material—and Benjamin Dreyfus, a top executive there, was a genius at distribution and marketing."

"Benjamin Dreyfus!" exclaimed Bellinger, so loudly that he startled me. "I know *exactly* who Benjamin Dreyfus is!" Then, more to himself than to me: "No, no, I shouldn't even bring this up yet."

"What is it?" I knew that whatever he might have in mind, it was not a living Benjamin Dreyfus. Dreyfus had been a key figure in the studio's growth, but he died twenty years ago, and I attended his funeral, where I sat in the back of the crowded Westside synagogue to avoid the familiar faces.

There was a new excitement in Bellinger's eyes—he seemed more animated, even, than in our first meeting. "Well, his grandson, Josh, is a vice president now at Perennial. And he's a very good friend of mine."

I looked at him patiently, wondering what he would think I could possibly find interesting in this fact about Dreyfus' progeny.

Bellinger shook his head like a wet dog trying to rid himself of water. "No, I'm going about this all wrong." He leaned over the table and considered me intently; for a moment, I thought he might grab my collar. "Mr. Nakayama," he said, "I'm not just a reporter. I'm also a screenwriter. I've had three short films produced in the last two years, and I've just finished my first full-length screenplay. The reason I'm telling you about my friend Josh Dreyfus is that he and Perennial are interested in buying it. And the reason I suddenly got all worked up is that if Perennial *does* decide to make this picture, I'd really like for you to be in it."

I just looked at him; I did not know what to say. Bellinger must have seen my surprise, because he leaned back and spoke more calmly.

"I know this is coming out of left field, Mr. Nakayama, and I'm sorry. But you see, there's a part in the film for an older Japanese man, and I wrote it with you in mind, even before I knew I'd ever get to meet you. Then when I *did* track you down for the article, I didn't want to mention it right away because I wasn't sure if you'd still have . . . if you'd still be . . . oh, I don't know. I didn't know if I'd still feel the same way about you. But you've still got it—the looks, the presence, everything."

By this point I had gathered myself sufficiently to fashion a reply. "I am flattered, Mr. Bellinger, but really, I cannot imagine doing another movie. It's been more than forty years since my last one, and the making of films has changed so much since then. The movies of today bear little resemblance to the pictures we made in my time. Besides, I have grown comfortable with my privacy."

"I understand all that, sir, and I realize this whole thing must seem very strange. But I can assure you that Josh Dreyfus is as excited as I am about bringing you back to the screen. And before you break my heart by saying no, would you at least take a look at the script?"

I sighed. I was, in fact, flattered by the young man's proposal, but the idea of appearing in front of a camera again was ludicrous. I am an old man now, four decades past my prime. It would be like an aging athlete trying to recapture his youth, despite his aching joints and bad vision. Certainly I didn't want to dash the young man's hopes, but I was comfortably retired. "All right," I said, "I will at least read the script. But I am telling you the answer is no."

Bellinger beamed brightly at this modest concession. "Thank you, Mr. Nakayama. My mother will be thrilled— she's so excited I've met you. And my father . . . well, maybe

if I get this film made, it will help him calm down about my future."

"Does your father not approve of what you do?"

"Oh," said Bellinger, glancing down at the table, "I don't know. I don't want to burden you with my troubles. They're kind of silly."

"Young man, one's troubles are never silly. What is silly is when one chooses not to acknowledge them."

He looked up at me uncertainly, and his whole bearing seemed to change. "Well, all right. Maybe you can understand this a bit. My father's getting impatient with this whole writing thing. He thinks it's unstable and he wants me to go to law school or business school, something that will make me some money."

"But you appear to be doing very well."

"Kind of, I guess, but not to him. I mean, I do get occasional pieces published in bigger magazines, as you see. But I'm a staff writer for a left-leaning weekly, which doesn't exactly impress the parents. As you can imagine, writing screenplays isn't very secure."

"What does your father do?"

Bellinger smiled wryly. "He's an accountant. And my mother's a teacher. Two rocks of Gibraltar. They don't understand people who live creative lives."

We both sat in silence, sipping our drinks, while I thought about what he had told me. It was the age-old dilemma of youthful dreams and parental expectation. "Nick," I said, "your father may seem narrow-minded or misguided, but he only wants what's best for you."

Bellinger looked up at me, surprised. "Do *you* think I should go to law school or business school? I think I would die if I did."

"I have no opinion on your actual path. I am only saying that your father is not speaking out of selfishness, but rather out of genuine concern for your future."

"My future will be fine," Bellinger insisted, "as long

as I do what I really want to do. As you said yourself, I'm not doing badly. I mean, I'm twenty-nine and I have three small films under my belt, plus more than a book's worth of articles."

"I don't doubt your talents or your dreams, Mr. Bellinger. I am merely stating that your parents know more than you think. And if they want something for you, no matter how disagreeable it seems, there is usually good reason."

He stared at me in disbelief. "But Mr. Nakayama, did you always do what *your* family wanted? From what I've read, your father was a government official, a very important man. He doesn't seem like the kind of guy who would have approved of his son becoming an actor."

"My father's opinions always carried great weight, but no, he would not have approved of my choices. And in some ways, you see, he was actually correct. After all, my career was finished by the time I was thirty." I paused, fearing that I sounded too harsh. "I am not suggesting that you blindly follow the path your father proscribes. I just think you should respect his opinion. If you act without your family's best interest in mind, you will at some point question the wisdom of your choices."

Bellinger nodded thoughtfully, but I could see that I had given him no comfort. And so, somewhat awkwardly, we resumed talking about his screenplay, and arranged for it to be delivered to my town house.

Of course, Bellinger had been correct about my father. He wouldn't have approved of my becoming an actor, although to my great sorrow—and relief—he didn't live to see it happen. My father tried to understand his son's unusual notions about the world, but he was of an older generation, one still steeped in tradition, with strict ideas of tasteful behavior and legitimate careers. He could not have fathomed the allure of such a frivolous occupation; he hardly understood my interest in the world outside Ja-

pan. This lack of understanding was most clearly apparent when I decided to come to college in the United States.

I was sixteen years old, an age that seems much more childish here in America than it did in Japan, where a boy of sixteen has already contributed several years of labor to the family farm or business. Because I was always an exceptional student, I had already completed secondary school—and because my school was run by a Catholic mission, I had a strong command of English.

The school my brother and I attended, the St. Francis School for Boys, was in the city of Saku, a ten-minute train ride from our village. My studies at St. Francis ignited both my love for theater and literature and my interest in Europe and America. The teachers—particularly our history teacher, sister Mary Martina, who'd grown up in Ohio, and our literature teacher, Nakayama-sensei, who'd studied in California—described America as a vast and friendly land, where books were as plentiful as the apples in Nagano, and where people from any station of life could rise to prominence and become a businessman, a professor, even a governor. Because Akira was two years my senior, he had no choice but to remain on the family farm and assume more of the burden of running it. But since I was the second son, I had more freedom, and after graduation I found a job in the nearby resort town of Karuizawa.

Karuizawa then, as now, was the favored summer retreat of the business and political elite of Tokyo, as well as of visiting tourists from the West. Within the town itself, there were lovely old temples on quiet, deeply shaded grounds where one could meditate for hours. Just outside of it, streams meandered through vast fields of growing rice, with green mountains rising above them all, sometimes shrouded by willowy fog. The land was sublime, and I could hardly believe my good fortune in being able to live there. I worked as an all-purpose hand at the inn of the

Ishimoto family, driving important visitors from the train station, bringing firewood up to their rooms, preparing hot baths for the guests. I would also take on odd duties for which there was no assigned help, such as securing alcohol for guests; escorting ladies into gentlemen's rooms through the secret back hallways; and acting as a caddy for the visitors who wished to golf on the pristine new courses near town. I worked Tuesday to Sunday, returning home to my family's village from Sunday night to Monday evening, and I enjoyed my new feeling of independence, as well as earning my own money, even though it mostly went to my family. My father disapproved of the work—he saw it as undignified and beneath my capabilities—but he could not object to the money I contributed every week, nor to the fact that, as everyone in the family remarked, I was growing into a fine and independent young man.

I might have stayed on at the Ishimotos' inn forever— working hard, drinking during the evenings with my fellow employees, practicing my English on the Westerners who passed through town—had it not been for the visit of Paul and Ann Warren, the wealthy American store owners from Wisconsin.

The Warrens arrived in May of 1907, just after the rainy season, before the country was paralyzed by summer humidity. They were staying in the inn's finest quarters, a ten-tatami mat room with its own private adjoining bath. I first saw them on the day they arrived. They stood in the lobby with the third member of their party, who appeared to be their guide. This man, whose name I learned later was Bill, was considerably younger than the Warrens. He looked to be in his middle thirties, although at that time, with Americans, it was hard for me to tell. He was, like Mr. Warren, dressed casually in linen pants and a loose cotton shirt, but on him the clothes looked somehow ill-fitting. Although he had a rough command of the Japanese language, his proficiency was nowhere near the level to which

we had grown accustomed in the service of such promi-
nent guests. This weakness was immediately apparent. As
I waited with two other employees to carry the Warrens'
luggage, the young man turned to Mr. Ishimoto and said,
"Allow me to introduce myself. My name is Bill Harmon. I
am Mr. Warren's interpreter, as well as his anus."

We looked at each other and bit our lips. Mr. Harmon
didn't notice our reaction.

"You have a lovely inn here," he continued. Then, turn-
ing to us, "I assume these room boys are a gift?"

Now some giggles escaped from our mouths, and Ka-
gane, who was standing directly to my left, hit me with the
back of his hand. There was even a glint of amusement in
old Ishimoto's eyes.

"Not exactly," said the proprietor. "They are too valu-
able for me to part with. But I hope you'll find their ser-
vices satisfactory."

At dinner that night, I watched the Warrens and their
interpreter closely. Mr. Warren—a handsome, fit, middle-
aged man with silver hair and tanned skin—thanked each
person who brought him a dish or refilled his tea. Mrs.
Warren, who seemed less comfortable with Japanese deli-
cacies like sashimi, was still clearly delighted by the col-
orful presentations of the food and the hustling, perfectly
synchronized staff. At one point, as I was removing a plate
from her setting, she glanced up at me and touched her
fingers to her neck. "My, you're a handsome boy!" she said,
blushing. "Good thing you don't understand me."

But I did understand—that, and much of the rest of
the conversation. Mr. Warren was telling Mr. Ishimoto—
slowly, allowing for the garbled translation—about building
his chain of hardware stores in Wisconsin and Michigan. He
had started out with just one about twenty years earlier,
and had parlayed his earnings from the first Warren's to
open another, then another, then another, until he finally
had some thirty-one stores. He was so wealthy by that time

that he no longer had to oversee the daily operations of the company. The Warrens' oldest son had taken over this responsibility, leaving Mr. and Mrs. Warren to travel. Only parts of this story, however, were related by Harmon, who was getting red-faced from the sake, and so I would subtly, when Mr. Ishimoto looked in my direction, translate the missing pieces.

The Warrens spent their first few days in Karuizawa the way most tourists did—going to hot springs, visiting the temples, shopping in the stores by the railroad station. Then one morning, Mr. Warren wished to go golfing, and so I drove him, along with Harmon and Kagane, to the new golf course just outside the town limits. Mr. Warren and Harmon were golfing, I was caddying, and Kagane carried everyone's lunch. They had just finished playing the first three holes when Mr. Warren started sneezing uncontrollably.

"Damn allergies," he said, eyes watering. Then: "Bill, I forgot my medication. Could you ask one of these boys to go back and get it?"

The interpreter turned to face us and said, "Mr. Warren is having trouble with his nostrils."

Kagane stared at Harmon in bewilderment.

"His nostrils, his nose!" said Harmon, waving his arms. "They are causing tribulation!"

Kagane looked at me now, and I shrugged. Finally, Harmon turned to Mr. Warren. "I'm sorry, sir, they don't seem to understand me."

I stepped forward and said in my most careful English, "I understand, sir. You have allergies and you need your medication."

Even in the midst of his sneezing fit, Mr. Warren stared at me in surprise. "You speak English!"

"Yes, sir," I said self-consciously. "But only a little."

"Well" And then he sneezed again. "Why didn't you let on before?"

"You had Mr. Harmon, sir. But since I am aware of your condition, please excuse me while I return to town. Will Mrs. Warren know where you keep your medication?"

"Yes, yes," said Mr. Warren, and with that I left for the inn, where I startled Mrs. Warren by asking in English for her husband's medication. I then sped back out to the golf course, and within a few minutes of Mr. Warren swallowing his pills, the sneezing fit subsided. For the rest of the morning, as they completed their round, he spoke to me in English—much to the consternation of Harmon, who kept giving me looks of displeasure.

When we returned to the inn that evening, news of my intervention had spread among the staff. I had always been held in a certain esteem because of my English, and this small incident suddenly made me a hero. The Warrens saw me differently as well.

The next evening, after my shift, I was sitting outside with Kagane near the employee quarters, which were about a hundred feet behind the inn. Mr. Warren came ambling back there about 10 o'clock, under a moon so bright I'd seen him from the moment he'd stepped outside. "Junichiro!" he called out as he approached, and Kagane departed without a word, leaving me to my encounter with the American.

I yelled back, "Over here!" and he came and sat on the tree stump that Kagane had just vacated.

After a comment on the night and the freshness of the air, Mr. Warren lit a cigarette and asked, "How'd you learn to speak such good English?"

"I went to an American Catholic school. I learned English from native speakers."

"Have you ever thought of coming to America? There's a lot of opportunity for a young man like you. You could certainly do better than washing dishes at a country inn."

I hesitated. "That is kind, sir. But America is very far away."

Warren shifted around to face me. "Look here, Junich-

iro. You're a high school graduate who speaks wonderful English. We've got a big university in my state of Wisconsin, and it happens to be right in my city. How would you feel about coming to study there?"

I laughed. "I am only the son of a farmer, sir. Such things could never happen for me."

"*I'd* take care of it, don't you see? I could easily arrange for the payment of your college fees. It's a bit late to register, but we should be able to swing it—the university owes me, considering how much money I give them. And I could send you a ticket for your passage over."

I looked at him in disbelief. "Mr. Warren, I could never accept . . ."

"Of course you could," he said, waving away my protest. "And call me Paul. Is this something you would *like* to do?"

"Sir, in my fondest dreams, I never—"

"Well then it's done," he cut me off, standing up again. He held out his hand, and I had already met enough Westerners by then to know I should shake it strongly. "I'll see you in Wisconsin," he said.

Although I was intrigued by Mr. Warren's generous offer, I did not mention it to anyone else. I was afraid that his proposal was the result of sake and the mountains, an idea that would quickly dissolve once he returned to the States. While Mr. Warren did tell me, on the morning he left, to "remember what we talked about," it did not surprise me when weeks passed, and then two months, without any word from America. It had all been a fantasy, one brief flash of possibility, as when a beautiful girl smiles at you from across the room and then returns to the arm of her escort. By early August I had resigned myself to returning home and helping my family with the harvest before seeking work at the ski resorts for the winter. But then one afternoon, a week before the end of the summer season, Ishimoto summoned me up to the front desk.

"For you," he said, handing me a package. It was wrapped in brown paper and covered with colorful stamps. "From USA," he added in stumbling English.

I took the package from him—it was lighter than it appeared—and saw that it had come from Wisconsin.

"The Warrens?" asked Ishimoto, and I nodded, unable to speak. His wife emerged from the back room and they both watched me like excited parents. At that moment something occurred to me. "Did Mr. Warren speak to you about this?"

"Oh, yes," said Ishimoto, and he could hardly contain his grin. "He asked if I thought you should go to America, and I said that we couldn't wait to get rid of you."

I laughed and opened the package, and there it was—a train ticket to Tokyo from Karuizawa, a ticket for passage by ship from Tokyo to San Francisco, and a bus ticket from San Francisco to Madison. *Dear Junichiro*, said the handwritten letter. *Please accept my apology for waiting so long to write you. It took a few weeks to arrange your travel and your paperwork for entrance to the university, but everything is finalized now. Please make the trip to Wisconsin as soon as you can, and we will get you settled here before school starts in September. You will be staying in the house of one of my good friends. You'll have a private room, and you should be very comfortable.* The letter went on to describe how exactly to obtain my visa, and what paperwork to bring with me when I came. I had to sit down to absorb the implications of it all, and I shakily translated to the Ishimotos, who were as thrilled as if they were making the trip themselves.

It is hard to explain, now, exactly why I was so captured by the idea of going to America. I loved Japan, its mountains and rice fields and serene, still temples—but there was also something in me that felt contained there; that needed a different setting in which to grow. It was perhaps a mark of my arrogance and immaturity that I believed I had to leave in order to do so. But the picture of America that had been painted by my teachers at St. Fran-

cis, and the expansive, entrepreneurial American spirit embodied by the Warrens, had enticed me to believe that America was the place of bounty and hope, or, as some said in Japan, the Land of Rice. And so I traveled home to my village four days after my tickets arrived, prepared to break the news to my family.

The first person I had to tell was my father. Although he was only forty-five at the time, I thought of him as old. He was as steady and silent as the mountains we lived in, not gregarious or hard-drinking like the other men I knew, and I was always proud to have such a respectable man as my father. The whole family was aflutter because every-one was home. The house was alive with the sounds of my mother cooking and laughing, and of the four of us chil-dren loudly recounting the events of the last few months. It pained me to know that I would deflate this happy scene with the news that I was bearing, and for the first two days there was no opportunity for private conversation with my father. I finally found him alone one morning, standing outside, looking out at the maturing crop of rice. It was a glorious day. The sky was clear and blue, and a gentle wind was blowing through the trees. The stream that me-andered past the house was full from a recent rain; our three old mules stepped gingerly down the banks to drink from the running water.

"It is nearly time to harvest," my father said as I ap-proached. I glanced out at the fields and saw that he was right—the rice plants were as high as our waists. After we harvested, we would dry the stalks on bamboo frames and then sell them to the makers of tatami.

"There is a good crop this year," I commented. "It should yield a high price."

"Your brother has become an able farmer," he said. "I am giving him more and more responsibility with every passing season, and you see he is very successful."

"My brother is becoming a man. I believe I detected

a gray hair this morning when he leaned over his bowl of rice."

My father smiled at this and then kicked the ground. His knee-high boots were splattered with mud. "Your mother thinks we might be losing you, Junichiro. She says that even when you are here, you are not really here."

"It is just the opposite, Father," I said, feeling a tightness in my throat. "Even when I am not here, I will always be here."

He pulled himself up to his full height, which did not quite equal my own. "So it is true that you are leaving us." He looked straight ahead as he said this, and I followed his example.

Even though I was taller than my father, I felt like a little boy. "I have been offered a chance to study at a university in America. An American family I met in Karuizawa is willing to pay my passage and university fees."

My father absorbed this news silently for a moment. "And why do you need to go to America for schooling? What is available to you there that you cannot find here?"

I could think of no way to answer that would make him understand, so I continued staring out at the fields. A crow dipped down among the rows of rice; the scarecrow my brother had devised, wearing our old clothes, did not seem to bother it at all.

My father kicked the ground again and spoke. "I will not stand in your way, Junichiro. But this opportunity is both more and less than you think. It will change you in ways you can't anticipate now. And if you go, you will never again see your father."

I glanced at him, and then turned my head away. "Of course I will see you, Father. It is only four years."

"Four years can be a lifetime. And the world you are about to enter will open up into many others." He paused and looked out at the hills. "It does not surprise me that you're going. You, of all my children, are always looking

forward, always seeing what's around the next bend. But you must remember to feel the ground that is right beneath your feet. Live where you are, not only where you think you should be. Otherwise, you will end up living nowhere."

I opened my mouth to speak, but he raised his hand and bid my silence.

"I wish you luck. You have been a good son."

I looked at him again, surprised by the emotion in his voice, and saw that there were tears in his eyes. But before I could say anything, he turned away and walked wearily back to the house.

I will never understand how he knew what would happen once I made the trip to America. But he was right about everything. My father was always right. And one week later, when my tearful family accompanied me to the train station in Karuizawa, my father embraced me long and hard, which he hadn't done since I was a child. We disengaged and I bowed to him deeply, hoping my respect and love were clear. And as I sat and lay and wandered on the ship for two weeks, I kept wondering whether I had made the right choice. Eventually, I would gain success and fame of a level I could not have imagined. But the man I sought to please—as he seemed to know already—was lost to me forever.

CHAPTER FIVE
October 9, 1964

The morning after my meeting with Bellinger, I took the cover off my automobile for the first time in months, coaxed the engine to life, and drove west toward the Fairfax district. I drove slowly, so as not to strain the large old car, passing the Chaplin studio on La Brea and the Pickford-Fairbanks studio on Santa Monica. I turned left at Fairfax and eased the car down into that lovely old neighborhood. All the buildings there—the Spanish-style apartments and English Tudor houses—look much the same as they did when they were built in the '20s. Once one crosses Melrose, the businesses, markets, and bakeries become solidly Jewish, and the sounds of Hebrew and Yiddish fill the air. Here is the famous Canter's Deli, filled with elderly Jews in the daytime, and with wildly dressed young people of every religion, I have heard, in the hours after midnight. On the east side of the street is Fairfax High School. And just across from the high school, a theater.

I remembered this theater; I'd even been here once or twice to see second-run films. It was a logical place to choose as a venue for old-time movies. Although much smaller than the lavish theaters where our pictures once played, the details were right, from the curved glass windows and cupped silver change hole of the ticket booth, to the ornate, gold-plated light fixtures, to the old piano that had once been used to accompany silent films. Suddenly I felt nervous about seeing it again, and after I found a space

large enough to accommodate my vehicle, I took several deep breaths to gather myself.

As I approached along the sidewalk, I saw workmen carrying heavy tools and equipment and heard the intermittent sound of drilling. The old marquee had been removed, replaced by black art-deco lettering that said, *Silent Movie Theater*. A middle-aged man stood in front of the ticket booth and examined a piece of paper. He was wearing khaki pants and a white long-sleeved shirt that was smudged with dirt. His blond hair was uneven, as if it had been cut by a child, and he had the meaty countenance I associate with the Middle West. As I approached, he looked up and said hello.

"Hello," I replied. Then I pointed through the open doors. "I have been in this theater before when it played second-run movies. What are you doing with it?"

The man, who I assumed was O'Brien, glanced over at the workers. "My wife and I just moved out here, and we're opening a silent movie theater. We're fixing it up—we have to replace the snack counter, renovate the bathrooms, that sort of thing. So the place will still have an old-time feel, but with all of the modern conveniences." He looked back at me and flashed the smile of a salesman; perhaps that was what he'd been in Ohio. "We're having a big opening night in four weeks—spotlights, red carpet, live music, the whole shebang. I hope you'll be able to come." He reached behind him and then handed me a flyer.

Chaplin Double Feature! it announced in thick black letters. *Come Celebrate the Grand Opening of the SILENT MOVIE THEATER!! Relive Hollywood's Glory Days!*

"Tell me," I said, lowering the flyer, "what other films will you be screening?"

O'Brien tapped his pen against the clipboard he held. "That's what I'm working on right now. There's the classics, of course—like Keaton and Mary Pickford and the Keystone Cops. And *Intolerance* and *The Sheik* and all *those*

old things. But I don't know what to show beyond the obvious choices. Do you have any suggestions?"

"Well," I said, stepping closer to him, "thank you for asking. I do, in fact, have several suggestions. I believe you should consider showing some of John Gilbert's films, as well as those of the Gish sisters and Harold Lloyd. Certainly Greta Garbo and Gloria Swanson. And you might consider Jun Nakayama."

A look of puzzlement crossed O'Brien's big Midwestern face. "Who?"

"Jun Nakayama, the great Japanese star."

"He was a star in *America*?"

"Yes," I said, trying to mask my impatience. "From 1912 to 1922, he made more than sixty films. He was one of the biggest stars in Hollywood, particularly in the years between 1915 and 1920. He starred opposite Fannie Ward, Lillian Gish, and Bessie Love, and did one picture with Gloria Swanson."

"Really? Now what was his name again?"

"Jun Nakayama. His most well-known work was the 1915 picture *Sleight of Hand*. Several others, including the World War I film *The Noble Servant*, may still exist in private collections. He worked with all the great directors of the day, including William Moran and Cecil B. DeMille."

"You know, I think I *do* know who you're talking about," said O'Brien, brightening. "Somebody else mentioned him also." He looked at me with a new respect. "You sure know a lot about silent films."

"I suggest that you try to find Nakayama's pictures. I believe that you will find them quite interesting." And with that, I bade him farewell and continued down the sidewalk to Canter's. I felt too unnerved to make the trip home right away, and ordered some tea and an apple turnover to calm myself down.

While I was thankful that someone had taken enough of an interest in silent films to open a special theater, I was

troubled by the fact that the proprietor seemed to know so little about them. How could he do the period justice if he didn't recognize the contributions of some of the silent era's most accomplished artists? How could someone who was clearly not a student of film present even the pictures he *did* know in an appropriate context? For silent movies are a singular form, one that viewers cannot appreciate without a basis for understanding what they see. They have their own rules and symbols; they depend on inference and audience involvement much more than outright explication; and every element—from the use of light and shadow, to the choice of color stock, to the suggestion of off-camera space—is vital in creating the overall effect and expressing a larger vision. And it is not simply that silent films themselves have been forgotten; lost, too, has been the language to discuss them. I was not convinced that the man I had met that day would be able to convey that love and understanding.

And I cannot deny that it bothered me that O'Brien was unaware of my own career. It made me question what other major actors and actresses he simply didn't know. I wondered what he would think if someone told him who I was. I wondered what he'd say if he realized that, even as we spoke, I was being considered for a part in a movie.

I pulled out O'Brien's flyer again and looked at the rendition of a crowded theater on an opening night. I myself, of course, had attended many premieres—both for other people's films and for my own. Those evenings, with their cameras, the lights, the crowds, the stars, were the grandest events in Hollywood. And as I sat drinking my tea, my mind wandered back to the most spectacular opening of all, the premiere of my greatest triumph.

Sleight of Hand, which opened in May of 1915, was a milestone not only in my own career; it was also one of the most important events in early Hollywood. The premiere was held at the brand-new Illustrious Theater, and the

Normandy Players had made special arrangements befitting the occasion. There were spotlights and red carpets, champagne was served in the lobby, and every influential producer, director, and executive was in attendance. The cordoned-off walkway from the street to the front of the theater held back the pressing throngs of people, who all gasped and reached out to touch us as we passed. Women screamed my name when I walked by with the young Japanese actress who'd been recruited as my date for the evening; a few of them cried and fell into each other's arms. Just inside the door stood Normandy, beaming, and when he saw us he lifted his fists in exultation. Already present by the bar was my costar Elizabeth Banks, who was appearing in her first dramatic role. She left her escort—another Normandy actor secured for the occasion—to come over and give me a kiss me on the cheek. "Jun, Gerard, Elizabeth!" someone called, and we all turned to face a photographer. That shot would be on the cover of the next day's *Los Angeles Times*, as well as that month's issue of *Motion Picture Classic*.

I had already been with the Normandy Players for more than two years before I was offered the lead in *Sleight of Hand*. In that time, I had appeared in a dozen films. Usually the roles were somewhat limited in scope: twice I played an Oriental drug lord, once a vanquished Indian chief, and once a Mexican marauder. While I continued to get favorable reviews, I was growing tired of these generally unambitious films, and was eager to expand the range of my characters. When Normandy approached me with the idea of starring in *Sleight of Hand*, I immediately jumped at the chance. I was hesitant about appearing with Elizabeth—I didn't know how well we would work together—but Normandy, despite his earlier misgivings about her, was convinced that having a female lead of her caliber would give the film a dangerous edge. And while her previous work had been in comedies, he saw an untapped passion in her,

a pathos, that he felt would be right for the part.

The basic plot line was simple: A young society wife, bored by life with her older husband, has taken to midnight excursions to illegal casinos, where she drinks and runs up a steady debt playing blackjack and poker. The proprietor of her favorite gambling joint is a wealthy Japanese named Sasaki. As she gambles away her husband's money, Sasaki offers to loan her more—for a price. If she fails to pay off her debt within thirty days, she must surrender herself to him for one night. She continues to lose, however, and to borrow more money, until she finds herself in greater debt than she could ever repay. What she doesn't realize is that Sasaki has rigged the games—his men who run the tables have made it impossible for her to win. The story culminates in a protracted scene between the two principals, where Clara Whitbrow—Elizabeth's character—begs for more time, and Sasaki insists he must collect. Her continued resistance only stimulates his fury, which he expresses not through angry words or histrionic gestures, but with concentrated glares of rage and desire. Finally, he embraces her and sinks his teeth into her neck, and carves an S into her shoulder with a knife. As he grabs her from behind and presses his weapon to her flesh, her eyes fly open in shock and rapture. It was the most radical scene ever filmed between a Caucasian actress and an Oriental actor, and it was this scene that stirred so much discussion and interest on the picture's opening night.

The erotic violence in the film was only fueled by the conficts between the principals. As documented years later in Croshere's history, and as I was already well aware, Elizabeth Banks had a problem with alcohol. She often arrived intoxicated to the set in the morning, and then slipped off to her dressing room at lunch for a cocktail. Several times Gerard had to send her home, and on the days she *was* sober, he worked her up with his scolding to a fever-pitch intensity that resulted in a masterful performance. For he'd

been right—despite her drinking, her acting was passion-
ate and authentic; perhaps the difficulties of her own early
life had instilled in her a great reserve of feeling. But re-
gardless of her talent, I was often irritated with her—not
just because of her drinking, but because of the tantrums
she would throw if the catered food was not satisfactory, or
the Klieg lights too blinding, or the mood music not to her
liking. It wasn't difficult for me to convey this rage through
the eyes of my character, Sasaki. And because I was see-
ing her off-camera as well, our friendship, which flashed
hot and cold on a near daily basis, created a tension that
was electric on the screen. All of these elements—along
with risky subject matter—made the three-week filming a
heady, intense, and volatile experience. When Normandy
played back the final cut for the actors, we were stunned
by the beauty of what we saw.

It is hard to convey now, in the different atmosphere of
the 1960s, how shocking *Sleight of Hand* was fifty years ago.
This was an era when people did not kiss in public—and
there was I, with my lips on Elizabeth's neck. This was
a time when Japanese moviegoers were seated separately
from whites—and there was I, with my name on the mar-
quee. This was a time when Caucasian actors still played
most Oriental parts, as Mary Pickford had done that very
year in *Madame Butterfly*—and there was I, playing the lead
in a major film. The sensation our picture caused was
something wholly unprecedented, surprising even to those
of us who were involved in its making. That first night, at
the premiere, an audible gasp went up from the audience
when Sasaki bent down over Clara's shoulder—and after
the curtain was raised, the standing ovation lasted a full
five minutes. Reviews of the film were ecstatic.

"An instant classic," wrote Kenneth Seaborne of the *Los
Angeles Times*. "Elizabeth Banks, in her first serious role, is
beautiful and tormented, and Jun Nakayama, as the evil
Jap Sasaki, is at his savage and sensual best."

"This picture will have everyone talking," wrote the *Herald Examiner*. "The chemistry between Nakayama and Banks is electric, and Nakayama is brilliant at conveying the beastliness of the Oriental nature. The future is unlimited for this slant-eyed son of the Orient. In its daring subject matter and its brilliant acting, *Sleight of Hand* pushes cinema to a whole new level."

Later, in his *History of the Silent Film Era*, Davis Croshere had this to say about the film:

> As important an event as Sleight of Hand *was to Gerard Normandy's career, it made Jun Nakayama a star. His concentrated stares, which showed both passion and rage, established him as the master of containment. All the other actors at that time tended to exaggerate gestures and facial expressions in order to compensate for the lack of sound. But Nakayama distilled all his emotion into the center of his being, and then let it be revealed through a single raised eyebrow or menacing glance.*

Terry Canterbury, in *Hollywood: A Historical Perspective*, agreed. Although he incorrectly identifies *Sleight of Hand* as the work of Ashley Bennett Tyler, who directed me later, he too saw the film as a key turning point in my career:

> Nakayama's intensity burned through the surface of his still, patrician face. He was both savage and aristocrat, primal and sophisticated, mysterious and completely irresistible. All the later brooding actors who broke women's hearts—the Valentinos, the Brandos, the Clifts—learned this art from Nakayama. His smoldering, sexual presence was unlike anything else that had previously appeared on the screen. He was the beautiful, brutal man of a forbidden race, the exotic "other" that women wanted to be ravished by.*

Indeed, over the several weeks that followed the release of *Sleight of Hand*, we heard reports of women fainting in the theaters. In several cities across the Midwest and

South, theaters were banned from screening the film be-
cause of the feared effect on public morals. In Los Angeles,
I was suddenly the recipient of much more focused atten-
tion. At parties, young women would press closely to me,
their hands wandering inside my jacket; I would often go
home with my shirt untucked and several phone numbers
stuffed in my pockets. My studio biography was released
to the public, and women seemed further intrigued by
the Hollywood version of my life, which gave me a feu-
dal background and transformed my simple father into a
wealthy landowner and high government official. "Let me
be the lady of your manor," one young woman said to me
at a party, pressing her ample breasts into my shoulder. "I
want to be your concubine," said another young woman,
"for you to ravish whenever you wish."

I confess that I was tempted by more than one of these
ladies. What young man, presented constantly with such
delicious opportunity, could possibly resist? As a boy in
Nagano, I'd thought that I'd be fortunate to someday find
one woman who'd consent to be my wife. Now I had dozens
of women competing for my attention. With my increased
visibility, my private house, and my limitless money, I was
able to entertain dates as much as I pleased, and, in fact,
could have had many more. But the young women I met
at parties and studio functions were largely tiresome, and
they lost their appeal rather quickly.

After distracting myself with several women in the
months following the release of *Sleight of Hand*, I focused
my attention back on Elizabeth. Even though I found her
unpredictable and often quite maddening, I knew that this
was part of her appeal. She always carried herself with the
air that I was lucky to be with her. And she never let me
forget that I was only one of several men with whom she
spent her time.

This is not to imply that she never behaved in an ad-
mirable fashion. There were nights, for example, when a

group of us actors would arrive at a popular night spot, and Elizabeth would smooth things over with the frowning doorman who was not accustomed to having Japanese patrons. There was also the evening of the Red Cross fundraiser, which was hosted by a group of society women who didn't normally care to mix with picture people, but who'd invited Elizabeth because of her role as a nurse in a recent film. "Mrs. Grace told me it would be social suicide to bring you," said Elizabeth sweetly, as she introduced me to the president of the local chapter. "She said that you'd embarrass yourself since you might not know how to eat with a knife and fork. This is the same woman who was kind enough to inform me that I really shouldn't spend time with you at all. So you see, Jun, you really *are* quite an unsavory character, and I'll bet you weren't even aware of it!"

In retrospect, I see that Elizabeth enjoyed these confrontations. She herself would have been unwelcome in such fashionable circles if she had not been a Hollywood star, and she liked to do things that challenged the norms of Los Angeles' social elite. But while she would dine with me, dance with me, charm doormen on my behalf, she still resisted me romantically. And the more she held back from me, the more fervently I made love to other women, either to punish her or to redirect my longing. It didn't work, however; it never really worked. For even when I was in the company of other young women—indeed, even as they lay naked and quivering in my bed—I thought of no one but Elizabeth Banks.

One of the more memorable events of that period was the annual awards banquet hosted by *Moving Image Magazine*. Every year, the magazine presented prizes in various categories as selected by their readers. I had attended this function the two previous years with Hanako Minatoya. But this year, because of the success of *Sleight of Hand*, it

seemed appropriate that Elizabeth and I attend together. We'd originally planned to go with several friends from the Normandy Players—the arrangements for such functions were not as tightly controlled as they would be just a year or two later—but when the logistics became too complicated, I proposed to Elizabeth that I just pick her up myself. I dressed in my best tuxedo and had my driver take me over to her house. And when I saw her in the doorway, I was immediately glad—and also proud—that I would be her escort. She looked beautiful. She wore a long black gown that emphasized the lovely contours of her body. The diamonds around her neck drew attention to the fragile collarbone, and her hair was tied up in intricate curls. When I stood beside the car and clasped my hands over my heart, she laughed. "You don't look so bad yourself," she said, glancing at me slyly. On the drive downtown, I held her hand, so thrilled by her proximity and the reception of our work that I thought my heart would burst.

When we arrived at the grand new Tiffany Hotel, I expected to be received as we had been at our premiere— the red carpet, the flashing cameras, the clamoring fans. But when I helped Elizabeth out of the car, the people all looked at us oddly. No one rushed over to greet us as we approached the front entrance, and despite the large crowd, it was eerily quiet. Then finally, near the doorway, a young man approached. "Why, welcome, Miss Banks, Mr. Nakayama," he said. "I'm Stephen Ward, from *Moving Image*. Please come inside."

Entering the dining room, we were met with the same curious silence—someone's face would light up when they saw Elizabeth or me, and then cloud over when they saw who we were with. The director Brett Roy walked up as we headed toward the front and clapped me rather hard on the shoulder. "Good to see you, Jun. Yes, it's quite good to see you. Not afraid to rock the boat a bit, I see." But before I could respond, he'd moved away.

Stephen Ward from *Moving Image* appeared again and guided us over the Oriental rugs to a table in the corner. Elizabeth frowned when he pulled out her chair. "You're putting us in an out-of-the-way spot, don't you think? We can hardly see the stage."

"Uh, yes, I apologize, Miss Banks. The center tables are already reserved."

The center tables were, in fact, all half-empty, but I was not in the mood to press the issue. Elizabeth gave him a displeased look, but then settled down into her chair. We had arrived twenty minutes before the start of the formal program. In the intervening time, people whispered and glanced over at us, but no one approached. I looked out at the room—the elegant tables with thick white tablecloths, the crystal chandeliers, the sea of furs and hats and diamonds and tuxedos—and suddenly felt completely unnerved.

"This is bullshit," said Elizabeth, crossing her arms. The waiter had left two large glasses of champagne, and she was drinking, I thought, a bit too rapidly.

"Elizabeth," I said in a warning tone.

"Oh, come on, Jun. Don't you see what's happening here?"

"Elizabeth, please try to calm down."

She stared at me as if she would have liked to empty her drink in my face. Just at that moment, mercifully, Gerard Normandy sat down beside me. He was jumpy, fingers drumming the table, shifting in his seat, but I didn't think much of it because he never sat totally still. His thinning brown hair, as usual, was wild as a bird's nest; it was rumored he went days without sleep.

"Good to see you, Jun, Elizabeth," he said a little too cheerfully. "I heard that you were here." He and I sat talking about the scheduled events for that night, while Elizabeth pointedly ignored us. After a few minutes, Normandy leaned close and said in a low voice, "Listen, Jun. I know

you and Elizabeth see a lot of each other, but you should have talked to me about your plans for tonight."

I looked at him. "I don't know what you mean."

A flush shot through his cheeks and settled in his ears, which turned an alarming shade of red. "I just mean . . . well, you *must* know what I mean. This isn't exactly a private occasion."

I hardly had time to consider the implications of what he'd told me before Elizabeth turned toward him, eyes blazing. "This is bunk," she said, too loudly. "You're all such hypocrites. You think that no one knows about *your* Chinese whore? Or Leonard Stillman's Mexican mistress? Or your own director who's taken up with one of the girls from Hanako Minatoya's company? At least Jun and I have the dignity to appear together in public. Oh, and there's another difference between us and the rest of you lying bastards—*we're not even fucking!*"

She said this last bit in an elevated voice that must have traveled across the room, for all conversation stopped. Normandy turned an even brighter shade of red. "I'm just telling you," he said, "we all need to be careful. Considering how sensitive everyone is about the film, it's better not to instigate them further."

With that he left us, and the room exploded in conversation. "Waiter," called out Elizabeth, "bring another glass of champagne. Actually, just bring the whole bottle."

We sat there hardly speaking until finally it was time for the program to begin. And while the center tables did eventually fill up, no one else joined us in the corner. With the lights down and the program under way, it was easier to forget our discomfort. The event was not particularly long—a few speeches, some joking, and then the awards. Despite the success of *Sleight of Hand*, it did not win the Moving Image Award for Most Popular Picture—but to everyone's surprise, I had been picked by the readers as the Most Popular Male Actor. When I ascended the stage, the

applause in the room was hesitant and scattered, and the presenter—actor Jacob Steele—did not look at me as he handed me the plaque. I gave thanks to everyone, including Normandy and Elizabeth—who lost the Best Actress award to Evelyn Marsh—and as I descended the stage to return to my seat, I heard someone say, "Lucky for him the votes were cast before tonight."

Despite the unpleasantness of that night at the Tiffany, I continued to reap the rewards of our picture's success. Not only did *Sleight of Hand* turn me into a highly visible figure, it also made me a very rich man. The windfall came in the form of a new contract from Perennial Pictures, which had just absorbed the Normandy Players. Perennial feared—with good reason—that another studio would tempt me away, and the competition resulted in my signing a new contract for the incredible sum of $10,000 a week. My next four films were also successful, becoming, along with *Sleight of Hand*, some of the largest-grossing pictures in the short history of Hollywood. And this dramatic improvement in my financial situation allowed me to purchase an eight-bedroom Spanish villa at the foot of the hills. I was the first person connected with Hollywood to move into the neighborhood, which until then had been the exclusive province of the city's downtown business elite, and while there were a few grumbles about the invasion of "picture people," my appearance brought no real repercussions. In fact, I adapted quickly to the life of a wealthy gentleman. I bought an entirely new wardrobe, as well as another automobile, a little roadster. I hired a cook, a live-in butler, a gardener, and a chauffeur. I acquired the finest and most expensive of Western-style furniture, and several classic Japanese wood block prints and landscape paintings. I was suddenly very popular and began to throw my own parties—large, festive events to which everyone in Hollywood clamored to be invited.

All the while, I continued to send money to my family, and to put them off with promises that I would visit them soon. It was, of course, quite clear to me that I would never return to live in Nagano. In just three years in Hollywood I had accumulated more wealth, fame, and glory than a hundred famous actors in Japan.

By this time, my family was well aware of my growing success in America. I would send them reviews and articles from the Japanese papers in Los Angeles, and my mother would write back with comments from the entire village. "We were so happy to read of your performance in *Purple Mountain*," she wrote in one letter. "And we all enjoyed the photographs. You look so different, Junichiro—so grown up and dignified. Mrs. Takahashi nearly fainted because she thought you were so handsome, and all the schoolgirls in town are asking for your autograph." They still thought of my career, though, as a temporary amusement, or something that might lead to similar work in Japan. "We await the day when you come home and start working in Tokyo or Kyoto," my mother wrote—but they seemed pleased that I was making a name for myself. And they were certainly pleased with the money, which allowed them to pay off their remaining debts and to build a large new house at the edge of their village.

I did not send them the reviews of *Sleight of Hand*. For while the critical response in the general press was mostly positive, the reviews in the Japanese papers were markedly different. Among certain factions of the Japanese community, there was the sense that the character of Sasaki reflected poorly on the Japanese male. In his deceit of the Elizabeth Banks character; in his devil's bargain; in his nearly successful attempt to collect his debt by force, he conveyed, they said, a negative image of Japanese men. There was a steady stream of criticism from commentators in Little Tokyo; owners of some establishments seemed less happy to see me; and the Japanese Embassy wrote an

official letter of protest to the Normandy Players and the Los Angeles City Council.

"Nakayama's portrayal of Sasaki," wrote the film critic for the *Rafu Shimpo*, "has set back Western understanding of the Oriental at least half a century. Our efforts to win recognition from Westerners as equal human beings have been undercut by this image of the Japanese man as cruel, base, and dishonest."

"It is unfortunate," wrote another reviewer, "that Jun Nakayama has squandered his considerable talents on this racialized and limited work."

Even some American commentators were troubled by the film, for entirely different reasons. A columnist for the *Herald Examiner* warned American husbands, "All taboos have been shattered in this scandalous picture. Don't leave your wives at home alone with your Jap houseboys." And Harlan Chaney, the congressman, wrote a letter to the *Los Angeles Times* in which he declared:

> This film is a perfect example of why the Japs are such a threat. Unlike the Negro, they refuse to accept their place. Unlike the Chinese coolie, they're smart enough for business. This picture proves beyond doubt that Japs believe they have the right to anything, even our pure white American maidens. If it is shown in Japan, you can be sure that tens of thousands of them will come to California—with the express purpose of colonization.

Surprisingly, it was Hanako Minatoya who spoke out most passionately in my defense, sending a letter to the *Rafu Shimpo* in which she asserted that actors could not shy away from playing difficult roles. But privately, even Hanako admonished me. "You should really be more careful, Nakayama-san," she said when I called to thank her for her letter. "I wish you weren't so convincing at portraying a brute."

I was not altogether surprised that the film stirred such

emotion—I knew it was inflammatory from my first read-ing of the script—but I was taken aback by the intensity of the public response. In my view, Sasaki's nationality was incidental to his fundamental nature. He was, indeed, a man of questionable morals—but this had nothing to do with his being Japanese. His background was simply one of many factors that made up a whole, compelling charac-ter, and not the central truth of his existence. And while it is true that Sasaki was perhaps rather brutal, it is terribly narrow-minded to think the way he was depicted was the result of racial prejudice. Some of it was attributable to the exigencies of film, which made difficult any complex characterization. Some of it was simply custom, and once I learned the expected boundaries—both in pictures and in life—I had no more troubles of the sort I'd experienced at the Moving Image Awards. Despite the opinions of critics in Little Tokyo and elsewhere, I believe that Hollywood made the fairest films it could. And was it not a mark of progress that a Japanese actor could be accepted as a lead-ing man at all?

After I finished my pastry and tea, I left Canter's and ven-tured back out onto Fairfax. As I walked down the block, I saw that a tow truck was parked in front of my car, and that a man in dark green work clothes was attaching a hook to its underside. I closed the distance between us quickly and yelled, "What are you doing?"

The man straightened up as I approached. He was perhaps in his early thirties, and a half-smoked cigarette dangled from his lips. His sewed-on name panel said *Dave.* "It's in a tow-away zone," he said. "Didn't you see the sign?"

Glancing over at the sidewalk, I saw that there was, in fact, an obvious sign: *Shuttle Makes Frequent Stops. Absolutely No Parking!* I turned back to Dave, who was leaning on the hood, and fought the urge to ask him not to touch it. "No,

I didn't. It is my mistake, but I am here now. Do you really have to tow it?"

Dave flicked away some ashes and sighed. "I don't care one way or the other." He pointed toward the building beside us. "It's this old folks' home that called it in. But I suppose as long as you move it, it'll be gone and they'll be happy. I don't know how you drive that big old clunker anyway."

Looking from the car to the man and back again, I said, "Excuse me, but this automobile is far from being a 'clunker.' It's a 1931 V-16 Packard, the very height of elegance and prestige."

The man shrugged, running his fingers through his visibly greasy hair. "Suit yourself. Me, I prefer the Mustang or the Viper." With that, he bent over and disengaged the hook.

"Thank you. I appreciate it." I gave a slight bow.

He winked and said, "No problem, old fella."

After the tow truck had driven away, I sat in my car for a moment before starting the engine. I was troubled by the entire episode—how had I missed the sign? I did not recall there being such a sign on Fairfax, but it was true I hadn't been there in quite some time.

I drove home thinking about the morning's events, but I couldn't ponder them for long. When I entered the building, George, the octogenarian doorman, handed me a package. It took me a moment to realize that it was Bellinger's manuscript; the messenger had come while I was out. Now I bore it upstairs like a long, unwanted letter to which I was obliged to reply. I went inside and opened the package and set the screenplay on the table, wishing I had been firmer in telling him no.

As I felt the weight of it, flipped through its ninety-eight pages, it struck me how much the moviemaking business had changed. In the early years, there were no screenplays, and no dialogue in the sense there is today.

Writers wrote loose shooting scripts, which described the characters' movements and expressions, and it was up to the director to extrapolate from there. Sometimes, though, the scenarios were even simpler. Douglas Fairbanks' *Robin Hood* was shot with nothing more than a one-page outline; Charlie Chaplin and Buster Keaton worked with no scripts at all. In the earliest days, only William Moran began a picture with a tight, structured written format of how he wanted it to unfold. And in all these scripts, there was little mention of what the characters should say—not like the screenplays of today, where the writer has to conceive of whole conversations, entire pages of verbal exchange.

It so happened that I had nothing planned for that afternoon, so I brewed some tea and settled down in my reading chair. I had no idea what to expect from Bellinger's screenplay, but I hoped that it would not be too painful.

Much later, when I finished the manuscript, the room was almost dark. I checked my clock and discovered that three full hours had passed—not once in that time had I stirred, except to turn on the reading lamp. Now that I had finished the screenplay, I did not want to put it down; I held it gently in my hands like a living thing. And I felt a sensation I had not experienced in decades, the unmistakable stirring of creative excitement, the quickening of artistic desire.

It was not simply that the plot was compelling, although that was certainly true. The story centered on the young Marbury family—Terrence, Diane, and their four-year-old daughter Nancy—who live in a small town in Central California. The wife is a teacher, the husband owns a farm supply store, and their lives are uneventful. But then a new neighbor moves in next door, an older Japanese man named Takano, and they come to believe that he has moved to their remote little town in order to escape some secret from his past. They grow convinced—because of his age, because of his bearing, and because of his accent—that he is

a former high-ranking Japanese official, perhaps a military leader from World War II. Although they are friendly with him, and bring him lemons from their tree, they speculate about his history and the circumstances of his arrival, and exchange increasingly far-fetched theories with their fellow townsmen. Their intense interest in him begins to shape the way they see everything else: their jobs, their own experiences, their daughter, even their marriage. Through all of this, Takano remains an elusive character who is friendly to the townsfolk and particularly to the Marburys' child, but who has no interest in satisfying anyone's curiosity. But what the Marburys believe Takano to be and who he really is turn out to be entirely different. By the time it is finally revealed that the town's assumptions are horribly wrong, everyone's beliefs are so firmly implanted that they cannot see past their own fear and suspicion. The several plot twists that ultimately play out at the end are as surprising as they are inevitable.

While the story intrigued me, what impressed me even more was Bellinger's handling of all the dynamics of his people—their expectations and misreadings of each other; the way that fear and fantasy distort their everyday lives; the price that people pay in their futile attempt to outdistance themselves from pain. And he captured perfectly the conflicts of California's Central Valley, where white and Japanese farmers had coexisted so uneasily. It was a wise, taut, compelling work, psychological and troubling. And the character of Takano, which was clearly who Bellinger wanted me to play, was sensitively rendered. It was a relief that the Oriental character was not a villain, and his actions, both in the present of the film and in his distant past, included elements that could even be called heroic. And while he was, in fact, quiet and mysterious, those qualities had more to do with the other characters' failures of understanding than with something inherently unreachable in him.

The thought of playing a complex, intelligent, dignified man, a Japanese who was not dishonest or brutal or hiding a violent past, was more than I could possibly resist. It was true that I was forty years out of practice and unversed in the ways of modern film. But it was also true that something of the old actor in me was stirred by the prospect of a challenging role. Moreover, I knew that this could represent my chance to finally portray a hero.

I did not call Bellinger that afternoon. I felt too overwhelmed, and I needed to make sure that my initial enthusiasm was not short-lived or superficial. But I began to have thoughts which indicated to me that I was now taking his proposition more seriously. I wondered if Bellinger had a commitment from Perennial—whether his conversations with Ben Dreyfus' grandson were informal or involved more concrete terms. I wondered what, if an agreement had indeed been struck, the process involved from there. I suspected that Bellinger, once the screenplay was sold, would have no say over who was cast in the film. But I also happened to know that there was no other Oriental actor of my stature. Steve Hayashi, who still appeared in the occasional B film, was simply not in the same league—and just as importantly, the Dreyfus grandson knew who I was.

I felt, I must admit, a certain apprehension, for a return to movies wouldn't be a simple matter. I was also quite nervous about the thought of doing a talkie. So many of my contemporaries had not survived the transition to sound—not only the actors and actresses whose voices were too high or too low or too grating, but those with fine voices who did not know how to use them, or whose voices could never live up to their viewers' fantasies. Still, I knew that I was unrivaled in terms of pure acting ability. And I speculated on who would be suitable to work on the film. Of course, my first choice for director—had it been possible—would have been Ashley Bennett Tyler, with whom I had partnered so successfully over the years.

As for actors, Terrence Marbury would have to be someone handsome and workmanlike, not an aristocrat like Gregory Peck or Cary Grant. Diane Marbury would be spirited with an undercurrent of sadness, pretty but down to earth, an actress who was at once pleasant to look at and also unassuming. There were very few actresses who met those criteria; very few who took their beauty for granted. One actress, however, from my own days in film, came immediately to mind. Of course, she is an old woman by now, and she hasn't spoken to me in many years. Merely thinking of her, though, brought back a flood of recollection. She had been an original, a true talent and precocious child, and her story was one of the saddest tales of all.

I met her in early March of 1917, after the Normandy Players had been absorbed into Perennial. I had just finished meeting with Gerard Normandy about my upcoming film—he was vice president for production at the new studio—and was stepping down from his office for a cigarette. The day was beautiful, clear and still cool from the morning's chill, and all the flowers and trees on the Perennial lot looked especially lush and bright. I watched the studio employees rush back and forth, some on foot and some on bicycles, as well as players in full makeup and costume. Many of them called out as they passed, "Hello, Mr. Nakayama!" and, "Loved your last picture, Jun!" I nodded and waved, aware of the people talking about me, the looks of admiration.

I was riding a string of remarkable successes. Since *Sleight of Hand*, my last eight pictures had all been hits, bringing the studio so much money and allowing for payment toward so many debts that people had started referring to me as "the paycheck." Benjamin Dreyfus, the head of marketing and distribution, had done a brilliant job of promoting my films; he'd also attracted a great deal of publicity for me. It seemed like every day brought another major press interview—just the previous week, I'd been on

the cover of *Moving Image Magazine*—and I was now receiving thousands of letters a week, from both American and Japanese fans. Elizabeth Banks, who'd also signed with Perennial, was experiencing a surge in popularity herself; she was now being taken seriously in dramatic roles and her last several films had been successful. Looking out across the lot at all the workers and players, feeling their energy and excitement, I was struck again by our tremendous good fortune. People moved about the studio as happily as if they'd discovered a new country, a place that had everything one could possibly need for the task of making pictures—not just cameras and stages and offices, but also a hospital, a commissary, even a functioning lumber mill to speed up the production of the sets. And I thought for a moment of how strange this all was—how we functioned in an alternate and make-believe world, which was more vital to us than the real one.

As I was standing at the foot of the stairs, I noticed a young girl across the courtyard. She was sitting on a low stone wall, picking flowers out of the garden behind her and gathering them into a bouquet. One passerby, and then another, gave her a look of disapproval, but she seemed oblivious to everyone around her. She was dark-haired and lovely, yet there was something in her manner that struck me as melancholy. After she had picked as many flowers as her small hands could hold, she turned back toward the courtyard and looked around with a detached and daydreamy air. Presently her eyes settled on me. I tipped my hat and she smiled brightly, looking so delighted that I wondered if we'd met somewhere before. Then she stood and seemed to float across the courtyard, her long, thick hair trailing behind her, her white gossamer dress hanging nearly to the ground. When she reached me, she stopped and looked up into my face with the innocent curiosity of a child.

"Hello," she said cheerfully. "I'm Nora. Who are you?"

I smiled indulgently and bowed. "I'm Jun. It's a pleasure to meet you."

She spread her arms wide and spun fully around, as if embracing the entire world. "It's perfect today, isn't it? I wish I didn't have to be here."

"Ah," I said. "But where else would you find such beautiful flowers?"

"At home in Georgia," she replied, turning back to me but looking somewhere else. "There were all different kinds of flowers and trees. It was like the whole world was alive."

That she called Georgia her home surprised me, for she lacked any trace of an accent. "And when were you last home?" I asked.

"Oh, too long, too long." She sat down on the stone wall beside me. "You're that famous Japanese actor, aren't you? 'The dark storm from the perfumed Orient.' I read about you last month in *Photoplay*."

I chuckled. "Well, Miss Nora, I don't know how famous I am. But yes, I am an actor. I'm under contract here with Perennial."

"My mother says your picture was immoral, but I rather liked it. I snuck out of the house to watch it with my friends." She giggled, and I wondered what she was doing there at Perennial. I had no doubt which picture she was speaking of.

"Thank you. I'm glad you enjoyed it."

"My mother thinks Japs shouldn't be in pictures at all, but she says you're a talented actor. She doesn't like *anyone* very much, to tell you the truth. Especially the men who work *here*." She gestured toward the offices. "She thinks they're all crooks. She liked the people in New York much better."

I peered at the girl more closely, thinking now that she looked familiar. She must have been sixteen or seventeen, although she acted more like twelve. "What did you say your name was again?"

"Nora," she repeated, as if the whole matter of names was tiresome. "Nora Niles." Then she looked into my face and said, "My, Mr. Nakayama, you're lovely."

Although she said this with genuine feeling, I knew at once that her words were innocent. She was simply expressing her appreciation for my objective appeal, as if I were one of the flowers she had plucked from the garden. In fact, just as my mind had formulated that analogy, she extended the hand that held the bouquet. "Here. I think you should have these."

"Oh, thank you, Miss Niles, but I'd rather you keep them. They're delightful, more befitting a lady."

"All right." The girl sighed and cast her eyes to the ground, and I was afraid that I had injured her feelings. But when she spoke again, the flowers had gone from her mind. "It's so nice to talk to people. There are so few lovely people in the world."

I considered her more closely—her blushed, rounded cheeks, her full lips, the irrepressible dark hair—and was certain now that I had seen her before. *How* I knew her—and who she was—struck me at precisely the moment that a high, shrill voice split the afternoon tranquility. "Nora!"

I turned around to look for the source of the voice, while the girl just kept her eyes on the ground.

"Nora, you come over here right now!"

Reluctantly, still not even glancing in the direction of the voice, the girl pulled herself up to her feet. But she didn't move from her spot, and in another few seconds a woman rushed over to where we stood. My immediate impression of this woman was that she was boiling—not merely angry, but actually bubbling with anger. She had the same dark curly hair as the girl, and the same brown eyes, though hers were devoid of wonder. She grabbed the girl by the elbow and shot me a look. "You come on, Nora. It's time to go home."

By this point I had realized that I was talking to Nora

Minton Niles, the young new actress who had signed with Perennial six months before to take the place of the departed Lola Moore. She was only sixteen when I met her that March day, and seemed much younger, though she had already appeared in six or seven films. She was there—or rather, her mother was there—to meet with studio executives; indeed, as I looked back toward where her mother had come from, I saw David Rosenberg, special assistant to the studio chief Leonard Stillman, standing at the top of the stairs.

"Mrs. Niles," I said now, as the mother pulled her daughter along. "Allow me to introduce myself. I am Jun Nakayama, and I am also an actor under contract with Perennial. I suppose this makes colleagues of your daughter and me."

The woman whipped her head around, and I was taken aback by the fury in her face. "I know exactly who you are, Mr. Nakayama. You and my daughter may work for the same studio, but you are *not*, in any way, colleagues. And my daughter's name is Niles, but my own name is Cole. Mrs. Harriet Baker Cole. Now please excuse us."

She led her daughter away, and I, along with everyone else in the courtyard, watched them go in silence. When I turned back toward the staircase, I saw Nora's flowers scattered all over the ground.

After the girl and her mother were out of sight, I walked over to David Rosenberg. He was a serious young man of about twenty-five, and whatever else his job description may have included, his main function appeared to be dealing with difficult people. Because his boss, Leonard Stillman, worked out of the studio's New York headquarters, Rosenberg acted as his eyes and ears for West Coast operations. "Some piece of work, that Mrs. Cole," he said as I approached. "You're lucky, Jun, that you got out of there with your balls still attached."

I stared at him, surprised. It had not occurred to me

that anyone could make something of the fact that I had been talking to Miss Niles, perhaps because she seemed like such a child. "She's very protective," I offered.

"That's one word for it," said Rosenberg, drumming his fingers on his arm. "She can't stand for men to talk to Nora—threatening her gravy train, I guess." He tried to kick a stone in front of him and missed. David was tall, broad, slightly awkward in movement, as if he wasn't sure his body really belonged to him. He often stood behind Stillman at public events, hovering over his much shorter boss. Now, he shook his head and chuckled. "Our first meeting, she told us she had a .38 in her handbag, just in case there was some kind of situation. Rumor is she carries a switch in her purse for when Nora gets out of line." He tried for the rock again and connected this time; it went skittering off the top of the stairs. "She just screamed at us for an hour about how 'limited' the girl's contract was, and it's the biggest first-time contract we've ever offered. We shouldn't be surprised at anything that woman does, though. She'd sue her own mother if it meant better terms."

"I actually thought the girl was quite charming," I countered.

"Sure she is," said Rosenberg. "Nora's a good kid. A little strange, but totally genuine." He shook his head. "We were in a meeting last month and I said to her, I said, 'Nora, you're set to do ten pictures in the next eleven months. We're glad you're so ambitious.' And she gave me that sad sweet smile of hers and said, '*I'm* not ambitious at all, Mr. Rosenberg. My mother is ambitious *for* me.'"

Over the next several months, as Nora Minton Niles appeared in one film after another, I learned more about her background. Nora's family, as she had told me, was from a small town in Georgia, where her mother had appeared in local stage productions. No one seemed to know what had become of the father. What they did know was that several

years before they came to Los Angeles, Harriet Cole and Nora had moved up to New York. There, Nora had starred in a series of small plays, and then bigger theater productions, before being discovered by a talent scout for Metro Pictures. In 1917, when I met her, Nora had been in California for less than a year. She lived with her mother and grandmother in a small house in Hancock Park; the famous mansion, which later attracted so many curiosity-seekers, would not be built until 1920. And from that house, her mother orchestrated every detail of her career.

Theories about Harriet Cole abounded. Some thought she was simply the kind of pushy stage parent who would soon become so common in Hollywood; some saw her as a frustrated former actress who was living out her dream through her daughter. It was rumored, too, that the name "Nora Minton Niles" actually belonged to the actress's dead cousin, and that Harriet had stolen it—along with the accompanying birth certificate—to add five years to her daughter's age so that the Gerry Society would not stop her from working in New York. Nobody knew what Nora's real name was, nor her mother's, and nobody dared to ask. Nobody bothered to ask Nora much of anything. It was Harriet who was Nora's public face; it was Harriet who always spoke for her; it was even Harriet who collected all her daughter's checks, since Nora was still legally under her mother's care. Later, given all that eventually transpired, I would wonder if Nora had even wanted to be an actress, or if she was simply carrying out the desires of an unfulfilled woman who would sacrifice everything, including her daughter, to get what she wanted.

But as I sit here this evening with Bellinger's script, I know that this train of thought is ultimately useless. It may be true, on purely theoretical terms, that Nora had the appropriate blend of dreaminess and sadness to play the role of Diane Marbury. Yet Nora has been out of pictures for as long as I have, and she is by now an old woman. Bellinger

and Perennial will surely seek a contemporary actress, someone versed in the modern ways of filmmaking. And such a choice would of course be appropriate. No doubt I am thinking of Nora because my mind has been wandering back of late to my own career in pictures. No doubt it is natural for my thoughts to settle on a familiar actress, despite the awkwardness that colors all my memories of her.

But perhaps, upon further reflection, Nora Niles would have been too young to play the role of Diane, even at the height of her fame. Nora was only twenty-one, after all, when the events occurred that drove her from the screen altogether. She never got a chance to play anything but spirited children and sad young teens. She wasn't in pictures long enough to play a true adult.

CHAPTER SIX
October 13, 1964

L ast Saturday, as usual, I met Mrs. Bradford for breakfast. Outside of monthly meetings with my property management firm, these breakfasts are my only consistent appointments. I don't mean to give the impression that I am lacking for things to do; in fact, I often attend the symphony or the theater. I also hold memberships to several museums, which I visit when there are notable exhibits. Moreover, I dine out several evenings a week, and I even—before I began to tire so easily on long drives—took frequent trips to Santa Barbara or the mountains.

Almost always, I undertake these excursions alone. There is something to be said for experiencing great art, or nature, by oneself; the absence of other people makes the enjoyment more pure, and one's perceptions grow acute and discerning. And certainly it is easier to make arrangements for one, as nobody else's requirements or whims can ever affect my plans. Nonetheless, I cannot deny that it is pleasant to occasionally partake in the company of others. This is why my regular meals and conversations with Mrs. Bradford have come to be so agreeable.

We have tried many different establishments in the Hollywood area, both classic diners like the Silver Spoon on Hollywood Boulevard and newer restaurants on Vermont and Santa Monica, but the place we have settled on as our mutual favorite is a quiet, older restaurant on La Brea. The proprietor, a Mr. Earhardt, makes superb spinach omelets, and I look forward to his cooking all week. That particular

morning, Mrs. Bradford wanted to meet later than usual, which gave me time to visit my barber. My hair had started to look somewhat untidy; indeed, the previous Saturday Mrs. Bradford had joked that I would soon fit in with the scruffy youths out on the Boulevard.

I entered the restaurant a few minutes early and found Mrs. Bradford already seated at the window table. She was wearing a yellow and white striped blouse and new white tennis shoes, and she seemed, as always, more youthful than her age. It is not that Mrs. Bradford *looks* younger than her sixty-some years; her hair is silver and there are wrinkles on her face and hands. But there is an alertness in her posture, a quickness, a perpetual brightness in her eyes, that makes it seem as if she is always poised for an adventure.

She greeted me warmly as I sat down, and as soon as I ordered my food, she launched into an involved story about the raccoon fight she'd broken up in her garden the previous evening. I tried to give the impression that I was following her story, but she must have sensed that my mind was elsewhere, for she stopped in mid-sentence and looked at me.

"What's the matter, Mr. Nakayama? You don't seem to be with me this morning."

I apologized and explained that I had been busy all week, and was still rather preoccupied.

"Is it because of the reporter? You met him this week, didn't you?"

"Yes," I said. "As it so happens, I did meet the young man. Twice, in fact. And I read several of his pieces. They're very good."

"Did you like him? Did you grant him an interview?"

"I did like him. He knew a great deal about the silent film era, and it appears he will be writing about me." I considered telling her about Perennial and the possible movie role, but it felt too premature. It would inspire a rash of

questions from her, I suspected, and more interest than I could cope with at the moment. My feeling was only confirmed when Mrs. Bradford smiled and said, "So now you have someone paying attention to you. No wonder you got a haircut."

"What do you mean?" I said. "My hair was getting long."

"Yes, but people often take better care of themselves when they want to impress somebody."

"Perhaps," I said, attempting to quell my irritation. "But that's not the case where Mr. Bellinger's concerned. Besides, for all you know, I could be trying to impress *you*."

This caught her off guard, and she laughed a bit, but it had the intended effect. When she spoke again, she addressed a different topic. "It must be strange to revisit that part of your life after all of these years."

"Yes, in fact, it is rather odd."

"You know, I'm dying to see one of your movies. Do you still have them around somewhere?"

I gave a short laugh. "No, I believe they have all been lost, and if any do remain, I do not possess them."

"What a shame. There *must* be some, somewhere." She brightened. "What about old photographs or movie magazines?"

"What about them?"

"Well, I'd love to read about you, silly. And maybe see some old photos."

"I do have some of those things, but they have all been put away."

"What do you mean, 'put away'? Can't you find them?"

"It would be a great deal of trouble."

"Well, I don't see why."

I sighed. "I'm afraid they're all in storage, Mrs. Bradford."

She did not respond for a moment, and then an unusu-

ally serious expression came over her face. "Mr. Nakayama, you never told me why you stopped."

"Stopped what?"

"You know what I mean. Stopped making films. You were a huge star with a flourishing career, and then suddenly nothing."

I thought carefully before I replied. "I was one of the casualties of sound. Once voices came into film, I, along with many of my peers, was finished."

"But Mr. Nakayama," she said gently, "talkies didn't become the standard until 1929. Your last movie was in 1922."

I kept my eyes on the table. "Things were changing very rapidly then. There came a time when it was clear I could not continue."

"Was it racism? I know there was a lot of anti-Japanese sentiment at that time. It's really kind of amazing that you got to be as famous as you did. It couldn't have been easy to be an Oriental man in Hollywood."

"On the contrary," I said. "For a large part of my career, Japanese art and culture were held in high esteem in America. They were seen as the epitome of refinement and class, and movies dealing with Japan were very popular."

"Yes, but still, there was all that agitation about property and citizenship. California didn't exactly roll out the welcome mat for Japanese people."

I took a sip of my tea and measured my words carefully. "One can always find prejudice if one specifically looks for it. But that was not the reason for my retirement."

"You didn't kill anybody, did you?"

I was so startled by this question that I looked up at her face and was relieved to see that she had been joking. "Of course not. Mrs. Bradford, what made you think of such a thing?"

She took her napkin out from under the silverware, shook it, and placed it on her lap. "Well, from reading all

those histories when I was trying to find out about you, I learned that there were a couple of big scandals. There was the Fatty Arbuckle situation, which I knew about already, but there was also the murder of the British director, Ashley Bennett Tyler. If I remember correctly, he directed you in some of your films. And isn't it true they never caught the killer?"

I was taken aback by her questions—I hadn't known she had done so much research. And I did not then, or at any time, wish to talk about Ashley Tyler. "Yes, he did direct me. And yes, it is true that they never caught the killer."

"There were suspicions, right? But never a formal charge?"

I forced a smile. "You've been doing your homework, Mrs. Bradford."

"Well, it was strange to me that the Arbuckle case is still remembered today, but this one, it's just disappeared." She leaned over the table, and I saw the same excitement in her eyes that I'd seen in Bellinger's when he talked about his film. "Mr. Nakayama, you were around when all of this happened. Do *you* know who killed Ashley Tyler?"

I gave a light laugh, which belied the sudden churning in my stomach. "Of course not, Mrs. Bradford. My dealings with Mr. Tyler were purely professional. I could not imagine why anyone would do such a thing, and I certainly don't know who was involved."

Mercifully, our omelets arrived and Mrs. Bradford dropped the subject. I had lost my appetite, however, and only took a bite or two of my eggs. Mrs. Bradford did not seem to notice. She chattered on about the novel she was reading, and about the status of her garden. And although I kept expecting her to bring up the Tyler case again, she did not return to that uncomfortable topic.

But as I walked back to my town house after our meal, it occurred to me that there could very well be people who

were still curious about those events from the distant past. It wasn't likely that anyone was pursuing the matter; as Mrs. Bradford said, one did not hear much anymore about the Tyler murder. But with the new theater opening, and especially with Bellinger's article, interest in that era might be stirred up again and produce this piece of unresolved history. I wondered if there were people I should try to find in order to clear up any potential misunderstandings—people like David Rosenberg, my old acquaintance at Perennial, who was present for the scandal and aftermath. As I thought more about the attention that would accompany Bellinger's article—and then, especially, when I thought about the possibility of being considered for a part in his film—I concluded that it would indeed be prudent to find these people and ensure that the record was clear.

And so it happened that I went to visit David Rosenberg this morning at the St. Mary's Retirement Home in Culver City. I had found my old colleague by calling the seven "David Rosenbergs" that were listed in the phone book, until I reached his son, Nathan, who was living in his old house. Nathan knew who I was, and seemed delighted to hear from me; he directed me to the retirement home where his father had been living for the last three years, battling Parkinson's disease. So I warmed up my car and made the short drive to Culver City. I took the surface streets past the old MGM studio, driving directly over the spot at La Cienega and Venice where the great chariot race scene was filmed for *Ben-Hur*, and then headed up the winding hills of the Culver Crest until I reached St. Mary's. It was, for a nursing home, a beautiful place, an old Spanish-style estate with a half-dozen buildings arranged along the top of a hill.

I parked my car and went into the front of what looked like the main building, and announced myself to the nuns behind the desk. But when a nurse led me to the patio, where a cluster of elderly residents sat in oversized wheel-

chairs and gazed out toward the ocean, I could not believe that the folded-in man she pointed out was my old friend David Rosenberg. He was about the same age as I, but looked twenty years older. Rosenberg had been formidable as a younger man, large and carelessly handsome, and it was startling to see him so reduced. When he turned to face me, though, I saw the same liveliness in his dark eyes that I had seen on a daily basis during the years we worked together at Perennial.

"Jun!" he said, patting my arm with his hand. "What a wonderful surprise! When Nathan told me that you'd called, I was sure he was kidding. You look the same, I see. Wish that were true for me."

I put my own hand on top of his, which was trembling a little. "It's good to see you, David. How have you been?"

"Well, if you had two or three weeks to spare, I'd tell you." He gestured for me to pull up a chair, which I did. We sat looking out at the view in silence, not knowing where to start. I stole glances at him now and again, examining the deep lines in his face, the unmistakable shaking of his arms and legs. "This place isn't bad, as far as retirement homes go," he said. "There are a few other old geezers who are still up to playing poker or watching a ball game, and the nurses here are generally nice. Never thought I'd find this old Jew in a Catholic-run joint, but my daughter-in-law's father is the head of the board, and this is supposed to be the best place on the Westside. Besides, I thought it would be too depressing to live with all those washed-up picture people at the Motion Picture Relief Fund Home. Too many egos and neuroses, not to mention shoddy face-lifts. I'd rather be with the regular people. So here I am."

I smiled and leaned back in my chair. "It seems quite comfortable here."

"Well, I'd rather not be here at all, you know. But when the Parkinson's hit, I couldn't really be by myself anymore, and I was too much for Nathan to handle. He's

a good boy—I shouldn't call him a boy, he's forty-six now, with two teenagers himself—but life seems to move too fast these days for people to care for aging parents." He chuckled. "Listen to me. As if life wasn't moving fast when *we* were young."

"We certainly weren't lacking for excitement. We worked hard, but we enjoyed ourselves too."

"We *did* work hard," said Rosenberg, struggling to pull himself up in his chair. "Look at the industry now—how Perennial and UA and MGM seem bigger and older than God. But we were there at the beginning, we watched them take their first steps. Without men like us, Jun, those great studios wouldn't be what they are today. Hollywood wouldn't even be Hollywood."

"It's true," I agreed. "The Valentinos, the Chaplins, everyone remembers them. But the men like us have largely been forgotten."

We were quiet for a moment, both lost in our own thoughts. David tried to pat my arm again, but his hand shook so badly that it hit my leg instead. "I'm sorry, Jun. I don't mean to sound so depressing. I've been sitting here feeling sorry for myself and haven't asked a thing about you. How's life treated you since we saw each other last? Do you have a gorgeous wife? Are there children?"

I shook my head. "No, David. I never married."

He considered me with genuine surprise. "But you had women scratching each other's eyes out over you. What happened? You weren't willing to give up the bachelor's life?"

"No, I just never found the right woman."

"I'm sorry to hear that," he said, and we dropped off into silence. Around us, several other residents were talking in loud voices to the pigeons that had gathered for bread. Beneath their voices was the sound of someone moaning, so soft I wasn't sure I really heard it.

"Listen, Jun," David said. "What brings you here today?

I can't imagine that time has changed you that much, and you were never the type to just drop in for a friendly chat."

I cleared my throat and placed my hands on my lap, trying to control my suddenly racing heart. "In fact, there *is* something I would like to discuss with you. I've been approached by someone who's doing an article about the new silent movie theater. It turns out that he's also a screenwriter with a film that may go into production—and he wants me to play a part in his movie."

Rosenberg struggled to turn toward me. "A part in a movie! Really? Why Jun, that's wonderful!"

I held my hands up before he got too carried away. "Nothing is certain yet; Perennial's still considering it. But Bellinger, the young man, seems very sincere." I paused. "His contact at Perennial is Ben Dreyfus' grandson. Did you know that he's the head of production now?"

David shifted in his chair. "Yes," he said in a tone that seemed faintly disapproving. "He's been making quite a killing these last few years. Remember *Leap of Faith*, that lucrative piece of fluff? Well, that was his. And several others like it."

I digested this information for a moment. "Well, the two young men are apparently good friends, and Bellinger has been speaking to Dreyfus' grandson on my behalf. Bellinger is very excited that he's managed to track me down. He's seen several of my films, he said; his parents are collectors. He's been trying to talk to others who were around in those years—and he's very interested in my time at Perennial."

David turned back toward the horizon—it was a clear day, and we could make out the shape of Catalina Island in the distance. He was quiet for so long that I wasn't sure he'd heard me. Then finally he said, "Don't worry, Jun. If he comes to me, I won't tell him anything."

I lowered my eyes. "I'm not asking you to mislead anyone. I would just hope that you would exercise discretion.

You know how the public is these days; they take little things and make far too much of them."

David looked down at his own hands now, observing his shaking fingers as if they belonged to someone else. "You don't have to worry, Jun. It was a difficult time for all of us. But if you're concerned about anybody making too much of things, maybe you should go speak with some of the others from the old days."

"I've thought of that," I said. "But I don't know where to start."

He curled one hand into a loose fist and brought it to his chin, as if pressing it there would stimulate a thought. "All the studio men are gone, at least the ones you would have worked with—your directors and all the execs."

I nodded. "There really aren't too many of us left."

"I don't know if this would help," he said, "but Owen Hopkins is still alive. He was quoted in a piece in the *Times* about the old District Attorney, Crittendon, and all the corruption in his office."

I remembered Detective Hopkins. He was a young man himself in the brief time I knew him, a steady, earnest sort who seemed out of place amongst the coarse, hardened older men he worked with. The more I thought about his role in the events of that time, the more I realized that Rosenberg's suggestion made sense.

"And," he said cautiously, "you should also talk to Nora. Lord only knows where she is now, but it can't hurt to cover that base."

I did not reply to his suggestion immediately, glancing instead at a pair of squirrels who were chattering at each other on the lawn. Then finally I said, "Your advice is always useful, David. I knew I was doing the right thing by coming to see you."

Rosenberg placed one hand on top of the other, as if trying to hold it still. "It's a shame you still have to worry about this. Some things should stay forgotten."

I laughed softly and changed the subject, directing my old friend's attention to a trio of new buildings that were going up near the 405 freeway. We talked of old times and of how the city had changed, and when David's breathing grew heavy and he paused longer before speaking, I took my leave of him and drove back down the hill.

This evening, as I sit here attempting to read, my mind keeps wandering back to my visit with David. It startled me to see him in such ill health, and I wonder if I looked as old to him as he had looked to me. When we were young, it seemed like aging only happened to other, less fortunate people; we worked and lived and stayed up all night as if we were immune to the claims of time. David went on, in the '30s and '40s, to become a mid-level executive, but he never rose to the heights one might have predicted for such a pleasant and talented man. Perhaps his ambition was held in check by his careful and scrupulous nature; perhaps, like so many of us, he'd been suited to a simpler time. He was a good man, and he'd always been friendly to me, and all in all I'd been happy to see him. But my vivid recollections of him in his youth made his current condition even more troubling. He had spent his whole life in the service of pictures. And like so many of us, he'd simply been forgotten.

CHAPTER SEVEN

It seemed like David Rosenberg was always there during my most important moments at Perennial. He was at the studio, for example, the day I met Nora Niles. He was also there on the night I met the man who would shape the rest of my career, the British director Ashley Bennett Tyler.

I met Tyler at a party at the Ship Café, which was, in the spring and summer of 1917, extremely popular with the Hollywood set. Unlike the formal Alexandria or the staid Tiffany Hotel, the Ship was a place where people let loose. It extended like a pier from the edge of the beach and reached out over the water. The design, feel, and fixtures were so authentic that on that one occasion, when I'd had too much to drink, I was convinced that we were floating out to sea. The large, inviting dance floor was always crowded, and the country's most popular bands would play on the stage. Waiters in black suits and white gloves glided through the crowd, balancing trays full of drinks. The air was thick with cigar smoke and the anxiety of picture people all attempting to secure their next deals. When stars were at the Ship—and they almost always were—they would often take the stage for impromptu performances; I remember one night when the comedian Tuggy Figgins instigated a shoe-throwing contest, for which the men—and some ladies—stood up on stage and aimed their shoes across the room at a bucket of punch. Everyone at the Ship seemed to know each other, or knew someone who knew someone else; the place was so exclusive that it often felt like you needed to show your credits to get inside.

That evening's party had been thrown by the studio on Tyler's behalf, in celebration of his latest picture, *The New Frontier*, which had just premiered that night at the Egyptian. Although Tyler had already made half a dozen films, our paths had not yet crossed, and I was curious to meet the British director who suddenly had the whole town talking. I had recently seen two or three of his films, which were markedly different from what was already becoming standard picture fare. Instead of silly romantic plots or slapstick comedies, Tyler wove tales of psychological and moral complexity. His new film was the story of an East Coast family who'd moved into the wilds of California. The setting was physical—vast and open, unlike the crowded streets of Boston—but the action was metaphysical, as the settlers struggled to forge an identity in this entirely different world. It had struck me as the work of a transplanted outsider, someone who never lost his sense of otherness despite the apparent confidence with which he moved through his new surroundings.

I attended the film and party with a chatty young lady whose name I can no longer recall. She was certainly an actress, or at least was trying to be; over the previous year she'd had bit parts in several forgettable pictures. We danced a few dances together, and then sat at a table with the actors Herman Spencer and Edmund Cleaves. I did not stay seated for very long, however, for young woman after young woman came over to us, imploring, "Jun! Jun! Won't you please come dance with me?" And I did, indulging them all, spinning to the music, my senses full of their lovely faces and soft white shoulders and fragrant, luxurious hair. Annoyed by my flagging attention to her, my date flitted off into the crowd. I didn't mind—I had plenty of acquaintances at the party—and it was the kind of vibrant, celebratory evening that made me happy just to be among people, to be who I was at that moment in time.

I had just commenced a discussion with Herman Spencer about Tyler's new film when I looked up and saw the director himself. He was sitting on a bar stool at the edge of the crowd, holding a half-empty glass in his hand. He was dressed like an English gentleman, which I learned later was his habit—tweed coat and pants, light vest, brown leather shoes. His blond-brown hair was perfectly combed; his square jaw anchored his handsome face; and his long, graceful hands looked like they had been washed, massaged, and laid out on a bed of pillows for display.

Despite his appearance, however, Tyler was somewhat unusual for a Hollywood figure. For one thing, he was a middle-aged man in a town that celebrated youth. He'd appeared out of nowhere, acting—badly, I should say—in two films in 1916, and then directing three more before he was put under contract by Perennial. It was rumored that he'd come from the New York theater, and had performed with another theater company in London after a stint as an officer in the British Army.

The thing that struck me that night at the Ship Café was that even sitting atop the ridiculously high chair, he looked perfectly at ease, as if he were in a garden drinking tea. I watched as a steady flow of partygoers approached him to congratulate him on his film. He listened to them all graciously, and responded to each speaker as if he'd never before received such a compliment. These interactions were all monitored by a fidgety young man who stood several feet off to his left, quietly keeping his eyes on the proceedings.

As far as I could tell, the director was not there with a woman. Several women had been associated with him in the fan magazines, but none with any evidence or consistency, and within the close-knit universe of Hollywood people, he was said to be a solitary figure. Through his short conversations with well-wishers that night, I never saw him look around to find a particular person in the crowd. Tyler's reactions to all the people who spoke with

him were polite and impersonal. He only changed expression when his boss, Gerard Normandy, approached with David Rosenberg in tow.

Gerard Normandy was himself, of course, a figure who commanded attention. It is amazing to think now, from the vantage point of old age, that this accomplished and remarkable man, this man who had already started his own company and was now head of production for a major studio, was all of thirty-three years old. He was not, however, someone who took advantage of his youth. He was terribly serious, always weighted down by the latest financing scheme or attempt to secure film rights, and even when he was out at festive places like the Ship, he looked like he was still at the office. But when Normandy appeared beside the director that night, even he seemed affected by Tyler's charm. He brightened, a smile cracked the surface of his face, and soon the two men were engaged in a lively conversation. It was Normandy who'd made Tyler, really; he'd convinced the studio to sign him to a long-term contract on the strength of his first three films. The studio's backers had readily agreed, for they liked the air of respectability Tyler brought to Perennial, at a time when city leaders were complaining more openly about the excess and frivolity of picture people.

As the two men talked that evening, people watched them with interest. David Rosenberg stood quietly a little to the side of them, ready should Normandy need the name of a financial backer, or distribution figures, or the gossip on an actress the boss was considering for a part in an upcoming film. He also ran interference if some not-quite-important-enough person attempted to approach. Tyler looked over at his own man once or twice, as if to make sure that he was still there. I watched all of this too, as curious as anyone else, and after a few minutes, Gerard saw me looking and waved me over.

I muttered apologies to my table and made my way

through the crowd while people reached over to shake my hand and called out greetings. Finally I arrived at the other side of the floor.

"Ah, Jun!" Gerard shouted above the music, smiling so widely that he looked almost sick. "I'm so glad to see you here. Have you met Ashley?"

"No, I haven't," I said loudly, receiving Tyler's firm, straightforward handshake, and I felt inexplicably nervous. But Tyler saved me—he pulled me toward him and leaned forward with a genuine smile.

"I admire your work, Mr. Nakayama," he said in a crisp British accent. "It's truly an honor to meet you."

"No, sir," I said, "the privilege is mine."

"You damned foreigners and all your formalities," said Normandy cheerfully. "It's enough to drive us uncouth Americans crazy."

"You are hardly uncouth, Gerard," said Tyler. "Although your suit's a bit loose. And those glasses make you look like an accountant."

It was true—Normandy's clothes were always a touch too large, and he did have the look of a lowly financial man—but I had never before heard anybody speak to him in this manner. Even Rosenberg, who'd greeted me with a wave when I came over, raised his eyebrows and watched for Normandy's reaction. Gerard, however, appeared to enjoy this exchange, in the way that a homely boy can sometimes be pleased by a handsome boy's teasing attention.

"So you're talented and slick and well-dressed, you old devil," he said. "And now you're telling me you're an expert in grooming. Remind me never to go out with you when I'm trying to impress a girl. She'll run off with you and never give me a second glance."

"You hardly need any help with women, Gerard," replied Tyler. "You're out with a different woman every time I see you. If I had a daughter, I'd lock her up whenever you came around."

"Oh, please. Those girls just want me to get them into pictures. If you want a *real* ladies' man, you should talk to Jun."

I was aghast at this exchange, horrified that this was the first thing that Tyler should hear about me, and I lowered my eyes to the floor.

Tyler, however, didn't seem to notice. "Well, he *does* cut quite a figure," the director remarked. "He looks like the tuxedo was invented for him. I suppose I'll have to keep my daughter away from *both* of you, then. The only man she'd be safe with is our friend David here, but that's only because he's dreadfully boring."

Rosenberg, hearing this, leaned over and said, "That isn't what they tell me, old man."

Normandy and Tyler both laughed. I continued to marvel at Tyler's informal manner with Normandy, which was particularly striking because everything else about the director appeared to be so proper. Nobody kidded with Normandy this way; he was one of the kings of Hollywood. And when I got to know Tyler better, I would see that he was able to speak in such a manner because of his age and accent, his air of class. It was all good-natured teasing of the highest order—tasteful, for Ashley Tyler was a gentleman.

"So Jun," said Normandy, turning back to me, "I've been thinking. Ashley's my brightest new director, you're my best actor, and it's time to put the two of you together. How would you feel about working on a film with Ashley? And Ashley, I'm not asking you, because I don't care what you think."

The director laughed. "I'm going to tell you anyway. I think you've been wasting Mr. Nakayama's talent on one-dimensional villains. With me, he could play characters of some complexity."

"And what do *you* think, Jun?" Normandy inquired, ignoring Tyler's comments.

"I'd be honored," I said. "I'm a great admirer of Mr. Tyler's films."

"Well, wonderful. It's settled then," Normandy said. "Why don't you both come by my office next week? David, do I have time on Tuesday?"

"For them you do," Rosenberg answered, and just at that moment my date reappeared, tugging at my arm. She gave me a look, and at her cue I introduced her to Tyler and Normandy, who shook her hand politely but did not offer anything beyond the requisite greeting. Disappointed, she turned away and began to pull me after her.

"See?" said Normandy, grinning at Tyler. "He can't fight them off with a stick."

The project that Normandy came up with for us was the World War I spy film, *The Noble Servant*. As he had promised at the Ship Café, we all met on Tuesday at his office, a cavernous room with heavy wooden paneling and stained glass windows, which seemed designed to intimidate anyone who entered. Both Normandy and Tyler were all business that day. The lightheartedness and kidding of the nightclub were gone, replaced by a focused but excited attention to the details of the project. It was Tyler who suggested Nora Minton Niles for the female lead, and this caused a prolonged discussion. While I was worried about working with someone so young—not to mention someone with an ever-present mother who had a reputation for being difficult—it is also true that I was intrigued at the prospect of appearing in a film with the unmistakable new darling of Perennial.

My enthusiasm only grew when Normandy laid out the plot, which reflected America's recent entry into the war. Nora was to play Sarah Davidson, the lonely daughter of an army general who is consumed with preparations for battle. My role was that of Nori, ostensibly a servant in the general's household but in reality a Japanese secret service

agent whose mission is to protect Sarah, and to discern who in the general's household has been stealing his secret war plans and turning them over to the Germans. Despite my objections to my character's unlikely name—which Normandy insisted sounded "authentic but pronounceable"—I was pleased with my part and with the story line. The Great War had made allies of the U.S. and Japan, and this affected how Japanese characters were portrayed on the screen. I had played spies before, yes, but always dangerous ones; now my character's motivations were purely noble.

Nori, who admires the heroic General Davidson, takes seriously his charge to protect his young daughter and to ferret out the spy in the household. Through his interactions with the servants and his careful observations of Sarah, he discerns that her suitor, Peter Mays, is in reality a German spy who has been courting Sarah in order to gain entry to the general's home. Nori knows the general would be furious if he learned that his daughter had inadvertently given the German access to his secrets, so, sacrificing the credit that is rightly his, he tells the general that it was Sarah who exposed the spy. This action, in one stroke, solves the problem of the army's secrets and raises Sarah in her father's esteem, thus inspiring the fatherly love and attention she has craved all her life. Even better, it draws the admiration of a handsome navy captain, who makes her forget about the German. Nori, his mission complete, is sent back to Japan, where he awaits his next assignment for the Allies.

Before the filming of our picture began, I attended another meeting in Normandy's office. I arrived first and listened as he and Rosenberg spoke cheerfully about the returns of Nora's latest film. Ashley Tyler entered next, looking impeccable in his white pants and blue sport coat. He was followed by Charles Laughlin, the slightly sickly young man who would play the deceptive German, and Arthur Bowen, the thick-necked actor cast as the navy cap-

tain. Then came John Wellington, the dignified older actor who would play Nora's father, the army general. Finally, Harriet Cole burst into the room, fifteen minutes late, followed almost reluctantly by Nora. Mrs. Cole was wearing an emerald-green jacket and dress and a rather severe black hat. She glared at Rosenberg and then at an empty chair that was pushed against the wall, until he understood that she wanted it placed in front of Normandy's desk. He moved it, she sat, and then she stared at Normandy and Tyler as if to indicate that the meeting could now begin.

It had been several months since I'd met Nora in the courtyard, and while I had since caught glimpses of her around the studio, I hadn't spoken to her at all. She appeared thin and slightly tired—still girlish, but some of the softness was gone from her face and middle—and there was the same lack of interest in the happenings around her, the same dreaminess I'd seen the day we met. She settled in a chair in the back of the room and conspicuously avoided looking at her mother.

Given the way my first encounter with Mrs. Cole had unfolded, I had not looked forward to seeing her again. But she kept strictly to the business at hand. She discussed the script in a professional manner, commenting here and there about a particular plot turn, questioning Tyler about his vision of especially crucial scenes. Although she refrained from saying anything explicitly negative, it was my impression, judging from her expression of distaste, that Mrs. Cole was not particularly enthused about the prospect of her daughter starring opposite me, and it was clear she had misgivings about working with the producer who was responsible for *Sleight of Hand*. Mrs. Cole was, I believe, in somewhat of a bind—pleased by the success of Normandy's films, which guaranteed attention for the current one; and afraid that some of the elements that had contributed to their popularity would carry over into his current project. She wanted assurances that there was no hint

of romance between my character and Nora's, and Tyler promised her that this was not the case. There was, in fact, a male romantic figure in the film—the somewhat roguish Arthur Bowen, who played the captain of the American warship—and Mrs. Cole accepted this news without comment. She then asked—as she apparently did at the commencement of every project—if she would have access to the filming.

Tyler replied firmly, "No, Mrs. Cole. I always keep a closed set." Then he softened. "You may, however, view some of the rushes."

"All right, I won't argue with that, but there are certain rules I still expect you to follow." Her daughter would never be alone with any man, she said—not me, not Bowen, not Tyler, not even the costume people. She seemed to see the entire male population of Hollywood as a group of predators, and her near-obsessive protection of her daughter's honor aroused my sympathy for the girl.

As the meeting progressed, Nora sat in the back corner staring out the window like a child who had accompanied her busy mother on an errand that had nothing to do with her. When she did turn back to face the room, it wasn't to engage in the discussion, but rather to watch Ashley Tyler, whose commanding manner captured even her fleeting attention.

When the filming began for *The Noble Servant* two weeks later, I found—as both Tyler and Normandy had assured me—that Nora was a pleasure to work with. She was always on time, always pleasant and prepared, and not given to the fits of hysteria or pique that afflicted so many other young actresses. More importantly to me, she was serious about her work. The melancholy I'd sensed from our very first meeting infused her portrayal of the sad and complex Sarah Davidson, and she was able to convey her character's emotions at being ignored by her father with subtlety and power.

In spite of her mother's worries—and the clear intentions of Arthur Bowen, who was famous for his exploits with young girls—there was nothing between Nora and any of the actors. Indeed, despite her earlier attentions to me in the courtyard, I appeared to be invisible to Nora. It quickly became apparent that the only man she saw was our director, Ashley Tyler.

I noticed her affection almost immediately. On the first day of rehearsal, as he moved about the set and shouted directions, I saw Nora looking at him with the unmistakable bliss of romantic adoration. One couldn't blame her. Tyler was, after all, a handsome man, and the sight of him with his sleeves rolled up was the very image of masculine vitality. His accent helped also—I'd heard many women comment on how appealing it was—and the brilliance of his films was undeniable. But perhaps the director's most agreeable trait was that despite his success and the attention from women, he did not act self-important. He dressed well, but was not a dandy—not like DeMille in his breeches and shiny high boots, or Erich von Stroheim with his white gloves and cane. He was simply a gentleman, self-possessed and confident, and clearly in command of his craft. Taken together with his reputation for being a caring man, Ashley Tyler seemed like any woman's ideal. The fact that he was forty-three—old enough to be Nora's father—didn't seem to deter her at all. There were, in fact, other examples of affection between beautiful young actresses and powerful older men—Norma Talmadge and Joseph Schenck, Gloria Swanson and Herbert Somborn. But the difference with Nora and Tyler was that it was she who was in pursuit. Indeed, as time passed, she took less care to disguise her affections.

There was the day, for example, when we were filming the scene where Sarah Davidson stands alone on her veranda, watching her father leave for yet another meeting. It was a typical chaotic day of filming. Our set adjoined

another, where a different director was shooting interiors for a Western, and we could hear his shouted directions through the thin barrier between us, as well as the hammering of crew members still building the backdrop. On our own set, a three-piece ensemble played something mournful to help create the proper mood, their music unable to drown out completely the cheerful notes of another band somewhere else on the lot. Nora, unlike many other leading ladies, was not particular about these details—not like Pola Negri, who was once thwarted from completing an emotional scene when a brass band (hired, rumor had it, by her rival Gloria Swanson) struck up a raucous song on a connecting set. But Nora seemed distracted that day nonetheless. Tyler was trying to get her to stand in a certain manner, to convey her desolation with the posture of her body, but no matter how she adjusted her shoulders and arms, the director was not satisfied.

"Now your father has left you behind again while he goes back out to the base," he reminded her through his megaphone. "He'd promised to have dinner with you, and to go see a play, but he's leaving you alone yet again. You've gone through *years* of being ignored like this, and you feel unloved and forgotten. Now put your arms around that post there and lean against it like it's the man you want to marry . . . There . . . No, a little more heavily . . . Look toward the camera . . . Now, Nora, I know you can do this."

Tyler, like all the great directors, was half-general and half-seducer. His deep, reassuring baritone commanded actors like the firm voice of God, and the effect—especially on women—was near-hypnosis. He gave clear directions about how to stand or where to go, and he tried to transfer the emotions of the character from his head to the actor's heart. With some actors—myself included—he did not need to express much verbally; I always understood what he wanted. But others, like Nora, needed clearer direction, a much more steadying hand.

That day, however, nothing seemed to work. He pleaded with Nora, coaxed her, and finally commanded her, but she was distracted and resisted all of Tyler's attempts. Finally, Tyler came out from his perch next to the camera, walked over behind Nora, and placed his hands on her shoulders. She shuddered visibly at his touch. He moved her gently into the posture he wanted, saying, "Here, here." Nora raised one of her hands to touch one of his, and her eyes closed in unself-conscious bliss.

A few days later, we filmed a scene where Nori, my character, is helping Sarah out of a car after she has sneaked out to a party with the German. The implication is that she is tired and perhaps a bit tipsy, which sets the stage for Mays to search through her father's office while she lies asleep on the couch. But following several botched takes, it was clear that something was amiss. Nora was too reserved, not trusting me to hold her up, and once again Tyler stopped and stepped toward her.

"Let yourself go," he directed Nora, in deep, reassuring tones. "Pretend you're falling into a bed."

He assumed my spot, placed an arm around her, and cradled her elbow with his other hand. And instead of just leaning on him, Nora totally collapsed, taking his instruction literally. As she fell into him, her face was shaped by an expression of such intense rapture that we all looked away in embarrassment. And Tyler, after awkwardly supporting her there, gently propped her up on her feet and said, "Perhaps you shouldn't fall *that* completely."

As far as I could tell, Tyler was nothing but a perfect gentleman in the years I knew him. Of course, given all that was eventually revealed, it is remarkable that he kept us fooled for so long. At that point, however, we believed everything we thought we knew about him. While people were aware of his special friendships with women, he did not appear to favor any one of them. It was his very elusiveness, I think, the odd combination of generosity and

restraint, that made him so irresistible. I saw his charm working on every woman he encountered.

The Noble Servant was only a modest success. It garnered mostly positive reviews—the *Los Angeles Times* declared it "one of the Jap's best yet"—but it was not the unqualified hit the studio had hoped for. Strangely, the very thing I liked about the film—my more sympathetic character—was precisely what left viewers cold.

"Interesting, but unrealistic," wrote the *Herald Examiner*. "It is hard to believe that Charles Laughlin is pegged as the guilty party. Whenever something goes missing and a soft-footed Jap is lurking about, you can be sure that the yellow-face is responsible."

"A nice stretch for Nakayama," wrote the critic for *Variety*. "But I prefer the cold-hearted, devious Jun who draws the viewer in and then rips his heart out."

The *Rafu Shimpo*, on the other hand, approved of this film. "Nakayama finally plays a man of character," its critic reflected. "A definite step forward in portrayals of Japanese men."

While the film was a disappointment to Normandy and Benjamin Dreyfus—who'd done everything he could to promote it—it also drew enough good notices for Nora Niles that she was picked to star in several new projects. Her growing popularity was good for the studio, but it was only a matter of time before it started to affect the careers of other Perennial actresses. For the fortunes of one could not rise, of course, without the waning in the fortunes of others.

During this time, I saw very little of Hanako Minatoya. We ran into each other occasionally at premieres or other events; and there was also the O-bon Festival in Little Tokyo one year, where we met at the Buddhist temple and then set lanterns on the Los Angeles River to guide the visiting spirits of our ancestors back home. Every few months, in

addition, we would meet for tea in the garden of her house in Pico Heights, and talk for hours amongst the cacti and succulents she cared for as tenderly as children. Hanako was as busy as I with work, although she still spent much of her time doing theater. She was offered many more roles in pictures than she actually took, and while this certainly affected her financial state, she seemed wholly unconcerned with fiscal matters. In fact, other than requisite appearances at the premieres of her films, Hanako did not have much to do with Hollywood; nor, outside of me, did she socialize with picture people. But she appeared quite content on those afternoons when I visited, always excited about her current theater project. And if she ever felt alone in that cavernous house, she certainly didn't show it.

One Saturday afternoon in May, we drove up to Santa Barbara to shoot a short promotional film at the behest of our respective employers. We arrived in time to have dinner with the director—a young newcomer from Perennial—and then retired early to our rooms. By 5:00 a.m. we were up again, in order to start shooting at 7:00. The whole process was very short, not even three hours, and by 10:00 the filming was done. At that point, I had not yet spent much time in Santa Barbara—which was still, in 1917, a provincial little town—and it seemed a pity to leave that beautiful area without doing a bit of exploring. So as we checked out of the hotel the studio had arranged, I asked Hanako if she was anxious to return to Los Angeles.

"No," she said. "Are you? I'd much rather stay here. Our lives will still be there when we get back."

And so we spent the rest of the day there in Santa Barbara, as giddy as children skipping school. Hanako, who loved the ocean, wanted to stroll along the beach, and we walked for two hours up and down that lovely coast, which was wilder than the coastline of Los Angeles. Dark bluffs jutted out over the surface of the sand, and the Santa Ynez mountains stood directly behind us, as green and

gentle as the mountains of Japan. It was a gorgeous day, the sun tempered by a cool ocean breeze, and I was glad I had brought a change of casual clothes—linen slacks and a button-down shirt. Hanako wore a flowered blue short-sleeve dress and a wide-rimmed summer hat, which made her look charmingly young. When we ventured down to the edge of the water and the surf splashed her toes, she laughed with surprise and delight.

Although the air did not feel especially warm, the sun must have been quite strong, for Hanako noticed that my cheeks were getting red. And so we wandered down State Street until we found a gentlemen's clothing store, where I tried on several pieces of headwear before choosing a cream-colored hat with a brown cloth strip along the base.

"He looks quite handsome, doesn't he?" remarked the middle-aged salesman, who did not appear to know who I was.

Hanako considered me out of the corner of her eye and replied, "I suppose he looks acceptable."

For lunch, we found a café by the edge of the water, where we watched the seagulls and pelicans fighting for space along the railings of the pier. Although our waiter was polite and attentive, it was clear he didn't realize that he was serving two Hollywood actors. Instead of being offended, we both felt freed, enjoying the novelty of not being watched, of not having to worry that our actions might later haunt us in a gossip column or a studio scolding.

"And our special of the day is a salmon," our young waiter recited, "served with a dill sauce as well as locally grown rice and greens."

"I'll have the salmon," I decided.

"Wonderful. And what would you like to drink with your meal, Mr.—"

"Tanaka," I said, which drew a smile from Hanako, before I told him I preferred white wine.

"Perfect. The salmon and a glass of Chardonnay." Then, turning to Hanako: "And what about Mrs. Tanaka?"

We lingered over our meals, each of us drinking two glasses of wine, watching the boats move slowly across the bay. Neither of us was ready yet to make the trip back home, and when the waiter told us about a cultural event taking place that afternoon, we decided on the spur of the moment to go. The Santa Barbara Community Arts Association, comprised of writers, artists, musicians, and patrons, was having its inaugural celebration at a place called Book Haven, which he assured us was a worthy destination in itself.

And so we followed his directions away from the beach, driving until we'd passed beyond the outskirts of town, so far I thought he'd somehow been mistaken. But then finally we came upon a large wooden sign with the words *Book Haven* carved into it. We turned down a gravel driveway through a thicket of oaks, driving into an old, dense forest. At the end of the driveway we saw a sprawling one-story house whose outward-facing walls were lined with bookshelves. The area in front of the house was filled with haphazardly parked cars, and we squeezed into a space about halfway up the drive.

"Where's the store?" I asked, confused.

"I believe we just found it," said Hanako.

I felt uncertain, as if we'd come not to a place of business but to a forest home of sprites and talking creatures. Hanako must have felt it too, for she slipped her hand through my arm, and that is how we entered. But once we were inside, our nervousness evaporated. There were books everywhere—against every wall, in every nook and cranny. Indeed, the house had been completely overrun by books, as if by a particularly lush and fast-growing ivy. The structure itself was fragmented, single rooms joined by open patios and a stone-covered courtyard, with bookshelves lining even the outside connecting walls. These

walls were covered—as were the exterior walls—with a narrow shingled roof just wide enough to keep the books dry. The courtyard was filled with potted plants, and the light that filtered through the mingling branches of the oaks gave one the feeling of being inside and outside at once.

"Welcome to Book Haven," said a young flaxen-haired woman as we entered, and she smiled at us like everyone had smiled that day, genuine and friendly and unknowing.

The central courtyard was crowded with dozens of people, all listening to a stern, mustachioed man who was giving a formal speech. We sat there for perhaps five minutes as he expounded on the importance of philanthropic support for cultural institutions, and although Hanako was too polite to complain, I could feel her impatience as undeniably as I felt my own. We did not wish to be listening to anyone's speeches on this stolen and beautiful day. And so I got her attention and nodded toward a side door, and we slipped into one of the rooms.

"This is such a wonderful place," she whispered. "It's unfortunate we didn't come on a different day."

"It doesn't matter," I replied, keeping my voice down as well. "Look, we're in the Drama section. Aren't you searching for a new play?"

"I'm appearing in one *now*," she said in a scolding tone, "which Nakayama-san doesn't seem to remember."

"I *do* remember!" I turned a corner and found that the room opened unexpectedly into another, larger room; over the door there was a sign that read, *Literature*. "It's just that I've been so absorbed in novels of late. Look—here's Tolstoy. May I read you *War and Peace*?"

"Not if you expect to return to Los Angeles this month."

"I didn't mean the whole thing. A passage." I slipped behind a bookcase and Hanako followed; we might have been the only people in the store. I read her the open-

ing pages of *War and Peace*, which I had loved so much as a young man, and which—along with so many other books I'd admired—I had not so much as looked at in years. As I read I leaned closer to her, self-conscious about my enthusiasm, and when I looked up I was surprised to see Hanako's face just inches from my own.

"Too many characters and battle scenes," she said, flushing a little. Then she slipped around the corner and entered yet another room, where she found a row of the Brontë sisters in new leather-bound editions. "This is more to my taste," she said, pulling *Jane Eyre* off the shelf and reading me the opening passage.

"Too many tortured souls and dusty old houses," I teased.

"You're quite hopeless," she said, shaking her head at me.

We kept turning corners and stumbling into new rooms, which themselves were divided by ceiling-high bookshelves behind which we lost one another. It was a honeycomb of a building, segmented and layered, and every time we found each other again I felt both surprise and relief. Twice we ran into other people looking at books— people who, like us, had left the event, or who had come to the bookstore just to browse—and both times we were so startled that we burst into laughter as the shoppers glared at us like unruly children.

After we had each read several passages from favorite books, only to have the other reject them, we finally found some works that we admired in common, by Dickens and Flaubert. Off the side of one of the catacomb rooms we found a small patio; we sat in its two wrought iron chairs and read from *Great Expectations*. I hadn't read a novel in many months, let alone out loud, but we easily got lost in the story. We stayed there in the shade of the oak trees for an hour or more, easing into a peace I never felt in the course of my everyday life. But then the event broke up and

people started wandering through, interrupting our perfection. And so we left our chairs regretfully and put the books back and then slowly made our way to the car.

As we drove back to Los Angeles in the fading light, I said, "Thank you for the afternoon, Minatoya-san. My earlier claims aside, it has been a long time since I've read anything but a shooting script."

Hanako turned to me, the ribbon of her hat now tied beneath her chin, her hands folded together on her lap. "It wouldn't hurt you to vary your forms of entertainment. There is more to the world than pictures."

"I know," I said. "There are just so many demands on my time."

"When is the last time you went to the theater?"

I sighed. "Far too long. And as you know, I'm particular about the theater. Having started there, like you, I am hard to please."

"You have not seen one of my own productions in years, Nakayama-san." Although her voice was lighthearted, the admonishment was clear. I remembered what she had said earlier, about my not knowing she was currently appearing in a play, and I was surprised by the realization that my attendance mattered to her. I wanted to respond that I doubted she'd seen all of my films, but I knew that the two were not equal. Hanako wanted me to attend—she cared what I thought—and the more I pondered it, the more I was baffled myself as to why I hadn't seen her perform in so long.

And that is how I found myself, a few weeks later, attending one of Hanako's plays. She had written an original work called *The Bottomless Well*, and she was appearing in the leading role. It was no small matter that this production was at the Pasadena Playhouse, which was already one of the theater's most respectable venues. But Hanako's reputation had grown to such an extent that even theaters which

didn't normally feature Japanese topics were clamoring to present her latest work.

It was a beautiful night in early June. The air was cool and the San Gabriel Mountains hovered so close that you could see their dark shapes against the sky. I was almost reluctant to go inside, but I slipped into the theater—as I always did on such occasions—just as the lights went down, in order to avoid the stares of curious fans. At Hanako's request, the management had reserved a seat for me in the exact center of the theater, close enough to discern the expressions on all the players' faces, high enough to take in the entire stage. I had not seen Hanako perform in a play for almost a decade, since I was a student in Wisconsin. So much had changed for both of us in the intervening years that it was as if we'd both become different people.

And yet we hadn't. For when Hanako stepped out onto the stage and the spotlight focused on her, it was as if time had collapsed and I was a college boy again, watching the work of an accomplished professional. And for the next ninety minutes I was utterly transported, completely captured by this woman and her story.

The play was set in a small fictional town in rural Japan. Hanako's character, Reiko, was a young woman of eighteen, living with her parents and younger brother on a small and struggling farm. Then her father is killed by a member of the yakuza in a dispute over land, and the yakuza, played convincingly by Kenji Takizawa, sets his eyes on the young girl's mother. It is clear that if drastic measures aren't taken, the women will lose the farm. But Reiko, who is a talented artist, begins teaching calligraphy to the children of the wealthy citizens in the nearby town. After many months of tireless work, she begins instructing not just the children, but also their parents; and then starts selling some of her own work to wealthy families in Kyoto. In this way she is able to support her family and save the farm. When a young nobleman comes along and finally

scares off the yakuza, it seems inevitable that he will ask for her hand in marriage. He does—but in the play's most unusual development, Reiko declines his proposal. She does not wish to desert her mother or brother, and refuses to put her fate—or that of her hard-won farm—into the hands of a total stranger. In the end the family stays just as it was—mother, daughter, and son—still working diligently to keep their small farm, and remaining independent.

As the play unfolded before me, I grew more and more impressed—by Hanako's writing, by the actors who brought the other characters to life, by the simple but effective sets that evoked a farmhouse in the country, even by the subtle, effective lighting. I was surprised by the plot she'd constructed, and realized that the content of the play—and not just Pasadena's interest—affected Hanako's decision not to present it in Little Tokyo. It was a risk both personally and theatrically, and I greatly admired her courage.

And her acting! Because I had only seen her in pictures for so long, I'd forgotten about her sheer presence on stage. She played the part of the grieving but determined Reiko with such love and conviction that the audience—even I— forgot she was acting. Indeed, the scene where she comforts her mother after learning of her father's death, only weeping when she is finally alone; and the scene where she walks the three miles to town, determined to find employment to save the farm, were both played with such sincere and believable emotion that I wondered inevitably how much of them were drawn from life, were created out of her own losses. But Reiko showed more emotion about the events that befell her family than Hanako had ever displayed. There was an openness and vulnerability in the character on stage that was never evident in the actress who portrayed her.

I was, quite simply, in awe—of Hanako's acting, of the courage and grace of the story, of the fact that she had written it at all. There was something so stripped down

and pure about her work, a quality not present in the gloss and artifice of her films. *This*, I thought, almost trembling, is a true work of art. And Hanako, a genuine artist.

After the play was over—after a standing ovation and three drawn-out curtain calls—I was ushered into a hallway backstage. I waited patiently for perhaps twenty minutes or so, signing autographs for the Playhouse staff and congratulating Kenji Takizawa and the other actors as they left to go home for the evening. Then, finally, Hanako emerged.

She had totally changed in my eyes—not just from the part she had played on stage, but from the person I had known even hours before. She looked the same, and yet everything about her—her eyes, her expression, even her posture—was infused with a different meaning. As she approached me, she looked cautious, as if bracing herself for what I might say. She needn't have worried. It was all I could do to keep myself from kneeling down before her.

"Minatoya-san," I said, bowing deeply and hiding my suddenly crimson face. Our ease of a few weeks earlier was gone; I felt awkward and entirely humbled. "You have outdone yourself. Words cannot express."

"Thank you, Nakayama-san," she responded, bowing in return. "It really is not very significant."

"On the contrary. Your characterization, the story, are both admirable."

"Really, it is the other players who are worthy of notice."

We continued along with this somewhat stilted conversation, and I found myself unable to say what I was thinking, or to even fully grasp what that was. But I was struck now by the difference between this Hanako in front of me and the one I'd just observed on stage. For she possessed herself again. The curtain was drawn. All signs of passion and vulnerability had been taken in, like a bright, rippling flag that's been lowered, folded, and neatly stored away for the night. And this controlled, contained person bore little

resemblance to the pained and open character on stage. I knew that what I'd watched was simply a depiction; that her seemingly open persona invited viewers to think they were truly seeing *her*. I also knew that Hanako *intended* that confusion, that complete identification with the character. Yet there was something in the extreme guardedness she exhibited now that immediately shut off that invitation. She so discouraged any suggestion that her play was related to life that I wondered which Hanako—the one on stage or the one in front of me now—was real; which one wore the true face and which the mask.

I wanted to say something, to tell her something, to express what I thought and felt. I wanted to ask her a million questions, but did not know where to begin. I wanted to say how much I admired her, still; how her work both shamed and inspired me. But I could not even bring myself to look at her directly, let alone speak in such rash and indulgent terms. So I said nothing. I simply congratulated her again, and after one final bow, excused myself and exited the theater.

But as I walked down the steps of the Playhouse and back into the beautiful night, I found, to my surprise, that I was whistling. And instead of returning directly to my car, I walked and walked under the star-filled sky through the streets of Pasadena, while dozens of mockingbirds filled the night with their exuberant songs.

CHAPTER EIGHT

I suppose I should take a moment to discuss more fully the state of Hanako's career. It had been, by 1917, five years since we'd met; five years since we had appeared together in those early films for William Moran. Since then, however, our trajectories had been markedly different. While the relative size of her roles and the significance of her films remained essentially the same, my own films grew bigger and bigger. Part of the difference may have been attributable to her being a woman. The most common parts available to lead actresses at the time were charming comic figures, or plucky heroines, or romantic leading ladies—roles for which Hanako, being Japanese, could of course not be considered. In addition, Hanako seemed reluctant to make strategic decisions that would have advanced her career. Rather than move to one of the large new studios, for example, she re-signed with Moran, whose pictures had been decreasing in both frequency and profit as they competed with Perennial and Goldwyn. Thus, while Hanako continued to receive positive notices, she appeared too infrequently—and in films too insignificant—to remain in the top tier of actresses.

This, however, didn't seem to trouble her. Although she never expressed regret that her film career had not lived up to its early potential, the irony of our situations was inescapable. For it was she who had first brought me into the pictures. But it was I who was now the star.

Despite her lower profile in Hollywood, Hanako was— and always remained—a much-admired figure amongst our fellow Japanese. She was deeply involved in the world

of Little Tokyo; she still appeared in plays at the theater, and she often organized productions starring Japanese high school students. She frequently dined in Little Tokyo establishments, and at least once a month she'd make a visit to the orphanage, where young discarded children of full or partial Japanese lineage would gather around her to accept the toys and books she brought them. Reviews of Hanako's plays often traveled to Japan, and all of her films were shown there. She was loved by the people of Japan, recent immigrants to America, and the second generation alike.

I, on the other hand, had become more removed from this world. There were practical matters that made it difficult for me to visit Little Tokyo. For one thing, it would have been impossible to move through the streets unharassed. As much as people had pointed and stared when I'd first begun appearing in the theater, my fame had increased a hundred-fold since then—it was, to be frank, of a different scale than Hanako's—and any unscripted appearance now would have caused a near riot. For another, Little Tokyo—which was essentially a stopping point full of boarding houses, bars, gambling establishments, and small family-owned restaurants—had few venues appropriate for the kinds of dinners and events that now occupied so many of my evenings. On social occasions and even for business dinners, I preferred the Los Angeles Athletic Club or the Tiffany Hotel. Only in very rare circumstances did I dine at Little Tokyo establishments.

This is not to suggest—as some unfairly implied at the time—that I avoided the company of other Japanese. And while it is true that I have not been to Little Tokyo for many years now, this has mostly to do with matters of convenience. Being so far removed from the Westside, it is rather out of my way; moreover, I hear that the area has changed substantially. Many of the old houses and shops have apparently been torn down in favor of apartments,

and I doubt that any of my former acquaintances remain. My absence from Little Tokyo for all of these years is solely for these practical reasons, and any suggestion that it is due to a lack of gratitude—or even, as some have whispered, to shame—is utterly ridiculous.

Contrary to common belief, I appeared in Little Tokyo frequently during the height of my career. Most years, I visited the Buddhist temple in conjunction with the summer O-bon Festival. And when important visitors were in town from Japan, I was often invited to functions in their honor. Many of them—I am thinking now of the young Crown Prince, as well as the opera star Yukari Irabu—specifically requested my presence. Most of these events were unexciting but pleasant—delicious food interspersed with conversation about life in Japan and America, preceded by much picture-taking and autograph-signing. But occasionally they grew rather tiresome, and sometimes people would regrettably embark upon topics inappropriate for social occasions.

I remember one such event in September of 1917, a dinner in the honor of Dr. Ishii, the Japanese foreign minister. Dr. Ishii had sailed from Tokyo to San Francisco and then taken a train to Los Angeles, where he would spend two days before boarding a cross-country train to Washington, D.C. The dinner took place in the beautiful home of Ichiro Matsui, the president of the Japanese Association. Mr. Matsui and his wife were, as everyone knows, among the most prominent members of the community. He had been one of the original backers of the Little Tokyo Theater, which is how we came to know one another; now he ran a successful floral distributing company, which helped finance his civic activities. The Matsuis' home was a large Craftsman bungalow not far from my own first house in Pico Heights, tastefully decorated with a blend of Japanese and American furnishings. The guests were ushered at first into a large drawing room, where we were served cock-

tails by a young kimono-clad woman who giggled when she handed me my drink.

It was a midsized gathering of perhaps twenty-five people, intimate and rather unremarkable. Dr. Ishii, a tall and fit-looking man whose hair was just starting to gray, spoke to the small group of people gathered around him with the air of someone who is accustomed to being heard. He had the self-assurance of a man whose privileged background and careful schooling have instilled in him an utter belief in his own importance. Something about him—perhaps his similarity to some of the prominent guests who'd stayed at the Ishimotos' inn in Karuizawa when I was a boy— made me feel immediately on guard. His wife, a handsome woman in her middle fifties who was almost as tall as her husband, looked equally aristocratic, but the laugh lines around her eyes and a softness at her mouth suggested a warmth that seemed lacking in her husband.

In contrast to the Ishiis, the Matsuis were more inviting, moving from person to person to ensure that everyone was comfortable. Mr. Matsui—a short, rotund man whose flushed cheeks and ready smile always reminded me of a wooden Buddha—had successfully expanded the influence of the Japanese Association, which worked to increase the standing of the Japanese population in the eyes of city leaders. The Association had led the effort to boycott gambling houses in Little Tokyo, and was now engaged in attempts to Americanize recent immigrants by offering English classes and encouraging people to get driver's licenses. Mrs. Matsui, who was equally as round and cheerful as her husband, did her part as well; she'd organized a cooking class to teach recently arrived Japanese wives how to prepare Western meals for their husbands.

There were others in attendance that evening—the head of the Japanese Business Alliance, two more members of the Japanese Association, the pastors of two churches, the head of a Buddhist temple, and a local painter named

Kato who was beginning to make a name for himself, along with his lovely fiancée, Miss Kuramoto. The Matsuis' son Daisuke was there as well, a handsome lad of perhaps eighteen, who had his parents' happy demeanor but not their rotundness, and who stared at me unabashedly all evening. Hanako Minatoya had not been able to attend, as she was appearing in a play in San Francisco.

After a pleasant prelude of perhaps thirty minutes, during which I spoke briefly with most of the guests and took photographs for the Association's newsletter, the entire party moved into a Japanese-style dining room with tatami mats, two long, low tables, and brightly colored seating cushions. Dr. Ishii was seated at the head of one table, with Mrs. Ishii directly to his left. Mr. Matsui sat across from her, and I to his right; his wife sat next to Mrs. Ishii. One of the pastors—a Mr. Hara—was seated on my other side. Across from him was Kato, the artist, along with his attractive companion. Young Daisuke Matsui sat at the end of the table.

The food was excellent and had been prepared by the finest chef in Little Tokyo, who'd been hired by the Association for the event. I believe we had just begun our third course—raw tuna and halibut arranged delicately on handmade ceramic dishes—when Dr. Ishii turned toward me and said, "I hear that Nakayama-san's most recent film represents a departure for him."

I lowered my chopsticks and nodded. "Indeed. I am playing a hotel proprietor who is hiding American soldiers from the German spies who are trying to kill them."

"I see. Perhaps the war has influenced the kinds of films being made here in America. It appears that prior to now, Nakayama-san has been *most* adept at portraying villains and fools."

I turned toward him but looked beyond his head, trying to quell my irritation. "I would humbly offer, Dr. Ishii, that *all* of my characters—even those who appear, as you say,

to be villains and fools—try to conduct themselves with honor. Some of them are perhaps more troubled than others, but there is always a good reason for their behavior."

Dr. Ishii did not immediately reply. Although I might have been imagining it, I thought that other conversation in the room had hushed and that everyone was listening to our exchange.

"Nakayama-san may not be aware of this," he said finally, "but not all of his films are available in Japan."

I took a sip of my sake and nodded. "So I have heard. I've also been told that the films that *are* available have not been translated, and that theaters hire people to stand behind the screen and interpret all the titles."

"I mean that some of his films are not available," the foreign minister continued, "because the theaters are not allowed to show them."

At this, Mrs. Ishii turned to her husband. "Oh, really. Why such dour conversation?" Then, turning to me and smiling, "You will have to excuse my husband, Nakayama-san. He is not a fan of motion pictures, so he does not understand how famous you are, or how much you have accomplished in America. Perhaps he's just jealous because our daughter thinks so much of you. You see, Nakayama-san is her favorite foreign actor."

The other guests began to nod in acknowledgment; around the table there were a few nervous smiles.

"He is important indeed," remarked Mr. Matsui, with slightly forced cheer. "He's raised the profile of Japanese here more than anyone else."

"I see," said Dr. Ishii, looking at his host directly. "The question is what kind of profile he's actually raised."

Everyone was staring at me now, and although I did not wish to engage the visitor on such complex issues, I felt that some response to him was called for. "I am well aware," I said carefully, "that there are some who do not look with favor upon my past works. But you must under-

stand that a mere actor such as myself has little control over the kinds of pictures that are made. I'm under contract with the studio, Dr. Ishii, and the only thing I can do—the honorable thing to do—is to make the best of the roles that are offered me."

These comments settled among the company for a moment, and then Mr. Matsui spoke again. There was an edge to his voice now that revealed his anxiety about his pleasant social evening slipping away. "Nakayama-san understands that some of his past films were less than ideal. In fact," he laughed nervously, "the Association once had occasion to write to him regarding one of his roles. But his parts have changed significantly in recent films, and I think it's time we recognized how much he's accomplished."

"Certainly," said Mrs. Matsui, smiling warmly again. "He is an unparalleled star in America, and his face is known all over the world."

"Exactly!" said Mr. Matsui. "Everybody knows him. He has stood bravely to represent the Japanese people in this state where there is so much hostility. And what better symbol could there be of modern Japan than a handsome, accomplished, sophisticated gentleman?"

"Well, I like him," said Miss Kuramoto, the artist's companion. "*All* the girls do." And the forwardness of this comment—particularly uttered by someone who'd barely said a word all night—made everyone turn in surprise.

"That includes, as you've no doubt guessed, my own wife and daughter," said Dr. Ishii. Then, glaring directly at me with a clear and cold gaze: "But I hear that Nakayama-san prefers *American* women."

At that moment, there was a commotion near the entrance of the room. A servant rushing in with a tray of food had collided with another going out, and now fish and tsukemono and dollops of seaweed were scattered all over the floor. Both servers were embarrassed and moved be-

tween picking up the fallen plates and bowing and apologizing to the diners. Mr. Matsui had stood up by this point, and his face was bright red, but his wife had already scurried over to the scene and begun assembling more servants to assist with cleaning up.

"I apologize," Matsui managed. "I only obtained these servants for the evening, and one never knows the quality of hired help."

"Oh, it's nothing," said Mrs. Ishii. Then, in a warm voice that seemed directed at the servants as much as it was to us, "I always have little accidents at my house. Why one time, I spilled a whole bowl of noodles on the floor, and then my husband slipped and sat down right on top of them. I said, 'Hideo, you should have told me you wanted *flat* noodles.' My goodness, was he mad! I think that was the only time he ever considered divorce."

Her husband looked at her sternly, and we all waited nervously to see how he would respond. But Mrs. Ishii gave him a disarming smile, and the tension around his eyes lessened visibly as he relented to her good humor. We all relaxed, and within a few minutes, the dinner conversation resumed.

The evening became more pleasant after the accident. Mr. Matsui discussed a recent visit to San Francisco; Mr. Shimura, one of the pastors—whose only mode of transportation was bicycle—told a story about taking a driving lesson; and Mrs. Matsui described the visit of three young women from Japan and all the attention they received from single men in Little Tokyo. Mrs. Ishii participated actively in the conversation, laughing easily and asking many questions. Dr. Ishii listened politely, chiming in occasionally with, "Is that so?" or, "How interesting," but offering no more than the simplest responses.

I thought we would get through the rest of the evening without further incident, but at the end of the meal, while we were eating manju and drinking green tea, Mrs. Matsui

turned to the foreign minister and asked, "Excuse me, Dr. Ishii, but what will you be doing in Washington?"

Dr. Ishii put his cup down and raised his head—waiting, it seemed, for all eyes to turn toward him before he began to speak. "I will be meeting with several members of Congress," he said, "as well as the Secretary of State."

Around the table there were various exclamations of awe and approval. Mr. Shimura nodded and said, "To discuss the war effort, no doubt."

"Yes, that is so. The two countries have much to discuss regarding the best use of our respective forces. But," he said, pausing, "there are also other pressing matters." He took a drink from his tea and looked around the table. "While the war has helped form an alliance between the U.S. and Japan, there is still much to be desired in how Japan—and Japanese—are viewed here in America."

"Indeed," offered Mr. Shimura. "The Alien Land Law and the Gentlemen's Agreement have severely limited our ability to forge stable communities." After a moment of reflective silence, he added in a more cheerful voice, "But that was years ago. We've made great strides since then!"

"Tremendous strides!" agreed Mr. Matsui. "And I believe that things will continue to improve. The efforts of the Japanese Association, for example, will help ensure that we put our best foot forward with the Americans. Right now, even as we speak, we've been working on a war bond drive in Little Tokyo."

Dr. Ishii examined his half-eaten manju and then placed it back on his plate. "There is no question, Matsui-san, that the work you do is valuable. Although if the world were as it should be, such efforts wouldn't be required. Yes, things are better, but the reprieve is temporary. When the war is over, I believe they will get worse again."

A somber mood fell over the table. No one spoke for several moments before Mr. Shimura asked, "Dr. Ishii, are you aware of something we aren't?"

"There is a move afoot," Dr. Ishii answered, "that, if successful, will make things more difficult for the Japanese who live in America. Even," he added, indicating young Daisuke, "for the ones who were born here. The efforts have been subdued temporarily because of the war, but there are still many men—many very powerful men—who are actively working on legislation that will curtail your standing. And, unfortunately, most of them are centered in the West, right here in California."

"It is regretfully true," Matsui concurred, "that many of the state's most prominent men are unfriendly to our interests."

"I tried to meet with members of the state legislature in Sacramento," the foreign minister continued, "but they all refused to see me. They consider you a blight on the face of California, and there is tremendous resentment among them, particularly about the success of Japanese farmers in the Central Valley. They are afraid that the farmers will continue to flourish, and that more Japanese will come." He paused. "Fortunately, the Americans who live in Washington and New York are generally much more rational. Being, on the whole, a more civilized sort, they do not see you as a national threat."

"What is there to do?" asked Mrs. Matsui.

"You must be strong," he said. "You must show the Japanese character. When there is blatant injustice, especially about land, you must stand up to those who would take advantage of you—or else we're no better than the compliant Chinese. When unfavorable bills come forth in the California legislature, you must rally your friends and allies to defeat them. But—and this is of equal importance—you must also show your willingness to get along here in America, to play by American rules—as you, Matsui-san, have already done so effectively. Above all," and here he looked significantly at me, "you must not do anything that presents us Japanese in a negative light."

"It is a difficult balance," said Mr. Matsui, "to be strong, and yet to try and win over their minds."

"How can we do it?" asked Mrs. Matsui, almost to herself. "There are so few of us, really, and so many Americans. How can we affect the way they see us?"

Dr. Ishii nodded. "You are correct, there *are* very few of you, Mrs. Matsui—not even 20,000 in Los Angeles. That is why I've never understood why those in prominent positions have not done more to advance our interests."

And here again he looked directly at me, and I returned his gaze. I could feel my anger rising. I was about to reply to his obvious challenge when Mrs. Ishii interrupted again.

"Politics, always politics," she said with the air of a wife subjected to one too many tiresome dinners. "You see what I must cope with? We're invited to a social occasion on my first trip to America, and my husband can't talk of anything but politics!" She leaned conspiratorially toward Mrs. Matsui, who was looking at her with gratitude. "I don't know what all these men are complaining about. It's *us* who have the truly difficult jobs, dealing every day with the likes of *them*."

Mrs. Matsui gave a wide, relieved smile, and the tension began to lift once again. "Indeed!" she concurred, turning toward us men. "Why, if you want to hear about *real* hardship, you should be here when my husband practices his speeches. He stomps and shouts and rehearses in front of a mirror. Why, it's enough to drive our cats out of the house!"

It was clear that all serious conversation was over, and after the guests had had one final cup of tea, we collected our coats and began to disperse. When the foreign minister passed me on the way to the door, he stopped and gave a curt farewell. His wife, however, bowed sincerely and smiled.

"I apologize for my husband's behavior," she said. "He

has a very limited way of seeing the world. And I believe, although he would never admit it, that he envies artistic men." I detected a glint in her eye. "Especially gentlemen as handsome as yourself."

As my driver took me home, I thought of Mrs. Ishii and her graciousness, which tempered slightly the unpleasantness of the evening. But the event itself caused a discomfort I still felt, like bad fish that had soured my stomach. Despite Matsui's defense and Mrs. Ishii's intervention, I was disturbed by what the foreign minister had implied. And if *he* felt these things—so strongly that he was bold enough to bring them forth in public—who else might have felt the same way? I experienced a wave of irritation at all of these people for their arrogance and naïvete.

I did not know what they expected of me. Did they think that I, one man, could affect how Americans saw all Japanese? Did they truly believe that I, a mere actor, could influence events in California and the rest of the country? I was certainly aware of my own popularity—just that week my car had been mobbed by a group of American schoolgirls when my chauffeur stopped at a store for cigarettes—but to think that such fame could be used to shape public affairs seemed utterly fantastical. I was not surprised that the foreign minister disapproved of my roles—as I've said myself on many occasions, some of them were troubling. But at least I played characters who were strong and resolute; at least I never took the comical houseboy roles that were favored by lesser actors like Steve Hayashi. Moreover, to assume the kind of stance that Ishii was suggesting would not have helped matters at all. Certainly I wished to play a wider range of parts—but the fact that I was given these starring roles at all was a benefit to *all* Japanese. One only needed to peruse *Variety* or the picture magazines to see that Hollywood—America—loved me. And this was what the foreign minister did not appear to understand.

Although it might have been true that some Americans did not embrace the Japanese, it wasn't prudent to meet this negative feeling with negative acts of our own. I did not believe in taking actions that would draw unfavorable attention. I believed, and still believe, that the best way to win acceptance is to be as agreeable—and American—as possible.

Dr. Ishii's behavior was especially maddening because I was engaged, even at the time of his visit, in an effort that would soon paint the Japanese of Los Angeles in a very positive light. The U.S. government had just released its second war bond, and Mr. Matsui had been working feverishly to encourage people to buy them. The Japanese Association had thrown the full weight of its support behind the effort—running ads in the *Rafu Shimpo*, passing out notices at churches and temples, posting signs in Little Tokyo and Boyle Heights. Even the motion picture industry had gotten involved—the short film that Hanako and I had shot in Santa Barbara was an appeal to audiences to purchase bonds. The response thus far was encouraging—as it had been with the first bond—but Matsui wanted to orchestrate a large public gesture to show the community's support for the war. He decided to organize a war bond rally, and asked Hanako, Steve Hayashi, and myself to appear. Hanako declined, citing her continuing commitment in San Francisco. And while I too normally turned down requests to promote particular causes, the importance of this endeavor made me readily agree.

The rally was held in Little Tokyo in the first week of October. The streets were so crowded in every direction that it looked like the entire population of Little Tokyo, waving small American flags, had gathered at First and San Pedro. After a series of rallying speeches from Matsui, Hayashi, myself, and a few other dignitaries, the crowd divided into lines to purchase bonds. My own line—I was set

up at an individual booth—was, of course, the longest, and after hours of smiling and signing autographs and posing for pictures, I was as tired as I had ever been in my life.

The rally's success—described in the next day's *Los Angeles Times* article, "Japs Set Record Buying Liberty Bonds"—directly led to an increase in box office receipts for my just-released new film. The majority of my viewers were—as always—Americans, and this boost in sales gave the studio an idea. Why not organize several stars with current or upcoming films to participate in the war bond effort? And why not, to attract as much attention as possible, send those stars on a trip across the country?

That is how I found myself, in the fall of 1917, a passenger on the "Victory Train." Perennial had recruited its then-biggest stars—myself, Elizabeth Banks, the comedian Tuggy Figgins, and the cowboy actor Buck Snyder—to travel together on a four-week war bond tour, culminating with a rally in New York City.

The trip was widely publicized for several weeks, and it created such interest on the part of the media that Perennial decided to rent the entire train. Two cars were reserved for the actors—one for Elizabeth and one for the three of us men—another for studio executives, another for members of the press, and several others for the theater owners, exhibitors, and distributors who were critical to a picture's success. A final car was reserved for the government employees who would coordinate the sale of the bonds.

The tour began with a kick-off rally at the train station in Los Angeles, complete with a live band and several speakers. Benjamin Dreyfus was there—he'd engineered the whole event—as well as Gerard Normandy, David Rosenberg, and a number of stars from Perennial. Even the mayor himself appeared, and after his brief remarks exhorting everyone to support the war effort, he bought his bonds right there on stage. The crowd was tremendous—

even larger than the crowd in Little Tokyo—with frenzied people screaming out our names and trying to push through the police lines. But although this event was only blocks from Little Tokyo, none of the faces from that earlier rally were visible here.

When the train finally started pulling out of the station, the four of us actors leaned out the windows and threw flowers at the crowd while a thousand brilliant flashbulbs exploded. And as we left downtown Los Angeles, we were met with a surprise—people were lined up for miles on either side of the tracks, shouting our names and waving American flags.

Once we got past San Bernardino, the crowds thinned out and we were able to relax. There was a double set of facing seats in our men's car, so Elizabeth joined us, sitting next to me and across from Snyder and Figgins. I did not know either of the men very well, although I'd met them at parties and studio functions. The studio's selection of its male stars was sensible, for both of these men—who were in their late thirties—were too old to enlist, and I, of course, was ineligible.

I'd heard that Snyder was a rather private man, a genuine former cowboy whose success in Hollywood had not altered his basic plainness. He'd been discovered years before at Gower Gulch, and it was said that he still roped cattle and raised horses and sheep on his ranch in the San Fernando Valley. Figgins was more of an enigma. He had that lovable, self-deprecating big-man persona, and yet out of the public eye he was unpredictable. His given name was Eugene, but he'd earned the nickname Tuggy at a party on the pier in Santa Monica. The story was that there'd been a footrace, several drunken men barreling blindfolded down the pier, and when Figgins broke the ribbon at the finish line, he kept going and flipped over the rail. He took the ribbon, several balloons, and the wooden barriers they'd been tied to down into the water with him. And as he

swam back to shore with this load trailing behind him, someone leaned over the rail and said, "Hey, he looks like a tugboat!" This eventually got shortened to Tuggy, and the nickname stuck. So did his talent for attracting misadventure. There was talk about drunken fights at questionable night spots and arguments with the studio—talk that might explain his presence on the Victory Train, which could have been an attempt to repair his image. He did not appear to be getting off on the right foot, however. Less than an hour into the trip, he sighed heavily and said, "Well, howsabout a little drink?"

David Rosenberg was on the train too—he'd been sent by Leonard Stillman to keep an eye on us—and at this, he sat up straight in the seat behind me. "Little early, Tuggy, don't you think?"

It *was* early—only 10:30 a.m.—but this didn't seem to deter the comedian. He loosened his tie, unbuttoned his coat—which barely closed over his soft, bulky frame—and said, "I'm boiling, sport. Need a spot of something cool. Now be a good boy and rustle up some beer."

At this, Elizabeth, who'd kicked her shoes off and crossed her legs on the seat, said, "One for me too, David, if it's not too much of a bother."

I tried to give her a look, but she avoided my eyes. Then I turned to Snyder, who shrugged. Unconcerned, he lit a cigarette and gazed out the window. When I glanced at David, though, he was pressing his lips together and furrowing his brow. He must have decided it wasn't worth the trouble of fighting, because he left and came back with the beers.

Despite this beginning, there was a general sense of excitement about the trip. The distributors and theater owners kept knocking on our door, wanting to meet us, and Rosenberg would shoo them away. The train's service staff would come in with our food, trembling with excitement, and then we'd all read their descriptions in the next day's papers of our clothes and eating habits.

At our first stop, in Phoenix, we held a rally at a football field, led by a contingent that included the mayor and the U.S. senator from Arizona. One by one, we climbed up on the stage to yell through megaphones on behalf of Liberty Bonds.

"Every bond you buy will help save a soldier's life!" shouted Snyder.

"Every bond you buy is a hammer in the Kaiser's coffin!" called out Elizabeth.

Figgins and I expanded on these general themes, as did everyone else who took to the stage.

After we'd finished exhorting the crowd, we each retreated to our booth to sell bonds. All proceeded smoothly until a young redhead reached into my booth and threw her arms around me. I returned her embrace briefly, but when I attempted to pull away, she tightened her grip around the back of my neck. Three policemen appeared, and after their repeated commands to let go of me went unheeded, they had to pry her loose. "Jun, Jun, I love you!" she sobbed, as the police began to pull her away. Before they succeeded, she took something out of her pocket and threw it at me. It was a pair of lacy underwear, and all the men grinned as I plucked it off my shoulder. Figgins, from the next booth, shook his head in amazement. "Normandy *told* me you were popular with women. But jeez, I had no idea."

Each official stop was a variation of the first—large crowds that grew as we progressed across the country, smiling politicians, fans crushing through police lines to get to us. We each had our own particular brand of followers. Elizabeth, of course, was loved by all the men—some of them shyly passed her flowers or love letters; more than one asked her to marry him, and a man in Cleveland paid $10,000 in cash for a clump of her chestnut hair. Young women loved her too—not society girls, but girls in waitress outfits and mothers old before their years, women who

knew where Elizabeth had come from and who believed her success gave them hope for their own lives. Figgins' fans were portly or scrawny boys and their adult equivalents, people who yearned not for heroic figures but for reflections of themselves. The working men were drawn to Buck Snyder, who was the archetypal Western hero. The men who liked me were the sophisticates, the urban men who liked elegant clothing and good cigars; who cared about culture and literature. Both Snyder and I were loved by the women. And there were thousands of women.

One day, somewhere on the great Western plains, the train came to an unexpected halt. Rosenberg, who'd been napping on one of the bench seats in our car, was awakened by the screech of the brakes. He yawned and said, "It must be a whistle stop. No need to get up."

But then someone else from Perennial—a teenager who was probably somebody's son—stuck his head in the door. "Gentlemen, would you mind coming back to the rear platform? There's a crowd out there waiting to see you."

We had not been expecting to make a stop that day, and Figgins was still in his nightshirt. Snyder was asleep in his upper bunk, with one boot hanging over the side, snores audible even with the noise of the train. I was dressed, as always, in a jacket and tie, but even I had been looking forward to a day with no public appearances. Elizabeth, David told me after he had spoken to her maid, was getting a massage.

"Can't we skip it?" asked Figgins. "I'm in the middle of something." What he was in the middle of was a flask of whiskey; it seemed to be his most treasured possession.

"Better not," said Rosenberg. "It looks like you've got several hundred people out there. The town's mayor declared a holiday today."

Figgins groaned and began to arrange his body to stand, which would take him several minutes. David went and shook Snyder's dangling leg; in a moment the actor, look-

ing sleepy, had jumped down from his bunk and pressed his cowboy hat to his head. Then Elizabeth burst into the car wearing a simple cotton dress, her hair tied up in a bun. "David, I'm just about through with this shit," she said. But by the time we all marched to the back of the train, she had composed her features into a smile.

The teenager had not been exaggerating. Surrounding the rear car was a large, excited crowd, against the backdrop of land so golden and flat it seemed to go on forever. As soon as we appeared, a high school band in full uniform struck up a cheerful song. The four of us stood against the railing and smiled for the cameras, while hundreds of children waved miniature flags.

"Elizabeth, Elizabeth!" the young girls squealed. "Let us see your new hairstyle!"

"Buck, did you bring your horse on the train? Show us your gun! Dontcha got your gun?"

"Tuggy, do the shell game!" a large man yelled, referring to one of Figgins' gags.

And then, directed at me, mostly by the children: "Mr. Jap! Talk Japanese to us! Swing your samurai sword, Mr. Jap!"

None of us fulfilled these specific requests, but we waved and smiled and talked to the crowd. We stayed out on the platform and posed for pictures—Snyder placing his hat on Elizabeth's head; Figgins imitating a film diva applying her makeup; I pretending to engage Snyder in a duel, our pointed fingers serving as guns—until David Rosenberg gave us a nod and we made our way back inside. As we disappeared we heard the crowd yelling, "Bye!" and, "We love you!" And although none of us had wanted to go outside, we all felt considerably cheered.

During the long nights, when the train made most of its progress, we entertained ourselves as best we could. Elizabeth, Snyder, and I would make our way to the rear cars and play poker with the theater owners and distributors—

something that the studio executives enjoyed, because the better these men liked us, the more willing they'd be to buy the new slate of pictures that included our latest titles. Figgins would not join in on these games—he said he didn't know how to play poker, although the truth was that he was more interested in the company of his flask and that, despite his jocular image, he was rather solitary. But the rest of us had no such problems. Buck Snyder, not surprisingly, had a marvelous poker face, his laconic visage foiling us time after time as he gradually accumulated wins. I did fairly well, although not as well as Snyder, and the distributors seemed amazed that a Japanese man could speak English and hold his own at a game of cards. And Elizabeth. I still see Elizabeth clearly, cigarette dangling from the corner of her mouth, taking swigs of whiskey straight from the bottle as she squinted at her hand, and cursing like a sailor—to the delight of all the men—whenever she had to fold.

Sometimes the four of us would avoid the rear cars altogether and engage in what Figgins called a "bunk crawl." We would enlist some of the studio men like Rosenberg as well—after they'd sworn not to tell their bosses. In each man's bunk, and in Elizabeth's car, there would be a different drink—beer in Buck Snyder's bunk, martinis in mine, gin and tonics in Elizabeth's, and so on. All of us—and at its height, the group grew to fourteen—had to fit into the bunk together before we could take a drink, a tangle of arms and legs, heads resting on shoulders, giggles that caught like sneezes in the overstuffed compartments as we all struggled to swig our drinks without spilling. In David's bunk, which was dominated by his own bulky presence, I was folded into a corner with Elizabeth pressed against me, and the feel of her skin against my arms, the smell of her hair, affected me more strongly than the liquor.

On more than one occasion, the evening ended with Snyder having company in his bunk. There were three

young maids on board—Elizabeth's, and two who were
traveling with the studio men—and each of them, at some
point, found her way into the cowboy's bed. Twice, women
came on board at one of the whistle stops, traveling with
the train and keeping Snyder company until the next stop,
when she disembarked and made her way back home. Fig-
gins, whose bunk was directly across from Snyder's, slept
through these assignations. But I was kept awake by the
giggling and clinking glasses—and then later in the night,
the loud and steady moans.

It was a singular trip, magical, separate from time, as
only an excursion removed from everyday life can be. We
were our own little society, with its own norms and rules,
self-contained, and never to be duplicated. I remember sit-
ting with Elizabeth on those quiet afternoons, staring out
the window at the changing scenery—the majestic moun-
tains, endless plains, the countryside which was so varied
and yet somehow all connected, the vistas of this endless
land, America. I remember thinking, now that I had time
to reflect, about the magnitude of my good fortune. Here
I was, as famous and accomplished as a man could be,
in a country not even my own. Two cars down from me
were executives who wished me to sign a new, more lu-
crative contract. Across from me sat a beautiful and desir-
able woman. And I was finally, by my actions here, doing
something I had never done—using my fame for a good
purpose, helping America, and, in turn, helping my fellow
Japanese.

And we did, indeed, use our fame for a good purpose.
In every city where we stopped, there was a tremendous
rally, and the crowds, swept up by the powerful combina-
tion of patriotism and celebrity, opened their pocketbooks
and wallets to buy. With each rally the four of us grew
more effective with our speaking, whipping the crowds up
into such a state of excitement that I thought half of them
might run off and enlist. I waved my hat, Buck Snyder

struck shooting poses, Figgins worked an invisible baton as if conducting the crowd, and Elizabeth waved her fist in the air in a gesture both inspiring and adorable. Bands broke out into patriotic songs and babies were dressed up in colors of the flag. In Denver, Chicago, St. Louis, Pittsburgh, every record for the sale of government bonds was broken. Our studio bosses were beside themselves—not because of the success of the war bond sales, but because this trip had made them realize the scope of our popularity. The size and enthusiasm of the crowds was overwhelming, and thrilling, and boded well for the future of motion pictures.

In retrospect, it is incredible how naïve we all were. Perhaps because none of us had witnessed war in our lifetime, we thought of it primarily as a battle of ideas, a struggle against evil that was essentially bloodless, or that only involved bloodletting by the enemy. We were like cheerleaders exhorting our team to victory. There was a gaiety in the air, in the crowds, that had no relation whatsoever to the reality of what was happening in Europe. Even the small pockets of Japanese who came to the rallies, yelling my name and waving American flags, were caught up in the excitement. Little did they know of the suffering that was enveloping the world. And little did they know what awaited them two decades hence, when the country was pulled into an even larger conflagration.

After a rally, the whole party of travelers would be enlivened—government men, studio men, and actors alike. The train itself would seem excited, its whistles more hearty, its engine chugging along with renewed vigor. Eventually David would chase the others away and escort us actors back to our cars. There, he'd arrange for meals—the cars were specially outfitted with dining tables so we could eat in privacy—and bottles of wine and beer. And we'd slowly wind down, talking of the particulars of that day's crowd, marveling at our own successful efforts.

It was on one of those nights that I escaped my bunk and made my way to Elizabeth's car. Snyder had enticed another woman on board in Pittsburgh, a big-bosomed brunette with too much makeup and cheap perfume, and I'd prepared for another long night of sleeping with pillows against my ears. But then, around midnight, I felt someone slip into my bed. My heart skipped—for a moment, I thought my dreams had come true—but when I turned over, I smelled the strong, stale scent of the Pittsburgh woman. She was naked—her fleshy breasts slapped against my face—and she breathed, "Take me, samurai soldier, brutalize me!"

I grasped her around the waist—her whole body shivered in response—and heaved her over to the other side of the bed. Then I slipped down out of the bunk and threw on a robe and fled to Elizabeth's car.

She came to the door in her nightgown—it was clear she'd been asleep—but she turned on the lamps and invited me inside. After I told her what had just transpired—which caused her much amusement—she arranged for someone to bring us a pot of tea. She led me over to the facing seats by the window, where we talked about that day's rally. Then we were still for a while. As the movement of the train rocked us gently, we looked out into the night at the gathering of lights that marked each little settlement we passed. Elizabeth took a puff of her cigarette and said, "These small towns, all the people who'll never travel more than ten miles from where they were born, they remind me of the place I grew up in."

I smiled, for although I'd come from a completely different land, I knew precisely what she meant. "But *you* left," I remarked.

"I know. I never belonged there. I realized there was something bigger. It was like my life didn't really start until I turned fifteen and ran away to Hollywood."

She told me of her girlhood—the departure of her fa-

ther when she was seven years old, her mother's daily trips to St. Louis to mend clothes and clean houses; the whiskey-soaked men her mother sometimes brought home; the bruises she woke up with in the morning. "She always picked the roughest, meanest ones," Elizabeth said, the lights from outside the window flickering across her face. "And then one night one of them came into my room. He put his hand under my nightgown, and when I screamed, my mother came in and started yelling at *me* for trying to seduce him. I left in the morning and went to my uncle's house to borrow some money. Then I caught the next train to California."

She told me all of this without a trace of self-pity, as if she were speaking of someone else. She'd put a robe on over her nightgown and she wore no makeup, and her face looked softer somehow, more revealing. Her hair was tied up but several strands had come loose; she kept brushing them away distractedly. And although it was she who was talking, it was I who felt exposed, and had she looked up into my face just then she would have read there all my turbulent feelings.

"Maybe that's why I haven't had too much luck with men. It's not like I've had much of an example. But *you*," she said, smiling again, "you sure have a lot of luck with women."

I laughed—I'm sure a bit too loudly. "You exaggerate, Elizabeth. It's our friend Buck Snyder who's having all the luck with the opposite sex."

"Only because you're pickier, Jun. I see all the screaming women throwing flowers and undergarments. And those women in Cleveland who spread their furs on the ground so you wouldn't have to walk through a puddle! You could have had your pick in any city."

I did not reply, and certainly didn't say what I was thinking—that the woman I wanted, "my pick," as she'd put it—did not appear to have any interest in me.

"This has sure been a better trip for you than for me in that department," she continued. "After all, no one's tried to crawl into *my* bed."

There was something in her voice when she said this, and when I glanced up at her face, I couldn't tell if what I saw there was amusement or invitation.

"I didn't know," I replied casually, feeling out the moment, "that you were seeking company."

"Oh, Jun," she said, and now her voice did something else, "that's only because you haven't been paying attention."

I met her eyes, and the message there was unmistakable. A door that had previously been closed had now, unbelievably, opened. As if of their own accord, my hands reached out and pulled her toward me. She moved easily from her seat over to mine. And then her mouth against my mouth, her fingers on my face, the robe and the nightgown falling open.

I could hardly believe it. I could hardly believe that this woman, this goal for so long out of reach, was flesh and blood, right there beneath my hands. But my nervousness was quickly subsumed by my knowledge of how to live in this moment. For she was, after all, a woman, with a woman's desires, and as I lifted her and set her back down on her seat, as I bent over her with the strength and assurance of a man accustomed to taking what was offered, I felt her give herself over, felt her loosen and release, her body quivering and open now, for me.

We didn't spend another night apart for the rest of the trip. This did not escape the attention of David Rosenberg, who rolled his eyes but refrained from comment; or of Buck Snyder, who said to me one day, winking, "Glad you finally pulled that gun from its holster." If Figgins noticed, he didn't mention anything, although his manner toward me grew colder. I didn't care, though, about any of them. Because finally, in those last few days of our trip, I had everything I wanted. Mornings with Elizabeth over

coffee and toast. Afternoons of laughter with our amusing companions. And nights, finally the endless nights, whose joy and completeness I could never describe, and of which there could never be enough.

When we arrived in New York, it felt not like the culmination it was intended to be, but rather like a premature coda. Our final rally was spectacular—red carpet and bands, stars of pictures and Broadway, the governor, the mayor, front page coverage in the *New York Times*. Tens of thousands of people all gathered in Times Square, people leaning out of windows and waving from rooftops, the sale of millions of dollars worth of bonds. Even our elusive studio chief, Leonard Stillman, turned out for the occasion, sitting with the politicians on the side of the dais. But after one last grand party and a night at the Plaza, we all went our separate ways—Elizabeth on a train back to Los Angeles, Figgins to his second home in Westchester, Snyder to an apartment where he was staying temporarily while he was in town for his upcoming opening; and myself out to Perennial's East Coast studio on Long Island, where I was set to begin my next film.

The success of our tour had far surpassed all expectations, and set the stage for the even grander tour the following spring featuring Mary Pickford, Doug Fairbanks, and Charlie Chaplin. Yet ours had been the original, and when it was over, I felt a tremendous sense of loss. Although I enjoyed the culture and nightlife of New York City—which was, along with all of its other attractions, a more hospitable place for Japanese—I could not escape my feeling of sadness. The month I had spent on the war bond tour had been the best month of my life. Even then, in those first few weeks after the tour, I knew I'd experienced something that could never be recreated. Never again would I feel as useful, as much a part of something bigger, as I did aboard that train. Never again, in all my years, would I feel so close to happiness.

CHAPTER NINE
October 23, 1964

I t is late in the evening, and I am thoroughly exhausted, having spent the last few hours attempting to forget this week's events by doing bookkeeping for my various properties. Work has always been my way to put unpleasant things out of mind, and these last few days have seen more than their usual share. By this afternoon, I was so troubled by my recent encounters that I was grasping for something—truly, anything—to distract me. Then I remembered the paperwork that awaited me at my desk, and as I have so many times when I've needed to calm myself over the years, I settled into it as one might into a soothing bath.

Back in the late 1910s and early '20s, when my income seemed limitless, I invested in a number of apartment buildings, as well as three houses, two commercial properties, and several empty parcels of land. My family's farm had impressed upon me the importance of property ownership, and I'm sure this knowledge was significant in my decision, all those years ago, to buy as much real estate as I possibly could. I'd had to make my acquisitions through a friendly real estate management firm introduced to me by David Rosenberg, since Japanese were barred from owning property. But it wasn't very difficult getting around this limitation, and I'd enjoyed the process of buying; I liked acquiring tangible things like land and clothes and automobiles, things that were purchased as a matter of course by white gentlemen of means. Of course, I only had the slightest inkling, when I bought those properties, of how

dramatically their value would increase. But time has proven that my investments were wise. The combined income from my commercial and residential rentals has been more than enough to live on, and when I recently sold two large parcels of land in Malibu to an aggressive investor, I made a profit of nearly a million dollars. I was lucky—my investments meant that when my career came to its rather abrupt end, I had a source of income to fall back on. So many of my contemporaries, who frittered away the cash that flowed like water in those pre-tax days, watched their incomes decrease and then dry up completely as their film careers drew to a close. In the '30s, some of them, desperate for money, held large auctions of old movie memorabilia. Two or three of them even auctioned off their houses.

I have a property management company take care of most of the day-to-day items of business—showing apartments, collecting rents, arranging for repairs—and they only contact me when some particularly large expenditure is required. This was an especially convenient arrangement during the Second World War, which I waited out in England while so many others were herded away to the camps. My management people have been very dependable over the years. That said, to keep myself occupied, I still manage one of the buildings myself. It is the Chestnut Arms—you may have heard of it. It stands two blocks north of Franklin, at the foot of the Hollywood Hills. My former costar Evelyn Marsh once lived there, as well as Edmund Cleaves, and the building, with its hardwood floors, fireplaces, turrets, and courtyard, looks much the same as it did in 1919, when I bought it for what now seems like mere pennies. It gives me a certain comfort to know that the old place still feels the same in the midst of constant change, and since it is within walking distance of my town house, and since I have little else to do, I directly oversee the management of its four units. Most of the time this is a pleasant enterprise, as the tenants who can afford such a

prestigious building are all stable, respected professionals. And this activity—the management, the tracking of accounts—has proven very useful; it gives me something to focus on when I am attempting not to think of other things.

As much as I have tried to absorb myself in bookkeeping, however, I cannot help but reflect on the last several days. For these days have been marked by events that have upset my peace of mind, and sent my thoughts along paths I have not wished for them to go. The first was all the more unsettling because I had not been prepared for anything disagreeable. I had awaited Tuesday's lunch with Nick Bellinger and his friend Josh Dreyfus with both anxiety and excitement, and I'm still not certain what to make of what occurred.

It had taken me several days to call Nick Bellinger, days I spent looking back over his screenplay and rereading certain sections again and again. I had wondered if I would find it less impressive when I returned to it; perhaps I had even hoped that would be so. Instead, the very opposite was true. With each successive reading, the themes seemed to deepen, the scenes became more subtle and engaging. And my interest in playing Takano continued to grow with each new day. The young man's story was brilliant, an incisive and original work, and I knew now that I wanted to be part of it. I told myself to believe that things would go as smoothly as Bellinger had assured me they would.

The day after I'd visited David Rosenberg at the nursing home, I placed a call to Bellinger. "It's wonderful," I told him. "The characters ring true, the dialogue is sharp, and you are telling a story that has not been told before."

"So you liked it?"

"Very much so."

"Well, that's terrific, Mr. Nakayama, because I have news."

With that, he informed me that Perennial had indeed

bought the rights to his screenplay, and was set to choose a director.

"My friend Josh is going to oversee production," he said. "And since the role of Takano is basically the anchor of the film, he'd love to meet with you as soon as possible." Bellinger promised to set up a meeting between the three of us, and asked if there was anything else I'd like to know.

"Yes," I said. "How's your article coming along?"

"Oh," he responded, in the tone of a boy reminded of his homework. "Well, I have all the information I need on the theater itself. But I'm having a hard time tracking down surviving actors." He paused. "Are you still in touch with anybody?"

"Like whom?"

"Oh, anyone," said Bellinger. "I've heard that Louise Brooks is still around somewhere, and Gloria Swanson. Ramon Navarro is still alive—didn't you work with him once? And I've heard rumors about Nora Minton Niles."

I paused for a moment. "I haven't spoken to any of those people in decades." Then, trying to keep my voice as casual as I could: "What exactly have you heard about Miss Niles?"

"Oh, you know, the same things that people have always said. That she's a recluse and no one's seen her for years. That she never married or had a family. That her mother kept a tight grip on her until *she* died, and no one's really heard from Nora since. She never really recovered, you know, after that business with Ashley Tyler."

I had been standing by the window, and now I sat down, trying to keep my hands and voice steady. "Do you know where she is?"

"The last I heard she lived on the Westside somewhere, but that was while her mother was still alive. Harriet Cole lived to be ninety-five, the old witch. Poor Nora. By the time her mother finally died, she was already an old

woman herself. You worked with her a few times, didn't you?"

My pulse quickened but I managed to answer. "Not so much. On only one or two films." With this turn in the conversation, my excitement had diminished. But as quickly as he'd brought up the subject of Nora, Bellinger moved on to something else, and I hoped his curiosity had been satisfied.

We met for lunch at an establishment called Castillo's in Beverly Hills. I wore my best brown suit and drove the Packard down Sunset Boulevard, the old route I used to take those long-ago mornings with Hanako. Of course, Sunset is very different now—crowded with people and shops, and lit up with brilliant neon in the evening. And Beverly Hills used to be untamed land, so far removed from the original studios that it might have been Santa Barbara. Now, Beverly Hills is the height of wealth and prestige, and as accessible—at least in geographical terms—as any corner pharmacy.

When I arrived at Castillo's, I was surprised to find that a young man in a vest—apparently employed by the restaurant—expected to park my car.

"I assure you," I said, looking up at the boy, who had rudely pulled open my door, "I am fully capable of parking this vehicle myself."

"I have no doubt, sir," he said, his hand curled over the top of the door. "But you see, everybody uses the valet here." He smiled a bit nervously, and I continued to glare at him.

"I would think that an establishment of this caliber would allow its patrons to park as they wished."

The boy looked at me more closely and his eyes softened a bit—he seemed to understand that he was addressing a man of importance, and was now attempting to behave more appropriately. "Castillo's is of the *highest* caliber, sir. That's why we don't want our customers to be bothered

by the inconvenience of looking for a place to park." He paused. "It's really kind of normal now, sir."

I did not feel like carrying the argument any further, so I reluctantly got out and handed the boy my keys. For a moment, as he drove my car away, I wondered if I would ever get it back. But since other arriving patrons appeared unflustered by this practice, I decided it was nothing to worry about. I walked into the entrance, and, seeing no sign of Bellinger, took a chair close to the door. There was a carp pond in the outdoor waiting area, and I watched the fish swim and bump into each other as I tried to maintain my calm. A few minutes later, Nick Bellinger appeared.

He was dressed in a jacket and tie, his hair was somewhat tamed, and behind him was a young man who I assumed was Josh Dreyfus. Bellinger introduced us, and I could tell that he was nervous from the speed with which he talked and the way he kept brushing his sleeves. The other man, who was indeed Mr. Dreyfus, had no such apprehension. He gripped my hand firmly and looked directly in my eyes. "Good to meet you, Mr. Nakayama," he said. "Nick tells me you knew my grandfather."

I was somewhat taken aback by this. I had thought he already knew about my association with Ben Dreyfus; that perhaps Ben had even talked about me. But I forced myself to smile. "Yes, he was an executive during my time at Perennial."

This younger Dreyfus nodded distractedly. Then the maître d' appeared. "Mr. Dreyfus! So delightful to see you! Would you like your usual table, sir?"

"Yes, Peter," he said, barely looking at the man. "I have special guests today." I watched him as we were led through the restaurant to our table. Although he was shorter than I, no more than 5'6", he carried himself like a much taller man, and moved through the restaurant as if he had built it. Here and there people waved at him, and he nodded or waved in acknowledgment. His brown hair was clipped

neatly and sprayed into place, and his gray suit looked as if it had been tailored.

We were seated at a corner table beneath a large potted palm. The restaurant was light and airy, with so many windows that it felt like we were dining outside. Around us, well-heeled men, mostly in their thirties and forties, laughed loudly over seafood and wine. The women—some of whom were with men but most of whom were clustered in small groups—wore suits in pale colors and glittering jewels and frequently stole glances at each other. Everyone seemed to be looking at everyone else, either directly or with the help of a mirror that took up an entire wall. A waiter appeared at our table with a bottle of Chardonnay, which Dreyfus sampled, considered, and approved.

"So you've read Nick's screenplay," Dreyfus said after our wine had been poured. "As I'm sure he told you, the studio's going to make it."

I looked at his face—the angular chin and nose, the brown eyes—and searched for some sign of his grandfather. There might have been some likeness, especially in the large forehead and slightly cleft chin. But where Ben Dreyfus had an optimistic air about him—as did so many of the young executives in the silent era who were giddy with the growth of their new industry—this boy's eyes were devoid of genuine enthusiasm and hardened beyond his years. I thought of what David Rosenberg had said, his tone of disapproval. "Yes," I answered finally, "I was impressed with the script."

Dreyfus sipped from his wine without taking his eyes off my face. "You know, Nick has his heart set on you being in the film. And usually writers have no say over casting decisions—but Nick's a friend, and this is a terrific piece of work, so I figured I should at least sit and meet you."

Again, I felt slightly uneasy. "Well, thank you for taking the time."

Dreyfus nodded. "Now, when were you at Perennial, some time in the '40s?"

"No, in the teens and '20s, right after the studio formed. I was there when your grandfather first started—he was younger than you are now."

"In the teens and '20s," he repeated. "So you appeared in the silents?"

Bellinger leaned forward. "Remember I told you, Josh? He worked with Gerard Normandy and William Moran. He starred in *The Noble Servant* and *Sleight of Hand*."

"That's right," he said. "You *did* tell me that. I'm sorry—I hear about so many people."

Listening to this exchange, I realized that Bellinger—perhaps because of his own enthusiasm—had overstated Dreyfus' knowledge of my career. "I made over sixty films," I said. "You can read about them in Croshere's history."

Dreyfus looked at me blankly. "Who?"

"He's a silent film historian," Bellinger explained. "Also a big fan of Mr. Nakayama's."

Dreyfus studied me as if I were an interesting relic—educational, but not particularly of use. "The '20s, huh? Well, that explains the vest chain and the two-toned shoes. You look like you just came from a party at Pickfair."

I glanced at him, not knowing how to respond, but he continued talking.

"So how long has it been since you've worked?"

"A long time," I admitted. "But I've stayed abreast of all the developments in moviemaking. In some ways it's not terribly different. I played a broad range of characters over the course of my career, and although I've been retired for some time now, I certainly believe that I could still hold my own." I stopped, disturbed by my realization that I was trying to convince him. But his ignorance of my work displeased me, as did the obvious difference between him and his grandfather, with whom he appeared to share a name and little else.

"Well," he said, after a short pause, "it's still early. The project is moving forward, but in terms of actors and roles, we've put no real thought into it yet. All I can promise is that you'll definitely get a screen test. And obviously I'll want to look at some of your previous work. Is there any picture in particular you think I should see?"

I thought for a moment and then pulled myself up straight. "Perhaps the two films that Mr. Bellinger mentioned. *Sleight of Hand* was my biggest success, but I believe *The Noble Servant* has also survived."

"Those were done by the directors that Nick just mentioned? Normandy and Moran?"

"Gerard Normandy did *Sleight of Hand*," I said. "And William Moran did my first two pictures. But *The Noble Servant* was directed by someone else."

"Oh, that's right," said Bellinger. "I'd totally forgotten. That one was by Ashley Tyler, wasn't it?"

I nodded, hoping we could leave the topic of directors and instead talk about the films themselves. But Dreyfus looked at his friend with new interest.

"Ashley Tyler," he said thoughtfully. "Now why do I know that name?"

"He was famous in his own right," Bellinger replied. "But you probably know his name because he was murdered in the '20s, and they never figured out who killed him."

"Really," said Dreyfus, and he looked from Bellinger to me and back again, his thin left eyebrow raised.

The rest of the lunch passed rather uncomfortably, as I had to cope now with the prospect of auditioning for a role, as well as with Dreyfus' interest in my previous work. Dreyfus, however, had a pleasant time all by himself, telling us detailed stories of projects he'd worked on, and behind-the-scenes facts about the stars of his films. I got the sense that he'd told these stories hundreds of times; that he switched into this amiable autopilot mode as soon

as the business at hand was completed. The only time he broke out of it was when someone approached our table, which occurred three times through the course of the meal. Once it was a producer with a current project at Perennial who wanted to discuss the budget of his film. Once it was an agent who was trolling for work for his client, a popular B-movie actress. And once it was someone who was not in the business, a middle-aged woman who asked for his autograph and hinted about her unmarried daughter. Dreyfus handled all of these intrusions with grace; he was clearly used to this kind of attention.

Through all of this, I sat there uneasily, feigning interest, and glanced occasionally at Bellinger. He could not take his eyes off Dreyfus' face, and it troubled me to see this talented young man in the thrall of such an unpleasant character. Back in the teens and '20s, the making of pictures had been a labor of love, a burgeoning art form that the creators took seriously. And if we became well-known, adored by the public, that was a by-product of our efforts, not the goal. But in present-day Hollywood, people are too enticed by glamour, and the art of making films, if it matters at all, is subsumed to the more alluring prospects of wealth and fame. This Dreyfus would have to do more than take me to lunch to convince me of his skill and commitment.

We parted after finishing our rather disappointing meal, and I retrieved my car safely from the parking service. As I drove back home, I remembered a young man I'd recently seen up at Runyan Canyon Park who'd been reading a tattered old copy of *Dubliners*. He was dressed in jeans and a faded blue button-down shirt, his leather shoes were scuffed and the laces untied, and his socks were of two different colors. He was so engrossed in his book that a naked woman could have walked in front of him and he never would have even looked up. That young man, I thought, knew more about the need and value of art than Josh Dreyfus ever would.

And yet, when Bellinger called me that evening, I told him I'd had a very pleasant time. Yes, I liked his friend Josh, I assured him; yes, I was willing to take the next step.

"He's a little much sometimes," said Bellinger, "with his stories of all the stars he gets to work with. But he's the best at making sure that a project goes through, and if he backs you, then you're sure to get the part."

"He seems," I said, reaching for the appropriate words, "a little less reflective than you."

Bellinger laughed. "Well, his job means he has to be kind of slick, I suppose. But don't be fooled. He's a workhorse—very committed."

I didn't doubt that he was—but to what? Still, I said nothing about my impression of him and let Bellinger continue to talk.

"He wants me to bring him some of your old films, which I'm going to do tomorrow. And then I guess he's going to talk to a few of the old guys at the studio—you know, to see what you were like to work with."

"I would think I'm past the need for recommendations," I said. "I believe my work speaks for itself."

"Of course it does. I'm sorry. I don't mean to imply he's looking for a recommendation. I think he just wants to get a better sense of your abilities."

"Better than you've already given him?"

He did not appear to hear the irony in this comment. "I'm just a young movie nut, like him; I wasn't there during your career. Besides, I think he's intrigued now by your whole era, period, and that can only be good for you."

I gripped the phone so tightly that several veins stood out on my arm. "Do you know what accounts for the sudden interest?"

"No, I don't. But I'm sure that whatever he finds will only hook him in further—to the silents, and to you in particular."

Even though this comment was meant to put me at

ease, the effect was precisely the opposite. Despite my dislike of Dreyfus, despite my suspicions regarding his taste, I did not wish to be disqualified from Bellinger's film based on a few people's twisted recollections. I tried to think of who still survived from that era and thought immediately of Nora Niles; her memory of what happened all those decades ago was the only one that actually mattered. But I was not ready to see her yet, if I would ever be, and so I tried to recall the other names that David Rosenberg and I had discussed. He was right—the old executives and producers were dead; and Hanako, who we had not discussed, was too difficult to contemplate. But there was also the detective, Owen Hopkins. He probably had a good perspective on the events of that time, and he might also be the easiest to locate.

And so I found myself driving out, two mornings ago, to the home of Owen Hopkins. I'd gotten the number from directory assistance and dialed him up the previous day. It must have been a shock to hear from a man he'd known only briefly more than forty years ago, and it took him a minute or two to place the name. Even when he did, he sounded cautious, uncertain, suspicious as to why I was calling him and what I could possibly want. It was only after I assured him that I bore no ill will that he consented to let me see him. He gave me directions to an exclusive neighborhood near the Santa Monica pier, and the house I stopped in front of, an old English Tudor, was huge, with a beautiful garden. I wondered how Hopkins' career had progressed after the short time I knew him. Either civil servants were better-paid than I thought, or he had bought his house before the area had grown so costly.

When I first met Hopkins, he was almost precisely my age—around thirty years old—although I remembered thinking he seemed older. Hopkins was not a tall man, but what he lacked in stature he made up for in heft—he was

solid and plain, substantial, as if he'd sprung directly from the earth. He carried himself deliberately, like every movement was a conscious decision. There was something about him that inspired trust, despite his badge and firearm.

The door was opened by Hopkins himself. Except for his thinned hair and a few fine wrinkles on his face, he did not look much different than he had as a younger man. "Mr. Nakayama," he said, and he furrowed his brow, his face pinching into an expression I couldn't interpret. He extended his hand and shook mine firmly.

After an awkward moment of standing in the foyer, he invited me to sit in the living room. Dozens of colorful toys were piled haphazardly in the corner. On the mantel, on the television, were framed pictures of children—sandy-haired girls and boys who were clearly related to the man I now sat across from.

"My big brood," said Hopkins, when he saw me looking. He kept brushing his sleeve with his hand, although there was nothing on it. "Five kids and thirteen grandkids. I thought I was going to be able to rest when I retired, but instead I run around after children all day." He stepped forward as if preparing to explain who was in the pictures, but then appeared to think better of it and sat down. "I'll tell you, it's harder keeping track of a bunch of energetic kids than it is to find a criminal. But you probably know all about that."

I smiled weakly, not wanting to engage him on the topic of family. It was so strange to be sitting in a house with this man, all these years after we'd first crossed paths, when our lives—and indeed the entire world—had been so dramatically different. I studied his face again, and did, now, see that it had changed, in ways more subtle than simply bearing the marks of time. He seemed hollowed somehow, not quite himself, as if the package of his body had been emptied out and replaced with less substantial material.

"Did you stay with the police department throughout your career?" I asked.

"No, just for a few years after your . . ." He gestured helplessly. "Your situation. But I moved up pretty quickly, and got to work on some big cases. The Stevenson murder, if you remember, and the Davis water scandal."

I nodded. Although I could not recall the details, I vaguely remembered that Hopkins had been a major figure in the investigations, unearthing corruption and making high-profile arrests. He had made his name as somewhat of a crusader; I'd seen his picture in the paper several times. "I went to law school then," he continued, "and worked my way up to Deputy D.A., which is as far as I could get without running for office. But Crittendon was still top dog, and there was no way I could take *him* on, especially with how personal those races get."

"It doesn't surprise me that you became so successful," I said. I noticed that he didn't ask what became of my career, but of course he already knew that.

He sat back in his chair now, hands gripping his knees, the knees themselves bouncing lightly. His eyes wandered from my feet back to the wall behind my head; he'd not looked me in the face since the moment he opened the door.

"Listen," he said, and his voice took on that purposeful tone I remembered from many years ago, but with an undercurrent of something else. "I don't want to waste your time here, or mine. What is it that you'd like to discuss? I'm thinking it has to do with that unfortunate Tyler case, since that's the only reason we happen to know each other."

I was taken aback by his directness, but also relieved that he had broached the subject. I wasn't sure where to begin or what to say, and so I settled on something harmless. "It *was* unfortunate," I concurred, "for so many of those involved."

"Not the least for yourself, Mr. Nakayama."

I did not know how to respond to this, and felt rather discomfited. "Well, that is all in the past and cannot be undone," I said. We sat there in silence for a moment. Outside I heard a child laughing, then a truck barreling down the street. When I spoke again, my voice sounded overly cheerful. "But things have been improving of late, Mr. Hopkins. You see, I have just been approached about playing a role in a new film for Perennial Pictures. As you may or may not know, this is the first such opportunity I have had in a number of years." I paused. "I'm concerned, though, that people might look a little too hard at certain incidents from the past. I anticipate that someone from the studio, or even the press, might start asking questions. In fact, they might even come to you."

Hopkins leaned forward and pressed his hands together, looking like he was in pain. "Damnit," he said. "Why can't they just let things be?"

"They might," I said. "They might find nothing. They might just leave you alone."

"And they might not. They might find everything." He glanced up at me now. "But why should *you* be worried?"

I looked away from him and down at the floor. "There are some perhaps unsavory details I would prefer to keep out of the public."

He reached out and straightened some magazines that lay on the coffee table, and I was surprised to see that his hands were shaking. "I understand. Believe me, I feel the same way. Some nosy reporter trying to dig up the past wouldn't do any of us good."

Until now I had thought that his reluctance to talk, his concern about people recalling the Tyler case, had solely to do with the facts of the murder itself. But the intensity of his worrying—and his shaking hands—suggested something else. "What do you mean?" I finally asked.

Hopkins leaned back and drummed his fingers on

his knee. And when he spoke, his voice was strained. "It wasn't done by the book, Mr. Nakayama. I mean, none of it was done by the book. We didn't follow up on some obvious leads, we didn't question everyone we should have." He paused. "And they never let up on Elizabeth Banks, poor girl. I know how much you cared for her. They just let all those insinuations continue to fester, and let people imagine the worst." He stopped and looked absently out the window. When he opened his mouth again, the words spilled out as if he'd been storing them up for years.

"I thought I was going to crack it. I thought I was headed in the right direction. Nora Niles' maid told me that Nora had tried to shoot herself once with her mother's .38, after they got into a tiff about Tyler. The bullet was lodged in her bedroom wall, and I wanted to go look at it, to compare it with the one from the murder. But when I went to my captain, he told me to drop it. He had some kind of order, and my sense was it came directly from Crittendon. I didn't want to let it go, you know, how could I? But my job was on the line. And then—well, it seemed like the promotions just kept coming after I backed off from the Tyler case."

He paused, looked down, and then back up at me again.

"So no, Mr. Nakayama, I'm not anxious to talk. I mean, some good happened out of that mess for me, but a lot of bad came of it too. It changed my career, my whole life, can't you see?"

He gave me a pained expression, and I followed his hands, which took in the entire room. I did not understand his meaning at first. Then I noticed the fineness of everything—the crystal chandeliers, the handcrafted furniture, the Oriental rugs.

I avoided his pleading eyes and said, "I see."

His breathing had grown more labored, his voice husky and raw. "I'm so sorry, Mr. Nakayama. I'm so sorry about what happened to you."

I continued to look away from him and tried to digest

what he'd told me. "It was the others who suffered, Mr. Hopkins. I was fine."

"I always thought you could have come through it, though. You could have pushed back. I never understood why you didn't."

I smiled wryly. "There were other things that kept me from resuming my work."

"Yes," he said, nodding, "I suppose there were."

He lowered his head and we each sat alone with our thoughts. As I reflected on what he had said and implied, I suddenly realized that he was referring to my friendship with Elizabeth, as if that alone had been the reason for my visit. In his mind, that entanglement was problem enough— as indeed it would have been in our time. I decided it was best to let him continue to believe that Elizabeth was all I wished to keep private.

Finally, Hopkins raised his head again, and spoke more evenly. "You don't have to worry, Mr. Nakayama. If anyone does come around, I'm not telling them a thing. That case died and was buried with Ashley Tyler, and I'm not about to dig it up."

Two days after my drive out to Santa Monica, my conversation with Owen Hopkins stays with me. It is not simply that his face, aged and yet so familiar, took me back to the hours I spent answering questions in a dim room at the old police headquarters. It is also his regret about what happened to the rest of us. I was not surprised that Hopkins had been dissuaded from pursuing his leads, but I didn't know that the police had treated Elizabeth so cavalierly, and that news was deeply troubling. For more than anyone else, Elizabeth's life was altered needlessly by the events of 1922. And it is not a stretch to think that everything that befell her in subsequent years was the direct result of Tyler's death and its aftermath. Who is to say that, had the truth come out, Elizabeth could not have continued

acting? Who is to say that she might not even be alive somewhere—years past her days of stardom, yes, but still full of the contradictions and passion and life that so compelled me in the time that I knew her?

CHAPTER TEN

In truth, things had already begun to change for Elizabeth before Ashley Tyler was murdered. The late teens and early '20s were not kind to her, and it is possible that even without the Tyler affair, her time in film would have drawn to a close. Indeed, several historians have asserted that the Tyler situation only hastened the inevitable. For if one considers that period more closely, it becomes sadly apparent that Elizabeth Banks was on the decline.

Although none of us could possibly have known it at the time, the war bond tour was the pinnacle of Elizabeth's fame. Not long after the Great War ended, her stature began to change. It wasn't obvious at first—she still had star billing in two or three films, and was still, for a while, a fan favorite. But gradually the roles got smaller and became distinctly fewer, with more and more time lapsed between them. The fan magazines began to feature her less often, and then buried her in their back pages. The most status-conscious Los Angeles hostesses—who had never been comfortable with Elizabeth's inelegant background—stopped inviting her to parties. I do not fully understand why these things occurred, or why the studio executives lost confidence. In hindsight, it is easy to say that times were changing—that the sultry women and girlish pixies of the 1910s were being replaced by the urban flappers of the '20s. Or that the studio had finally tired of her drinking and inconsistency, when there were hundreds of other young hardworking girls lined up to take her place. But I believe that the answer was more mundane; that pictures were simply leaving her behind. Elizabeth was, at thirty-

five, a mature woman; she already had been when I met her years earlier. In picture terms, she was already old. What the screen loved was fresh-faced children.

In the months after we returned from the war bond tour, we saw each other several times a week. Sometimes at my house but more often at hers, we would spend the evening together. Elizabeth would dismiss her maid for the night and cook dinner for me herself; she made what she said were the "foods of her youth"—Polish sausage and sauerkraut, beef and vegetable goulash, stuffed cabbage, and crusted tuna casserole. I would sit at the kitchen table drinking martinis while she cooked, and at those times, as she stood in front of the stove, hand on her hip and spatula waving in the air while she emphasized some point, I could see beneath the mask of the film star the Midwestern girl she'd once been, the beautiful, bored girl then named Laura Berenski who would have ended up, had she stayed in her small hometown, as a housewife raising babies. I saw that girl too as she sat, delighted, in front of the fire, as if she'd stumbled accidentally into someone else's house and had been invited, unexpectedly, to stay. But then she'd open a bottle of whiskey—she was drinking more and more—and start to complain about how the studio was treating her or snipe about some rival actress. And then I'd remember who we were, and where we were, and that we could never really escape from our own personas, even when we were alone.

We never went out in public together—we couldn't have, of course—and when I drove to her house, I took care to park my new Pierce Arrow in the back garage where nobody could see it. In truth, I did not mind these inconveniences. If we were alone, away from our fans, then I had her completely to myself. And in me, as she talked of her past life and her hopes for the future, she had what she wanted anyway: a devoted audience. Each evening we were together I would watch her intently—every move, every

gesture, every unconscious smile or frown, every sweeping away of a strand of hair from her face. I would sit taut in my chair, using all the strength I had not to spring up immediately and take her in my arms. For despite our freeness on the train, our relationship—back on dry land—was now undefined. Elizabeth kept a certain distance from me always, even as she drew me in with her stories. On some of those evenings we made love and on others we did not, and it was entirely at her whim. Even when we did make love, however, I still felt like I was striving. Her body she gave to me willingly. But Elizabeth herself was always out of reach.

We saw one another regularly for more than a year. But then in 1919, after Elizabeth made a film with Ashley Tyler, our evenings together became less frequent. Part of this was simply logistical—when one of us was working on location, it was impossible to socialize. Yet a larger part—especially after they made their second film together—was simply that she enjoyed Tyler's company. In the months after their film *Tea for Two* was released, she began spending as much time with the director as she was with me. He would tell her stories of his childhood and read her Browning and Shakespeare, in a voice that made her understand, she said, the beauty of their language. Once he discovered her love of chocolates, he sent her a box every week—a practice he duplicated with Nora Niles, I learned later, although in her case the treat of choice was licorice. "He's wonderful company," Elizabeth told me once when I pressed her on the matter. "And unlike some men," she said, giving me a significant look, "he's interested in my mind."

I would like to say that none of this bothered me, particularly since Elizabeth assured me repeatedly that there was nothing romantic between them. Whether she truly saw Tyler as a mentor and teacher, as she claimed, I cannot really say. Perhaps his stable, caring presence suggested the father figure she never had, and indeed he

was trying to help her—going so far, it was said, as to encourage her to get her drinking under control. Perhaps she was grateful that he continued to cast her, even as her star was clearly falling. Whatever the reason or combination of reasons, his own place in her life grew larger as mine diminished.

Several events from this period illustrate how our roles in her life were changing. There was the time, for example, when Elizabeth and I were playing croquet in her sprawling backyard and a delivery man came to her door. He brought a huge bouquet of spring flowers, a box of chocolates, and a package of books, and if there had been any doubt in my mind who these gifts were from, they vanished when Elizabeth read the card, put her hand to her cheek, and exclaimed, "Oh, Ashley!" She did not share with me the contents of the card, or the titles of the books. But for the rest of our game she smiled to herself, and barely paid attention to me.

Then there was the night in 1920 at the Tiffany Hotel. I was dining with Hanako Minatoya, Steve Hayashi, Kenji Takizawa, and several others who had gathered to discuss the idea of forming a Japanese Actors' Association. We had met at the elegant Tiffany because our group was less likely to draw a crowd of eager fans there than we would have in Little Tokyo. Despite the beautiful setting, however, our discussion was sober. There was growing concern that the tone of films depicting Japan had taken a turn for the worse, and there appeared to be fewer roles for Japanese actors. Amongst our group, there was no agreement yet on what should be done, or even on the basic premise, and as we sat there beneath the large stained glass windows, we discussed the issue from different angles. Hayashi believed that this change in tone, as well as the most recent pieces of restrictive legislation making their way through the State Assembly, were a temporary response to the emergence of Japan as a significant power after the war. Hanako agreed,

but her emphasis differed. "It's precisely *because* Japan is becoming a power," she said, "and *because* we immigrants are doing well here, that this backlash will only grow, not diminish."

I wasn't yet sure where I stood on this matter. I wanted to side with Hanako—I always wanted to side with Hanako—and I certainly hoped to provide support to my colleagues. But I believed that they were making too much of things, for we were, after all, mere actors. And no matter what the Hearst papers or other agitators said, the world of film was distinct from the world of politics. While it was true that some actors had found the conditions so unfavorable that they were starting to return to Japan, it was also true that Hanako and I still appeared in significant roles, and *that* was a better measure of our acceptance, I thought, than any vague notions of disfavor.

Takizawa was asserting that an Actors' Association was critical, and that I, as the best-known face, should be the head of it. I was about to argue that lending my name to the cause was sufficient involvement when all eyes at my table turned to the dining room entrance. Standing there in coat and tails was Ashley Bennett Tyler. And holding his arm, in an evening gown and fur, was none other than Elizabeth Banks. Tyler scanned the room as he waited for the maître d', and his eyes quickly settled on me. He smiled widely—there was no evidence of awkwardness or guilt—and began to steer Elizabeth across the thick carpet toward our table. When she saw me, she gave a wide artificial smile and then appeared to pull back on Tyler's arm. The light from the crystal chandeliers reflected brightly off of something in her dress, and I felt it sear through me like a heated spear. I could tell by the way my dinner companions hushed and exchanged glances that they were all well aware of my association with her.

"Hello, old chap!" said Tyler cheerfully as they reached our table. "Fancy meeting you at a dive like this."

"Mr. Tyler," I said, rising and shaking his hand. Then, looking at his companion, who avoided my gaze, "Miss Banks."

Tyler looked around the table and spotted Hanako. "Ah, the lovely Miss Minatoya! It is such a pleasure to finally meet you. I have seen at least a dozen of your films, and you can count me among your many admirers." He bowed, the light glistening off his hair.

"It is a pleasure to meet you as well, Mr. Tyler," Hanako replied. "I have heard nothing but the most favorable things about you." And as she lifted her face, I saw, to my amazement, that Hanako Minatoya was blushing.

Tyler worked his way around the table, introducing himself to each person. I watched him as he talked. Even as he bowed and shook everyone's hand, it was they who appeared to be humbled. Unlike so many Americans in Hollywood and elsewhere, he seemed totally comfortable with a group of Japanese. His performance drew the attention of the tables around us, but he did not appear to notice. It concluded when he had finished circling the table and arrived back to his starting point, where he said, "And may I present Miss Elizabeth Banks."

Elizabeth nodded and said hello politely, but she did not—unlike her escort—circle the table. She appeared to be quite ill at ease, but that may simply have been a reaction to me. For after my initial greeting, I did not speak another word to her. I felt anger curdle in my stomach— anger at her for spending less time with me; anger at her willingness to appear in public with Tyler. I glanced at her a few times and saw the troubled, caught look on her face, but otherwise I did not make eye contact. Indeed, I turned my back to her completely as she and Tyler left to be seated.

After they were gone, there was a general buzz at my table, which only increased when our waiter brought over two bottles of wine, courtesy of the British director. "That

Tyler!" my companions said, over and over. "How impressive he is! What a gentleman!"

The last of the events involving Tyler and Elizabeth was my Independence Day party of the following summer. This was one of the final parties I ever threw at my mansion. For the first few years after I purchased it, I would have large gatherings perhaps twice a year, which coincided with some particularly large film release or a prestigious awards event. Then, in 1920, when Prohibition drove drinking into private homes, I began to host parties more frequently. I'd had the foresight to buy a truckload of whiskey before the Amendment, and that—along with the fact that I had more time on my hands—contributed to my willingness to host elaborate events.

Sometimes I would put on "international" parties, where each room would be decorated with the décor of a different country and a sampling of that country's cuisine would be served by appropriately attired waitstaff. Sometimes the parties would be masquerade balls, and I recall several memorable costumes from those nights—Buck Snyder as Teddy Roosevelt, Tuggy Figgins as Napoleon, the contract actor John Vail as the rumpled, balding Gerard Normandy, and the Russian actress Svetlana Rambova as Queen of the Jungle, with elaborate furs draped over her shoulders and twin pet lions in tow. There were nights, too, when we would shut all the lights off and play the game *Murder*, fumbling with our drinks through the unlit mansion, screaming out loud in fear and delight when a hand fell upon us in the dark. My home, with its great rooms and balconies and gardens, made a perfect place to host large parties. On more than one occasion, when my servants awoke in the morning, they would find guests sprawled out asleep on chaise lounges by the pool, ties loosened, hair unpinned, shoes—and sometimes more intimate articles—strewn across the grass and bushes.

The Independence Day party of 1921 was a markedly smaller affair, both because of logistics—I'd had to reserve half of the yard for the staging of fireworks—and because by this time, for reasons beyond my understanding, my events were no longer as popular as they'd been just a year or two before. I'd invited only about fifty of my closest friends and colleagues, and we began at 7:00, with the idea that the guests would eat and converse until it was dark enough for the fireworks. The whole party took place outside, where white-coated cooks labored over open grills, and a bar was set up on either side of the yard. Because it was still light out, many of the guests—even those who had been there before—took a tour of my garden. It was sectioned off into different areas for roses, cacti and succulents, and colorful annuals; the Japanese garden, which I had installed upon moving in, had long since been taken over by perennials.

It was a little after 7, and I was talking with the actress Evelyn Marsh—my costar in *The Patron*—when Nora Minton Niles arrived. I had invited her, as I always did, but was pleasantly surprised that she'd actually come. Her date for the evening was the young British actor Russell Riner Jones, the black-haired and handsome but somewhat dim male lead of her most recent film, *Liberty at Pine Hill*. He was a sweet young man, and harmless, and he watched Nora with sad, soulful eyes—but perhaps precisely because of his devotion, Harriet Cole despised him. Nora must have come up with a tremendous story to escape from her house for the evening. She looked quite happy on Russell's arm, and I was pleased—with a burst of almost fatherly affection—to see her at my party.

Not twenty minutes after Nora's arrival, Ashley Bennett Tyler appeared. He went directly over to where the actor John Vail was standing, and although I hadn't been aware that the two men were friends, it was clear by the way they bent their heads together and laughed that they

knew one another quite well. The director had been quite busy of late, and was probably in need of a party. Rumor had it that he'd recently appeared in court on behalf of his servant, who'd been charged with a morals violation for soliciting young boys. It was precisely the kind of story that Dreyfus tried to keep out of the papers, and indeed there had been a few articles. But Tyler's court visit had had its intended result—the District Attorney ultimately dropped the charges, and the whole affair had settled down quickly.

At the party, Tyler and Vail were not left alone for long, because the moment that Nora realized the director was there, she rushed over to him, her young man behind her. By this time, Evelyn Marsh had moved off toward the food, so I made my way over to Tyler as well.

"Ah, Mr. Nakayama!" said Tyler as I approached. "What a festive occasion." Then, turning to Nora and bowing his head slightly. "Good evening, Nora. What a pleasure it is to see you."

This innocuous greeting caused Nora to flush, and she pressed her hands together with glee. "Mr. Tyler, I didn't know you were coming! Oh, what a wonderful surprise!" She beamed at him unself-consciously, and for a moment I thought she might start jumping up and down like a child.

"Well, it's a special day, isn't it, Nora? Although for us Brits, your Independence Day is no cause for celebration." He smiled, and Nora laughed as if he'd uttered the most original thought in the world. Next to her, Mr. Riner Jones looked miserable.

"Oh, Mr. Tyler, it's been so long since I've seen you," Nora gushed. "When will you direct me again?"

"Soon, Nora. Soon. We have several pictures in the works. If things go as planned, one of them will start shooting in two or three months."

"Two or three months! That's far too long!" Her shoulders slumped in disappointment, and her lower lip pushed

out like a little girl's. Then, just as quickly, her expression reversed and she looked at him brightly again. "I know what we can do! Russell and I are going out to Jake's Joint tonight. Why don't you come with us?"

Tyler threw his head back and gave a hearty laugh. "You're being rather rude to your host, don't you think? And what will your mother say about you frequenting a speakeasy?"

"We're going much later, after the fireworks. And Jun can come too! My mother won't say anything at all, Mr. Tyler, because as far as she knows, I'm locked in my room for the night. That's the *only* good thing about our dreadful new mansion—it's so big that she can't keep track of me."

Tyler gave a smile both indulgent and avuncular. "You and your young man enjoy your evening together. Besides, Mr. Vail and I have other plans."

But Nora would not be put off so easily. "You do? Well then, can we come with you?"

At this, John Vail smiled and cast his eyes down. He was a small man, compact and handsome, and his quick, dry wit was a welcome fixture at any party, as well as on any set. Vail was the kind of actor who an audience recognized, but whose last name often escaped them. Although he'd never appeared in a starring role, he always had steady work, usually as the main character's best friend or younger brother. Tyler glanced at him now and appeared to suppress a smile of his own. "I'm afraid not, Nora. This is strictly men only. Your original plans sound more appropriate."

Nora looked dejected again and was about to lodge another protest when an audible murmur rippled through the crowd. Following everyone else's eyes and gestures, I turned toward the house. There, on the landing, stood Elizabeth Banks. She had just arrived, in a gown too elegant for the casual nature of this gathering. Her hair had been curled and tied back from her face, and she held her-

self straight and momentarily still, as if waiting for a formal introduction. But while she knew several of the people who were standing close by, she did not appear to see anyone around her. She was looking directly at Tyler, and then at young Nora, and there was an expression on her face unlike anything I'd ever seen, and I knew what it was for, and it frightened me. She commenced a slow, gliding walk out away from the house, and although I cannot logically explain why this was so, it felt like we had all done something terribly wrong and were now having to account for our behavior. Finally, she rounded the corner of the pool and closed the rest of the space between us. John Vail, glancing up, saw her approach.

"Uh-oh," he said, "there's going to be a ruckus."

I moved aside to make room and she arrived like a queen; one could almost imagine a string of servants carrying her train. "Hello, Jun," she said perfunctorily, but she did not look at me, for her eyes were fixed on Tyler. "Good evening, Ashley."

The director did not have a chance to reply, for Nora Minton Niles bubbled over. "Miss Banks, it's such a pleasure to finally meet you!" she said with the same excitement she'd shown about the speakeasy. "You're even more beautiful in real life than you are in the pictures!"

This departed so drastically from the usual behavior of most actresses that no one knew how to respond. Even Elizabeth seemed taken aback. Then Tyler—always Tyler—stepped in to make things better. "If that is true," he said, "then it is because my cameramen have not been doing her justice. Is it really possible that the two of you have never met?"

"That's right," said Elizabeth, who had recovered by now. "You've been keeping Nora all to yourself." She looked at him sharply, and then pulled out a cigarette, holding it up expectantly. John Vail and I both struck matches and he, with a wink at me, prevailed.

"I've wanted to meet you forever!" Nora continued, oblivious to the machinations around her. "I've been a fan of yours since *Sleight of Hand*—oh, even longer than that! Since your wonderful comedies back at Triangle. Can you believe that when *A Holiday Caper* came out, I was only ten years old?"

A cold, thin smile fixed on Elizabeth's lips, and she looked down her nose at the younger actress.

"I have been in Hollywood," said Elizabeth, "since before anyone knew what pictures were going to become. Back then, hard work and talent actually *meant* something to people, and you had to have some skill to be successful. It is amazing," she added, lifting her chin higher still, "the kinds of roles they give to children these days."

"Now Elizabeth," said Tyler in a slightly scolding tone, "I think we *still* reward hard work and talent. And if I'm not mistaken, you yourself were quite a youngster when you started in this business."

I watched the two of them, who were clearly—despite the presence of other people—having a conversation with each other. And I thought, not for the first time, that it was difficult to resent the director, as he had never let his friendship with Elizabeth affect his dealings with me, nor change the way that he behaved toward Nora. Yet if Nora was the subject of their argument, she herself did not seem to know it. Seeing the admiration on her face as she gazed at the older actress, I realized that Nora was totally unaffected by the jealousies and competitiveness that poisoned most other people in Hollywood. She had never felt passionate about being an actress, and she seemed indifferent to being a star. She did not take stock in or even understand the effect her beauty had on others. It did not cost her to compliment or admire Elizabeth, for if one does not see oneself as part of a competition, one has nothing to win—or to lose. Nora was a star, yes, and a talented actress. But she was not and never would be a diva.

Elizabeth must have finally understood this herself; when she struck again, she aimed where she knew it would hurt.

"Well, Ashley," she said in a saccharine voice, "according to you, I still *am* a youngster, at least in terms of my learning. Why, if it weren't for all those nights you spend teaching me about books and art, I wouldn't know any more than I did in primary school."

This latest dart struck home. But even as Nora registered the kind of time that Elizabeth was spending with Tyler, she reacted not with womanly jealousy, but with a childlike turn of logic. "Oh, Mr. Tyler, that sounds so wonderful! Would you mind helping me with my studies too? I know you're busy, so we could arrange it for whenever you wish. In fact," she said, brightening, "if my mother would allow it, maybe you could even come to my mansion!"

I did not hear how either Tyler or Elizabeth responded, for at that very moment, my butler Phillipe came out to tell me that one of the hired waitstaff had taken ill. That left his staff a man short, with at least another hour of food service before it grew dark enough for the fireworks. As we looked out on the guests, however, things seemed to be well in hand. The crowd had topped out at around forty people, and most of them had eaten already. Phillipe and I decided no additional steps were needed, and that he and the remaining staff would be able to man the party without any interruption of service. Then, as I looked out at the people sipping drinks in the beautiful colors of sunset, which just now lit the San Gabriel Mountains a brilliant pink, I felt a deep sense of satisfaction. The guests were in good hands, and I think it is fair to say that people knew that when Jun Nakayama set his mind to something—whether it was a film or a party—the proceedings would always be carried out with the utmost of class and professionalism.

If there was anyone who was not enjoying herself, it was, of course, Elizabeth. After her initial encounter with

Tyler and Nora, she flitted from group to group, flirting with the men, laughing too loudly, and taking drink after drink from the waiters' trays. As she looked up at the men seductively, as she touched them lightly on the arm, my stomach felt distinctly upset. But if she thought this behavior would have an effect on Tyler, she was surely disappointed. Tyler and Vail stayed to themselves in a corner of the garden, speaking only to those who approached them. Nora and her date, meanwhile, were quite popular that night, perhaps because it was so rare for Nora to be out at any social function; or because her openness and clear delight at everything she saw were so disarming and pleasant to observe.

At some point, apparently having run out of options, Elizabeth made her way back to me. I was alone momentarily—I had just finished talking with a new contract actor from Perennial—when she appeared at my side. She was holding a martini and her eyes had assumed the glaze they often did on long nights of drinking. "What a fabulous party," she said, voice heavy with sarcasm. "I hope you're having as great a time as I am."

I took the drink away from her to keep her from spilling it. "You should slow down a little, Elizabeth, don't you think?"

"Why?" she asked, glaring at me. "I'm not hurting anyone. You think I should be a teetotaler like Nora, don't you? The prissy little bitch." She screwed up her face when she said Nora's name, and I was angry on the young girl's behalf.

"Nora's a very sweet girl," I said. "And she's never done anything to you."

"Never done . . ." She looked at me sharply, then let out a bitter laugh. "Give me a break, Jun. Do you know how many roles she's gotten this last year—roles that should have been mine? Do you realize what they're doing to me? And now, as if that isn't bad enough, she's trying to take Ashley too."

At this her eyes welled, and I suddenly felt sorry for

her. "Elizabeth," I said gently, placing my hand on her shoulder. I had touched her this way a thousand times, but now, in the presence of all my guests, she flinched and moved away. I felt it like a slap in the face.

I could not remain there with her, so I walked off to find Phillipe and check the status of the fireworks preparations. Tyler and Vail had disappeared, and I wondered if they had already left. There was no time to think about that, however; Phillipe said the men I'd hired to stage the fireworks show were ready to begin. Phillipe and two others went inside the house and turned off all the lights, while I instructed the guests to gather on the west side of the lawn, where chairs had been arranged for everyone to sit. Once the guests were settled, Phillipe turned off the outside lights and we all sat still in the darkness. Across the wide space of my parklike grounds, we watched a twenty-minute display of explosions, swirls, blooming flowers of colorful light. The guests oohed and aahed at the firework that looked like a sprouting plant, which then put forth a burst of bright red petals; and again when one explosion produced a sprinkling of stars that blinked and glittered before they faded into the darkness. It was a wonderful display, ambitious for such a small setting, and when it was over, the crowd broke into a spontaneous cheer.

"Here's to the fireworks!" someone called out.

"And here's to Jun! To Jun Nakayama, for throwing such a wonderful party!"

Everyone shouted and cheered and raised their glasses, and I bowed to them with a flourish. The night had been a success. And despite all the complications, I now felt pleased with how everything had turned out.

The waiters circulated with bottles of champagne, and the guests gathered to receive their drinks. As I looked around the yard, I realized that Elizabeth was missing— and I did not remember seeing her before the fireworks had started. She might have left, which would not have

been particularly surprising considering how upset she had been. More likely, given the amount of her consumption, she had simply slipped away somewhere to rest. She knew every room in the house and would have felt perfectly comfortable letting herself into a guest room or the library, or asking Phillipe to take her to my room. So after taking one last look around at the guests—who had all assumed the calmer rhythms of a long party winding down—I headed into the house to look for Elizabeth. I checked first in my own bedroom, which was undisturbed, and then in the downstairs library. I looked in the kitchen, in case she was getting something to eat, and then in the drawing room where she sometimes sat in front of the fire. Finding her in none of these usual spots, I ascended the back stairs and was surprised to encounter John Vail outside of one of the bedrooms, leaning against a wall and smoking a cigarette. His hair was slightly ruffled and his tie undone, and when he saw me, he appeared distinctly amused.

"Hello there, handsome," he said. "Quite a party, isn't it?"

We were standing in front of one of my many guest rooms. Sometimes when parties lasted late into the night, guests slept in this room to avoid returning home to angry spouses; sometimes two of them would stay here together. People had developed an understanding about this room over the years, and they knew that they did not have to ask my permission; that I'd know someone was taking advantage of this open invitation if the door to the bedroom was closed. It was closed now. And I could not understand why Vail was waiting outside, but I didn't have time to inquire.

"I'm not sure you want to do that," he said as I placed my hand on the doorknob. But I pushed past him and opened the door and flipped on the switch, bathing the room in light.

Tyler and Elizabeth were standing at the foot of the bed, locked in an awkward embrace. Tyler's hair had been

tousled, his cheeks were flushed, and his shirttails were hanging, untucked. And Elizabeth—she didn't seem to realize or care that someone had turned on the light. Even as I stepped into the room with Vail right behind me, she continued doing what she was doing, which was trying to undress Tyler, one hand moving feverishly under his shirt and the other trying to open his belt buckle. She pressed against him and lifted her lips to his face, and he attempted to draw away.

"Elizabeth, Elizabeth, you must pull yourself together." Then, looking over at us, "Elizabeth, somebody's here."

She did not seem to register this statement at first, for she continued to push against him. Then she turned, saw us standing there, and started to cry. She lowered her head now and began striking Tyler's chest, and I could not look upon them anymore. I felt as if my gut had been ripped open. I did not know whether I was more upset with Tyler or Elizabeth; I just knew I had to get out of that room, to try and erase that image from my mind. All Elizabeth's claims to the contrary were irrelevant now, and I did not wish to speak to her. It didn't matter what denials or pleading would come. I had seen what I had seen.

But perhaps I had not really seen what I had seen; perhaps the shock of sight obscures understanding. When I think back to that night with the wisdom of hindsight, I remember things that did not occur to me at the time. Like the fact that Elizabeth was fully clothed, and that Tyler's voice and words were not consistent with the tone of seduction. Even as Tyler's arms were circled around her, I later realized, he was not embracing her with the passion of a man embracing a woman, but with the care of someone holding something fragile together and trying to keep it from falling apart. Perhaps I did not fully understand what I had seen, but on the other hand, I understood enough. For whatever Tyler's intentions toward Elizabeth were, her own true desires were clear.

CHAPTER ELEVEN

I t is impossible to say what might have happened for Elizabeth if the next few months had been different. Although her time as a star might have ended regardless, perhaps she could have taken smaller roles. Or perhaps she could have retired from the screen altogether and moved on, as some did, to a different kind of life full of friends and charity functions, even family. Certainly either of these outcomes would have been more desirable than the one that finally awaited her.

But it is morose to dwell on the end of Elizabeth's career when there is much to consider now about my own. For despite my discomfort with the young Josh Dreyfus, he turned out to be true to his word, and someone from Perennial called me earlier this week to schedule me for a screen test. After our lunch at Castillo's, I wasn't confident that Dreyfus would contact me. But perhaps he had further discussions with Bellinger, or he was able to see some of my films, for the woman on the phone was extremely polite and sounded pleased about my imminent return.

I am not ashamed to admit that I feel quite nervous, which is not surprising given the nature of this opportunity. I've found myself increasingly preoccupied of late with matters that have nothing to do with acting—things like what kind of clothing one wears for a screen test, and how early one should arrive. Less trivial are questions about how I should prepare, for while I am confident of learning my lines—and while I have experience with dialogue from my time in the theater—I have never, of course, spoken in front of a camera. Maybe it would be useful to attend a film

or two in the coming days, so I can study how the actors use their voices. If I knew how one went about such things, I might even consider hiring a voice teacher, as did many of my fellow actors from the silent era during the swift transition to sound. I feel—oddly—more uncertain about this screen test than I did about my very first film, or even about the first play I put on at the Little Tokyo Theater. On the other hand, one could say that my *lack* of fear on those occasions was a mark of youthful ignorance, and I am all too aware now of how fortunate I was; of how quickly even the biggest stars can be forgotten.

And yet, despite my hopefulness about this new film, I cannot let go of my recollections of the past. It has been years since I've reflected on what happened to Elizabeth, but I've found that, particularly since my conversation with Owen Hopkins, my thoughts keep turning to that time. And as I ponder the strange directions in which our lives sometimes take us, as I consider the opportunity that lies ahead of me now, my memories of developments in Elizabeth's life give way to thoughts of certain moments in my own. For there were several key events in the months after my Independence Day party, events whose importance I tried to minimize at the time. They might not, in themselves, have been significant turning points. But at the very least, they presented themselves like markers on the road, signs that indicate where one might expect to arrive if one continues along the same path. Certainly one of those signs was my lunch with Gerard Normandy in October of 1921.

We met at a restaurant in Hollywood, a new place that had opened in the rapidly expanding western part of town. As I waited for Gerard in the lobby—he was perpetually late— the maître d' and waiters kept staring in my direction. They must have known who I was, and at first I thought they were debating whether it would be rude to approach for an autograph. But then at one point the discussion ac-

tually grew rather heated, until the men—no doubt conscious of their rising voices—looked back over at me and then grew still. I kept my eyes trained straight ahead, but I cannot deny that I was starting to feel uneasy. Usually when people were talking about me, it was with excitement or admiration—but these men seemed discomfited by my presence. So I was relieved when Gerard arrived a few minutes late, suit as rumpled as ever. He shook my hand and gave me a cheerful, "Good to see you, Jun!" Then after a short delay, we were guided to a table.

It was rather an unfavorable seating arrangement, I remember—a small two-person table adjacent to the door where the waitstaff entered and exited the kitchen. It was not the kind of table at which men like Normandy and I were accustomed to being seated. The restaurant did not serve alcohol, this being Prohibition, and unlike some other diners who pulled bottles from under their tables, neither of us had secreted in any wine. But by this point I was so hungry that these inconveniences did not deter me. Gerard, for his part, didn't seem to notice. Nor did he notice the less than adequate service, which was perfunctory almost to the point of being rude.

We had a satisfactory lunch—I ordered fish and Gerard ate a large, rare steak, which I remember thinking would be good for his general vigor—and had moved on to coffee and apple pie when Gerard wiped his mouth with a napkin and cleared his throat. "Look here, Jun," he said. "I'd like to talk some business."

I had been anticipating something of this sort, for my three-year contract was due to expire the following March. It was not unusual for Normandy to broach the subject so early; it behooved both myself and the studio to settle terms for the next contract as quickly as possible. "Ah, yes," I said, "the unromantic side of our business. I'm disappointed in you, Gerard. When we've done this before, it's always been over port and cigars."

Normandy grimaced, as if smiling through a toothache. "Jun, we're friends and you know how much I admire you. I first signed you, after all, took you right away from poor William Moran. But, well, I think we both realize that things have changed these last couple of years."

"Yes they have. Perennial's been doing very well. I've heard people say it's now the most powerful studio in Hollywood." It was true. With hugely successful films like *One Hundred Sins* and *Love Among the Ruins*—and with the rise of stars like Gideon West, Lily Dawson, and Nathaniel Moore—Perennial seemed unstoppable, the nexus of creative and financial power in the motion picture industry.

"Well, who's really to say as far as those things go? But you're right, it's been a good time for the studio." He paused, picked up his fork, and moved a piece of apple around on the plate. "The thing is, Jun, we haven't had much luck with *your* pictures lately."

I had been smiling when Normandy started to speak, and now I took care to preserve my expression. "Perhaps you're stating things a little too strongly, Gerard. Both *Geronimo* and *The Cat's Last Laugh* did well."

"Yes, *fairly* well. Which is say, they broke even. But the fact is, Jun, you haven't had a bona fide *hit* in almost two years, really since *The Patron*. And it's making Stillman and the others nervous. Very nervous."

Now the smile had faded from my lips, and the pieces of apple on my plate could not have been less appealing if they were riddled with worms. "It may be true that I've experienced a bit of a dry spell," I allowed, "but you must admit the material I've had recently hasn't been first-rate. Match me up with a good script and good costar, let me work with Tyler again, and I'm sure the next film will do better."

Normandy looked even more pained now, and waved the waiter off when he came to freshen up our coffee. "I'm afraid it's not so simple, Jun. There's a history here. Not

everyone's been happy about you being with the studio, but they were willing to go along with it as long as your pictures made money. But the mood in the country is different now, especially here in California. Jun, you *must* feel it. If the studio were to sign you to another multiyear contract, why, it wouldn't do either of us any good."

I sat still for a moment as I absorbed the implications of this last statement. "Are you saying that the studio isn't planning to re-sign me?"

Normandy was shifting in his seat. "I'm not saying that anything is certain yet, Jun. I'm just saying be prepared. Stillman is nervous, very nervous—and if we have any more scenes like we did during the filming of *Geronimo*, that will just about seal the deal. There's no margin of error these next few months."

"But that incident was highly unusual," I protested. "You can hardly judge my entire career by one unfortunate event. I shouldn't have to remind you of this, Gerard, but my films are among Perennial's biggest hits!"

Normandy sighed. "I realize that, Jun. But that was yesterday. This business only cares about tomorrow. I'm sorry, you know I'm your friend; that's why I asked you to lunch. The best I can tell you is to make your last few pictures under this contract, and we'll see what we can do. I'll try to pair you with Tyler or someone comparable. In the meantime, just keep your head down."

This is, to say the least, not a comfortable memory. Gerard had—as he indicated—met me out of friendship; a less caring executive would have simply let my contract go unremarked until the end result was obvious. After that day I still believed that everything would sort itself out; it seemed unreasonable for the studio to discard a star on whom so much of its own success had been built. And perhaps it would have, had other circumstances not intervened. It is possible, however, that even if the events of 1922 had never occurred, my career still would have drawn

to a close. I was, by the day of that lunch with Gerard, at the beginning of my tenth year in Hollywood. My time in pictures had already been longer than most. As much as I am loathe to admit it, even without these additional complications, my season might have reached its denouement.

But I see that I am once again speaking of myself when I'd intended to reflect on Elizabeth. This conflation is perhaps inevitable, since our careers now seem to have been so intertwined. And yet I feel it is necessary to explain more thoroughly the events of Elizabeth's life. For the months immediately following my Independence Day party were surely trying for her as well. She was not cast in a new picture through the remainder of the summer and fall, and in October I began to hear open speculation that her contract would not be renewed. Her embarrassing behavior at my party had been noted by the studio, and there were whispers that she was drinking more heavily. I was certain that she was aware of the rumors about her contract, and I imagine she was deeply anxious about the outcome. Indeed, considering the uncertainty of my own contract status, it might have been helpful for us to discuss our situations.

But we did not discuss our contracts, or anything else, for this would have required us to speak to each other. And that we did not do for several months. It is hard to say whether this silence was the result of my pride, for the image of Elizabeth in Ashley Tyler's arms was still fresh; or of Elizabeth's desire not to see me. But the fact remains that Elizabeth and I didn't see one another through the summer and fall of 1921.

In the meantime, the rest of my life went on. I resumed going to parties and studio events, although I was starting to find the other partygoers, with their constant talk of roles and contracts, to be a little tiresome. I also made two pictures during those months, including one in the fall with Nora and Ashley Tyler. Although I'd worried about how

Tyler and I would behave with each other, his profession-alism diffused any possible awkwardness. I cannot deny that it caused me a certain discomfort to be around the di-rector, particularly since I knew that he was still spending time with Elizabeth. But he never mentioned that night at my mansion. He simply proceeded with directing the film and treated me as he always had, and for this distance, this propriety, I was grateful. Besides, by the middle of the film I was no longer so occupied by visions of Elizabeth and Ty-ler. Other things were happening that turned my thoughts in an altogether different direction.

Inevitably—months later—I did run into Elizabeth, at a Thanksgiving party at Evelyn Marsh's mansion. We nod-ded politely from across the room but did not approach each other. This happened again at Perennial's holiday party early in December, and then again a week later at Buck Snyder's ranch. At this last party, however, Elizabeth gathered the nerve to cross the room and speak to me.

"You've been quite the social butterfly lately," she said. She was wearing cowboy boots, a denim skirt, a red bandana, and a cowboy hat, in keeping with the Western theme.

"It's unavoidable," I said noncommittally. "It's the height of the party season."

"I suppose. To tell you the truth, I'm about ready for it to be over. These things aren't all that fun if you're not drinking." She held up her glass, which was filled with a dark brown liquid, and I noticed that there was no redness in her eyes, no sour smell of liquor on her breath.

"Well," I said, raising my own gin and tonic, "some-times they're no fun even if you are."

She smiled a chastened, self-conscious smile, and took in my cowboy hat and fringed leather vest. "You look good as a cowboy, Jun."

We stayed there together for a few more minutes, speak-ing of the holidays and Snyder's ranch and the amusing

sight of the studio executives dressed up in Western garb. We did not discuss anything substantive, and steered clear of mentioning Ashley Tyler. But it was a thawing, a beginning, and as my driver took me home, I felt more peaceful than I had in several months.

I will never know what might have become of Elizabeth and me. I would like to think that, given time, we could have gotten beyond the impasse of that summer and fall. I would like to think that we could have moved to a new understanding—that even if our romance wasn't meant to continue, we could have remained close colleagues, even friends.

I have every reason to believe that such an end was possible. For in the weeks after Snyder's party, Elizabeth changed. It was clear she was attempting to get her life in order—either to improve her chances of securing another contract, or simply for the sake of her health. I even heard from several people that her drinking had stopped—largely due to the help of Tyler, who stayed with her during the hardest hours and kept the suppliers away.

After avoiding me for altogether for several months, she telephoned me twice. The first time was early in January, to wish me a happy new year and to congratulate me on my just-released film. Again we stayed away from any difficult subjects, but we had a pleasant conversation about the weight we'd both put on from all the holiday parties, and the havoc wreaked on our gardens by the recent rains. Elizabeth sounded well, and I remembered how pleasant she could be when she wasn't distorted by alcohol. As I laughed at her stories of trying to save her drowning plants, I realized how much I had missed her. We approached each other with the hesitation of new friends, potential lovers, and I enjoyed this careful tenderness, this polite feeling out, and looked forward to what would happen between us next.

* * *

Elizabeth's second call, in February, was very different. I had been up past midnight, drinking alone, and for this reason I was not totally myself when the phone rang at 6 in the morning.

"Jun," said the voice on the other end, and it was so racked with sobs that at first I couldn't place it. "Jun, you have to come quickly. Ashley's dead."

Now I realized that it was Elizabeth. And since her words made no sense, I assumed she was drunk, or else I was having a dream.

"Ashley's dead!" she repeated.

"What?" I said. "What are you talking about?" I was still half asleep.

"He was found dead this morning, right there in his bedroom. I was with him last night, Jun. He was fine!"

I was starting to comprehend what she was saying. "You were with him?" I didn't know whether the twisting I felt in my stomach was shock over the news or jealousy.

"Yes, I was with him, but I left around 9, and he walked me out to the car. The next thing I know, I get a phone call this morning telling me he's dead!"

"Who called you? The police?"

"No, no. The studio."

"The *studio*?"

"Yes, I don't know who found him, but the studio is calling people. Tom Stewart from Benjamin Dreyfus' office called about half an hour ago."

"Why did he call you? What did he say?"

"I don't know. But I'm going over there. I think people are there already. Jun, will you please come with me?"

I couldn't answer right away—this was too much information to consider all at once. Tyler, my favorite director. Tyler, the man who everybody seemed to admire. Tyler, my rival for Elizabeth's affections. Could it be true that he was dead? I couldn't believe it, and I had no desire to go to his house, not even for Elizabeth. But in the end I couldn't

deny her, not when she was in such a state, so I agreed to meet her at the director's home.

Tyler's bungalow court was not unlike the one I live in now—a group of two-story buildings arranged in a U-shape around an open courtyard. I arrived before Elizabeth and stood there in the morning winter cold, still trying to absorb the news. There were no police yet, no reporters, no indication that there was anything amiss. I saw a drape stir behind the window of another apartment, but nobody came outside. Elizabeth appeared shortly, her eyes red and her coat drawn tightly around her. She gripped my arm hard and I remember thinking, bitterly, that she never held me with such urgency when I made love to her. I resisted the urge to shake her off and placed my hand on her back, guiding her to Tyler's front door.

I didn't recognize the man who answered our knock, but he appeared to recognize us, for he stepped aside without speaking and let us in. I had never before been inside Tyler's home, and my first thought, as I laid eyes on the couch, the fireplace, his fine paintings and pieces of sculpture, was to wonder about the hours he passed there with Elizabeth; how often and in exactly what posture they had talked. Despite the good furniture and expensive art, the place already felt lifeless to me. It was dark and sad and too carefully decorated—the home of a man concerned more with appearances than comfort.

But perhaps it was unfair to judge Tyler this way, for his home was already changed. What we found when we stepped inside was five gloved men engaged in frantic activity; the sounds of furniture being moved around above us indicated that there were more upstairs. These were studio employees, several of whom I recognized, and they were working so fast they didn't stop to acknowledge us. One of them was going through Tyler's desk. Another was examining the hutch in the dining room, removing and replacing every plate. A third was lifting each paint-

ing, touching its frame, and feeling the wall behind it. Yet another was on his hands and knees, peering beneath the couch. I didn't know what they were searching for, but there was a growing collection of papers and photographs on the dining room table, along with two bottles of whiskey. The whole tableau made me think of a film set, the final frantic preparation that went into making it perfect before the actors stepped in to perform their scene.

Elizabeth gasped when she saw what was happening and gripped my arm even tighter. She wavered a bit as she walked, and I wasn't sure if her unsteadiness was due to alcohol or grief. She led me to the kitchen, and I realized with a fresh spasm of pain that she knew every inch of the place. We found an older black man sitting at the table, and when he and Elizabeth saw each other, they both let out a cry.

"Willy!" she said, rushing over to him.

"Oh, Miss Elizabeth," the old man answered, "I can't believe it."

Once again I suppressed my distaste. The man seemed respectable enough—he was neat and well-dressed—but this was the person on whose behalf Tyler had testified in court to combat the morals charge. After some more tears and sounds of grief, Willy relayed his story. He'd come in right at 5 a.m. as always. He first took in the dishes that Tyler and Elizabeth had left by the couch, and then fixed his boss a pot of morning tea. But when he took it upstairs, he found Tyler on the bedroom floor. He knew immediately that Tyler was dead, but was uncertain about what to do, so he called David Rosenberg at home.

"I thought Mr. Rosenberg would ring the police or the doctor," he said. "And then the next thing I know, all these men showed up. I don't like them disturbing Mr. Tyler's things, Miss Elizabeth, but what can I do? Maybe they'll listen to you."

Elizabeth sat down at the table and didn't answer. It

occurred to me—as it must have to her—that there were certain things she might want removed. "Where is he, Willy? I need to see him."

"I'm not sure you want to do that, Miss Elizabeth."

"Please, Willy." And after considering a moment, he said, "All right, then. Let's go upstairs. He's in his room, right where I found him."

We walked past the men in the living room, who continued to ignore us. Willy led us up the staircase to the second floor, and as Elizabeth's breathing grew more labored, I thought I smelled a faint trace of liquor. There were two doors on each side of a long, lit hallway, and Willy led us to the second one on the left.

Tyler was lying faceup on the carpet, just at the foot of the bed. His body was perfectly straight, hands at his sides, legs and heels together. He looked, as always, unfailingly proper, as if he'd observed his sense of decorum even into his death. He was wearing a heavy crimson robe, the top half of which was open, revealing a triangle of pale white flesh. His eyes were open and he appeared startled; it was hard to know if this had been his final expression or if it was part of the mask of death. The sight of him was like a blow to the stomach. Beside me, Elizabeth let out a small cry.

"Oh, Ashley," she said. She kneeled down beside him and took one of his hands. "I didn't know he was ill. I didn't know there was anything wrong with him."

"Neither did I, Miss Elizabeth," said Willy. "He always seemed like he was in such good health to me."

I stood there suspended, not knowing what to do. It was real, the body was real, the man was truly deceased. And yet what I felt more strongly than the shock of his death was jealousy at the sight of Elizabeth kneeling beside him, caressing his lifeless hand. I did not wish to look at Tyler anymore, so I raised my eyes to watch the studio men. There were two of them working in the bedroom as well, going quickly through Tyler's closet.

"What are they doing? What are all these men doing?" asked Elizabeth, as if she had just then noticed them.

We heard the sound of someone mounting the stairs, and then David Rosenberg appeared. From his face it was clear he was surprised to find us there. He nodded at the studio men, who kept working. Then he walked over to Tyler's body.

"Jesus. This is terrible!"

Willy faded back against the wall, making himself invisible, and Rosenberg kneeled down to question Elizabeth. "When did you last see him?"

"Last night. I came to visit him about 7 o'clock, and left about 9. He walked me out to my car and gave me a book and kissed me goodnight. I had no idea that . . ." And now the tears began again.

"Did anyone see you?"

"My driver," she said. "And anyone who was near their windows in the evening."

David nodded. When he used a handkerchief to wipe off his face, I saw that his hands were shaking.

"Sir," said Willy from the back of the room. "Sir, has anybody called an ambulance? Or the police?"

"Yes, we called the police," said David. And then a statement I found very odd: "They're giving us another ten minutes."

David got up slowly, his large frame filling the space of the bedroom. He moved around, looking at a picture here and touching a book there, as if he were an anxious visitor examining the furnishings while waiting for his host to appear.

Elizabeth continued to kneel with Tyler, and I almost felt sorry for her. "Oh, Willy," she said. "He was such a good man. What am I going to do?"

It was not a frivolous question. His friendship had been critical—for keeping her fading career alive and, apparently, for her efforts to curtail her drinking.

The stairs creaked again as someone walked heavily up them, and then several policemen appeared, wearing high-laced boots and mackinaw jackets. As they entered, I realized that I'd seen one of them before—at the studio, on sets, sometimes as security, sometimes filling in as an extra when the script required a police officer. "I'm Captain Mills," he said to Elizabeth, and I saw that she recognized him too. Then he glanced over at me and lifted his eyebrows. "What's the Jap doing here?"

Elizabeth stood up. "He came with me," she said defiantly. This did not address, of course, the question of what *she* was doing there, but that question remained unasked. Instead, the police went right to work.

They all fanned out around the body and Elizabeth moved back, looking like she wanted to protect him; it seemed so odd, so improper, even to me, that all these strangers should see Tyler in this state. Captain Mills knelt down beside his left shoulder and held his ear to the dead man's nostrils. "Cold as ice. Been dead for a while, I think." He stood again, and had just turned toward the other men when Elizabeth clutched my arm and made a sound. She gripped me so hard her fingernails broke through my skin, and I looked where she was pointing: at the floor, where Captain Mills' black leather shoes were leaving marks in dark horseshoe shapes all over the wood.

"Uh, Mr. Rosenberg, sir," said Willy. "Look, sir. Look at the floor."

Everyone stared, Mills twisting around to see the marks his shoes had left. Then he took a white handkerchief out of his pocket, lifted his foot, and wiped the bottom. It came away dark red. He rushed back over to Tyler, and two of the other policemen bent down and rolled the body over.

There was a melon-sized crater in the lower part of Tyler's back. It looked like the inside of a volcano—dark, red, churning. On the robe and on the rug were bits of bone, intestines, coagulated pockets of blood. Elizabeth screamed

when she saw this and fell into my arms. I, already numb from the shock of his death, could not assimilate this new information. And now we saw an even darker stain on the rug, spreading out to the left of the body and toward the bed. The policemen turned the body on its back again, and one of them opened the robe. There, just below the navel, was the entrance wound, and then the sand-colored curls, the shriveled penis. The men examined the wound, and then lifted both sides of the robe.

"It went clean through," said one of the kneeling cops. "Couldn't see the hole from outside."

Captain Mills shook his head and whistled, and even Rosenberg seemed at a loss for words. "Well, this changes things a bit," he said.

Elizabeth leaned heavily into me and I thought she would faint, but instead she just started to cry again, gulping for air as if she were drowning. "Somebody shot him?" she asked.

"Looks that way," said Captain Mills.

She looked at Rosenberg. "Oh, David, who could have done such a thing?"

"Good question," said Rosenberg. He seemed truly shaken.

"Did he have any enemies?" asked Captain Mills, as the officers stood up and began to examine the room once again. "Any unpaid debts, angry lovers or husbands, a dispute over one of his pictures?"

Rosenberg shook his head. "Not that I know of. People liked him. And women couldn't get enough of him. It was the accent, I think, and his high-class looks. All these British bastards have it over us that way."

"All the more reason to look at women and husbands. Was there anything else? Disputes with employees? Some actor or actress he didn't cast?"

Rosenberg shrugged. "You can never keep actors happy, but that's nothing new . . ."

218 ✿ Nina Revoyr

"Miss Banks," the policeman asked, "do you have any idea who might have done this?"

She shook her head, still clutching my arm. "No, I can't imagine who would have done something like this. I can't imagine who'd want to hurt Ashley."

Captain Mills had taken out a small notebook and was scratching in it with a pencil. "Who has access to the house?" he asked of no one in particular.

Rosenberg thought for a minute. "Well, he asked Gerard Normandy to keep an extra set of keys. Other than that," he said, looking at Willy, "the only person I know of is him."

All four of the policemen turned toward Willy now, who instinctively stepped back. "I found him this way," he said. "I came round about 5, like I always do, and he was laid out just like that."

"Mr. . . ."

"Parris," David said. "Willy Parris."

"Mr. Parris, how long have you been in Mr. Tyler's employ?"

"Almost four years now. Four years this May."

"Were you unhappy with Mr. Tyler in any way, Mr. Parris? Maybe he didn't give you time off when you wanted it, didn't give you a raise?"

"No, I never had no problem with Mr. Tyler. No problem at all. Best boss I ever had. I'd do anything for him."

"You leave him alone!" Elizabeth shouted. "You leave Willy alone! Willy wouldn't hurt an insect, let alone Ashley, and it's shameful what you're trying to imply!"

And slowly, all of the policemen's eyes came to rest on Elizabeth. I could feel the shift, the new curiosity.

"Miss Banks," Captain Mills began, "you were close to Mr. Tyler, correct?"

"Yes, very close," she replied, and she didn't seem to notice the way they circled her, the scent they picked up in the air.

"Would you say that your friendship was . . . intimate?"

"That's none of your business!" she said, pulling her sweater around her.

"Well, would you say that you had a strong affection for Mr. Tyler?"

She touched her mouth, and her hand was shaking. "Yes. A very strong affection."

"And was his affection for you equally strong?"

She shook her head—not as if she were answering no, but as if she were trying to deny the presence of their questions. "Oh God, don't make me talk about Ashley when he's dead and somebody's killed him!"

Captain Mills stepped forward. "Miss Banks," he said slowly, "how did you know to come over this morning?"

"Why, Mr. Stewart . . ." But when she peered at Rosenberg, he looked away. "Tom Stewart from Benjamin Dreyfus' office called me."

Captain Mills looked at Rosenberg. "Is this true?"

Rosenberg shrugged his shoulders. "I don't know *how* she knew to come. She was here before I was, in fact."

Elizabeth stared at him in disbelief. "You bastard! You *know* he called me. He called everyone this morning. How the hell do you think *these* thugs knew where to come?" She gestured toward the studio men.

I held her and kept her from falling over, and now the captain turned to me. "And what might *you* be doing here?"

"I came with Miss Banks," I replied.

"Were you with her when she received this supposed phone call?"

"No, I was at home, and she called me."

"So you weren't with her this morning."

"No," I said, and the glance the captain now exchanged with his deputy made me think I might have said something wrong.

"Well, at least we know where to start, gentlemen,"

said Captain Mills. "Let's take all three of them down to the station. We should have this thing solved by evening."

Before I could protest, the police grabbed us from behind and led us down the stairs. We stepped out into the courtyard. By now a small crowd had gathered, and the police had cleared a path to the street. The onlookers stood behind the policemen's outstretched arms, and as we passed, they pointed and whispered. The three of us were loaded into separate cars, and when we reached police headquarters, we were ushered quickly inside. I caught glimpses of Elizabeth and Willy before we were led off to separate rooms. Elizabeth seemed disoriented, dazed, as if she were not a part of what was happening around her. She was enveloped in grief, and I got the sense that, now that her protector was dead, she didn't much care what happened to her. But Willy's face was drawn, eyes wide open and alert, and I knew that he was afraid.

The policeman who had escorted me now led me down a dim hallway and through an unmarked door. The room he took me to was dark and windowless, with only a small wooden table and three chairs. The walls were gray and plain, and one of the overhead bulbs had burned out. The table was scratched up, the chairs worn and uneven, and there were gashes in the wall encased with dark, dried stains. My shock at the sight of Tyler had now given way to the urgency of self-preservation. I circled the table, not knowing what to do with myself, and felt the first stirrings of panic. I wanted to get out of that room as quickly as I could. Just being there made me feel like a criminal.

In a few moments, the door opened and Captain Mills came inside, accompanied by two men in jackets and ties. Mills pointed to one of the chairs, and I sat down.

"Nakayama," he said, "this is Detective Jones and Detective Hopkins. They'd like to ask you some questions."

Mills left and shut the door behind him, and the two men turned to face me. The older detective, Jones, was tall

and slightly stooped. His shoulders were drawn up and his hands lifted and poised—ready, it seemed, to fight at a moment's notice. The other man, Hopkins, was young in the face but seemed older than his years. He looked as stoic as a farmer, and just as uncomfortable in a suit and tie. Hopkins took a seat across the table. Despite his casual, untidy appearance, his movements were sharp and quick, his eyes alert.

"Jun Nakayama, correct?" the older man asked.

I cleared my throat. "That's correct."

He sat on the table in front of me and curled his hands over the edge. "I understand you were at Ashley Tyler's house this morning."

"Yes, I was."

"Now, what did you happen to be doing there?"

I looked up at his face, his watery blue eyes; a slight, unpleasant smile curled his lips. "Elizabeth Banks called me this morning and told me that Mr. Tyler was dead. She was very upset and wanted me to accompany her to the house."

"Now why was she so upset?"

"She'd just heard that her friend and director was dead."

"Were *you* upset?"

"Of course. He was my friend and director as well."

Jones took his hands off the table and folded them together in his lap. "Well, he *was* your director, that much is true. But I'm assuming he was a different kind of friend."

I inhaled quickly—I couldn't help it—and knew that Jones was pleased by my reaction because he leaned in a bit closer. Hopkins leaned over too, and nodded reassuringly. "It's okay, Mr. Nakayama. Just answer the questions. The truth is going to come out anyway."

Detective Jones glanced over his shoulder, and there was a hint of irritation in his face. He pulled himself back from this distraction. "So many friends in this sticky busi-

ness. So many little intrigues. Now why did Miss Banks call *you*?"

"I suppose she trusts me. We have known each other for many years."

"Yes. I hear she's a friend of *yours* as well."

Hopkins leaned back in his chair now and crossed his arms. "Where were you when she called you?"

"At home."

"Had you been there all night?"

"Yes. I stayed in yesterday evening."

"Are you sure you weren't with Miss Banks?"

I looked at the wall beyond them. "No, I wasn't. In fact, she was with—" I stopped myself, not wanting to implicate her.

Jones stood now, smelling blood. "Yes, we know. She was with Tyler. And from there she came to you?"

"No."

"Are you sure you didn't go over there together and shoot him?"

"No. Of course not. Why would we do that?"

"Maybe you knew she'd gone to see him and waited until she left, then went over there and shot him yourself."

"No!"

"It bothered you that she saw him, didn't it, Jun?"

I paused before responding. Jones had stepped closer and was hovering over me; Hopkins leaned forward again and put his elbows on the table. "Miss Banks can spend time with whomever she pleases."

"But it bothers you just the same."

"I said it's fine."

"You hate to think of it, don't you?" Jones continued. "That fancy British asshole with the nice clothes and pretty accent, fucking the woman you love."

"I don't think about such things."

"Sure you do, you little rat." Jones' body was taut, but his voice was growing softer and softer. "You have to work

with the bastard, and probably all you can think about is him in the sack with your lady. It's like torture, isn't it? Seeing him every day, imagining them, and knowing all the time that no matter what you do, you'll never be able to compete, because he's a British gentleman and you're a fucking greasy little Jap."

My hands were shaking, not from fear, but from the effect of Jones' words. "I admired Ashley Tyler," I said, looking down at the table. "I had no ill feeling toward him."

"That's bullshit," said Jones, his raised voice like a cracking whip. He leaned over abruptly, his face inches from my own. Hopkins stood too, as if preparing to hold him back. "You're just a damned liar, like the rest of them," Jones hissed. "Too fucking big for your britches. Shit. If you want my opinion, the pictures started to stink as soon as they let foreigners in them. You should have stayed where you were and not shown your ugly face in California. You went over there and shot him, didn't you?"

"No, I didn't."

"You knew Elizabeth had been there, and you went over there and found him in his robe, probably because he'd just fucked your girlfriend. Maybe it was something in his eyes, maybe you even smelled it on him, and you couldn't stand it, and you just had to go and kill him."

All the anger and fear that had been building in me now burst like a broken dam. "No! No, I had nothing to do with this! Look at my hands—is there a gunpowder stain? Look in my house—I don't even own a gun! Talk to my butler—he was home with me all last night! Talk to Ty-ler's neighbors—I have never been to his house before this morning. Don't you think someone would have noticed if I'd walked through the courtyard? Or if I went into his house last night?"

I stopped abruptly and started to shake. I clenched my fists and tried to prepare for the next wave of accusa-

tions. But Jones just looked at me curiously, as if observing a young child who was throwing a temper tantrum. Hopkins watched quietly, and I may have imagined it, but the expression on his face seemed troubled. Then, without saying another word, they nodded to each other and left.

I stayed there in the interview room for what felt like weeks. Eventually the door cracked open and a familiar face peered in. "You can go now," Hopkins said, and I blinked up at him, unspeaking. "We're finished with you here," he added gently. "You're free to go home."

I thought at first that he was trying to trick me, but then he stepped back out again and kept the door open. I stood and walked into the hallway. The station, or at least that part of it, was eerily quiet; there were no policemen milling about.

"You should go out the back way," said the young detective, and his voice was kindly. "You'll be able to avoid the cameras that way."

I heeded his advice and went out a back door, into an alley filled with garbage. It was dark outside—the whole day had passed. There was no one on the streets, so I walked through downtown and then along a series of small roads. I walked the entire six miles back to my house, and did not emerge again for several weeks.

In retrospect, I realize that the police never truly suspected me or they would not have let me go so quickly. Even Jones' harsh line of questioning was just meant to shake loose information, some fact that might set them down the proper path. He upset me, I think, more through his insinuations about my personal life than by his suggestions that I was involved in Tyler's murder. For as I stayed locked up in my house during those weeks after the killing, I felt a shameful and uncontrollable anger at Tyler, the very jealousy that Jones had accused me of. Perhaps I hadn't allowed my envy to come fully to light until some-

body else had unleashed it. I liked Tyler, and admired him, and had never wished him ill—but there was a part of me that was not altogether displeased that he was now out of the picture. This feeling would then be followed by shame at having such thoughts, as well as genuine sadness about his death.

For the first several days after Tyler was murdered, I couldn't bring myself to dress in the morning. Phillipe would make me breakfast and bring me the paper, and then leave me to myself. He delivered my only communication with Elizabeth during this time, a note asking her how she was holding up; I couldn't send a telegram since the telegram companies were all in the pay of the papers. Her reply arrived the following morning, by way of her maid: *Police were terrible. Have to go back this afternoon. Can't sleep, can't eat, don't know what to do.* But the fact that she had sent a note at all, and that it was coherent, assured me that she was basically all right.

I called several people, including David Rosenberg at Perennial, but no one would come to the phone. The only person who tried to reach me during this time was Hanako Minatoya, and I couldn't bear to speak to her—not so much because of Tyler's death but because of the shame I felt on so many accounts, most immediately my friendship with Elizabeth. For that piece of information, like so much other private business in the wake of Tyler's death, quickly became known to the public. The front page article in the *Los Angeles Times* two days after Tyler's death detailed how Elizabeth had called me on the morning of the murder, and how we'd had "a long and close friendship." This alone was bad enough, but on the second page the paper had published a sidebar with the names of all the men with whom Elizabeth had ever been linked. I cannot say now what troubled me more—seeing my own name there in stark black-and-white or seeing it at the end of a rather long list of men, most of whom I knew and had worked with. Our affair had been grist for the Hollywood rumor

mill, yet until then it had stayed out of the general public. Now everyone knew, which would only cause further damage to our already fragile reputations.

In those days, I got news about the case the way that everyone did—from the *Los Angeles Times* and the *Herald Examiner*. The first day's story was about the death itself and the questioning of Elizabeth, Willy, and me. The second day's news included the story about Elizabeth's love interests, but the speculation slanted more toward Tyler's supposed enemies—a driver with whom he'd had a falling out, a jealous producer whose wife had pursued the director, a recently fired contract actor from Perennial who was rumored to supply drugs for other actors. There was also more extensive coverage of Tyler's friendship with Elizabeth, which the paper characterized as "an unofficial engagement." I knew this to be untrue, though the inaccuracy of the claim didn't make it any less painful. The third day's news focused almost entirely on the fired actor, who'd apparently had a public confrontation with Tyler over drugs in the days before the murder. But then the man turned up—he'd been vacationing in Mexico—and he had been there on the day of the murder.

It was the fourth day's news that changed everything. The headline was two inches high, all capital letters: "*STARLET'S NIGHTGOWN FOUND IN SLAIN DIRECTOR'S CLOSET!!!*" And then, beneath it, in regular headline type: "*Long-Rumored Affair between Tyler and Niles Confirmed.*" There was a photograph of Nora looking lovingly at Tyler, on the set of *The Noble Servant*. The story reported that a pink nightgown had been found which bore the monogrammed initials NMN, and there was even a picture of the garment in question. The nightgown was one of many items of women's intimate clothing that had been found among Tyler's things, all tagged with initials and dates. There were also, apparently, pornographic photographs of the director with several of Hollywood's leading ladies, as well as dozens of "passion-

ate" love letters from Nora and Elizabeth, "so intense they could not be reprinted." Nora Niles had been brought in for questioning the day before, "a grueling, five-hour session," and then her mother had been interrogated separately. Both claimed that they had been home at the time of the murder, reading in front of the fireplace. I wondered who the other items belonged to, and who might have been in the photographs. But the press, despite a statement from Detective Owen Hopkins that the police were pursuing several different leads, had clearly latched onto a new favorite suspect, because they spoke of nothing else for several days.

I was already concerned about how Nora was doing—I had thought of her a great deal in the previous weeks—and with this latest news, my worries only grew. Her devotion to Tyler was even deeper than Elizabeth's, and this was probably the most devastating loss she had ever suffered. Now there was also the unpleasant complication of her own name being dragged into the papers. I wanted to write her about Tyler, but there was no secure way; a telegram wasn't safe and Harriet would intercept a note. And I needed to talk to her for different reasons as well. I had been trying for some time to find a way to approach her, but now, with the death of Tyler, any efforts I made would undoubtedly be thwarted.

The newspaper stories that came out over the next several days were increasingly breathless. One revealed that Nora too had been secretly engaged to Tyler; another insinuated that she was pregnant. Each of the stories touched upon the nightgown, describing some new detail—the lace fringe along the bottom, the burgundy monogram. One of the stories described Nora's life with her mother, painting Harriet Cole as a clutching presence who was capable of anything, even murder, to protect her daughter's career. These stories ran for about a week, and then the reporters turned their interest back to Elizabeth, and then on to more peripheral suspects. Owen Hopkins was quoted

as saying that the police had one witness—one of the neighbors saw a man leave Tyler's apartment, or a woman dressed as a man—but no clues as to the individual's identity. While they knew that the bullet was from a .38 caliber snub-nosed revolver, the weapon itself had not been found. These details were dry, however, with no inherent drama, so the press focused once again on the famous suspects. After three or four weeks, when the papers were still full of insinuations but no hard facts, it was becoming apparent that there would be no arrest.

Tyler's funeral was held five days after his death at St. Francis Cathedral in Hollywood. I had not planned to attend—I didn't want to be seen—but on the morning of the service, there was a knock at my door. I opened it and was surprised to find Hanako Minatoya standing on my doorstep. It was highly unusual for her to appear at my home unannounced, but I had refused to take her calls.

"You must come, Nakayama-san," she insisted in Japanese. "It is the proper thing to do."

Of course she was right, so after a halfhearted protest, I dressed quickly and went outside. Her driver greeted me as he helped us into the car, but otherwise, to my relief, he did not engage us in conversation. Hanako spoke little on the way to the service, and while I could not bring myself to meet her eyes, I noted, when I glanced surreptitiously in her direction, how dignified she looked in her black dress and hat. When we arrived at the church, there was a tremendous crowd filling the sidewalk and spilling onto the street. The driver cursed as he inched through the people. At the curb, someone opened the car door for us, and I groaned involuntarily at the crush of curious faces. I kept my head down as I walked toward the front of the church, worried what people would say. But Hanako squeezed my arm tightly and whispered tersely in my ear, "Stand tall. Jun Nakayama does not cower."

Once inside, ushers helped us to the front of the church. Hanako greeted our acquaintances and led me to my seat, and I tried to ignore all the whispers. Gloria Swanson was there, looking as beautiful and cold as ever. She was seated next to her great friend, young Rudolph Valentino, and his soon-to-be bride Natachka Rambova. Across the aisle sat Doug Fairbanks and Mary Pickford, her sober expression evoking the tough businesswoman she actually was rather than the young pixie that America hoped she would always remain. Chaplin was with them, as he often was, unusually still in this atmosphere of sadness. Bill Hart sat behind them with his rival Buck Owens, both men appearing uncomfortable in suits rather than their usual cowboy garb, and Norma Talmadge held tight to the arm of Joseph Schenck. Scattered among the stars were the directors, Tyler's peers—DeMille, Griffith, Allan Dwan, even Erich von Stroheim, who had not yet created the opulent films that would make his reputation. The executives were there as well—Normandy, Stillman, Mayer, Goldwyn—although they all seemed unapproachable. They could not be pleased with this turn of events. Tyler's murder fed into the growing perception that Hollywood was full of immorality and excess, and these men would be the ones who had to deal with it.

Although many actors and actresses were in attendance that day, Nora Minton Niles was not among them. I hadn't expected her to come—I knew she was overwhelmed—but she'd sent five thousand white roses, so many that they lined the aisles and were arranged around the coffin, which was placed in the center of the stage. Beside the coffin was an empty director's chair with *Tyler* inscribed on the backrest; next to it, on a table, was a megaphone. I was staring at this absently when I heard a buzz move through the crowd. Elizabeth Banks had arrived.

She was wearing a heavy black dress with a large hat and veil, and leaning heavily on her maid. From the hesitant, uncertain way she was walking down the aisle, I knew

that she was probably drunk. Even from fifty feet away, I could hear the sound of her sobbing.

"It's all right, Miss Elizabeth. It'll be all right," her maid said. Her voice echoed in the sudden silence. Although Elizabeth was having difficulty even staying on her feet, nobody rose to assist her. Finally, an usher gestured toward one of the pews, and the maid helped Elizabeth into a seat three rows in front of us, next to David Rosenberg. As Elizabeth sat down, it looked to me—although I couldn't be sure—like David moved slightly away from her.

I do not recall much of the service itself—what the priest said, or the eulogies, or the music that was played. What I do remember is the faint shouts of the people outside pressing against the door; the steadying grasp of Hanako, who kept hold of my arm; and the sobs of Elizabeth, who never stopped crying. I watched her through the entire service, and I could feel my anger rising. She had not acknowledged my presence or even glanced in my direction. If there had ever been a doubt about where her affections lay; if I'd ever allowed myself to think that I might mean something to her, then her behavior on the day of Tyler's funeral disabused me of those notions. For it was clear she didn't care for me, not in the least. I knew that our friendship was over.

After the service, a caravan of dozens of cars made its way to the Hollywood Cemetery. Hanako and I did not join them. Instead, she guided me back toward her car, shielding me from the cameras and grasping hands. When we were almost to the sidewalk, though, a reporter pushed through the crowd and stopped in front of us. "Jun, Jun!" he called out, waving his notebook. "Is it true that you and Tyler were riding double on Elizabeth Banks?"

The crowd went quiet as everyone awaited my response. But then, Hanako stepped in front of me and faced the reporter. She did not excuse herself or explain what

she was doing there with me. She did not chastise him for being inappropriate. She simply fixed him with a cold and withering look, a glare so devastating that although he was several inches taller, she appeared to be looking down at him. She stared at him this way for what seemed like half a minute. Then, lowering his head, he slinked away.

We didn't speak during the drive back from the service, and when we reached my house, Hanako looked at me squarely. "I'm afraid to leave you alone, Nakayama-san."

"I'm fine," I said, trying to sound steady.

Hanako glanced down at her hands now. "You must take care of her."

"Who?" I asked, genuinely puzzled.

"Elizabeth. You must take care of her. She has nobody else."

I did not know how to reply to this, so I nodded at her vaguely. It was difficult for me to think kindly of Elizabeth. It was difficult to think of her at all.

After a moment of uncomfortable silence, I bade Hanako goodbye. As I made my way back to my own front door, I realized that I'd forgotten to thank her. I turned quickly, but the car had already gone around the corner. And it was only years later that I came to understand how difficult this day must have been for Hanako, how generous she'd been in escorting me. Absorbed as I was in my own sense of shame, I failed to comprehend this at the time. I failed to see that she'd put her own reputation at risk for the sake of a friend who did not deserve her, for someone who was not even half the man she believed and maybe wished him to be.

Weeks passed, weeks I spent mostly at home, seeing no one but my servants. The maid soon resigned, then the chauffeur and the gardener, citing family obligations and better employment elsewhere; none of them could look me in the eye. Just Phillipe remained, and he was my only company. I tried to amuse myself by reading and drawing

him into an occasional game of chess, but mostly I walked aimlessly through the rooms of the mansion, which suddenly felt like a museum after closing hours. Indeed, sometimes when we spoke to each other in the cavernous front entranceway, I could faintly hear the echoes of our voices.

I did not hear from Elizabeth, although I read that she'd been escorted home twice by the police, who found her stumbling drunk outside of the Tiffany. And I did not hear from Nora, whom the papers reported had been "sent away because of a nervous condition." After a while, the articles became less frequent and Hollywood started returning to its regular business.

More than a month after Tyler's death, David Rosenberg called to apologize for Perennial's silence. Gerard Normandy was ready to talk, he said. Although they were still reluctant to draw up a new contract, they did have a potential project. He told me the last few weeks had been eventful. One of the things they had discovered in the wake of the murder was that Tyler wasn't who they had thought. The director's real name was Aaron Towland. Far from having a theater background in England and New York, he'd been third-generation antique salesman from Brooklyn. He'd left a wife and two children in Flatbush, and had disappeared in 1912 without a forwarding address. Mrs. Towland hadn't known what had become of her husband until she saw him in a picture. With the news of his death, she had contacted the studio and informed them of Tyler's true identity, hoping to secure assistance for their children. This information had thrown the studio into a frenzy, but they'd successfully kept it out of the papers, and they were just now getting their operations back in order.

But that was all moot, said Rosenberg. They wanted to see me. Could I come in and meet with him and Normandy in a week? I told him I could, and I hoped the shaking in my voice did not betray my joy and relief. It was going to

be all right, I thought, despite everything. I was going back to work.

Had I not received an unannounced visit five days later, I might, in fact, have done so. I might have met with Normandy and found a way to continue my acting career. But I did receive a visit—one that, in some sense, I'd been expecting for weeks. After that day, I knew that I would never appear in a picture again—not for Normandy, or Perennial, or any other studio. And I would not see David Rosenberg for forty-two years, until I drove up to the nursing home in Culver City.

CHAPTER TWELVE
October 30, 1964

This has been a week of the most unexpected revelations, which have led me down a path of such reminiscence and regret that I find myself now at the top of Runyan Canyon Park, looking down at the lights of the city. I hadn't planned to go for a walk this late in the evening, and certainly not after dark. But my thoughts were too unruly for me to stay still, and after today's incident involving the bird, it seemed best to leave the confines of my house.

I had been sitting in my dining room when something struck the window, the sound of the impact accompanied by a tiny cry. When I went outside to investigate, I found a small green hummingbird lying on the walkway. Its head was folded under its body, and the wings, which normally move so fast one can only see the blur, were now flapping ineffectually. The little body shuddered as if it were racked with cold. I couldn't tell whether the bird was seriously injured or just trying to gather itself enough to fly away. But I felt like I was intruding on a private struggle, so I returned inside and began to brew some tea. I could not get the sound of the impact out of my mind, however, nor the sight of the struggling bird. So after another few minutes, I ventured back outside and found that the hummingbird was still.

I felt responsible, as if I could have saved it. After my initial jolt of surprise, I moved closer to get a better look. The bird had settled on its side with its neck at a strange

angle, and there was a small pool of clear liquid beneath its head. I stared at the lifeless body for a few more minutes, and then I took a shovel out of the garage, dug a shallow pit beneath the bushes on the side of the town house, and used the blade to push the bird inside. I replaced the dirt and packed it down, and then, because the procedure seemed incomplete, took a small flat stone and lodged it upright at the head of the grave. It was childish, I knew, but the burial felt necessary, and afterwards I went inside and drank some tea to calm my shaking hands. I couldn't concentrate on my book anymore, nor could I suppress the feeling that the bird had represented some kind of omen, and so I left the house and came to the split log bench on top of Runyan Canyon.

It is silly, of course, to attach such significance to a single dead hummingbird. Yet with everything else that has occurred this week, I could not help but see this incident in relation to those other events, and to invest it with more than the appropriate level of sadness. The week had started uneventfully—I made my usual phone calls regarding my properties and took my regular morning walks. It all began to unravel when Mrs. Bradford came to get me, to pursue this mad idea she'd concocted.

For the last month or so, Mrs. Bradford has been telling me that there's something that she wished for us to do. She wouldn't tell me what it was, and I, being a man who has never been fond of surprises, repeatedly declined. Then, over breakfast last Saturday, after another of my refusals, an expression of real disappointment came over her face. "Please, Mr. Nakayama," she pleaded. "It won't take long—and it would tickle me so much."

And that is how I found myself, five mornings ago, at an old Craftsman bungalow off of Franklin. Mrs. Bradford had picked me up ten minutes before, and when she pulled into the driveway, I turned to her. "You brought me to someone's house?"

She gave me a mysterious smile. "You'll see."

The door was answered by a slight, rather short man about ten years younger than I. He had a pencil-thin mustache and was almost totally bald, except for a patch of hair over each of his ears, as textureless and flat as fresh paint. "Mr. Nakayama," he said, "this is quite an honor." He bowed deeply, hands at his sides, in a manner that was meant to be Japanese.

"This is Bernard Weisman," Mrs. Bradford said. "We worked together for years. He's the head of the research department at the L.A. Public Library."

"I'm very pleased to meet you," I said, still baffled as to why we had come.

Mrs. Bradford smiled and rubbed her hands together, like a little girl anticipating a long-awaited treat. "I recently discovered that Bernard is a huge fan of silent films. When I mentioned your name, he got very excited and insisted that I bring you over to meet him."

"I see," I responded, forcing a smile.

"Come in, come in," said Weisman. "I'm being so rude. Please let me take your coat."

After he had relieved us of our outer garments, he led us into another room. I stopped as soon as we crossed the threshold. An old reel-to-reel projector had been set up behind the couch; against the wall was a portable screen. There was a film in the projector, and when I turned back around, Mrs. Bradford and her friend were watching me expectantly.

"I see you have a film there," I said.

"Yes," said Mr. Weisman. "A *silent* film."

I took a breath. "Oh, really? Is it one of the classics? I know that some of the old Griffith films are available now, as well as several Chaplins and Keatons."

Weisman folded his hands in front of him and looked extremely pleased with himself. "Well, I do own some of the Griffith films, as well as some of Chaplin's and Keaton's.

But what I have here is something that's harder to find. It's one of yours, Mr. Nakayama. *The Patron.*"

My heart began to race. I turned away from their eager faces as Mrs. Bradford exclaimed, "You see, I *told* you he was a fan!"

"That film," I said, after I'd recovered my voice, "I didn't know any copies had survived."

"Well, very few of them have, sir, but I'm a serious collector. I have almost a hundred silent films, some of them even more obscure than this one."

"Why don't you sit down, Mr. Nakayama?" said Mrs. Bradford. "I've been dying to see one of your films."

"Perhaps this isn't such a good idea," I replied.

"Why not?"

"Well . . . it all seems rather . . . indulgent."

"Oh, come on! This is perfect! Bernard's set it all up. I'd love to see you in a movie, Mr. Nakayama. And when's the last time you saw one of your own pictures?"

I wanted to walk directly out of that house and all the way back home. I wanted them to forget this ridiculous notion and let me get back to my life. For she was right—it had been decades since I'd watched one of my own performances, and it was not only because they were difficult to find. I worried—and only now could I admit this to myself—that our films might indeed be as archaic and silly as the public has determined them to be. I worried that our titles and silent mouthing of words would appear anachronistic. I worried that the limitations of early technology would reveal themselves in unsophisticated camera work and laughably simple backdrops. And I worried, most of all, about how I would appear; that I wouldn't measure up to my image of myself.

But there was no way I could tell them any of this, nor was there any way to refuse this viewing without appearing trite or dramatic. So I sat down unhappily, next to Mrs. Bradford, and breathed deeply to slow down my heart.

Mr. Weisman practically danced around the room, turning off lights, adjusting the screen, and then assuming his spot behind the projector. In a moment, the motor-like sound of the projector started up, its whirring and hiccuping undisguised by the live music that usually accompanied the films in theaters. Then, on the screen, the image of curtains, which were pulled back slowly to reveal the words, *Perennial Pictures*. This was followed by the appearance of Evelyn Marsh, as herself, out of costume and character. Then the title, *The fairest blossom in the garden of youth*, which was replaced by Evelyn again, in the uniform of her character, Gillian.

Finally, as the projector continued to roll, I was looking at an image of me. First the introductory frames, in which I wore a kimono and gave a formal bow. Then the title, *The mysterious visitor from exotic Japan*. This dissolved into a shot of me in character, wearing a sharp Western suit and a vest chain. I stood easily and smiled confidently into the camera; my face looked fresh and unlined. It was hard to believe that this vital young man was me—but it was, in 1919, at age twenty-eight.

The moment my face first appeared on the screen, Mrs. Bradford grabbed my arm. "That's you!" she said, gripping me tightly. And then more softly, "Oh, my goodness. Look at you."

Almost against my own will, I did. After my first few minutes of extreme discomfort, I began to follow the story. In this film, I played Kurashima, an art collector from Japan who is making the rounds of the social circuit in New York City. Kurashima is extremely knowledgeable about art; he knows the arcane histories behind some of the world's most famous paintings, and he has a well-deserved reputation for finding and supporting the freshest new artistic talents. During the course of attending parties and openings, he meets several young women who are drawn to him for his looks, his wealth, and the air of mystery that sur-

rounds him, including Gillian Stevenson, played by Evelyn Marsh, a museum shop girl with whom he falls in love.

All proceeds nicely in terms of his rising status among the social set, as well as the developing romance between the two principals. The two flirt subtly: In one title, Gillian tells Kurashima in a clothing store, *Every girl wants to wear furs*—to which he replies, with a sly smile on his face, *And every gentleman is looking for a fox.* Then one night, tearfully, the girl confesses that she is promised to another, an impoverished painter whom her parents have forbidden her to marry because of his inability to provide for her. Kurashima is deeply disappointed at this turn of events, but even more saddened by the girl's predicament. So rather than emphasizing his own ability to give her a comfortable life, he purchases a dozen of her young man's paintings—thus solving, with one stroke, the painter's financial difficulties, and securing his reputation in the art world.

Although I'd been irritated at Mrs. Bradford for pulling me into her scheme, I felt more at ease as the film went on. For I realized that, despite my fears, the picture was every bit the accomplishment I'd remembered. The lighting was subtle and lovely, the sets minimal but perfectly suggestive of galleries and party locales. There were several comic sequences that were still amusing in this modern time—the young artist painting with smelly socks on his hands because he cannot afford gloves or indoor heating; Kurashima, not understanding American cookware, using a metal dustpan to make pancakes. Ashley Tyler—who'd directed—had made ample use of what were then the advancements of dissolves, cross-cuttings, and multiple cameras. Much was suggested by the adjustments of light, and some of the most important events were conveyed indirectly—like the solitary kiss between the two principals, which was shot in silhouette through a rice paper screen door; and the final farewell between Kurashima and

Gillian, which was dramatized by close-up shots of the touching, lingering, and ultimate withdrawing of hands. I was pleased by the quality of the actors' work, for Evelyn Marsh was at her charming best; Tim Buchanan, as the artist, was effective as well; and my own performance still held up under scrutiny all of these decades later. I conveyed both the easy confidence of a wealthy socialite, and then, later in the film, the resignation of a noble man who has sacrificed love for honor.

As the story unfolded, I remembered—for the first time in many years—the satisfaction I took in viewing silent films. Watching movies today is a passive experience, and there is little demand on the viewer's imagination. But *this* movie—like all silents—relied on suggestion, and it was up to the audience to supply the absent connections. This movie demanded the active use of the viewer's own mind, and when it was over, I felt we had experienced the film instead of just receiving it. In my time, we'd treated the audience as if they were adults, not children who required their meaning to be spoon fed. And for that—as well as for the merits of this particular film—I found myself quite proud.

But the feelings I had as I sat in the dark were more complex than pride. I saw, too, how untranslatable our films must seem today, for audiences who are accustomed to voices and sound effects, to gunfire and music and wordplay. Yet there was a quality of freshness and innocence that was clear in Evelyn, in myself, in every aspect of the picture. We performed in front of the camera with unabashed joy, as if we lived only for that moment. And in fact we had, for our work did not stand the test of time. Our images—quite literally—had crumbled.

The film ran about seventy minutes, and after the credits, Mr. Weisman turned on the lights. I found Mrs. Bradford looking at me with a strange expression. "Mr. Nakayama," she said, "you were wonderful." She paused

and shook her head. "I mean, I knew you'd been an actor, but I had no idea. I totally believed you as that character, and felt awful when he lost the girl. I could absolutely follow the story, even without a lot of titles. You conveyed such strong emotion, just by the expressions on your face. And my goodness . . ." She appeared to blush. "I can see why women fainted in aisles."

I smiled awkwardly; I did not know what to say.

"This is the only one of yours I have, unfortunately," explained Weisman, who had come around to sit in a chair across from us. "But now that I've met you, you can be sure I'm going to dig up several more."

"I want to see them too," said Mrs. Bradford. "I want to know more. I can't believe you've managed to keep so quiet about this, you old rascal."

I pressed my hands together and avoided their eyes. "I don't know if any other films survived. I myself have never seen them."

"Well, don't you worry," Mr. Weisman said. "If anyone can track down obscure old films, it's me."

I did not reply to this statement and sat there quietly with my thoughts. Pride and shame and memory all mingled together inside me. For while I understood my reactions to the picture in general, I did not know how to respond to the actor I had watched up there on the screen. That young man was dynamic and fearless, unafraid to defy expectations. That young man had worked tirelessly for the love of the work. I wondered what had happened to him.

Despite my misgivings, I started to see that the day's events had changed Mrs. Bradford's view of me. She was different with me now, shyer, on our drive back to my town house. When we arrived, she peered at me and said with unusual gravity, "Thank you, Mr. Nakayama. That was not only a real pleasure, but also a privilege."

"It was nothing," I replied, and then I got out of the car.

As I left Mrs. Bradford and retreated to my home, I began to feel—to my own surprise—a sense of reassurance. For my deepest concern—that my acting would not live up to my memory of it—had been comfortably put to rest. Certainly I will have adjustments to make for this new era, speaking for the camera being one of them. But I feel more confident now about the prospect of being the anchor for Bellinger's film, and I believe I can acquit myself quite well. Indeed, as I think about the contemporary reception to *The Patron*—which was a significant hit for Perennial in 1919—I can admit to myself how much I enjoyed being in the limelight. I have missed taking part in a vibrant social scene, and I have also missed the work of making motion pictures. I am looking forward to returning to the studio, to being surrounded by bright and creative people, more, perhaps, than I have cared to acknowledge.

As I enjoyed my tea that evening, remembering the film, I also found my thoughts returning to the business of acting, all the other things with which I will have to acquaint myself. Perhaps I should seek an agent, which is something that none of us had in the silent era. Perhaps I should think about securing a publicist, to handle the inevitable rush of media attention. Perhaps I should arrange to get an unlisted telephone number, to make me less accessible to the enthusiastic fans who will surely attempt to call. Some of these complications existed in my time, but the world has grown busier and more demanding since then, and I must ensure that I am well-equipped to handle it.

I was able to enjoy my thoughts of the future for half a day. For that very same evening, David Rosenberg called from the nursing home. "Listen," he said, "Ben Dreyfus' grandson came up here today. He wanted to talk about you."

My stomach dropped. "I see."

"He's not exactly the most endearing character. Launched straight into it, and hardly said hello. He wanted

to know what you were like, what kind of actor you were, and if you were all right to work with."

"What did you tell him?"

"What do you think I told him?" David said. I could hear voices rising in the background, but couldn't tell if they were arguing, laughing, or crying out in pain. "I told him you were the greatest actor of your generation. I told him you were an absolute professional, a real pleasure to work with. I told him that what happened to you, your leaving pictures and then practically dropping out of historical record, is one of the most regrettable things in the history of Hollywood."

"That was unnecessary." I was glad he couldn't see me, for I believe I might have blushed. "I'm humbled by your words, David, and I thank you."

"Oh, shut up, Nakayama. Humility never became you. Anyway, I know you expected this boy to come around, so this wasn't a real surprise. But I wanted to tell you that things did take a bothersome turn."

I waited. Through the phone I heard a wail, but David did not seem to notice.

"He asked why you didn't make any pictures after 1922, and I told him the same thing you probably told him, that you were offered crappy roles. He didn't buy it, and kept saying that it had to be something else. That it was too strange that you stopped working so abruptly."

I tried to control my breathing. "And so what did you say?"

"Nothing, old man. I said nothing. Even if I *were* inclined to speak about that time, I would never do it with a kid like him. He's too self-involved and immature to understand the complexities—he doesn't exactly have the sensitivity of his granddad." He paused. "And that's my point. Jun, he's real interested, and he's convinced he's going to dig something up. I don't know whether he wants to discredit you or find something he can use to help market

you. But he's not going to drop this, and I think you need to be prepared. He even mentioned that it was notable that your career came to an end around the time of the Tyler murder."

I said nothing, but gripped the phone so hard my knuckles turned white.

"He's on to something, Jun, and this is not the kind of kid who takes no for an answer. He has access to everyone and everything, including all the records at Perennial . . . Did you manage to find Owen Hopkins and Nora Niles?"

"I did have the opportunity to speak with Hopkins," I said. "I have not yet spoken to Nora."

"Well, it's time to try harder, Jun. You want to get to her before he does." He paused again. "Is there anyone else we're forgetting?"

I shook my head miserably. "I don't know."

"What about Hanako Minatoya?"

I started at the name. "I have no idea what became of Miss Minatoya."

"Did she know about what happened?"

"I'm not sure."

"You're not sure?"

"It's difficult to explain. We didn't speak of such things explicitly. But she always seemed to know more than I told her."

For a moment neither one of us spoke. Then Rosenberg said, "When was the last time you talked to her?"

"It's been years. Probably more than a decade."

"The last I heard she was living in Pacific Palisades, running acting classes."

"Yes, that's right. She always did love the ocean." I remembered our days out at Moran's studio in the Palisades, the walks we took together through the hills.

"You should go find her, Jun. Just to cover all the bases."

"I will."

"She was something, that woman. A real class act. So

quiet and beautiful, but tough as nails." He paused. "You know, I never understood why you didn't marry *her*."

I gave a light laugh. "Oh, we were far too much alike. We would have driven each other mad."

"I'm pretty sure she would have been willing. It's really kind of a shame. I think you were scared, Jun. She was the only one of those women who was honestly your equal."

I laughed. "What makes you so sure she would have had me?"

"Oh, she would have. I knew. I think that you knew, too. Hell, Jun, everybody knew."

I did not wish to continue on the subject of Hanako, so I asked, "Do you know where I might locate Nora Niles?"

"Yes, I do." Then David told me that Nora Niles lived in Brentwood, and that his associate at Perennial could furnish the exact address. "Be strong, Jun," he said. "Remember, it was a long time ago. Even if the truth outs, it'll be all right."

But I didn't believe him—either in 1922 when he first gave me this assurance, or in 1964 when he repeated it. I don't presume that, if I had been more forthright, I would have had a longer career—but I might at least have had the opportunity. The course of my time in film—and of others' time as well—might well have been very different. I wish I could say, as people do, that I didn't recognize the pivotal moments of my life as they were happening. Because I did. I knew precisely. I knew precisely and was powerless to stop them. It was as if I were watching something terrible unfold from behind a glass window and could not get through to intervene. My whole life changed in a few brief moments, and I knew it. I just didn't know how dramatically, how finally.

Despite my attempts to steer David away from the topic of Hanako, our conversation brought back a flood of recollections. For he was right—she'd been my equal, and in fact

my superior, and working with her had been one of my greatest pleasures. I was an ardent fan before I ever met her, and remained so for the rest of her career. I admired not only the finished product of her art, but also her bearing, the way she conducted herself. Hanako, unlike so many other Hollywood actresses, was never impetuous or prone to high drama. She was the consummate professional, not given to piques of rash behavior, and she had a stabilizing effect on every cast and crew she worked with.

That said, however, I do recall one or two instances when she acted out of character. They were odd little incidents, and perhaps I don't usually include them in my memories of Hanako because they seemed like such minor aberrations. Nonetheless, upon further reflection, I must admit that there were in fact one or two times when Hanako acted in a manner that could be thought of as impulsive.

There was, for example, the incident during the filming of my second picture, *Jamestown Junction*. We had reached the point in the film where Hanako's character, Mrs. Lee, a cook for a Chinese work crew, encounters a fallen prospector who'd upended her pot of beef stew earlier in the picture. Moran directed her to kick dirt on the injured man, but Hanako protested strongly. Moran looked at her in surprise—no one ever questioned his decisions—but Hanako stood firm.

"A woman of substance would never do that," she argued. "She would never stoop to the level of that common thug. She would do the proper thing—she would stop and assist him, even the very man who insulted her."

Moran stared at her. Finally, though, he shrugged his shoulders and agreed to do it her way. I was shocked by her behavior, but quickly forgot it. Moran had acquiesced, resolving the disagreement, but now I wonder what would have happened if he hadn't. Hanako had revealed a strength of will I hadn't known she possessed, and I am not sure she would have relented.

That, however, was a minor event. There was another incident, several years later, where Hanako behaved in a manner I actually found rather alarming. This was in the fall of 1921, soon after my lunch with Gerard Normandy. We were shooting *Velvet Sky*, the first film I had done with her in almost eight years, and it was only possible because Moran had loaned her out for a two-picture arrangement with Perennial. It was, of course, a great pleasure to work with Hanako again. I had forgotten how much of a creative challenge she presented, and in the first two weeks of shooting, her presence pushed me to the limits of my abilities.

Then one morning, Hanako did not arrive for our 7:00 a.m. start time. The director, James Greene, paced about on the set, worried about the tight shooting schedule. It was so unlike Hanako not to be on time that I began to grow concerned for her well-being. But then, at 8:00, she arrived on the set and immediately approached the director.

"Good morning!" said Greene, relieved.

Hanako stopped before him. I saw on her face not anger precisely, but a firm control that indicated more than tears or flushed cheeks how upset she truly was. "I have been hearing some interesting things in the news these last few weeks, Mr. Greene," she said. "Very interesting things indeed. For example, are you aware that the Native Sons of the Golden West are promoting a constitutional amendment?"

He stared at her as if she were speaking in Japanese. "What are you talking about, Miss Minatoya?"

"They want a constitutional amendment that would bar immigration from Japan and deny American citizenship to all people of the Japanese race, even those born here in America. The idea has been embraced by the Native Sons, the Oriental Exclusion League, and the Los Angeles Anti-Asiatic Association."

"Miss Minatoya," he said calmly, "I don't know what you're referring to."

She glanced down, the muscles clenching in her jaw. Then she looked up at him again. "California is being 'Japanized,' they say, like the South is being 'Negroized.' They're working to get all the state's congressmen behind a policy of exclusion. It is quite an interesting proposal, don't you agree? *And this studio is fully supporting it!*"

No one moved. It was so quiet you could hear people breathing. "Where did you hear about this, Hanako?"

She paused for a moment. When she spoke again, her voice was cold and even. "I read a quote from Leonard Stillman in the *Herald Examiner*, saying how Perennial was standing behind the proposed amendment. More jobs for Californians, that's what he said. Keep California pure and white."

"I don't know anything about this," Greene insisted. "But I'm sure that whatever Mr. Stillman said, he wasn't referring to you."

She smiled, but there was no mirth in her eyes. "It doesn't surprise me that you would believe that."

Still nobody moved. Hanako's eyes scanned the set and then settled on me. "What about you, Mr. Nakayama?" she demanded. "Do you have an opinion on this matter?"

I did not know what she was asking, or what she wanted from me. She should have known that I did not follow politics at all, and thus never grew impassioned, as she clearly had, about the developments of the day. In addition, I agreed with James Greene—this matter had nothing to do with people like us. I stood there silently, and Hanako turned away. I could not understand why she was acting in this manner, nor why she said what she did next: "I regret that I will not be able to continue my work here."

Now Greene looked very worried. "What?"

"My work here has now concluded, Mr. Greene. You will have to find someone else."

"Look here," said the director, stepping closer to her,

"you're overreacting, don't you think? You've got to get back on track here. I mean, we've got a picture to finish."

"I regret that is none of my concern."

"May I remind you, Hanako," he said, trying another tack, "that you are under contract?"

Now Hanako looked him straight in the face, and he actually took a step back. "It is unfortunate that the *rest* of your countrymen do not share your same sense of propriety."

And with that, she simply walked off the set. We all assumed that she would come to her senses and return later in the day, or perhaps the next morning, but she did not. She departed, she quit in the middle of a project, with a rashness that was most unexpected. Gerard Normandy was furious, and although he and Greene found a replacement—a young Chinese actress—she was nowhere near as talented as Hanako, and so the quality of the film suffered greatly. Normandy cancelled Hanako's contract and swore that she'd never work for Perennial again. And she didn't, or, over the next twenty years, for any other studio either, for it was shortly after this incident that she returned full-time to working with her theater company.

She was correct, of course, in her assessment of the coming legal changes. In retrospect, I realize that her anger was justified, and that my silence that day was wholly inadequate to the weight of the situation. For the very next year, the Supreme Court ruled that immigrants of Japanese descent could not be U.S. citizens; and two years later, Congress passed new legislation barring all further immigration from Japan.

Both these incidents were occasions when Hanako did not act in a manner consistent with her usual equanimity. But upon further consideration, I realize it is perhaps not totally accurate to portray them as moments of rashness. In both cases Hanako knew precisely what she was doing, and in both cases she held strong convictions. I recall them now because they were so unusual for a Japanese woman,

and because I myself could not imagine behaving in such a manner. It is not fair, though, to characterize her behavior in the same light as that of other actresses. Hanako was a woman of principle, and she stood by her beliefs, even if they sometimes caused her to act in unpredictable ways.

I waited several days after my conversation with David before I tried to call Hanako, a delay for which there is no easy explanation. When I finally did attempt to reach her yesterday, I discovered that her number wasn't listed. I reported this to David, who called me back this morning with the distressing news that Hanako—dear, stubborn, gifted Hanako—passed away two years ago. "She had cancer of the uterus, apparently," he said. "They didn't discover it until it was too late, and then she didn't tell anyone."

I am sure you understand my surprise at this news, as well as the fact that it caused me considerable sorrow. Hanako, my mentor and dear good friend, was gone, and I hadn't known anything about it. The news of her passing rendered me incapable of social interaction, so I canceled my usual weekend breakfast with Mrs. Bradford and unplugged my telephone. I spent the day recalling the events of the past and wishing I had photographs of Hanako. Some of these memories I had not allowed myself to revisit before, as they caused me a certain discomfort. But today I was powerless to stop them, and did not want to, and I could see Hanako Minatoya, and hear her voice, as clearly as if she stood right before me. It was these memories—helped along by the incident with the bird—that finally drove me out of the house and all the way up to the top of Runyan Canyon. And here I have sat for the last several hours, watching darkness descend on the city. There are thousands, maybe millions of lights spread out before me, each with a set of people and a story. I wonder how many of those people are following courses they will one day regret, making choices they will

look back on many years from now and wish they had handled differently.

I remember the last two times I saw her. They occurred within weeks of each other, almost fifteen years ago. After that, we lost track of one another, and although I often wondered how she was, I did not call upon her again. Now time has collapsed and I can recall those last two occasions as clearly as if they'd happened last week.

The first was on a winter night in 1949. Hanako had received the Best Supporting Actress designation from the New York Film Critics' Circle for her role as Nurse Suzuki in *The Longest Hour*, and the studio—20th Century Fox— was throwing a small party in her honor. If you have even a moderate knowledge of film, you may have heard of *The Longest Hour*, which is still mentioned along with *From Here to Eternity* and *All Quiet on the Western Front* as one of the finest war movies ever made. If you should ever have occasion to see this film, you will understand why Hanako was once heralded as one of the best actresses of her generation. You'll note her dignity and restraint, but if you look in her eyes, you will see there the unbendable will. Note the grace with which she moves, the way her careful assurance seems to calm all the people around her. Note the way she is able to convey emotion with a simple slight shift of the eyes, or with a deflation—like air escaping—of her shoulders. And note, too, her still considerable beauty, intact and powerful even in 1949, when she was sixty-one. There is no question that hers was the best female performance of that year, and perhaps of many years before and after. She later received a nomination for the Academy Award, although she was not the eventual winner; perhaps the members of the Academy did not see fit to give the award to a Japanese so close to the conclusion of the war. Fortunately, the critics appeared to have no such reservations and gave Hanako her just recognition.

The party took place at Yoshimura, the grand old restaurant off Second Street. It was not by any means a standard studio affair; there were only about thirty guests, all seated along two long tables set up in the traditional Japanese style. I had been nervous about the party, for I had not seen Hanako—or almost anyone else in the business—for more than twenty years. But I could not refuse the invitation of my old dear colleague, who had always been so helpful to me.

Upon entering the restaurant, I saw Hanako immediately. She was sitting at the end of the first long table, and I was struck by how little she had changed over the years, the leniency with which time had treated her. Her hair was still black and her face still lovely, and when she turned her head and laughed at something, she looked like the girl I had known in my youth. When she saw me a moment later, she came right over to greet me.

"Mr. Nakayama," she said in English, "it's so wonderful to see you." And to my surprise, she placed her hand on my forearm and squeezed it. I saw the fine network of lines around her eyes and mouth, the only evidence of age. Our eyes met and we were silent for a long moment, as if it would trivialize all that had happened in both of our lives to make small talk in the company of others.

"You were wonderful," I said. I feared she wouldn't realize I was speaking of her performance, but she seemed to understand.

"Thank you. It's my first film in years, you know. I've been spending my time in the theater."

"You have been working all this time?"

"Yes. What else was there to do? I took a hiatus during the war, of course, but even then I managed to work." Then, in Japanese, "I put a little company together in Manzanar and did plays for the internees." She paused. "I heard you managed to stay out of the camps."

"I went to England," I said. "I rented a flat in the country and took long walks through the hills."

"Did you work?"

"No. I didn't try to."

She sighed and returned to English. "I wish you'd consider working again."

I gave an indulgent smile. "Miss Minatoya, you know as well as I do that I'm finished with all of that. Besides, who would be interested in hiring an old man like me?"

"I would, in a moment. It's never too late to step back into it—I mean, look at me."

We smiled at each other, and there was so much I wished to say. Her grip on my arm grew stronger and she returned to Japanese. "We must catch up with each other, Nakayama-san. Just the two of us. Let's arrange to have tea sometime soon." Here she gave me an odd, bemused smile. "I won't let you get away from me again."

I sat down at the second table, next to a young Caucasian man and a younger Japanese woman. Hanako continued to greet people happily and usher them in, as if she were the hostess of the event and not its guest of honor. I recognized several of the others. There was Steve Hayashi, from the old days with Hanako's theater company, who still appeared in occasional films. On the other side of the room was the old widow Takayama, who'd been Hanako's landlady in Little Tokyo in the early years. Beside her was Seiichi Nakano, the other main player from Hanako's old company, a talented actor who'd left the theater to enter real estate. Nakano had courted her when we were all in our twenties, but for reasons I never knew, she turned him down. All of the guests filtered into the room and found spots at the long tables, which were already covered with plates of sashimi and vegetables, as well as bottles of sake. Finally, Hanako herself came back to her seat, and then a middle-aged Caucasian man from the studio got up and turned to face the guests.

"My friends," he began, "we're here to celebrate a very special actress and a remarkable woman. I think all of you

know and appreciate the quality of the performance for which she's been honored by the New York Film Critics' Circle. But I'm not sure that everyone is aware of Hanako's accomplishments over the years, or the long odds against which she's struggled. Hanako Minatoya's career didn't begin with this movie. No, it started more than forty years ago, when she joined a traveling Japanese theater company—at the ripe old age of eighteen. She then went on to star in a series of silent films, most of them directed by the legendary William Moran. And then, when prejudice against the Japanese grew so strong that working in film became impossible, Hanako did not let up. She redirected her talent and energy into teaching, and back into the theater, where she acted and directed and produced plays with her own company for more than twenty years. *The Longest Hour* is the first film she's made since 1921—and guess what, folks: Hollywood is finally ready for her now. Hanako's a testament of what can result from the marriage of talent and perseverance. She had every reason to lose hope and give up acting, but she didn't, simply because she had no other choice. So thank you for coming to honor her, but really, the honor is ours. I speak not only for 20th Century Fox but also for the entire community of film lovers when I say it is really us who are privileged, and me in particular, simply to know her and to have had the tremendous good fortune of being able to watch her work."

He then called for a toast, and everyone raised their glasses. This was followed by equally flattering tributes from other executives, and then from Steve Hayashi, who made everyone laugh with his story of Hanako as a teenager, eating French fries in a diner with chopsticks. After the tributes were finished, we all settled down to eat, and several kimono-clad waitresses moved quickly about balancing black-lacquered boxes of food. When they laid the first course out before us—unagi so tender it fell apart at the touch of our chopsticks—the young woman beside me

turned and asked, "So how do you know Miss Minatoya? Were you part of her theater company?"

"No," I replied, "I was only in theater for a short time."

"She's incredible, isn't she?" the girl said. "She was my acting coach, you know, and I just got my first part in a film. It's called *The Angels* and it'll be out in two months."

Her date considered me more closely. "You look familiar," he said. "Are you sure you weren't ever in movies?"

I laughed. "I did appear in a few films when I was younger. Probably nothing you would know."

"I'm a film buff," he said. "I probably *would* know. In fact, I'm the one who pushed the studio to hire Hanako for this role, because I was familiar with her earlier work." He raised his chopsticks and pointed them at me, and I suppressed the urge to tell him how rude this was. "I know who you are. You're that actor from *Sleight of Hand*. What's your name again? Jin? John?"

"Jun," I said. "Jun Nakayama."

The man waved his chopsticks like a conductor's baton. "Oh my God! I loved that old film! You were so dashing and dastardly. But I don't think I've seen you in anything else. Whatever happened to you, anyway?"

He was speaking loudly, and other people began to look in our direction.

"I made many films, actually," I said, lowering my voice. "The film you mentioned just happened to be the one that received the most notice."

One of the people who was drawn by the young man's voice was Steve Hayashi. "Jun? Is that really you?"

This drew the attention of Seiichi Nakano, who got up in order to see me. "Jun! What a pleasant surprise!"

Head after head began to turn in my direction, both those who knew me and those who were simply curious about what was causing the sudden commotion. The eyes felt probing, intrusive, and I wanted nothing more than to

wriggle away. But it was too late. And now Hanako, notic-
ing, stood up and made everything worse.

"Everyone," she said, "I want to acknowledge the pres-
ence of a great and renowned actor, one who has had a tre-
mendous impact on my work. Sitting in back there, trying
not to be noticed, is the incomparable Jun Nakayama. If you
want to see acting in its highest form—not to mention a
very handsome young man—I recommend his films *The Pa-
tron* and *The Noble Servant*. And if you want to see what I used
to look like, so you can appreciate how old and ugly I've
become, you can see us together in *The Stand* and *Jamestown
Junction*. Mr. Nakayama was a wonderful friend in the early
days of my career. Since I know how much he hates to come
out in public, I especially want to thank him for being here.
This success I'm enjoying recently is his as much as mine. So
much of what we struggled for is finally happening."

She looked at me meaningfully, and while I knew she
had meant this gesture kindly, it somehow only made me
feel worse. And it felt no better when the room dissolved
into a general buzz, people talking, no doubt, about who
I was and what I was doing there. A moment later, Steve
Hayashi kneeled beside me. Despite being in middle age
now, his features had settled into a kind of permanent
youth. I could see how his elastic face lent itself to both
comedy and menace, the two most common types of roles
he still appeared in.

"It's good to see you, Jun-san," he said. "We've really
missed you."

I told him it was a pleasure to see him as well, and then
did not know what else to say. He had always been a de-
cent sort, although only a second-rate actor—but now his
continuing career and friendship with Hanako were more
than I could bear to consider.

Around me, the glances and whispers continued. "Why
do you think . . . ?" I heard one person start. "It's such a
shame . . ." said another.

This was precisely the reason why I had avoided such gatherings—in order to stay away from people like Steve Hayashi. I did not care to hear more about Hanako's great success. I didn't even care to hear about Steve Hayashi, who had never become a star, but who had continued to work in theater and film for all of these years. I was more uncomfortable in that room full of Hollywood people than I would have been at a party of stockbrokers. Watching Hanako that evening, as she smiled graciously at everyone who came to congratulate her; as she reveled in the glow of finally receiving recognition after decades of tireless work, I felt a growing sense of emptiness. She had continued to do what she was meant to do with her life, in spite of all the obstacles. She had pressed on, unmindful of fame or prejudice or financial stability, and now, years after any reasonable person would have given up, she was finally being rewarded.

But I realized something else as I watched her that night. Even without the endorsement of the New York film critics, she still would have been this happy. She had never acted in films or worked in the theater for attention or approval. She had not needed recognition or an adoring crowd to make her feel that she was doing something valuable. Although she had now received a major award, the victory was almost redundant. In pressing on for all those years, she had already won.

I saw Hanako only one more time, a few weeks after the party. She had sent me a card thanking me for my attendance at Yoshimura and inviting me to tea at her house. Although I was somewhat apprehensive about seeing her alone, I was also—I must admit—rather pleased. In the time that we were colleagues, we had shared many hours of pleasant conversation—just the sort of give-and-take I had missed so much in the intervening years, as my life had grown more solitary. I was curious to see whether our

minds still met in this fashion; whether there was still the same ease between us.

As I drove out to her home in the Palisades, the decades fell away. Highway 1 was wider than it had been in 1912, when we used to drive out in William Moran's company car, and there were many more houses cramped together along the beach. But the hills were the same, and the ocean, and I might have been twenty-one again, driving along the coast to my fantasy job beside a talented and beautiful woman.

Hanako lived in a small house that was nestled in the hills. The yard was a shaded alcove that cut into the hill itself; from the back, one could just make out a sliver of the ocean. The setting was peaceful and we talked easily in English, which came more naturally to me, now, than Japanese. The garden had a carp pool and a small arching bridge, flanked by two stone lanterns. Other than Hanako's beloved cacti, which lined the side of the house, the scene reminded me of gardens from my youth.

"This looks like Japan," I remarked as she led me over the bridge and to a small table at the far end of the garden.

"I had the lanterns shipped over four years ago," she said. "I went home soon after the war. My sister's husband and children were lost in the bombings at Osaka, and I wanted to make sure that she was able to care for herself."

"I am sorry to hear that. My family was fortunate. They were in Nagano-ken, and were spared any serious damage."

She gestured for me to sit, and poured green tea from a porcelain pot. "It is incredible—the great destruction, and now new cities rising whole from the ashes. Japan is reinventing herself and shaking off the past. Have you visited since the end of the war?"

I shook my head. "No, I haven't been back at all since I first came to America."

She looked at me strangely. "Why such a long absence?"

"I don't know," I said, although of course I did. I had never been as popular as Hanako in Japan, where people had viewed films like *Sleight of Hand* with disapproval. And after the passage of the immigration laws, there was such a backlash against all things American that Hollywood films—including mine—were despised. Then, of course, there were the events of 1922. For the several months that followed, I thought about making a trip to Japan after my career had resumed. By the time it became clear that it would never resume, I was simply too ashamed to go home.

Hanako considered me sadly, and then said in Japanese, "That's truly unfortunate, Nakayama-san."

I looked down at my tea, and then over at the pond, where several large carp, all flecked orange and white, were pressing their mouths to the surface of the water, working their lips like mute humans.

"But I suppose," said Hanako, returning to English, "your decision to stay here isn't hard to understand. When I came to America as a teenager, I never thought I'd spend the rest of my life here. I always believed I'd return one day to Osaka."

"Why didn't you?"

"There was too much opportunity. I don't know if I could have had such a varied career in Japan. Certainly I could not have run a theater company." She looked at me over her cup of tea. "You always knew you would stay here, didn't you?"

"Not at first—I planned to go home after university. But I suppose I knew I would stay once I entered the theater."

"It was so simple in the beginning," said Hanako. "It was as if we would always be acting in good productions, working with talented people, with the whole world ours for the taking."

I nodded. "I could not have imagined a better way of life."

"But even more than the work," she said, "I loved the

newness of it all, the sense of possibility. The excitement of working with other people who inspired and challenged me." Here she took a sip of tea and looked out over her garden. "It's funny. Some of my best memories of that time don't involve the films at all. Some of my dearest recollections have to do with you, for example, and all the hours of conversation we had together."

I gazed out where she was looking, between the hills and toward the ocean. "Yes," I said, "it was a wonderful time."

"Do you ever wonder," she said, "what might have happened if we had lived our lives differently?"

And at first I thought she was referring to professional choices, my leaving Moran and her staying with his company. Then I thought she was referring to my lifestyle as a young man, the parties and liquor and women. Then I thought of Ashley Tyler's death and all the events that preceded and followed it. But finally I came to think that she meant something else entirely, something my mind had often circled around but had always declined to embrace. "There is no use," I began, trying to find the right words, "in wondering what might have been."

"Indeed. But perhaps I speak not merely of what might have been, but of what may someday still be."

I glanced at her briefly and found her eyes searching my face. Her hair was tied back into a neat bun and she wore a silk Western blouse and long skirt. And in this simple, unmannered outfit, she looked more lovely than a thousand gilded starlets. "I am far past the age of dreaming," I said to her gently. "I am an old man now, simply living out his days."

We were silent for several minutes. Two birds were calling to each other plaintively from opposite sides of the garden, and the wind was softly rustling through the trees. "Mr. Nakayama," she began again, finally, "why did you stop working?"

I turned to face her. "You know why, Miss Minatoya. You know very well. Certain circumstances made continuing very awkward."

"But that only limited your career in film. You still could have worked in the theater."

"I was fine, I didn't need money," I said. "I bought property, and with rents and investments there was enough to last me through several lifetimes."

"I'm not talking about your livelihood. I'm talking about the work. What about the *work*? You could have had a whole new career. Certainly you would have been welcome in my company. It's tragic that your talent went unused."

I shook my head and stared up at the trees, trying to find the calling birds. "I am flattered that you think so much of me, Miss Minatoya. But I had no interest in returning to the theater."

"You mean, after having been such a star in the movies, the theater was no longer enough?"

"No, I didn't say that. I simply would not have been fulfilled. My ambitions had always been of a larger scale."

"Perhaps that's true," she said after another silence. "But perhaps your ambitions were so large that they could never be fulfilled. You never married either, never had children."

"That's hardly fair. You have a lovely house and a successful career, but no husband, no family, no children. You speak of me, Miss Minatoya, but you are really no different. You are equally alone in the world."

She shook her head. "I may have no family, but I am far from alone. And unlike you, it wasn't my choice to remain unmarried. I *did* want to have a husband." Now she looked at me directly. "But it was not in my power to make that happen. And there was no one else I wanted to marry."

She continued to look at me, and I turned my eyes away. The implications of what she'd told me lay heavily on my mind, and there was no proper way to respond.

"This tea is delicious," I said to her finally. "Did you have it sent from Japan?"

I felt her eyes on my face, the weight of their disappointment. "Yes," she said, "it came from Shizuoka." And in that brief moment, all the tenderness had gone from her voice.

We had a few more strained exchanges, and it was clear we would not return to our former ease. After another twenty minutes or so, I prepared to take my leave. Hanako reiterated her interest in having me work with her company, and I said I would consider it, although we both knew that I would not.

At the door, she bowed deeply, a formal parting. "Goodbye, Nakayama-san," she said in Japanese.

"Goodbye, Minatoya-san," I responded, following her lead, and then I turned and walked slowly away.

And as I drove down Highway 1, retracing the route I knew so well, my mind ventured back to another exchange with Hanako, at the Pasadena Playhouse thirty years ago. For it occurred to me that the moment when I greeted her backstage; when I stood speechless and astonished by the power of her work—that moment could describe my entire life. I didn't keep my silence, I realized now, because I did not know what to say. I kept my silence because words would have diminished what I felt, and the strength of those feelings confused me. And now, when it was many, many years too late, I mourned this inability to speak my own heart, as well as the empty decades that have followed. For it seems to me now that I have been reliving that moment through all the long years of my life. It seems to me that I have always been standing there with joy within my grasp, wanting to reach for it, but forever holding back.

CHAPTER THIRTEEN
November 4, 1964

This bar, the Oak Grove Pub, is only three blocks from my town house, but I have never had occasion to stop here until tonight. It is a dark place with wooden interiors, as its name would suggest, with a clientele of plainly dressed, middle-aged people who are all clearly regular customers. I have walked by the green door many times—it is usually propped half-open—and wondered what the place was like inside. When I finally ventured in several hours ago, all the patrons turned toward me and squinted at once, like cave dwellers startled by a sudden light. Despite this rather inauspicious beginning, the bar has been a comfortable place to pass the evening. The bartender—a hard-of-hearing man named Tom—has kept my glass full of whiskey all night.

"Sure you're all right to drive there, John?" he asks with every refill, although I've told him several times that my name is Jun and that I live close enough to walk.

"I'm fine, thank you," I say now, forgoing the explanation. "How much do I owe you?"

"Own it?" he says, while he pours a pint of beer a bit further down the bar. "No, I don't own it, I'm just the bartender. The owner, he's one of those old Hollywood types. I never see him but he sends my checks on time."

I wonder who the owner is, and if it's someone I once knew, but refrain from pressing further. I don't wish to discuss old Hollywood. Indeed, all I wanted to do when I got home this afternoon was to drink some good Scotch and pass the evening alone. I don't have much of a taste for

alcohol anymore, which explains why my liquor cabinet was empty, thus forcing me to venture outside. But this morning's events were so trying, and my sense of equilibrium so consequently shaken, that I needed something to calm me down before I slept.

It is not surprising that my meeting with Nora Minton Niles should be so discomfiting. It's been over four decades, after all, since we last spoke to each other, and the circumstances of our parting—which I've put out of my mind for so long—were anything but simple. But perhaps because of my own ability to dull the edges of memory, I had somehow managed to convince myself that our meeting would be nothing unusual, and that the past would remain safely in the past.

I drove to Nora's house in Brentwood after my mid-morning tea, arriving at 11 o'clock. Although I had not actually spoken to Nora directly—David Rosenberg, true to his word, had helped make the arrangements—I felt confident that her agreeing to a meeting with me was indicative of her general good will. I was—I must admit—rather apprehensive, an anxiety I tried to temper by telling myself that she wouldn't receive me if she harbored bad feelings. Nonetheless, as I got ready, I took extra care to ensure that my hair was well-combed; that the pants and jacket I wore were neatly pressed. Approaching the address that Rosenberg gave me, I stopped at a small flower shop and bought a mixed bouquet. Then I drove the last few blocks to Nora's home.

The house was small and undistinguished, a white Spanish-style affair with a red tile roof. The hedges in front of the windows were overgrown, and grass sprouted up through cracks in the walkway. As I got closer, I noticed that the windows were covered with a thin gray layer of grime. There was nothing special about this house, nothing to mark it as the home of a former actress who had once been one of the biggest stars in Hollywood. When I knocked at the door, it was opened immediately by a middle-aged

woman with red hair and a stern expression. I thought I had come to the wrong address, until the woman said, "Mr. Nakayama, I presume."

"Yes," I said, "I am Jun Nakayama. I have come to pay a visit to Miss Niles."

"So they told me. They said you were a contemporary of Miss Niles. I'm sorry to say I'm not familiar with your work." Then she seemed to remember herself, and moved aside. "Excuse me, sir. Please do come in."

I stepped into the house and took off my jacket, which I hung over my arm, declining her offer to take it.

"I'm Amanda," the woman said, closing the door behind me. "I've been with Miss Niles for fifteen years."

"This is a lovely house," I ventured, not knowing what else to say. "How long has Miss Niles resided here?"

"Oh, for thirty years at least, since she auctioned off the mansion. She lived here with her mother until Mrs. Cole passed away ten years ago."

"You knew Mrs. Cole?"

"Yes, I did." Although she was too polite to say anything unpleasant, the distaste in her voice, the wrinkled nose, made it clear that she did not hold Nora's mother in high regard.

"I trust that Miss Niles has been well all these years?"

"I suppose so, sir, under the circumstances."

I wondered which circumstances she was referring to. Did she mean the fact that Nora's career had been aborted in the prime of her youth, when by all measures her greatest accomplishments should have lain ahead of her? Did she mean the sad truth that Nora lived with a bitter, dominating woman who chased away her daughter's every chance at happiness?

Amanda lowered her voice and gestured for me to step into the living room. "She hasn't had many visitors over the years, Mr. Nakayama. I'm afraid that you'll find her much changed."

I wasn't sure what she meant by this, but I did not have time to wonder, for in another moment we had entered the living room. It was small, full of heavy furniture, with thick, drawn curtains that shut out the midday light. As my eyes adjusted to the darkness, I saw that several movie posters hung on the walls, from some of Nora's biggest successes. Piled on the old piano, and on the lion-footed coffee table, were stacks of programs and old movie magazines. Framed photographs hung everywhere, mostly stills and publicity shots of Nora. And sitting in the middle of the large brown couch was Nora Minton Niles herself.

It was—there's no sense in hiding it—rather a shock to see her. She looked unreal—or perhaps I couldn't accept the reality she presented. Nora's hair was plentiful and still very dark, but it had the dull, lifeless quality of a stuffed animal head, which only mocked its previous vitality. Her face was carved with deep wrinkles, and her skin so worn one could practically see through it. When she glanced up at us, her eyes—once such a dazzling blue—were muted and slightly unfocused. Had I not known her true age, I would have guessed her to be eighty. In truth, she was sixty-two—eleven years younger than I.

Amanda went over to the couch and sat down beside her, while I remained at the periphery of the room. "Miss Niles," she said gently, touching Nora on the shoulder. "Miss Niles, Mr. Nakayama is here to see you."

"Who?" Nora's voice was incongruously loud, and she sounded distinctly annoyed.

"Mr. Nakayama, your former colleague. Mr. Rosenberg arranged it. You spoke with him last week. Do you remember?"

She shook her head, baffled, but then she looked up at me. I held the bouquet out toward her, and her face softened a bit. "I remember you. You're the flower man."

After a moment of uncertainty, I stepped forward and said, "Yes. Yes, Nora. I'm the flower man."

"I loved your film," she said. Then her voice changed again. "My mother thought it was indecent."

"I am sorry to hear that. But I think she couldn't always have disapproved of me. After all, we did eventually work together."

Nora gazed at me intently, which was rather unsettling, for I did not know whether she was seeing me as I was, or as she had known me in the past. "You and I? My mother let us work together?"

"We appeared in six films together, don't you remember? *The Noble Servant* was the first."

At this point, Amanda must have felt that our visit was going well, for she stood up and smoothed down her apron. "I'll go bring the tea. Would you like something to eat?"

I shook my head, and felt slightly panicked at the thought of her leaving the room. She must have sensed my apprehension, because she smiled and said, "Don't worry, Mr. Nakayama. She's perfectly harmless."

When Amanda departed, I sat rather uncomfortably in the armchair directly across from Nora and held my jacket in my lap. Her mind seemed to have wandered off again, and she stared smiling at a spot beyond my shoulder. I took the opportunity to study her more closely. Beneath the mass of wrinkles, the face was familiar but distorted, as if I were looking at her through a slab of cracked glass. Her lipstick was dark red, and her mascara too thick; beneath her hair I could see the gray roots. She wore a cream-colored dress with wide, elaborate folds, which was buttoned up to her neck and ruffled at the sleeves. The bottom of the dress was dark with dirt, and her shoes—cream-colored as well, and rounded like a ballerina's slippers—were worn and dirty. Suddenly I realized that the outfit looked familiar. Surely it could not have been her costume from *Flying Princess*, her comedy from 1917. But as I glanced around at the old furniture, the posters and pictures, I knew it was entirely possible.

"How have you been, Nora?" I asked, my voice too loud.

She didn't respond for so long that I thought she hadn't heard me. Just as I was about to repeat my question, she said, "I haven't made a picture in a very long time. But I'm writing a book now. A novel. Would you like to hear it?"

I hesitated, but then said, "Certainly."

She stood up and then, more nimbly than I would have expected, rushed over to her piano. There, she picked up an untidy stack of papers and sat down on the piano bench. "Wayward Winds," she announced, and she began to read. While I understood that the story was about a river and some trees, I could not determine anything more about it. The sentences did not connect, the words were like the spewing of a broken water sprinkler, plentiful but erratic. What struck me more than anything was the sound of her voice, which was at once so familiar and so changed. If I closed my eyes, I could have imagined that this was the Nora of my youth—except I could not, and the person before me was a worn, unbalanced woman, a sad caricature of the lively girl she once had been.

After fifteen minutes or so, she stopped reading and looked up at me expectantly. "It's wonderful," I said. "Have you been writing long?"

"Oh yes!" she said smiling. "It helps to pass the time. It gives me something to do until my next role comes along."

At this moment, Amanda reentered the room, bearing a tray of tea cups, a pot, and some scones. She placed these in front of us and poured our tea, and then, after determining that all was in order, turned around and left us again.

"Have you been working?" Nora asked, and I was sure now that she knew who I was.

I thought about Bellinger's film and my upcoming screen test. But looking at her holding that yellowing manuscript, I said, "No. It has been some time since I appeared in a film."

"We were good actors, weren't we, Jun? Everyone used to love us."

"Yes, we were."

"Everybody loved us. You and me, and Mary, and Elizabeth Banks, and Charlie Chaplin, and Ashley Tyler."

"Yes, Ashley Tyler," I said, and my pulse quickened at speaking his name. "As a matter of fact, Nora, I wanted to talk to you about him."

"I miss Ashley." She gazed sadly at the floor. "He was always so good to me."

"I believe that he cared for you deeply."

"My mother said he only wanted one thing from me, but it wasn't like that. He loved me for my mind."

I paused for a moment, wondering how much she knew. "Your mother perhaps did not see Mr. Tyler for who he truly was."

"He said I didn't have to do what she told me to do. He treated me like a grown-up. He believed in me!"

I did not know what to say to her, so I looked down at my tea.

"I saw him again," she said. "I saw him before they buried him. I paid a funeral attendant to let me in, and I kissed him and gave him a rose. I wanted to lie down there in the casket with him, but the attendant took me away." She stared at a spot beyond my head, and I wondered what she was seeing. Then she said, "It wasn't his baby, was it?"

I held fast to the chair to steady myself and worked to calm my breathing. "No, Nora," I managed to answer. "No, it wasn't."

"My mother thought it was his, you know. My mother thought it was Ashley's. But he never loved me that way. Never. Not even when I wanted him to."

I drew myself up straight and spoke softly, as if trying to keep a frightened animal from scurrying away. "Excuse me, Nora, but there are some matters I'd like to discuss with you about that time. Or rather, some things I hope

you'll choose *not* to discuss. There's a young man from Perennial named Josh Dreyfus, who happens to be Benjamin Dreyfus' grandson, and he may come here asking questions about me."

She looked at me as if just noticing my presence. "Benjamin Dreyfus' grandson?"

"Yes, do you remember Benjamin Dreyfus, from the studio? His grandson may want to know a few things about me, and perhaps about you as well. About some of the things that we experienced together."

"Benjamin Dreyfus' grandson," she said. "Yes, he was already here."

I had just leaned over to pick up my tea, and at this, my hand stopped in midair. "Josh Dreyfus was already here?"

"He came last week. He wanted to know about you. I didn't like him and asked Amanda to send him away."

I sat back, my mind racing in several different directions. "So you didn't tell him anything about the past?"

"He tricked me! He said he was Benjamin. But I saw his hair and his sunglasses and I didn't want him in my house."

I wasn't sure whether or not to believe her. In her condition, she might remember an encounter with Ben Dreyfus as if it had occurred last week. "If he comes back, are you going to talk to him?"

"He wasn't a nice man! I don't want him in my house!"

Her voice was loud and she sounded upset, and I knew her state of mind would not be improved by the question I had to ask next. "Nora," I said gently, "what happened to the baby?"

"Gone, baby," she said in a sing-song voice. "Gone, baby. Baby gone."

"What do you mean by *gone*, Nora? Did you go to the doctor?"

"My mother took it," she said. "I didn't want her to. My mother took everything I loved. Just ask Ashley."

At this, she began to cry, a soft sound that gradually built into a wail. She rocked back and forth and hugged herself, and the sound of her crying brought Amanda rushing back into the room. "I think you should go now," she said.

"I'm sorry, Miss Amanda. I don't know what happened." And I *was* sorry—not only for that day, but for all of the days, forty-two years ago and all the time between.

"There, there," she said, putting an arm around Nora, who calmed down almost immediately. Her cries quieted to whimpers, and she looked at the floor; she no longer seemed aware that I was present. In another moment, Amanda stood and led me to the foyer. I glanced back toward the living room one last time, more sad than I could find the words to say.

"She has good days and bad days," Amanda said by the door. "These last few days have been difficult."

"She mentioned that Josh Dreyfus was here. Is that true?"

"Yes. He came two days ago. He didn't stay long."

"Nora said he came last week."

"She's just confused. He came and immediately began to pressure her. A most distasteful young man."

"I'm sorry I upset her."

She peered at me suspiciously again. "As I said, she's not used to visitors. But thank you for the flowers. I'm sure she'll enjoy them."

With that, I left the house and drove shakily down to the pier at Santa Monica. I needed to be outside and to breathe some fresh air, so I walked along the boardwalk for several hours until the sun began to set over the ocean. Then, exhausted, I drove back home.

As I sit here this evening in the Oak Grove Pub, I'm both

troubled and relieved by the day's events. On the one hand—and I know this is entirely selfish—I'm glad that Nora wasn't willing to answer Dreyfus' questions. But on the other, given her state of mind, there is no telling what she remembers or thinks of the past, and it is always possible she might speak to him later. Besides that, I was truly disturbed by her condition. It distressed me greatly to see her so alone in her mind, and to think that I might have had something to do with her condition. I suffered as well because of what happened to Ashley Tyler—admittedly not as much as either she or Elizabeth, but my own troubles were not insignificant. And yet I have my health and comfort and certainly my mind, all things that have eluded poor Nora.

To be sure, seeing her again—and having even our limited conversation about the past—has also stirred up certain difficult recollections. For truth be told, in the atmosphere of hysteria that followed the Tyler murder, I was not as sensitive to Nora's circumstances as I would have liked. In my urgency to protect my own name and career, I did not offer her solace or comfort. I did not, as any decent man would have done, try to speak to her about matters that concerned us both. And if I now have questions about things that transpired; if I now feel excluded from decisions in which I might have had some say, the fault is completely my own. Still, I cannot help but wonder what might have been had I tried to talk to her after Tyler was killed. Nora—or her mother—might have made different choices, and the long decades that followed the end of my career might not have been so full of regret.

Had Tyler not been killed, Nora's relationship with her mother might have evolved into something different. It was already apparent that Nora was growing tired of Harriet's constant supervision, and during the filming of *The Latest Game*, our penultimate film together, I began to notice a change in the way she behaved around her mother.

Instead of listening to—or at least tolerating—her mother's comments and advice, she would simply turn from her, and sometimes go so far as to get up and leave the room. During a review of the rushes, when Harriet criticized the angle at which her daughter held her head, Nora stood up, stomped her foot, and exclaimed, "Mother!" A few days later, I saw Nora and her mother on the Perennial lot, gesturing and shouting at each other. Even Nora's appearance had changed—she'd cut the long, flowing hair into a less girlish style, and had abandoned the flowery gossamer dresses for the sleek, fitted dresses of the '20s. It was noted by several people that she was starting to look more grown-up. I wasn't truly surprised when, a few weeks later, I began to hear word of Nora going out at night, attending various parties; apparently Harriet hadn't found a way to keep her daughter from escaping their huge new mansion. One evening, I even saw Nora at the Cocoanut Grove, dancing with Charlie Chaplin. There was a new, more worldly aspect in her carriage and expression, and I found my eyes returning to her again and again. She appeared happy and intoxicated, looser than I'd ever seen her, almost desperate in her need to be free.

I do not know what caused this sudden marked rebellion. Perhaps she'd finally realized that it was she and not her mother who held the real power in the family. Perhaps it was a natural consequence of a young woman coming of age. Or perhaps it was simply that she was in love, since her most common companion during her nights on the town was Ashley Bennett Tyler. The young Mr. Riner Jones was gone, and for a while he was replaced by several other, older men. But whoever Nora might be entangled with in a given week or month, it was Tyler who accompanied her most often. Nora's mother was aware that she was going out in the evenings; one of the arguments I overheard was about a party she'd attended without her mother's consent. I almost felt sorry for the woman, since the one thing

she had control of, her creation, as I'm sure she saw it, appeared to be slipping away. On the other hand, I was glad, in an almost paternal manner, to see Nora enjoying herself and achieving some separation from Mrs. Cole.

That evening I saw her dancing at the Cocoanut Grove may have been the last carefree night she ever had. For it was only a few weeks later that the incident occurred that changed everything forever. It happened during the making of Into the Wild, the otherwise undistinguished work that achieved a certain notoriety because it was the last picture that Tyler directed, as well as the last film in which both Nora and I appeared. Indeed, it almost didn't proceed to shooting at all—the studio had not been for it, but Tyler convinced them, partly by promising to scale back my role. In subsequent years, I've often wished that he had not succeeded; the course of all our lives might have been very different.

Into the Wild was filmed up in what is now the Angeles National Forest, in a small open space enclosed by cedars and Douglas firs. This clearing was the size of a house and lit with a nearly preternatural light, which filtered in through a break in the branches far above the forest floor and hit the ground as bright and focused as a spotlight. Every morning for more than a week, a caravan of cars would make its way up through the winding mountain roads, followed by a truck which carried the film equipment. The trip was only twenty miles, but it took well over two hours, as most of the road was not paved. We drove up in street clothes and got into costume in unheated temporary sheds. Our hands would shake in the sharp morning cold.

The plot involved an explorer, played by Tyler, his bride, played by Nora, and his Indian wilderness guide, which was me. Tyler was both acting and directing, and I saw immediately the effect that this dual role had on Nora. Playing Tyler's wife seemed to stir her to a new level of agitation, so that when she talked to him, or touched

his shoulders, or enfolded herself in his arms, there was a flush in her cheeks that had nothing to do with performance. During the few scenes when their characters quarreled, her anger and disappointment seemed utterly real, and she would continue to rage or cry after the camera stopped rolling. Even these shows of emotion, though, seemed different somehow—not girlish pouting, but rather more womanly suffering. As usual, her mother wasn't present, since Tyler had barred her from the set. But on the last day of filming, Mrs. Cole made the trip to the forest uninvited, and following a brief argument with Tyler—and after she informed him that her driver had left—he reluctantly allowed her to stay.

We were filming a scene where the explorer finds that the party's belongings have been ransacked in the night. He is angry at first, and then consoling to his wife, who fears correctly that there are hostile Indians—one of them played by John Vail—lying in wait in the woods. The scene requires a subtle shift from surprise to anger to fear, and Tyler kept reshooting it to get Nora's expression right. Harriet, standing a few feet to the left of the camera, was growing increasingly angry. She clenched her fists and paced in a tight back-and-forth pattern. To this day, I do not know what caused her to be so upset—whether it was the sight of Ashley Tyler laying hands on her daughter (his character embraced hers when she saw what had become of their belongings), or the realization that Tyler disapproved of her, or if something else had happened between her and Nora. But as Tyler and Nora continued to reshoot the scene, Harriet became more vocal.

"Hold your head up straight," she instructed her daughter. "The cameraman can't see your face." Then: "Why are you wearing that ridiculous dress? Couldn't the studio have found something better?" Then: "You look like a stupid starstruck child, gazing into his face like that."

As Harriet spoke, Nora grew more upset, which resulted

in her missing her cues and stumbling over her marks and forcing Tyler to do more takes. Watching this, I felt embarrassed and powerless. The men in the film crew were bothered too. The cameraman, with his hand still cranking the camera, gave Harriet dirty looks; the prop man stepped right in front of her holding a reflector in order to cut off her view. John Vail, his face covered with paint and head crowned with feathers, lit a cigarette and mumbled under his breath, "Wicked old dried-up bitch." Tyler himself, typically, attempted to ignore Harriet, until finally one of her jabs made Nora burst into tears.

"Mrs. Cole," he said gently. "Please, you're upsetting your daughter, and it's making it difficult for her to concentrate on the scene."

"My daughter's moods are none of your concern!" insisted Mrs. Cole. "You are simply her director, and don't ever forget it. Stop acting like she's your wife!"

"Mother!" pleaded Nora.

"You shut up, you little slut. Let me finish."

But Nora didn't let her. Before Harriet had the chance to say anything else, Nora turned and ran into the woods. We were all so shocked that none of us reacted at first; then, finally, Tyler called out after her. He and Vail hurried off in the direction she'd gone, with Harriet close behind. They returned a few minutes later, without Nora.

"I'm sure she'll be back in a moment," said Harriet. "She's very prone to dramatic scenes lately."

"Well, if you'd just ease off of her—" began Tyler.

"I can say what I want! She's my daughter!"

"She's not a child! No matter what you choose to believe. She's a woman, and she's tired of you treating her like property!"

"And since when do *you* have such intimate knowledge of my daughter's feelings?"

"It's obvious. It's obvious to everyone! You're doing her much more harm than good!"

They broke off as quickly as they'd started.

"At any rate," said Tyler, lighting a cigarette, "I'm sure you're right, and she'll be back shortly."

But when she wasn't back shortly; when thirty minutes had passed and there was still no sign of her, Tyler suggested that the men split up and search for her, and that one stay behind with Mrs. Cole. There were mountain lions in the forest, and bears as well, none of which would bother us when we were shooting in a group but were more likely to attack if someone was alone. We knew that Nora couldn't defend herself against a wild animal. And it was easy to get lost in the wilderness.

I entered the woods heading north, walking along a small stream. For the first ten minutes I could hear the other men's calls and echoes—"Nora! Nora! Nora!" Then all human sound was lost, and I heard only the sounds of nature—the rustle of trees, birds chirping, the music of the stream. I made my way through thick underbrush, pushing back branches that were moist with frost. The air was pure and crisp and smelled of pine. Every few minutes I would see a patch of disturbed earth and wonder if it was the sign of a human or of some wild forest creature. Several times I heard strange noises and knew that something was watching; it was as if I were back home in Nagano again, making my way through untouched woods.

I must have walked uphill for thirty minutes or more, calling Nora's name, and then I reached a point where the air was even more chilly and the ground was spotted with snow. It was early November, and perhaps forty degrees at that elevation; I was sure that Nora wouldn't have walked so far in the cold without even a shawl. But just as I was about to turn around, I heard a girl's voice. It sounded like she was talking or singing to herself, and when I stood still to listen, I knew I hadn't imagined it. "Nora!" I called out, and the voice stopped for a moment and then resumed singing again. I pushed through some thick bushes that

grew up to the banks of the stream and found myself in a small clearing, with Nora not ten feet away from me. She was sitting on a large, flat rock which abutted the trickling stream. When she saw me her face lit up, as if she'd been awaiting my arrival for hours and had wondered what was causing the delay.

"Jun!" she called out. "Isn't it beautiful here?"

I stepped closer to the edge of the rock. "Everyone is worried about you, Miss Niles. You're very far from the set."

"Oh, who cares about the set! I want to be *here!* Here, away from everyone and everything!"

I didn't speak, and she turned to face me. "I don't mind *you* being here, Jun. I like to be with you. Why don't you come over and sit with me?"

I hesitated. The rock was the size of a dining room table, but finally I sat on the very edge and looked out over the stream.

"You don't have to sit so far away, Jun. I'm not going to bite you." She slid toward me, so close that her dress, which was now rather muddied, touched and then covered my leg. She took my hand in hers and leaned her head against my shoulder. "My mother is terrible, isn't she?"

I held myself as still as I could. "She's just concerned about you, Nora."

"She's *not* concerned about me, Jun, isn't it obvious? The only thing she really cares about is herself. And money! Money! Money!"

I said nothing, for she wasn't mistaken.

"And she's so ridiculous about men," Nora continued. "She gets so angry when I go to a party with someone, as if I'm going to marry every man I dance with. And poor Ashley. She's always carrying on about our 'inappropriate friendship.' Well, we *have* no such friendship. How could we have? She's there almost every time I see him." She looked up into my eyes, and the sight of her face so close

to mine made something jump in my stomach. "But now I get to see *you*, Jun," she said almost sleepily. "It's so nice to see you here by the river."

She placed her hand on my cheek, and as much as I told myself to pull my head away, as much as I saw a door opening that I did not wish to enter, I could not remove myself from her touch.

"You're fond of me, aren't you, Jun?"

I could feel her warm breath on my lips. I kept telling myself that this was Nora, who was only a girl—but the touch of her hand, her smile, said something different. "Of course," I said. "I like you very much."

"No, I mean you're *really* fond of me." And with this she leaned closer, so that I could feel her warm, full breasts against my arm. I felt a stirring and tried to keep my breathing steady. But I was not a strong man, I had never been strong, and she knew what she was doing to me.

"Miss Niles," I said, "you must be freezing. Let's go join the others and get you back to the warm."

"I *am* cold. You should feel how cold." She took both my hands in hers and held them against her cheeks, which were, despite her words, soft and warm. Then she guided one hand slowly down the length of her body, under her dress, and onto her knee. "Why don't you warm me," she said, although her flesh was hot to the touch. For one last moment I tried to pull myself away—but then, unaccountably, I thought of Elizabeth, of her arms around Tyler in my guest room that night, of her shrinking away from my touch. I was filled with an anger that transformed into passion for the young girl in front of me now. My hand moved up her thigh and I grasped her by the shoulder, laying her down on the rock. And as she held me close, as her breathing grew ragged and short, she whispered in my ears, and kept saying my name, and then moved into a place without words.

About six weeks after Ashley Tyler's death, just before I

was to return to the studio, a visitor called upon me at my home. I was sitting in the courtyard taking my afternoon tea when Phillipe came out, looking distressed. "Mrs. Cole is here to see you, sir."

I looked at him for a moment. "Show her in."

"Certainly." He turned away, and then shifted back again. "Would you like me to remain outside with you, sir?"

I smiled—apparently even my servant was aware of her reputation. "No, Phillipe. I'll be fine."

A moment later he returned with Harriet Cole, who strode toward me as if she'd been in my courtyard a hundred times before. Watching her approach, I realized that I had been expecting her visit. "Mrs. Cole," I greeted her, standing.

"Mr. Nakayama."

I bade her to sit in the chair across from me. She was dressed entirely in green, even her hat and shoes. I wondered how she would speak to me, in what form the anger would come. It occurred to me that I'd never been alone with her.

"What brings you to my house?" I asked.

"I think you know very well, Nakayama. My daughter."

Phillipe reappeared with a cup of tea, which Mrs. Cole received without acknowledgment. After giving me a significant look, he left the courtyard and reentered the house. He then assumed a spot just inside of the door, out of earshot but within clear sight.

"How is Miss Niles holding up?" I asked, trying to sound as normal as possible. "I know this is a difficult time for her."

Mrs. Cole brushed her sleeves off as if they were covered with something distasteful. "I find it amusing that you even deign to ask. You certainly haven't shown concern for her before."

I looked down at my hands, which suddenly seemed useless and pale. "On the contrary, Mrs. Cole. Not a day

goes by when I don't think of her. Where is she now? Is she still at the mansion?"

Beneath her hat, I could see her eyes grow sharper. "No. She's had to go out of town for the time being. She's safe where she is, however. She's being very well cared for."

"Because of her nerves?"

"Partly. But not only that. I'm sure you won't be surprised to learn that she's with child."

Although I kept my expression impassive, my hands began to shake. "I see."

"I thought it was Tyler, she doted on him so. What a bad piece of luck for that man. If I had known the truth, he'd still be alive."

I stared at her. "What are you saying, Mrs. Cole?"

She drank from her tea as calmly as if we were discussing my plants, the particulars of their need for light and water. "I'm saying you're very fortunate, Nakayama, that I didn't know the truth. If I had known at the time that I learned of her condition, you and I would not be sitting here today."

I tried to focus on keeping still. Although I did feel a flicker of fear, what Nora's mother was implying did not surprise me. Harriet was, in fact, one of the primary suspects in Tyler's death. Now I knew her motivation. "I'm not sure what you mean, Mrs. Cole."

"You should be ashamed, Nakayama. She told me all about it. How you found her in the woods by the river. How you lay with her on the rock. I know it was you, and had I known six weeks ago, it would be you and not Ashley Tyler who was dead."

I breathed deeply, waiting to answer until I could keep my voice even. "Why are you telling me all this, Mrs. Cole? What's to keep me from ringing up the police?"

She scoffed. "I've admitted nothing. And don't think of going to anyone. The police won't help you, anyway. They answer to me."

This did nothing to calm my nerves, but then she let out a genuine laugh. "You don't have to look so frightened, Nakayama. I don't plan to kill you—one death is enough, don't you think? But if you ever go near my daughter again, I *will* come after you, and damn the consequences." She sipped her tea and gave me a cruel little smile. "Don't think you'll get any protection from the legal system, either. The D.A. is a close friend of mine, and he'll keep that little rube Detective Hopkins under control. They won't do anything, Nakayama. They'll never do anything. The best thing you can do to keep yourself out of trouble is to leave well enough alone."

I exhaled. "I appreciate you coming to visit, Mrs. Cole. I will do anything I can—discreetly, of course—in terms of helping the baby."

She put the cup down and folded her hands together. "You will do nothing of the sort. You will not even *see* the baby. And don't think I'm letting you get away with this." She lifted one hand and curled her fingers, examining the nails. "My daughter's career is ruined; she may never make another film. If you make one false move, I'll tell everyone in Hollywood about how you took advantage of her."

I sat up straight. "I did not take advantage of her, Mrs. Cole."

She scoffed. "I realize that Nora can be stupid and headstrong, but she would never have a Jap for a lover."

"But Mrs. Cole, when I went searching for her, my intentions were honorable. I never meant—"

"Are you saying my daughter is a whore?"

"No! I'm simply saying . . . it was not a situation of force."

She arched her eyebrows and looked down her nose at me. "You disgust me with your sneaky Jap ways. Insinuating yourself with everybody. You think you're something, but let me tell you, no amount of money or fame or fancy clothes can change what you are underneath. Those fools

who run the studios let everything get out of order, but I'm going to set things straight. And if I *ever* see your face on the big screen again, I'll make sure that everyone knows what you did to my daughter."

I looked off toward the doorway, careful not to make eye contact with Phillipe. "Mrs. Cole, is this really necessary?"

"She's paying, and even your little slut Elizabeth's paying, and you're the one who caused this mess to begin with. So yes, it *is* necessary. You're through, Nakayama. If you try to work in pictures again, I'll ruin you."

Mrs. Cole's threats did have an effect on me; they were the immediate reason I canceled my appointment with David Rosenberg that week. Yet it would be untruthful to say she was the only thing that kept me from returning to Perennial. While I certainly couldn't put it past Mrs. Cole to "come after" me—the fate of Ashley Tyler was enough to prove that her threats were credible—I did not believe that she would ever expose my connection to her daughter. For the news of our tryst, and word of the pregnancy, would hurt Nora even more than it would damage me. Her mother *couldn't* go to the public—to do so would kill whatever remaining chance Nora had of resuming her career. I knew—and I think I knew this even the day she came to call—that Mrs. Cole would kill me before she'd ever reveal me.

If Mrs. Cole alone did not keep me from working, then the question remains of why I did not work. Even after I canceled my meeting at Perennial, David tried to reschedule, going so far as to call upon me at home to try and convince me to come back to the studio. But I declined every overture, until he finally relented, and at that point I knew my career was really over. Although this may seem shortsighted in retrospect, the reason for my refusal was simple: In my heart of hearts, I did not believe that I deserved to work again. Consider all the damage I had wrought. One brief lapse, one fleeting moment of weakness, had resulted

in a pregnancy, a murder, the destruction of four careers, and one of the biggest scandals ever to hit Hollywood. It seemed only appropriate that I should suffer as well, beyond the self-inflicted suffering of guilt. I thought I should be punished, and if there were no cause for the law to punish me, then I would have to dole out the penalty myself. This may seem like a severe line of thinking, but I was actually being lenient. Had we been in Japan—or had I been a more honorable man—I would have hastened my death with my own hand. But we were not, and I was not, and this was the best that I could do. I was finished the moment I lay with Nora on that rock.

And then there is the other matter, the question of the child. While it is possible that the child was fathered by someone other than myself, simple logic and timing suggest that it was mine. And if this is true, if I was truly responsible for Nora's pregnancy, then I was either the reason for a dangerous and illegal medical procedure, or there is, somewhere, a middle-aged person who is actually my child. I would like to say that I have thought about this over the years, but in truth I have tried to block it from my mind. It is only in these last few weeks, when so much else has come flooding back, that I have wondered if Nora completed her pregnancy, and if there was in fact a child, and what it might think or feel about its father.

After Harriet Cole's visit, I did not speak to anyone about Nora and Tyler for a very long time. I did not speak of Elizabeth either, even after her untimely death five years later, when she was only forty-one. The papers said it was consumption, but I suspected otherwise, for after Tyler was gone there was nothing left to keep her from the bottle. My sorrow for her was private and deep, and filled with regret; if I'd been a better man I would have helped her. But her death was one more tragedy to add to all the others, and I did not discuss it with anyone for several years.

When I finally did, it was entirely by chance, and while I learned several things I rather wished I didn't know, they also helped me understand what had happened.

This was in the winter of 1931, long enough after the events that ended my career that I could appear in public without being recognized. I had by then moved to my present town house, and purchased my current car, the Packard—a suitable choice for a mature gentleman no longer in the flush of youth. Although several of my neighbors did know who I was, I could generally conduct my daily business without anyone bothering me.

I was taking lunch one afternoon at a small nondescript restaurant off the Boulevard—I avoided any place that was frequented by picture people—when a man slid into the booth across from me. I was about to ask him why he was interrupting my meal when I recognized him as John Vail. He was still handsome, still slightly fragile-looking, although his hairline had crept back an inch or two and there were deep lines now in his forehead. He grinned the old mischievous grin that had made him such an effective scoundrel. "Hello, gorgeous. Fancy meeting you here."

I smiled. To my surprise, I was genuinely happy to see him. "John Vail," I said. "How have you been?"

He told me he was well—he was still in pictures, but on the other side of the camera now, writing scenarios—and he was kind enough not to ask about my career. After telling me about the latest project he was developing, he hesitated and said, "We sure do miss you down at the studio. You wouldn't recognize the place. It's *so* uptight—not the jovial place that you and I cut our teeth on. And the sound equipment, the technicians—hell, the whole idea of sound period. Sometimes I think we've gotten so caught up in voices that we've forgotten about character and story."

"Well, times have changed, and change is inevitable."

"Maybe, but it's been real tough on people. Gloria Swanson and Greta Garbo have done all right, but John

Gilbert and Clara Bow are finished. Their voices weren't even *bad*, you know? They just weren't what people imagined. Shit, Clara was the biggest star in Hollywood four years ago. Now she's done and she isn't even thirty."

We sat staring at the table, which was streaked from the dirty towel that had been used to wipe it. Vail must have realized who he was talking to, for now he looked up at me sheepishly and shook his head. "And you too. What a horrible shame. I wish they hadn't run you out, the prejudiced bastards."

I looked up at him. "What do you mean?"

"The studio men," he said. "The way they talked about you. It was almost like they were *glad* you got caught up in the Tyler mess, because it gave them an excuse to let you go."

I considered this information for a moment. "You're mistaken, John. David Rosenberg came personally to ask me back to work."

"Yeah, but that was David, don't you see? Not Normandy or Stillman. It's not like they were tripping all over themselves to give you another contract. By that point, with all the papers making a fuss about the Yellow Peril, they considered it an embarrassment that you were under contract. I heard them talking about it, Jun. It wasn't a secret. Why do you think the roles were drying up?"

I pressed my lips together to quell my irritation. "They were not 'drying up.' I was just being more selective. It was Ashley's death that changed everything. If he hadn't died, I might *still* be a leading man. I might be as big as Fairbanks, as Gary Cooper."

Vail looked at me sadly and started to say something, then appeared to change his mind. "Well, yes," he said finally. "The murder did have its reverberations. Poor Elizabeth Banks. Poor Nora Niles. Not to mention poor all of *us* for how clean pictures got after the studios agreed to the Hays code."

Neither of us spoke for several moments. Then Vail shook his head and said, "The funny thing is, if Nora really *was* pregnant like people said, and if Harriet Cole did kill Ashley, then she went after the completely wrong guy. Ashley Tyler *couldn't* have made Nora pregnant."

"Why do you say that?"

He looked at me with genuine surprise. "Why, Ashley was as queer as a three-dollar bill. He wouldn't have touched a woman if his life depended on it."

I just stared at him. "How do you know? Are you sure?"

"Yes, I'm sure. And I know the surest way you can. I have, how can I put this? *Intimate knowledge* of his preferences."

I paused for a moment, recalling my Independence Day party—John Vail's tousled hair, and Ashley Tyler's. "But what about his family in New York?"

"I don't know, but my guess is he probably *had* to marry. Hell, even I was married for a couple of years, until she found me in the sack with her brother. But Ashley wasn't cut out for the family scene one bit. Why do you think he fled to California?"

I sat there stupidly, trying to take all of this in. Vail's predilections did not surprise me; I'd known he didn't have a taste for women. But Tyler? "He was homosexual? I had no idea. I knew his servant was homosexual, because of that morals charge. But Ashley himself? I can't believe it!"

John threw back his head and laughed. "Oh, Jun, you're such an innocent. Willy Parris wasn't queer. He was picking up boys in Westlake Park to take back to Ashley."

I shook my head; I was totally speechless. But as I thought about it, I realized the signs had been there all along. Tyler was so proper, and he never joined the other studio men on their trips to the after-hours clubs and brothels. And although he was surrounded by adoring women, he'd always claimed that his friendships with them were chaste. Now I knew why. I wondered if *they* knew. I considered the irony

of the fact that all of these women, who were so desirable to others, desired the one man who wouldn't have them. And I thought of Ashley Tyler, or Aaron Towland, and the elaborate fictions he had weaved, which were as much of an accomplishment as anything he ever committed to film.

"Who knew about him?" I asked now.

"Oh, everyone. The studio knew. Why do you think there were so many people at his place the morning he was found? We were trying to get rid of the evidence that he was anything but a red-blooded lady-killer. Of course, we had no idea about his life before pictures. He had us believing he was practically royalty, the clever bastard."

"You were there that morning?" I asked, surprised.

"Yes, I left before you and Elizabeth arrived. I removed some of his letters, some compromising photos. There wasn't much, but they wanted me to get rid of it all."

"What about the revealing pictures of him with the actresses? The lingerie? The perfume-scented letters?"

"There were no pictures—that was pure fiction, and the papers ate it up. Or rather, there *were* pictures, but like I said, they weren't of women. The letters were real; women wrote him all the time. Most of the intimate garments were planted—except, interestingly, Nora's nightgown. She *had* given him one, the poor desperate thing. Maybe she thought it would somehow make a difference."

"But he didn't touch her."

"No, he didn't touch her. I never understood why all those women tortured themselves over him—he wasn't going to change. But Nora really loved him, I think, as much as a young, unbalanced girl can love anybody. She was there that morning too, you know. Showed up right when I did, just desperate to see him. I shuttled her out of there before anyone could see her."

"Nora was there too?"

"Shit, Jun, the whole studio was there. I'm telling you, they didn't want anything to be out of their control. Every-

thing the press got hold of was because the studio wanted them to. When we found out who Tyler really was, hell, that threw *everyone* for a loop. I guess the old bastard was a better actor than we thought." He shook his head. "But you know, that still leaves the question of who got Nora pregnant. From what I hear, there were more than a couple of candidates."

"What do you mean?"

"Well, the rumor was that Nora was stepping out all the time. I don't know whether she was doing it to prove a point to her mother, or maybe she just needed affection, but there were several men who claimed to have slept with her. You never know if it was just talk, but there was definitely interest. Why do you think Tyler started escorting her around? He wanted to make sure that all those wolves stopped sniffing up to her."

My mind was working to incorporate this new information. Vail continued to talk.

"The word was that she stopped seeing those men once Tyler put the clamps on her. But obviously someone got through his iron defenses." He pulled out a cigarette, lit it, and took a long drag. "So who knows who the lucky daddy was? My guess was always Clarence Hand, he had such a crush on her. Or Jacob Steele, since he fucked everything in sight." He exhaled a stream of smoke and glanced at me sideways. "Then there's you, I suppose. You always did well with the ladies. And you did find her up there in the mountains."

I laughed loudly. "That's funny, John. Amusing indeed. You've always had a strange sense of humor."

All of Vail's revelations disturbed me, for they made Tyler's death, and the ruining of the actresses' careers, seem even more unnecessary. I did wonder, though, if they were accurate. If he could be so incorrect about the end of my own career, then he could have been wrong as well about Tyler's circumstance. I knew that he was probably

right about Tyler—the evidence, including his own expe-
rience, was insurmountable. Harriet Cole, on the other
hand, clearly hadn't known. And Nora and Elizabeth either
weren't aware themselves, or had embarked on the futile
effort of trying to change him. That the studio had made
such an effort to cover up his secret was not a surprise; the
news would have been explosive. A homosexual director
would have been just as damaging to Hollywood as a scan-
dalous and unsolved murder.

Regarding my own career, however, it was wrong-
headed of Vail to assert there was a backlash against me
simply because of my race. As I've said, my career was
slowing down of its own accord—both because of my own
increasing selectivity, and because my time in the public
eye had already spanned ten years. Certainly I was getting
less favorable material, and was appearing less often with
A-list actresses and directors. And certainly the studio did
not extend itself to sign me to another contract. But these
things could have occurred to anyone at that stage of his
career.

On the other hand, perhaps there was some element of
truth to Vail's interpretation. For over these last few weeks,
as I've been busy with preparations for my return to the
screen, I have found myself remembering certain troubling
events from the months before Tyler's murder.

There was, for example, my golf date at the Westside
Country Club. I was scheduled to tee off at 8:00 a.m. with
a foursome that included Mr. Matsui—the head of the
Japanese Association—his now twenty-two-year-old son
Daisuke, and Mr. Hiroda, a successful agricultural maven
from the Sacramento area who was one of the biggest sup-
porters of the Little Tokyo Theater. When we approached
the pro shop to acquire our caddies, the sleepy college-age
youth behind the counter sat up and said, "I'm sorry, but
there must be some mistake."

I gave him an indulgent smile. "Young man, it's far too

early to be dealing with such inconveniences. We have an 8:00 a.m. tee time, and we are ready to begin."

The youth—who looked like he might be home for the summer from a place like Harvard or Princeton—scanned his schedule and shook his head. "I have a Rosenberg here, from Perennial. Now what is your name?"

"Nakayama. Yes, David Rosenberg made the reservation for me. He often makes such arrangements under his name, for if it leaks out that I am going to be appearing somewhere, it is impossible to keep the public away. Now please, assign our caddies and we'll be on our way. I'll even send you an autographed picture for your trouble."

The young man started to fidget and would not look me in the eye. "I'm sorry, sir, but that won't be possible."

My patience had run dry. I put both hands on the counter, leaned over, and gave my most direct stare. "Is our tee time taken? We can always wait awhile. I understand if you're doubled-scheduled. These things happen."

"No, it's not that . . ." His voice trailed off and his eyes wandered up to the wall, where the rules of the club were posted in black wooden frames. There was a sign that said, *Tee Times by Reservation Only*. Another said, *Bring Your Own Shoes*. Then, a small sign just below and to the right of the others: *No Japs or Negroes Allowed*. I blinked and looked again to make sure I had read it correctly. When it was clear there was no mistake, I felt a queasiness in my stomach. Matsui and Hiroda looked just as ill as I. Turning back to the boy behind the counter, I said, "I've golfed here several times before, and there has never been such a policy. Where's the manager, young man? I wish to speak with him."

The youth squirmed, and if I hadn't been so angry, I might have felt sorry that he'd been placed in such a difficult position. "Mr. Evans isn't here, sir. He won't be in today. But that policy, it's been in effect for six months now. And it'd do no good to complain. Mr. Evans proposed it himself. The whole Board of Trustees voted to approve it."

We stood in silence for a moment until I could trust myself not to reach out and strike the boy. "Young man," I said finally, "do you know who I am?"

He gulped. "I do, sir. And I'm tremendously sorry."

As awkward as that morning was, I can honestly say that such occasions were rare. Not everyone shared the policies of the Westside Country Club, and certainly in some cases—as had always been true—my celebrity helped smooth over such limitations.

This might have been what occurred when I had lunch with Gerard Normandy, the day we discussed my contract. As I've thought about it over the last several weeks, other details of the lunch—and in particular, of my time in the lobby beforehand—have come back into my mind. I always remembered the whispered discussions of the maître d' and waitstaff while I stood by the fountain, the glances in my direction, my growing sense of unease. But what has come to me more recently is what happened when Normandy first arrived. For it is clear to me now that right after he greeted me, he was called over to speak to the maître d', and that at one point Gerard raised his voice and said, "Why, that's preposterous! This man is a motion picture star! He can eat where he damned well pleases!" And it seems just as clear—although I cannot be certain my memory is accurate—that at some point the maître d' said in return, "I'm sorry, sir, he's just not welcome." Those were the only full sentences I heard, although there are snippets of Gerard's voice I now recall, things like "Perennial gives you a great deal of business . . ." and "If you persist in enforcing this ridiculous rule . . ." Whatever he said must have been persuasive, for soon we were seated at the table by the kitchen.

Then finally there was the incident that Gerard brought up at that same luncheon, which occurred during the filming of *Geronimo*. We were scheduled to film a fight scene in

the San Fernando Valley—I was playing the lead role—and when my driver took me out to the shooting location at 7:00 a.m., there was a group of perhaps forty onlookers gathered outside of the fence. This was not unusual—people often watched us film on location. As we made our way through this particular group, however, I saw that they were carrying signs. They did not say, *Jun, I love you!* or, *Marry me, Jun!* like the ones I was accustomed to seeing. Instead, they said things like, *Keep California White*, and, *Jap Go Home*, and, *No Japs Welcome in Hollywood.* A large banner held up by several people said, *Hire American actors. Swat the Jap!* And when I looked at the people's faces, they were as ugly as the language of their signs—compressed, bitter, crimson with anger. I was so unnerved that I locked all the doors.

"Jesus," my driver said, easing his way through the people to the gate. Several of them hit the car with their fists; somebody spit on the windshield. There was so much yelling and banging that I was afraid the car might be overturned, or that the mob might break the windows and pull us from our seats. But the driver, honking and cursing, finally made it to the entrance, where a Perennial worker ushered us safely through.

"They're organized, the idiots," said the worker when he opened my door. "The Anti-Jap Exclusion League got word that you'd be filming here today."

I appreciated his sympathy, but it did not do any good. Although the protestors remained outside of the gate, their coordinated chants of "Jap Go Home!" were so loud and persistent that none of us could concentrate. I simply ignored the yelling and attempted to play the scene, but the rest of the actors were hopelessly distracted.

"We're going to have to do this another day," the director said eventually, after conferring with his cameraman. "Preferably where no one can find us."

I cannot deny that these incidents were deeply troubling to me, both at the time they occurred and long af-

terward. Perhaps I have not been completely exhaustive in my descriptions of certain encounters from that era. But if I have not recounted these more upsetting events in any significant detail, it is because I do not wish to make too much of them. The kind of incident that occurred during the filming of *Geronimo* was fortunately never repeated, and unpleasant scenes of any degree were relatively few. I recount them now not out of a sense of self-pity, for certainly no one was more fortunate than I. I recall them simply to acknowledge that there may have been some truth to Vail's interpretations.

Perhaps I did not fully appreciate that what occurred in the outside world affected what occurred in pictures. For when one recalls some of the other things that were happening in the city—the vandalized fruit stands, the stoning of Japanese mailmen, the horse manure smeared on the front door of the Little Tokyo Theater—it is difficult to claim that the atmosphere in California had not become more hostile. And when one considers the legal decisions of the early 1920s—and then, of course, the regrettable developments of the early 1940s—it is hard to maintain that dislike of the Japanese was a small, localized phenomenon. It's possible that I, despite all my popularity, came to be seen as a symbol of a disliked group of people. Indeed, as much as I am loathe to admit this, one can hardly read the difficult events of that time—the *Geronimo* protest, the incident at the golf course, even Perennial's decision not to renew my contract—as anything other than an obvious rejection based solely on the fact of my race. I had been admired—loved—for years; that much was true. But like many loves that are forbidden or that carry the tint of shame, I'd been relinquished in the face of public disapproval.

CHAPTER FOURTEEN
November 19, 1964

I have finally returned to the safety of my own quiet town house, after a night and day of nerve-wracking mishaps. It was fortunate, to say the least, that Mrs. Bradford was home when I called. I dialed her number from a phone booth in front of the old DeLuxe Theater, which now stands empty and deserted. I should not have been there by myself at such an hour. As I waited the twenty minutes for Mrs. Bradford to arrive, two jumpy, stringy-haired young men were watching me closely, stepping out of the shadows toward me and then back again. My car—the old Packard—stood useless at the curb, one tire so flat it rested on its rims. When Mrs. Bradford finally appeared a few minutes after midnight, I nearly collapsed with exhaustion and relief.

I was at pains to describe how I'd arrived at this place; I could hardly keep the events straight in my own mind. I had started out the evening at the Tiffany Hotel, in the center of old downtown. Although the Tiffany had once been one of my favorite places, I hadn't eaten there in over forty years. Perhaps in my distracted state I did not appreciate the passage of time, for despite my absence of several decades, I thought it was perfectly reasonable to stop by the Tiffany and unwind with a drink in the bar.

When I parked my car across the street from the hotel, however, my surroundings were unrecognizable. The Tiffany's granite façade was still there, and its insets of burgundy tile. But the buildings around it had fallen into disrepair, and the storefronts—at least the ones that were

occupied at all—belonged to shoe shops and discount clothing stores. Unsavory people milled about on the sidewalks, and when I entered the lobby I wasn't sure if I had found the right place. I had, of course; this was indeed the hotel. It just wasn't the place I remembered.

The grand two-story lobby had been reduced to one floor, the marble columns were gone, and the lush Oriental carpet had been removed, now replaced by scratched linoleum tile. Old furniture from the rooms upstairs—beds, dressing tables, desks—had been stacked together and pushed haphazardly into a corner. There were people in the lobby, yes, but not the men in suits and ladies in gowns that one would have found there in the '20s. The half-dozen people sitting on ripped couches against the wall were dressed in worn, disheveled clothes, and several of their faces were streaked with dirt. Some of them mumbled to themselves, and one was snoring loudly. I could smell them from where I stood.

"Let me ask you something," called out one man. He was wearing a wool cap and a ski jacket with the stuffing coming out of the sleeves. I looked around to see who he was addressing, but nobody replied.

A metal desk stood where the concierge used to be, and a bored-looking young man in a security guard's uniform slouched on a small chair behind it. When I approached, he glanced up from his newspaper. "Tour hours are over," he said. "You'll have to come back tomorrow."

"May I look around the lobby?" I asked.

He shrugged. "Suit yourself. The old dining room's closed, though. They're using it for storage."

I looked beyond him to the old wooden check-in counter, which remainted intact, but seemed out of place now in those dingy surroundings. The space above it was covered with plywood. "What happened to the stained glass?" I asked, remembering the beautiful thirty-foot windows that filtered in the afternoon light.

"They covered 'em up. The bums outside were throwing rocks through 'em."

While I stood there staring at the old check-in area, the man in the ski jacket said more loudly, "Hey, can I ask you something?"

The guard sighed impatiently. "Pete, shut the hell up! Can't you see we've got a visitor here?"

I turned toward the entrance to the bar. The heavy wooden door had been replaced by a glass door that had several cracks running the length of it. Inside were decorations from the dining room—tablecloths, paintings, broken chandeliers. I could not bear to look around me anymore, so I turned back to face the guard.

"What is this place?"

He looked over at the people on the couches and then up at me. "It's a crash pad for people who got problems up here," he said, tapping his forehead. "I guess you could say it's one step up from a flophouse."

"This used to be—"

"Some kind of fancy hotel. I know, can you believe it?"

I thanked the guard and walked back outside and across the street to my car. I did not feel entirely safe—disheveled men lingered in doorways, and a younger woman in gaudy clothing and too much makeup looked me up and down before continuing down the street. By the time I got back into the driver's seat, I was shaking all over. I could not reconcile the squalid hotel I'd just seen with the place I had frequented as a young man. I could not understand what the years had done—to the Tiffany Hotel, and to all of us.

After a moment, I gathered myself and drove the four blocks west to the Biltmore. That hotel, thankfully, still had a restaurant and bar, and the patrons—while not as glamorous as the patrons of old—were still a respectable sort. I had several glasses of Scotch, and stayed in the bar all evening. For the first time, I felt truly old. And per-

haps with all the talk of Thanksgiving approaching, I felt more melancholy than usual; I knew that this year, like every year, I would spend the holidays alone. I must have had more to drink than I realized, for when I got back in my car, I hit a curb turning the corner. Then, in need of something cheerful, I had the urge to drive over to the old DeLuxe Theater, where in my altered state of mind I half-believed that one of the old vaudeville troupes might be performing. I hit another curb or two as I made my way through downtown, and when I reached the old theater, I found that it had been abandoned. I got out of my car for a closer look, and when I returned, I discovered that my tire was flat. For a moment I panicked; I'd never changed my own tire. Then I thought of Mrs. Bradford.

She was kind enough to drive me home without asking any questions, accepting my explanation that I'd had a difficult day. She went so far as to accompany me into the house, which would have caused me discomfort under normal circumstances but seemed perfectly natural now. After seeing me to my armchair and asking where the cups were, she brewed me a pot of strong coffee. Then, as I drank it, she called the automobile club and arranged for someone to retrieve my car in the morning. After that had been settled and she was sure I was all right, she sat down on the couch across from me. I noticed, even in my altered state, the graceful lines of her jaw and neck, more apparent because her hair was tied back. She looked, at once, quite younger than usual, and also—given the hour—rather tired.

"I'm starting to worry about you," she said.

I waved her away. "I'm fine, Mrs. Bradford. I'm fine."

"I'm not so sure about that. I tried to find something for you to eat with your coffee, and your refrigerator's totally empty. There's nothing in there but iced tea and some Japanese pickles." She leaned forward, an expression of concern on her face. "Mr. Nakayama, you need someone to look after you."

I assured her again that I was fine and that all I needed was sleep, and so, after one last disapproving shake of the head, Mrs. Bradford took her leave.

But I haven't been able to fall asleep, and I'm not sure that sleep will come to me tonight. My mind keeps working like an engine that is idling too high. I can't keep myself from going over what happened today at Perennial, when I went to do the screen test for Bellinger's movie. I cannot stop reliving the troubling details—of the screen test itself, and of my meeting with Josh Dreyfus that followed it.

Dreyfus had instructed me to come at 3 o'clock, my first indication that the day would not go well. I like to work in the morning, when my mind is sharp and my body still full of energy. But there was nothing to be done, and so at 2:30 p.m. I arrived at the Perennial gate. Upon gaining entrance to the studio grounds, I was struck first by how familiar everything looked. The main buildings were the same, and the fountain in the courtyard, and the flower beds along the south wall. But there were significant changes as well. For one thing, the grounds were much larger, taking up several city blocks, perhaps square miles. There were little golf carts everywhere, weaving through the people. Huge billboards dominated the sides and fronts of the buildings, with likenesses of current stars looming fifty feet high. The people, on the whole, seemed more aware of themselves now; even the stagehands and office people had too much makeup and expensive-looking haircuts. As I stood at the steps leading up to the main building, a cluster of about thirty people came moving slowly down the sidewalk, with a young woman bellowing a history.

"This fountain was a gift from Gregory Coleman, the oil man. It was placed here in 1918 after one of the producers at the time, Gerard Normandy, gave Coleman's mistress a part in a movie."

I wanted to shout a protest to this false information.

Bessie Calloway, Coleman's lover, had indeed starred in several films, but she only met Coleman—a close friend of Normandy's—after the oil man had already given him the fountain. More fundamentally—and this was the stronger reaction—I could not believe that this woman was leading a tour; that more than two dozen members of the fawning public had been allowed to enter the studio. In my day, we would not have dreamed of opening the studio up that way—it was a place of serious work, and was not meant for public display.

A few minutes before the appointed time, I made my way into the central building and asked for Dreyfus. The woman at the receiving desk directed me back outside and told me to look for Stage 4. I had never been to this part of the studio before, but her directions were accurate, and in a moment I arrived at the proper doorway.

"Ah, Nakayama," said Dreyfus as he opened the door. "Come in, come in."

He led me over to the stage, where a half-dozen people milled about. A camera was set up to face it, although the cameraman was busy reading a newspaper. Offstage to the right was a haphazard collection of props—a stuffed cow head, nineteenth century rifles, and dark green monster suits. Dreyfus introduced me to the other people—a man of about forty whom I recognized as the director Steven Goodman; a younger man named Tony, who was the assistant casting director; Kenneth Gregory, an older gentleman who would be the producer; and a girl named Star, who appeared to be someone's assistant. Also present was an actress I recognized as having played supporting parts in several films, a lovely young woman in her late twenties whom Dreyfus introduced as Beth Michaels. I felt overdressed. After much consideration, I had settled on a tan suit, yellow vest, and navy-blue tie, but the other men wore casual slacks and short-sleeve shirts, with the exception of Dreyfus, who at least had on a jacket. Tony did not

even have proper shoes; his large feet spilled out over a pair of leather sandals.

"Where's Bellinger?" I asked.

"Ah, Nick," said Dreyfus. "Well, Nick isn't here. I know he wanted to be, but I find that it's a mistake to involve the writer at this stage. He often has too strong of an opinion about who should play what, and can't get past his own ideas."

I was not pleased, and wondered why Bellinger hadn't warned me of his absence. But there was no time to worry about it, because then Dreyfus clapped his hands and walked to the front of the room.

"We're going to do two scenes," he said. "Jun, Beth here is going to play Diane Marbury. The first scene is the one where Takano's working in his garden, and Diane comes up and introduces herself. The second scene is where Diane and two of the townsmen confront Takano about his role in the war. Star here has the scenes copied out for you to use. I take it you already have them memorized?"

I nodded; of course I did. I had, in fact, committed all of Takano's lines to memory; I had already begun to think of them as *my* lines.

"All right then," said Dreyfus, "why don't you two assume your spots?"

I did not quite know how to position myself, but when I saw Miss Michaels go to one corner of the stage, I moved toward the other. I looked back at Dreyfus and his colleagues, who observed me like a jury. "Just relax," said the director, Goodman. "I know it's been awhile. But the screen test process hasn't changed, Jun. It's much the same as it was in your time."

I nodded, but didn't say what I had just then realized—that I'd never before *had* a screen test, or indeed an audition of any kind. Moran discovered me at the Little Tokyo Theater, and after that, all the parts had simply been of-

fered. Nonetheless, I attempted to carry myself as if I had been through this process many times before.

I stood there awkwardly until Goodman called out, "Action!"

Beth Michaels walked toward me, and then she began: "Hello? Excuse me, sir. Are you the new owner of this house? I wanted to introduce myself—my name is Diane Marbury."

I stepped forward to face Miss Michaels and was met with a radiant smile and an outstretched hand. This was all in character, but the warmth of her eyes, the encouragement, seemed genuine. "Hello," I said too loudly. "I am Takano. Yes, I have just moved into this house. And you are my neighbor, with the husband and son."

Once we started, everything changed. For after a few moments of initial discomfort, I remembered what it was like to inhabit a character; to become a being that, until that moment, had existed only on paper, and make him real for the rest of the world. As Miss Michaels and I settled into that first critical scene, I felt the last forty years fall away. Yes, I was doing something different than before—I was using my voice, speaking someone else's thoughts—but the process of becoming a character was exactly the same. Miss Michaels and I had a natural rapport, and we played the parts well, knowing exactly how to look at each other and how to use the space between us. When we reached the end of the scene, she smiled at me brightly, and I was filled with a surge of exhilaration I hadn't known in decades.

But when I looked over at the studio people, they were stone-faced. I must admit that at that moment I felt rather deflated, since I thought we had done so well. Then the casting director, Tony, shook his head.

"I wanted to rib by za rake," he said. "This pu-race is berry du-rye. *Live* by the *lake*," he said. "*Very dry*. We've *got* to do something about that accent."

I did not know how to respond to this, but it was clear

he wasn't talking to me. "Yeah, it's pretty pronounced," said Mr. Gregory, the producer. "Much worse than I expected."

"Well, you know, he was in all those silents," said Tony. "Back then, it didn't matter what they sounded like."

Goodman, the director, glanced up from his notes. "Well, it's not that big a deal to just loop the voice," he said. "But the other problem is that he's so uptight. That whole containment thing might have worked back in the '20s, but for *this* part we need some pizzazz."

With that, they looked up at Miss Michaels and myself, as if they'd just remembered we had functioning ears. Star gave us each a glass of water, Tony played with his hair, and Dreyfus said, "Let's try the second scene."

"I have a question," I interjected, and I was suddenly more conscious of the sound of my voice. Was it heavily accented? I hadn't thought so before. Now I would have to be more careful when I spoke. "This scene, with the townspeople. Do you think Takano is primarily angry or frightened?"

Dreyfus shrugged. "I don't know. You're the Japanese man. What would *you* be?"

"It is not a matter of his being Japanese—and anyway, he's Japanese-*American*. It is a matter of this individual man and his particular character. I myself would be angry, but in truth probably frightened as well. After all, he's a man under unjust suspicion of being a war criminal."

Gregory shot Dreyfus a glance, then looked away.

"What is it?" I asked.

Dreyfus sighed. "Well, see, that's the thing, Nakayama. We've rewritten the story a bit. Ken, Steve, and I all think that it would be more interesting if Takano actually *was* a war criminal. If he was one of the men who led a death march, or something like that. Just think about what it would be like for these poor townspeople to have a monster like that living amongst them."

It took me a moment to find my voice. "But that would defeat the whole point of the film. The point is that people

project their fears on this man unfairly, and that's dependent on the premise—the *unshakable* premise—that this man is not the villain they imagine."

Dreyfus gave Gregory the kind of look that two adults exchange over the head of an impudent child. Then he turned back to me. "Listen. All that psychological stuff is interesting on paper. But the fact is, a war criminal with a secret past is a lot more compelling than a man who has nothing to hide."

"But that is not the film that Bellinger wrote."

"Bellinger sold his script to the studio. It's not his anymore." Dreyfus said this coldly, though when he spoke again his voice was much softer. "Look, Nakayama. I can see it's no use doing this other scene right now. Let's go up to my office and talk. I can tell you where we're thinking about going with this movie, and why. Everyone else, just take a break. We'll be back in half an hour."

I was sure he was taking me away to tell me I would not get the part. But I had concerns that went beyond my own possible involvement, for I was disturbed by the film as he envisioned it. What he was proposing was the kind of villainous role I used to play fifty years ago. I would have hoped there'd been some progress since then.

With a genuine bow to Miss Michaels, and a nod to the others, I followed Dreyfus toward the door. Instead of going to his office directly, however, we headed outside to a different building, where Dreyfus carefully opened a door marked *Stage 3* and indicated that I should follow him in. He took us to the edge of a set. Several actors, who all looked vaguely familiar, were seated around a table, in what appeared to be a holiday dinner scene. We stood watching for a few minutes, Dreyfus gesturing for me to move closer. And what was noticeable about the set—the first working set I'd visited in decades—was how quiet everything was. The director would give directions, but after he yelled "action," nobody spoke but the actors. There was no coaxing

director, no cameraman wrestling with his equipment, no noise from the adjoining set, no live music. It was just the voices of the actors, everyone else working quietly so their sounds would not be captured by the microphone. Watching this, I thought of the irony—silent films had never been silent. Quiet sets like this one had never existed until the advent of sound.

After a few minutes, Dreyfus led us out again, speaking as soon as the door was shut behind us. "That's a little family picture due out next Thanksgiving. I just wanted to show you a modern-day set." With that, we went back into the first building, up some stairs, and into his grandfather's office.

I had not been in this office for forty-two years, and the sight in front of me—much like the rest of the studio that day—was both different and familiar. Where Benjamin's office had been cheerfully untidy, papers falling off desks and scripts piled high, his grandson's was perfectly neat. There was not a loose scrap of paper anywhere, not a thing out of place. Benjamin's office had been a place of excitement and activity. Josh's office lacked that comfort, that casual reality; it was as if the space existed merely for show, and no actual work was conducted there.

He waved me to one of the chairs that faced his desk, then lit a cigarette and sat down. I glanced at the pictures on the walls—there was one of him with Frank Sinatra, another with Susan Hayward, and a shot of him, leering, with Sophia Loren.

"You have worked with some true stars," I ventured, not knowing what else to say.

"Yes, I've been lucky." His voice, however, suggested nothing of the sort, and I realized that he truly believed his enviable position had come about through his own work and skill. He took a long drag on his cigarette, blew out a mouthful of smoke, and leaned forward. "Listen, Nakayama. I'm sorry about all that down there. It wasn't fair of me to

put you through that when I already knew what the result was going to be."

I cupped my hands over my knees and looked at him. He scratched the back of his neck and continued.

"I think you know that I've been asking around about you. I did check out a couple of your old films, and Nick was right, you were great. But success in those old movies doesn't mean that someone can hold their own in the movies of today, you know what I mean? So I wanted to get a better sense of who you were and what you were like to work with. And I ended up uncovering a lot of other stuff too."

My heart began to race, but I didn't speak. Dreyfus took another drag of his cigarette.

"When Nick reminded me of the Tyler murder, I realized I *had* heard your name before—my grandfather mentioned it when I was a kid, and I knew there was some connection. But I *didn't* know that you'd actually worked with Tyler or that you knew the actresses involved with the murder case. When I found *that* out, I figured it might be worth my while to look into things a little more deeply." He tapped his ashes into an ashtray on his desk. "Then I started hearing all these theories about the murder— Elizabeth Banks' drug dealer, Nora Niles' mother, maybe even Nora herself. I asked the archive guys to dig up everything they could on the case, and they came back with a lot, mostly from my granddad's old papers." He took another drag and blew out a mouthful of smoke. "Apparently, Elizabeth Banks was on the outs when Tyler was killed, and Nora Niles wasn't the surefire box office draw that everyone had expected, not to mention that her mother was a pain in the ass—so no one was going to stand and catch them when they started to fall. But there's much more to the story than that."

"Mr. Dreyfus," I said, "I really don't—"

"Let me finish." He sounded more eager now, and I was growing uncomfortable. "Nora Niles' mother wrote

a letter to Leonard Stillman about two months after the murder. Without saying anything too overt, she practically admitted that she killed Tyler. Did you know that?"

I cleared my throat. "About Mrs. Cole? No. Well, I rather suspected."

Dreyfus seemed to find this amusing; he smiled and shook his head. "I don't know if you're aware of the other part. Because the other thing she said was that she'd been furious with Tyler because she thought he'd gotten Nora pregnant. Did you know that?"

I shook my head no.

"Well. Nora was pregnant, and her mother thought that Tyler was the father, and it was only after he was already dead that she discovered it wasn't him." He paused, eyes bright with excitement. "She said it was *you*, Nakayama. She said that *you* got Nora pregnant. I couldn't believe it. I mean, I still can't quite believe it."

I looked away, trying to formulate some kind of explanation. But Dreyfus kept on talking.

"I might have just dismissed it as the rant of some crazy woman out to ruin your career, which I guess she did—she threatened to go public with the whole thing if Perennial hired you again. Then the archive boys dug up Gerard Normandy's journal, and it turns out he knew that Nora was pregnant, because Tyler, or whatever the bastard's name really was, told him before he was killed. He also told Normandy who the father was." He stopped here, whistled, and crushed out his cigarette. "Boy, was Normandy hot at you! You're the one who couldn't keep your pants on, and it's Tyler who got killed, and Tyler wouldn't have touched Nora anyway cause he was a flaming queer." He shook his head in wonder. "You almost brought the house down, Jun—the director, two actresses, not to mention yourself—and the whole town had to deal with the aftermath."

I looked down; I didn't bother to deny it. For while the

truth sounded more lurid coming out of Dreyfus' mouth, it was still, undeniably, the truth. All of my efforts to keep it at bay had come, in the end, to nothing. It was there, it had always been there, and now it had finally come to light. I had not been able to keep the errors of my past concealed, as I had hoped. I had not been able to keep them from myself.

"You were at the heart of a murder mystery," Dreyfus said, not noticing my discomfort. "You had a half-breed baby with a leading actress, and no one ever figured it out! And now here you are, forty-odd years later, trying to make a comeback. Well, Nakayama, I have to tell you, I can hardly believe it. And there's no question about your chances of getting this part."

I forced myself to meet his eyes and accept the bad news head-on. It was only appropriate, I thought. It was what I deserved.

But then he grinned and said, "It's perfect, Jun. It's almost too good to be true. This story's going to make our movie the hit of the year!"

I must have looked bewildered, for now he hit both palms on his desk excitedly and spread his arms out wide.

"We're going to make it public, Jun! We'll leak it! The whole damned thing! Don't you see how brilliant it is? There's an unsolved murder from the early days of Hollywood, plus a mystery child, and it all involves some of the biggest stars of the silent era! And now, forty years later, we've finally solved the murder. Because this is what else I found out, old man. I found out that the police and the District Attorney knew damned well who did it, and that they took payoffs from Harriet Cole for years! Travis Crittendon didn't give a shit about clearing you or Elizabeth Banks; he hated Japs and he thought Elizabeth was a slut. I'm sure you heard that he killed himself twenty years ago, after he lost his last race for D.A. But did you know he did it with a pearl-handled .38 just like the one that Harriet

Cole used to own? He probably got it from her and kept it as insurance, to keep the payments coming. She probably worried every day that he'd expose her." He pounded on the desk again, closed-fisted this time. "Yes, this is a hell of a story, Jun. And the man who was at the center of it all—the man who got the actress pregnant and who should have been the target of the murder—is starring in a new film from Perennial!"

I was speechless. I stared at Dreyfus in complete disbelief.

"The press is going to eat it up," he said. "And the public! Oh, we'll make it sound like you and Nora were secretly engaged so we don't piss off the church ladies in Iowa. But it's going to be huge, and there'll be such a tremendous buzz that they won't be able to sell the tickets fast enough. We're going to be a hit, Nakayama! *You're* going to be a hit! If you think you were big before, that was *nothing* compared to how big you're going to be now. Money, women, all kinds of attention. You've waited *years* to regain your glory, and now you've finally got your chance. You're going to blow them away. You're—"

"Mr. Dreyfus," I interjected as my stomach sank, "I do not wish to revisit that particular time. If the film does not succeed on the basis of its artistic merit, then I'd rather that it not succeed at all."

"Oh, it will, it will, don't worry, old man. This other story will just make people pay attention."

"I don't *want* people to pay attention to that aspect of my life. I don't want them to reduce our careers to a lurid scandal."

He waved his arms, stood up, and then sat down again. "Oh, I know you're shy about it, but really, Nakayama, don't be such a prude. It's a great story, actually, and it makes you kind of a rogue. It gives you a dangerous edge, a sex appeal."

I swallowed hard. I wasn't sure what kind of man this

story made me, but it wasn't a man I liked or wished for others to know. "Mr. Dreyfus, that was a very painful time. I don't care to dredge it up, for any reason."

"I'm sure it was difficult—but what better way to come to terms with it than by turning it into something productive?"

I felt like the walls were closing in around me; like the air was being sucked from the room. I felt an overwhelming urge to be out and away—not just from that room and that distasteful young man, but from his knowledge of my past and from the past itself. I couldn't believe what he was proposing and I couldn't stand to be in his presence, not for a moment longer. "Excuse me, I have to leave," I said abruptly, and then I stood and turned to go.

"Well, call me in a day or two," said Dreyfus, who was clearly nonplussed by my reaction. Perhaps he was accustomed to making awful proposals that people were first offended by and then ultimately accepted. I would have left the room without looking back, but then he added, "Don't you want to know about your child?"

This froze me in my tracks, and I half-turned toward the desk. Of course Dreyfus would have tied up this final loose end; of course he would have followed that part of the story. On the one hand, if I stayed ignorant of the fate of my child—if I could hold on to the possibility that there hadn't *been* a child—it was easier to deny the whole episode. But part of me desperately wanted to know, and now that he'd revealed that there'd indeed been a birth, I didn't want Dreyfus to have more knowledge of my life than I did.

"It was a boy," he said, almost gently. "You have a grown son. He lives in Seven Acres Residence in Pasadena."

This little bit of knowledge made my entire body shake. I managed to ask, "What's his name?"

Dreyfus smiled now, a nearly genuine smile. "Charles Riley. Charles Chaplin Riley."

CHAPTER FIFTEEN
December 10, 1964

Until this morning, I hadn't been to Pasadena since 1947, when I attended an exhibit at the Huntington. The city looks surprisingly unchanged—the Craftsman bungalows are still in pristine condition; the public buildings are all stately and well-kept. Pasadena, unlike Los Angeles, has a reverence for its history, and does not appear determined to reinvent itself or to eliminate all vestiges of its past.

The Seven Acres residence is at the north end of the city, in the foothills. I obtained the address from directory assistance, and rather than giving Charles Riley the chance to say no, I decided to appear with no warning. I was apprehensive, and even as I drove to Pasadena in the car I've been renting—my own car appears to have been stolen from in front of the theater—I wasn't sure if I'd reveal my connection to him. I had no way of anticipating how I would react—whether I would maintain possession of myself, or be so undone by the presence of this man that I would be incapable of normal social discourse. As it turned out, I had little reason to worry.

The first thing I noticed about Seven Acres was its geographical isolation. As I said, it stood in the foothills, with the San Gabriel Mountains looming behind it. When I approached, I saw that the entire property was bound by a black iron fence. At the parking kiosk, a young security guard inquired as to the purpose of my visit, and I indicated that I was visiting Charles Riley. He nodded and handed me a parking pass. "You're aware of all the rules here, I take it."

I did not know what he meant, but I nodded yes. Entering the grounds—I was still several hundred yards from the main building—I saw a group of people walking on the grass. They were moving haphazardly toward the edge of the grounds, and sometimes one of them would try to wander off until a woman, who was clearly the leader, touched him lightly and redirected him to the group. Then the smallest one turned her face to the sky and released a blood-curdling shriek. At this point, I looked away and saw another group of adults seated around a table. Two of them were playing a board game, and the others appeared to be watching. Then one of the players took a handful of pieces and stuffed them into his mouth, which caused his opponent to hit the board and upset the rest of the game. I wondered what kind of place I had come to, and as I got closer to the building, I saw the sign: *Seven Acres Residential Facility: Assisted Living for the Mentally Retarded.*

After I parked, I sat in my car for a moment. I had no idea my child was in a place like this. In the weeks since I had learned of his existence, I had envisioned all sorts of things. He would be in his early forties now—what was his profession? Maybe he was a lawyer or businessman, a physician or a stockbroker. Or maybe he had followed in his parents' footsteps and worked in entertainment, as an executive or writer or agent. Certainly at his age he would have a wife and children. Certainly, then, I would finally have grandchildren.

But as I sat in my car and stared at the sign, my visions of Charles Riley were altered. Or rather, the vision completely dissolved, for I could not conceive of what a grown man's life would be like in a place like the one I had come to.

I got out of the car and entered the building through a large glass double door. At the front desk, an overweight woman greeted me heartily.

"I am here to see Charles Riley," I said.

She smiled. "Really? Well, that's a surprise. Charlie doesn't get any visitors, other than the student volunteers from Pasadena City College. How do you happen to know him?"

I cleared my throat and tried to keep my voice steady. "I'm a friend of the family, you might say."

The woman, whose name tag read *Norma*, pushed a pen and paper toward me. It was a visitors' sign-in sheet, and after a moment's hesitation, I wrote down my real name and address.

"Are you a friend of his birth parents?" Norma asked. "They abandoned him, you know."

I looked down at my hands, uncertain of what to say, but Norma didn't notice my awkwardness.

She leaned toward me and said in a theatrical whisper, "They say his parents were movie stars, and that he was a love child. Do you know if it's true? We've always wondered who his parents might be. I'll bet his daddy was Antonio Moreno; he has the same good looks."

"I don't know," I said. "It was my wife who knew the details."

Norma called for someone to take me back to see him. My escort, a young nurse named Miss Greer, was efficient and businesslike. As we made our way down the hallway, she explained the purpose of Seven Acres.

"What's happened historically is that retarded adults have no real place to go. So we give them a place to live, and structured activities. Some of them are quite self-sufficient; a few even have jobs, doing things like being checkers at grocery stores."

We walked by a middle-aged woman in a wheelchair whose eyes showed no comprehension of her surroundings. "Hello. Hello. Hello," she said.

"Well, hello!" said Miss Greer. "How are you, Annie?"

The woman just grinned, and said even louder, "Hello! Hello! Hello!"

"Tell me," I said, "how did Charles come to be in a place like this?"

Miss Greer sighed. "Well, often, when parents discover that their children are retarded, they don't want them anymore. They grow up in orphanages—special orphanages for children who will never be adopted—and then when they're eighteen, they're sent here. Charlie's a special case. His records indicate that his mother—a woman named Margaret Riley, although she went by something else—did all sorts of crazy things to induce a miscarriage. Someone beat her and kicked her in the stomach repeatedly. She drank heavily or maybe took opiates. This child wasn't wanted, regardless of his mental state. In fact, her behavior during the pregnancy might have contributed to his condition."

I didn't reply. I thought of the long months that Nora spent in hiding, having no contact with anyone but her mother. As far as I knew, Nora had never been especially fond of drink, had not been one for drugs—what exactly had Harriet driven her to, or forced her to endure? What, in my cowardly absence, had I missed? We walked out through the back of the building and onto the grounds. Miss Greer surveyed the lawn, where several residents were sitting.

"What is he like?" I asked. "How aware is he of the world around him?"

Miss Greer smiled warmly. "Oh, he's lovely. Very kind and good-spirited. He'll hug you for no reason, pick you a flower at the drop of a hat. He's not incoherent like some of our other residents. It's more like he's permanently frozen at ten. The other residents love him, and the employees do too. He's really quite a charmer. You'll see."

We set off down the lawn, toward a figure in a chair who was facing the mountains, watching something move in the grass. "Charlie?" she said, when we got within earshot. "Charlie, there's someone here to see you."

He turned around and smiled broadly, and my heart

froze in my chest. This was my own flesh and blood. And if I had harbored any doubt about his parentage before, it vanished in that moment. The curly dark hair, the full cheeks, the bright smile were Nora's. But the square nose and high forehead, the olive skin and oval eyes, were clearly mine. His face was both shocking and completely familiar. It was as if I had contained the knowledge of that face for all of these years, and had spent my life waiting to find it. "Miss Greer!" he said happily. "There are kittens!"

"Oh, Charlie, how delightful!" We stopped at his side, and he pointed out toward the bushes, where several small kittens were scurrying about and climbing on top of each other.

"Charlie, I'd like you to meet someone. This is Mr. Nakayama." Then, turning to me, "This is Charles Riley. He loves cats and big difficult puzzles."

"And baseball," he said, still watching the kittens.

"And baseball!" she added. "Sorry, I forgot. He watches the games on television, and last year we even took a group of residents to a game at Dodger Stadium. I'm not much of a sports fan myself, but Charlie talked about it for months."

"Can you take cats to baseball games?" he asked, looking up at her.

Miss Greer laughed. "Oh, Charlie. I don't think so."

"Miss Greer," I said, "do you mind if I spend a few minutes with Charlie alone?"

She hesitated for a moment, and I could see that in fact she did mind. In the end, however, she shrugged and said, "Just call out if you need anything." Then she left me alone with my son.

I pulled a chair up beside him. He appeared younger than his forty-two years, as if the worries of life that normally cause gray hair and wrinkles had passed him by completely. I did not know what to say to him, and he didn't

seem to notice my presence. He hummed softly, a happy tune that I recognized but could not quite name. Finally, I ventured, "Who's your favorite player?"

"Gil Hodges," he said. I knew too little about baseball to formulate another question, so I asked, "What else do you like, Charlie?"

"I like puzzles, and cats, and baseball," he explained again patiently. "And Bugs Bunny, and tacos. And movies."

I moved a little closer and studied his face. In it, I saw bits of myself, and my brother, and even, faintly, my father. As I looked, my whole life, its choices and errors, seemed to lay itself out plainly before me. "What kind of movies do you like?"

"Pirates. Musicals. Cowboys. 'We don't need no stinkin' badges!'" Then he sang, in a surprisingly beautiful voice, "Maria, I just met a girl named Maria!"

"You're very talented, Charlie."

"I know," he said. "My parents were movie stars."

I must have started to cry at this point, for now he looked at me with a worried expression. "Mister, are you all right?"

"I'm fine, Charlie."

"It's okay to cry. Miss Greer always tells me it's okay for boys to cry."

"Yes, it's okay, it's okay," I said, as if it were he who needed comfort.

We gazed off toward the kittens again; two of them were wrestling and yowling.

"Tell me, Charlie," I asked when I'd regained my composure, "do you ever get lonely out here?"

He looked at me directly now, and I got my first real glimpse of his eyes. They were warm but not entirely occupied; he was like a rough sketch that had never been completed. All those years he had lived so close to me, just a car ride away. All this time I'd had a family and did not even know it. "Oh, no, sir," he said, "I'm very happy. I have

Miss Greer, and Dr. Stevens, and all of my friends. I'm always very busy, you know."

I leaned closer to him, until we were almost knee to knee. "Do you ever wish you had a family?"

"I *have* a family. They all live here."

"No, Charlie," I said, and my intensity was scaring him, so I leaned away again. "Do you ever wish you had a mother and father?"

"I *have* a mother and father. They were movie stars."

"Do you know who they were?"

He stared at me as if I were the one who was perhaps a little slow. "My mother and father," he insisted, as if that clarified the issue. Then he turned toward the cats again and said to me sadly, "I never met them, you know. They were always so busy. They were always too busy for Charlie."

EPILOGUE
May 5, 1966

On the occasion of Charlie's forty-fourth birthday, the staff at Seven Acres threw him a party. They do this for all their residents—I have visited several times when someone else was having a birthday—but in Charlie's case, the celebration was bigger. It was a measure of how well-liked he is that all the people who worked at the facility appeared to be present, even those who were supposed to be off that day. I had not assisted much with the planning—Miss Greer had taken care of that—but I did bring paper hats for everyone to wear, as well as a sheet cake baked by Mrs. Bradford.

She and I arrived early enough to help set up the tables and chairs. Gradually, starting at 2 o'clock, the residents began to gather. Some of them understood the purpose of the party, and smiled and clapped with glee. Others seemed unaware—they were unaware of everything—but still happy to be a part of something festive. Charlie came out at 2:15, and looked truly surprised by the people, the balloons, the pile of gifts on the table. "I'm forty-four! I'm forty-four!" he shouted, clapping his hands, and then he ran about hugging everyone.

Miss Greer had placed the candles in the cake, and it took Charlie three breaths to blow them out. Then he opened the presents—a T-shirt from Miss Greer from her recent trip to the Grand Canyon, a Dodgers cap from the receptionist, and a picture book of cats from one of the social workers. Mrs. Bradford had bought him a puzzle, a 500-piece picture of the California coastline that would

keep him occupied for days. When he opened my gift—a camera—he laughed out loud, and then proceeded to take pictures of everyone present until the entire roll of film had been used. Anticipating his enthusiasm, I had brought an extra roll, and after I changed the film he pointed the camera at me.

"Put on the party hat! Put on the party hat!" he demanded. I declined at first, but after more goading from Charlie, who was joined by Miss Greer and the rest of the staff, I placed the cardboard cone hat on top of my head and slid the elastic band beneath my chin. Charlie jumped up and down, laughing—I gathered that I looked quite silly—and Mrs. Bradford reached up and straightened the hat. Then, smiling at me, she placed a hand on my shoulder and pulled a loose thread from my coat.

Almost a year and a half has passed since I first met Charlie, a period full of unexpected pleasures. After the first time I went to see him, I stayed away for several weeks, shaken by my knowledge of his condition as well as my shame that it had taken me so long to find him. But when I had time to grow accustomed to the idea of him— and time, as well, to recover from my experience with Josh Dreyfus—I wanted to see him again. I have had no real family for all of these years, and now I suddenly had a child, just a few miles away.

I went to see Charlie a second time, about a month after the first. And then I went again two weeks later, and a week after that, until I found myself visiting him regularly, two or three times a week, and arranging all my other activities around those visits. We settled into a comfortable routine—I would join him outside or in the common room, and we would work on a puzzle together or play a board game. He was uncertain of me during the first few visits—a discomfort only augmented, I suspect, by my own nervousness and sorrow—but gradually we grew more at ease with one another. I decided early on that it would be

best not to reveal my connection to him, as this could only cause him pain and confusion. Better that he think of me as an interested friend. And he did. The first time his face lit up when I walked in to see him, I felt a joy deeper than I had ever thought possible.

I didn't realize these visits were having an effect on my demeanor, but one morning, during our usual Saturday breakfast, Mrs. Bradford put her fork down and looked at me. "You've been so happy and preoccupied lately," she said. "You're always sneaking off to secret places, and you even walk like you're twenty years younger. I catch you smiling when you don't know anyone's looking. What's happening, Mr. Nakayama. Are you in love?"

I laughed. "No, Mrs. Bradford. But I cannot deny that my life has changed significantly." I told her then, haltingly, that I had recently discovered the whereabouts of my long lost son. I did not explain the circumstances of his birth or the identity of his mother, nor did I outline how I had remained ignorant of his existence for so long. Mrs. Bradford listened to all of this with obvious interest, but she knew me well enough not to press for details. At the end of my story, I felt a rush of adrenaline, the result of having told someone of Charlie's existence. "I go out to see him several times a week," I said. Then: "Would you like to come with me sometime?"

In truth, I was as surprised by this invitation as Mrs. Bradford—yet once I issued it, I realized it was genuine. I wanted her to come to Seven Acres with me; I wanted to share my son. She agreed to accompany me, and I do not know whether this initial acquiescence was out of politeness or curiosity. I do know that when I took her to Seven Acres and introduced her to Charlie, I was as nervous and proud as any young father would be of a beautiful newborn child. I had not told her—I had not found a way to tell her—what kind of place he lived in. But perhaps she already knew what Seven Acres was, or perhaps she was simply ex-

ceedingly tactful, for when we parked on the grounds and she got her first glimpse of the residents, she did not seem particularly surprised. And when I introduced her to Charlie, who stood and hugged her as if he had known her for years, she smiled and said that she was very glad to meet him, and her words seemed completely sincere.

She now comes with me to Pasadena on a regular basis, in the new car I purchased—a Jaguar Mark II—after the police gave up looking for the Packard. Because we suddenly had something more to talk about, and an activity in common, we found that our Saturday breakfasts were not sufficient. We started having breakfast, and then dinner, two or three times a week, and then, almost without even noticing the transition, we were dining together every day. Since it was expensive to eat out so often, Mrs. Bradford began to have me to her house. Our conversations about Charlie led us to a more personal vein of discussion—she told me more, in those months, of the challenge of being a professional woman in the years she worked for the library; of her marriage to Mr. Bradford; of her complicated feelings of both pride and disappointment in their three adult children. I told her of my family and how I came to the U.S., and finally shared with her some of the details of my career. I never spoke about Nora or the Tyler murder, nor about the circumstances surrounding Charlie's birth. It may be that she had figured it out, or at least discerned that he was not conceived in marriage. She never pushed me for details, never asked about his mother. But our talk inevitably returned to him, his disposition and interests and needs. One evening I expressed my lingering regret that he had not gotten to live a normal life.

"He's happy, Jun," Mrs. Bradford said. "No, he's not going to accomplish great things in the world—but he's cared for, he has friends, and he has no real troubles. And now he's got you, whether he knows what you are to him or not. He goes to sleep every night completely at peace.

How many people can say that? I mean, honestly, Jun. Is it really such a terrible life?"

I have found that, as in this particular instance, Mrs. Bradford possesses genuine wisdom. This past year has been a happy one, and—why not admit it?—part of my gladness has to do with her steadying company. When we take dinner together, when we drive through the Arroyo Seco toward Pasadena and see the San Gabriel Mountains covered with snow, I am sometimes filled with a sense of contentment that I would previously have found unimaginable. And when we sit in the garden with Charlie, working on a puzzle or watching the cats with the fresh smell of eucalyptus around us, I can't imagine how my life could be improved.

One afternoon about two months ago, as Mrs. Bradford and I were driving through Hollywood, we saw a large billboard on the side of the Boulevard. It was an ad for a film called *Stranger in Paradise*, and it wasn't until I saw the glowering image of my old acquaintance Steve Hayashi that I realized it was Bellinger's movie. I was so undone I almost drove off the road, and when we came to a stop at the next traffic light, Mrs. Bradford touched my arm. "What is it?" she asked, and I told her what I'd seen. The movie had been made after all.

In the following weeks, I heard more about *Stranger in Paradise*. The reviews were mixed, but thanks to an aggressive marketing campaign, the film did fairly well at the box office. Dreyfus had the hit he wanted, and while I did see one article that commented on the stereotypically evil figure of Takano, no one else seemed bothered by the characterization. I did not see the film, although I couldn't help but read the articles, and then one day while I was going through the channels on television, I happened upon an interview with Nick Bellinger.

He looked totally different now than he had when I met him. His unruly hair was short and slicked back; his

shabby clothes had been replaced by tailored slacks and a fresh, new button-down shirt. There remained a hint of awkwardness about him, but for the most part his manner was remarkably polished. The interviewer asked how he had conceived of the character of Takano, and Bellinger took a studied pause before answering. "Well, I've always been interested in the legacies of war," he said. "It's often such an intangible thing, and I wanted to see what would happen if an actual, tangible part of the war—a war criminal—was placed in the midst of this small American town."

I shook my head. Bellinger had called me after my meeting with Dreyfus, trying to convince me to take the part. "I know it's different from what we talked about," he pleaded. "But this is our big chance. This is *your* big chance. Once this film is done, then you'll have *other* opportunities, and the real power to affect what kinds of roles you play."

"That is what they told me fifty years ago," I said. I didn't tell him the rest of what I knew—that once you gave up even a little of yourself, it wasn't long before you gave up everything. But he'd learn that for himself soon enough.

It would be dishonest to claim that I did not have mixed feelings; that I didn't experience certain pangs of envy. When I saw Steve Hayashi's face on the billboard, and later, in the paper, I couldn't help but imagine being in his place. I would have conducted interviews and appeared on television. I would have been recognized again on the street. An appearance in that film could have led to more parts, and I might—at long last—have resumed my career. Certainly I was always a stronger actor than Steve, and no matter how limited the role of Takano was, I could have brought to it a level of depth and complexity that was simply beyond his capabilities. On the other hand, I cannot imagine, now, doing a role that I found so distasteful, and there is a particular satisfaction in declining it. One

of the luxuries of being obscure is that one no longer has a status to maintain. And perhaps I was not, despite what I believed, so eager to return to the screen. I did not wish to recreate the characters of my past, and I can't say that I regret my decision. I had finally made a choice that Hanako would be proud of.

Several months before Mrs. Bradford and I saw the billboard, Bellinger's article on the Silent Movie Theater appeared in the *L.A. Observer*. I read through the entire piece right there at the newspaper dispenser, resting the open pages on the top. To my surprise, I found that while Bellinger described the careers of Cecil DeMille, Harold Lloyd, Clara Bow, Gloria Swanson, and Mary Pickford, he made not one mention of me. He even wrote of some of the less well-known players, like Mae Marsh, Constance Bennett, and Lawrence Gray. But Nakayama wasn't mentioned at all. I did not know whether this omission had been his choice, or whether a cut had been made at the behest of the editor. It occurred to me that Dreyfus might have had a hand in the matter, since he was very angry when I declined the part in his film. I cannot deny that I was disappointed by my absence from Bellinger's history. But, along with so many other slights, major and minor, I absorbed it and simply moved on.

The article did have the intended effect of creating publicity for the theater, and, by all accounts from newspapers and from Mrs. Bradford—who once attended with her friend Mr. Weisman—the theater does very good business. One evening, about a month ago, they happened to show my picture *The Patron*. I know this not because I pay attention to their listings, but because I received a letter from a young film student at USC.

"I have heard of you before in my studies of early film," wrote Heather Noguchi, "but I'd never seen one of your movies until last night. Your performance was brilliant, and I plan to find as many of your movies as I can. It makes

me so proud that there was such an accomplished Japanese actor way back in the beginning of Hollywood. I know it could not have been easy. I can't thank you enough for your work, which has reignited my love of film—imagine my happiness when I discovered that your address was listed! I don't want to bother you, Mr. Nakayama. I just wanted to tell you how much I admire your work, and I look forward to seeing more of it."

This letter was, I must admit, a great pleasure. While I used to get mail from fans on a regular basis, I don't think I have ever received a letter that gave me more satisfaction than this one. I told Mrs. Bradford about it, and she seemed delighted as well.

"The funny thing is," I said, "the owners didn't know anything about me. How did they decide to run that picture?"

"I don't know, Jun," she replied, and then she smiled slyly, and I knew exactly where the picture had come from.

Despite my absence from Bellinger's article, despite my misadventure with Dreyfus, I do not regret my encounters with those two young men, which occurred almost two years ago now. For something good has come out of it, something besides the obvious result of my learning about Charlie—the popularity of the O'Briens' theater, and the fact that, after decades when they were totally ignored, people seem interested again in silent films. I do wish, of course, that my own contributions were recognized. But as a true lover of the medium in which I worked, it gives me an almost paternal delight to hear that day after day, night after night, people are lining up to see Gloria Swanson, and Rudolph Valentino, and Charlie Chaplin, and John Gilbert, and Clara Bow, and Harold Lloyd, and Mary Pickford. For silent films were more than just a prelude to talkies. They were also an accomplishment in their own right. What our films lacked in sound they made up for with other things— photography, direction, editing, lighting, storytelling, and,

finally, acting. The best of the silents were works of subtlety and beauty; of fresh, sometimes exhilarating art. There was a purity to silent films that can never be recaptured in this clamorous age of sound effects and talking. We who made them knew that the most vital parts of stories—as of life—can never be reduced to mere words. We understood that moving images are the catalysts of dreams—more eloquent when undisturbed by voices.

And even though my few years in the public eye were followed by decades of obscurity, I harbor no regrets about my career. I had a brief moment of unbelievable glory—but that is more than most people ever have. Certainly my time in movies could have lasted much longer. And of course I wish that—if only once—I could have portrayed a hero. Yet surely there was something of value in the roles I did play. Surely my very presence on the silver screen was itself some kind of victory. If I could never play adventurers like Fairbanks, or lovers like Valentino, at least I played characters of substance. For it is better—is it not?—to attempt to change things slowly than not to strive for progress at all.

It is true that my career and life might have played out very differently. But consider the fates of my closest contemporaries. Ashley Tyler was murdered, Elizabeth Banks killed herself with drink, William Moran died of a heart attack before he was forty, and Nora Minton Niles went mad. It is hard to claim, when one considers their lives, that what happened to me was so awful.

I remember Elizabeth telling me once that she could never go home to her little town in Missouri and resume the quiet life she had fled from. I remember her saying that such a fate seemed worse than death, for once her world had expanded to include so much, the thought of it shrinking again was unbearable. I do not recall what I thought of her feeling at the time, but I certainly don't share her sentiments now. One thing this last year has taught me is the virtue of companionship, the quiet joy of ordinary plea-

sures. I grieve for the way my errors of judgment affected Nora and Elizabeth, and of course I regret the fate of Ashley Tyler. I also mourned for years, selfishly, the destruction of my career, all the pictures that I could have made, and didn't. But it is too late for me to do anything about those past failures except to claim them, accept them as my own. And this I have done and must do in order to accept the recent blessings that life has unexpectedly provided me. For I have come onto something—not totally divorced from my past, but with a life and a value all its own. And I would not trade what I have today, the afternoons with my son, for any measure of fame or success.

It is now a full month into the baseball season, and next week we're taking Charlie to a game. Dodger Stadium sits high on a hill just off the Pasadena Freeway, and on Saturday afternoon we will pick him up and take him there. I am told that the view of the mountains from inside the stadium is lovely, particularly when they're lit orange and red at sunset. I am told that the Dodgers' former star and one of Charlie's heroes, Jackie Robinson, grew up in Pasadena, and perhaps after the game we will try to find his house. The weekend after that we will go to Santa Monica, where a Ferris wheel and several other rides have opened on the pier. Soon after that we will go to the zoo, which has just received two new lions. There appear to be an infinite number of activities in Los Angeles, things I never thought to do until recently. But my son is interested in everything, and wants to go everywhere, and Mrs. Bradford is always happy to join us. She has her own suggestions for places we might visit, and she and Charlie talk excitedly about where they want to go next. My plan is simply to take them wherever they wish. I am sure that they will keep me quite busy.

Author's Note

I would like to thank the following people for their help with this book: Jennifer Gilmore and Kyoko Uchida, my indispensable readers. Richard Parks, for his patience and belief. Johnny Temple, for being the most committed and conscientious publisher any writer could ever hope for. Johanna Ingalls, for her tireless work and unflagging sense of humor.

I am indebted to several written works and their authors, particularly Jeanine Basinger, *Silent Stars*; Kevin Brownlow, *The Parade's Gone By . . .* and *Behind the Mask of Innocence—Sex, Violence, Prejudice, Crime: Films of Social Conscience in the Silent Era*; Roger Daniels, *The Politics of Prejudice: The Anti-Japanese Movement in California and the Struggle for Japanese Exclusion*; Sessue Hayakawa, *Zen Showed Me the Way*; Sidney D. Kirkpatrick, *A Cast of Killers*; John Modell, *The Economics and Politics of Racial Accommodation: The Japanese of Los Angeles 1900–1942*; and Tony Villecco, *Silent Stars Speak: Interviews with Twelve Cinema Pioneers*. I am also grateful to Daisuke Miyao for his brilliant work on Hayakawa, which helped me understand the kinds of roles my own fictional actors would have been able to play. In addition, I learned a great deal from movie magazines of the silent film era, particularly *Photoplay* and *Motion Picture Classic*.

There are a few intentional adjustments in the dates, names, or histories of particular real places, variations from fact that I kept in service to my story. Scenes occur at the Pasadena Playhouse or Runyan Canyon Park, for example, when those places did not actually open until several years after the events of the novel. But by the time I learned the true dates, those settings were so integral to the story and so entrenched in my imagination that I could not bear to find alternative locations.

I am grateful to Jason Reed, who let me stay in his cabin and introduced me to my favorite place on earth. Thanks also to Stephanie Vaughn and everyone else at Cornell, who afforded me the quiet and space—again—I needed to complete this book; and to my friends and colleagues at Children's Institute, who gave me flexibility, understanding, and time.

Finally, my love and gratitude to Patsy Cox—for all the things I've already thanked her for, and the many more I haven't.

Also available from the Akashic Books

SOUTHLAND by Nina Revoyr
348 pages, trade paperback original, $15.95
*WINNER OF THE LAMBDA, FERRO-GRUMLEY, AND ALA STONEWALL
AWARDS; A *LOS ANGELES TIMES* BEST SELLER; EDGAR FINALIST; A
BOOK SENSE 76 PICK; *LOS ANGELES TIMES* "BEST BOOKS OF 2003" LIST

"The plot line of *Southland* is the stuff of a James Ellroy or a
Walter Mosley novel . . . But the climax fairly glows with the
good-heartedness that Revoyr displays from the very first page."
—*Los Angeles Times Book Review*

"Fascinating and heartbreaking . . . an essential part of L.A.
history." —*L.A. Weekly*

LOS ANGELES NOIR
edited by Denise Hamilton
360 pages, trade paperback original, $15.95
*WINNER OF THE SCIBA AWARD; A *LOS ANGELES TIMES* AND SCIBA
BEST SELLER

Brand new stories by: Michael Connelly, Janet Fitch, Susan Straight,
Héctor Tobar, Patt Morrison, Robert Ferrigno, Gary Phillips,
Christopher Rice, Naomi Hirahara, Jim Pascoe, and others.

"Akashic is making an argument about the universality of noir;
it's sort of flattering, really, and *Los Angeles Noir*, arriving at last,
is a kaleidoscopic collection filled with the ethos of noir pio-
neers Raymond Chandler and James M. Cain."
—*Los Angeles Times Book Review*

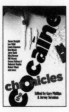

THE COCAINE CHRONICLES
edited by Gary Phillips and Jervey Tervalon
270 pages, trade paperback original, $14.95

Brand new stories by: Lee Child, Nina Revoyr, Laura Lippman,
Susan Straight, Ken Bruen, Jerry Stahl, Bill Moody, Emory
Holmes II, Deborah Vankin, Detrice Jones, and more.

"*The Cocaine Chronicles* is a pure, jangled hit of urban, gritty, and
raw noir. Caution: These stories are addicting."
—Harlan Coben, award-winning author of *Just One Look*

SONG FOR NIGHT by Chris Abani
164 pages, trade paperback original, $12.95

"*Song for Night* contains, at once, an extraordinary ferocity and a vulnerable beauty all its own."
—*New York Times Book Review* (Editors' Choice)

"What makes this book a luminous addition to the burgeoning literature on boy soldiers is the way the Nigerian author both undercuts and reinforces such hopeful sentiments . . . The lyrical intensity of the writing perfectly suits the material."
—*Los Angeles Times Book Review*

WITH OR WITHOUT YOU
by Lauren Sanders
318 pages, trade paperback original, $14.95

"A wickedly crafted whydunit . . . Sanders shows a surprising ability to simultaneously make you feel infuriated with and sorry for her borderline-schizo heroine." A-
—*Entertainment Weekly*

"Sanders' vibrant, vigorous second novel is a sendup of America's obsession with pop culture, B-list celebrities, and prison life . . . In lyrical potent prose, Sanders navigates the terrain of loneliness, obsession and desperation with the same skillful precision as her vulnerable, calculating protagonist."
—*Publishers Weekly* (starred review)

THE UNCOMFORTABLE DEAD
by Subcomandante Marcos & Paco I. Taibo II
268 pages, trade paperback original, $15.95

"Great writers by definition are outriders, raiders of a sort, sweeping down from wilderness territories to disturb the peace, overrun the status quo and throw into question everything we know to be true . . . On its face, the novel is a murder mystery, and at the book's hear, always, is a deep love for Mexico and its people." —*Los Angeles Times Book Review*